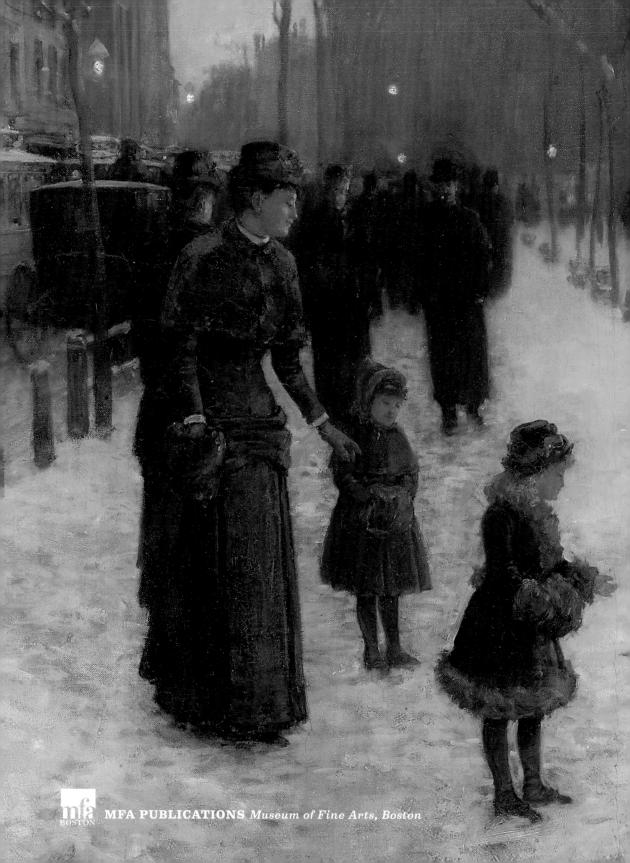

a guide to the collections of the museum of fine arts, boston

Entries by

Gilian Shallcross

Introduction by

Malcolm Rogers

MFA Publications

Museum of Fine Arts, Boston

465 Huntington Avenue

Boston, Massachusetts 02115

www.mfa.org/publications

© 2009 by Museum of Fine Arts, Boston Library of Congress Control Number: 2008941976 ISBN 978-0-87846-730-3

All rights reserved. No part of this book may be reproduced in any form or by any electronic or mechanical means, including information storage and retrieval systems, without written permission from the publisher, except in the case of brief quotations embodied in critical articles and reviews

The Museum of Fine Arts, Boston, is a nonprofit institution devoted to the promotion and appreciation of the creative arts. The Museum endeavors to respect the copyrights of all authors and creators in a manner consistent with its nonprofit educational mission. If you feel any material has been included in this publication improperly, please contact the Department of Rights and Licensing at 617 267 9300, or by mail at the above address.

While the objects in this publication necessarily represent only a small portion of the MFA's holdings, the Museum is proud to be a leader within the American museum community in sharing the objects in its collection via its Web site. Currently, information about more than 330,000 objects is available to the public worldwide. To learn more about the MFA's collections, including provenance, publication, and exhibition history, kindly visit www.mfa.org/collections.

For a complete listing of MFA publications, please contact the publisher at the address above or call 617 369 3438.

Additional material adapted from

Masterpiece Paintings from the Museum of
Fine Arts, Boston. Copyright © 1986 by

Museum of Fine Arts, Boston, in association
with Harry N. Abrams, Inc.; American

Decorative Arts and Sculpture: MFA

Highlights. Copyright © 2007 by Museum of
Fine Arts, Boston; and Arts of Japan: MFA

Highlights. Copyright © 2008 by Museum of
Fine Arts, Boston.

All photographs are by the Imaging Studios. Museum of Fine Arts, Boston, unless otherwise noted.

Front cover: Winslow Homer, Boys in a

Pasture, 1874 (detail), p. 337

Back cover: Vincent van Gogh, Postman

Joseph Roulin, 1888 (detail), p. 258

Frontispiece: "Barna da Siena," The Mystic

Marriage of Saint Catherine, about 1340
(detail), p. 163

Pages 2–3, 5: Childe Hassam, Boston Commo

Edited by Matthew Battles
Copyedited by Patty Bergin
Designed by Lisa Diercks and
Terry McAweeney
Series design by Lucinda Hitchcock
Produced by Terry McAweeney and
Jodi M. Simpson
Printed and bound at CS Graphics PTE LTE
Singapore

Trade distribution:
D.A.P. / Distributed Art Publishers
155 Sixth Avenue, 2nd floor
New York, New York 10013
Tel. 212 627 1999 Fax 212 627 9484

REVISED EDITION, 2009 Printed in Singapore This book was printed on acid-free paper.

Contents

The Museum of Fine Arts, Boston: Past, Present, and Future 7
Malcolm Rogers, Ann and Graham Gund Director

- 1 Art of Egypt, Nubia, and the Ancient Near East 17
- 2 The Classical World 55
- 3 Art of Asia 91
- 4 Art of Oceania and Africa 147
- 5 European Art to 1900 157
- 6 Native Art of the Americas 265
- 7 American Art to 1900 279
- 8 The Modern World 349

Figure Illustrations 389

Index of Artists and Works 391

Credits 399

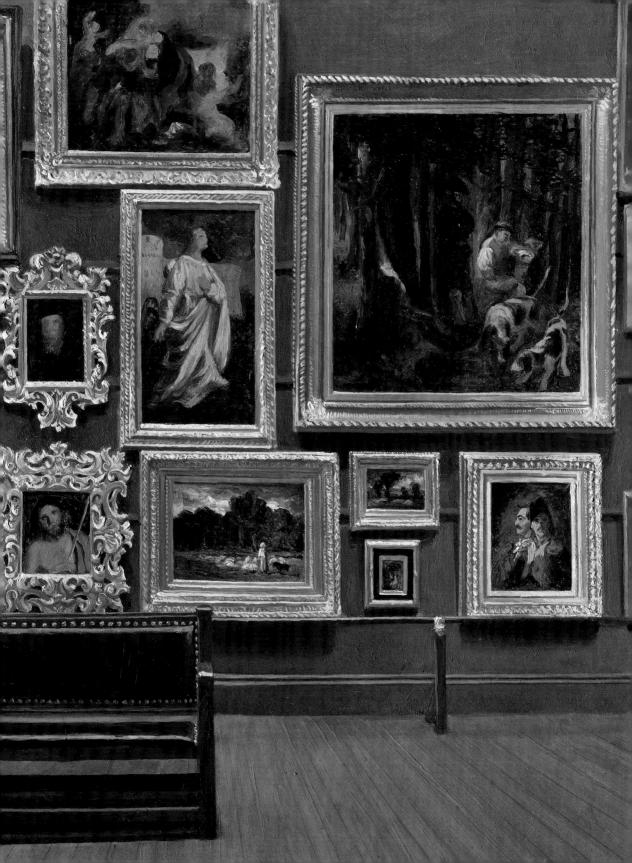

The Museum of Fine Arts, Boston: Past, Present, and Future

Malcolm Rogers Ann and Graham Gund Director

Two truths have motivated me in all that I have done in my professional life—as a museum curator, and later as an administrator and director. First: that great works of art embody much of what is best and most enduring in the human spirit, and have the ability to inspire, to delight, and to comfort. And second: that great institutions such as the Museum of Fine Arts, Boston, are crucial components of a civilized society, resources for every member of the community, and indeed for the citizens of the world.

The Museum houses and preserves one of the world's greatest collections of art. It serves as a resource for those already familiar with art, as well as those for whom art is a new experience. And through exhibitions, programs, research, and publications, it seeks to encourage inquiry and to heighten public understanding and appreciation of all the arts.

The Museum has been proud to share information about its collection since publishing its first handbook in 1872. In the early years of our history, handbooks most often were purchased by visitors who wanted to learn more about the impressive objects they had seen in the galleries. As the nineteenth century turned into the twentieth and the Museum's reputation spread internationally, the audience for these publications expanded far beyond our visitor base. Readers who had never visited the MFA purchased guides to acquaint themselves with its riches. In this new, extensively revised, and redesigned edition, we offer access to the best of these riches, from longstanding treasures to our most notable recent acquisitions.

Among the Museum's most valuable treasures are its curators: their knowledge and research are essential components in preparing a guide such as this. The works of art illustrated here were selected by them, in many cases because these works represent the very best of a period, genre, or culture. Many also reveal something important or interesting about the artist who created the work, or the

fig. 1 The picture gallery in the MFA's original Copley Square building, painted by Enrico Meneghelli in 1879.

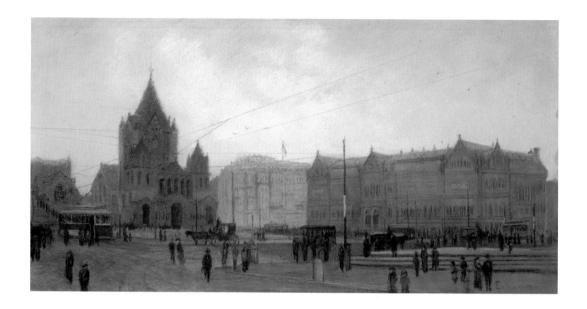

collector who purchased it. Through rich critical and historical detail—accompanied by superb photography from the Museum's Imaging Studios—readers will learn the fascinating stories behind hundreds of extraordinary works of art.

The MFA has long been, and remains, committed to producing exceptional and beautiful publications, which are an important aspect of our mission of sharing our collections with a global audience. More recently, technological advances have given us another very powerful tool in that effort: the Internet. Over the past several years, the MFA has taken a leadership position in the museum world by utilizing twenty-first-century resources to develop collection information beyond the scope of traditional published guides. In December 2000, the MFA became one of the first art museums to offer public access to its database: our Web site, www.mfa.org, provides information about thousands of works of art, with numerous photographs to illustrate them. In the next few years, that database grew steadily, garnering great public support. In 2005, we decided to make available online the record for *every* work of art we own.

By offering access to all of our object records, we have reached a level of accessibility that is unmatched among museums. We are committed to freely providing information about our holdings, and today are one of the few museums in the world to offer extensive provenance about our collections online. By opening our database to the public, we have empowered researchers from across the nation and around the world to begin their own voyage of discovery into the Museum's collection.

fig. 2 Copley Square, in
Boston's Back Bay, was the
first home of the MFA. This
view of the square in 1911,
painted by K. Calhoun,
shows the MFA (right) and
Trinity Church (left).

A Brief History of the Museum

The Museum of Fine Arts first opened its doors to the public on Independence Day, July 4, 1876, our nation's centennial. The red-brick Gothic Revival building, designed by the firm of Sturgis and Brigham, was one of a number of institutions that had been encouraged to build on land in the recently filled Back Bay. The Museum soon found itself in distinguished architectural company, with two of the finest buildings in America, H. H. Richardson's masterpiece, Trinity Church (1872–77), and McKim, Mead, and White's Boston Public Library (1888–95) to its northeast and northwest, respectively.

Recognizing the potential of the proximity of the three institutions, in 1883 the city removed a street to create Copley Square as the focal point of the Back Bay. The square, named for the great Boston painter John Singleton Copley, is now recognized as one of the most distinguished public spaces in America.

Even on its opening, the Museum already owned many notable works of art. These were acquired primarily by gift and bequest from public-spirited Bostonians; it would be decades before the new Museum had sufficient funds available to purchase works. Ranging across geography and time, many of these early acquisitions retain their prominence in the collections today. Among them are Washington Allston's *Elijah in the Desert*, the first oil painting to enter the collection; Thomas Crawford's marble *Hebe and Ganymede*; two monumental paintings by François Boucher; seven Egyptian mummies; and the Eighteenth-Dynasty sculpture of the lion-headed goddess Sekhmet. Other outstanding works, notably J. M. W. Turner's harrowing *The Slave Ship*, were lent by private collectors.

As the quality and size of the collections grew, the responsibility for enhancing and shaping the Museum's holdings was transferred from the trustees to a professional curatorial staff. The first curatorial department, the print department, was established in 1887. It was followed in the same year by the department of Classical art, then by departments of Japanese art in 1890, Egyptian art in 1902, and Western art in 1908.

In 1897 the Museum acquired the print collection of Henry F. Sewall of New York. Comprising some twenty-three thousand impressions, the collection systematically represented the history of Western printmaking from its origins through the eighteenth century. The purchase was made possible by the bequest of \$100,000 from Harvey D. Parker, the founder of Boston's Parker House Hotel and the eponym of the Parker House dinner roll.

The Classical collection owes its shape to Edward Perry Warren, scion of a wealthy Boston paper manufacturing family. Warren lived in Sussex in the British countryside, and virtually cornered the market in classical antiquities at

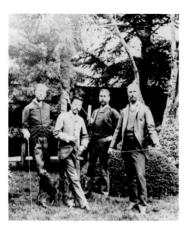

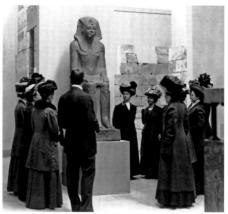

fig. 3 The Bostonians Morse, Fenollosa, and Bigelow traveled throughout Japan with their translator and fellow connoisseur Okakura, searching out works of art. The four are shown here in Japan in 1882.

fig. 4 Visitors to the MFA's Egyptian gallery in 1910 view a seated statue of Ramesses II.

the turn of the century. Bostonian prudishness had frustrated Warren—he would later commission a copy of The Kiss from Auguste Rodin—and he now took a certain pleasure in submitting to the Museum Greek vases whose decoration was frankly erotic. The Museum responded by editing compromising areas with strategically placed daubs of paint (removed in recent years). Warren directed works of major significance to the Museum between 1895 and 1905, to be purchased and donated by local supporters, notably Catharine Page Perkins, Henry Lillie Pierce, and Francis Bartlett.

The Museum's outstandingly important collection of Japanese art is largely the work of three nineteenth-century Bostonians: Edward Sylvester Morse, Ernest Fenollosa, and William Sturgis Bigelow. Each came to collecting in a different way. Morse, a zoologist, traveled to Japan in 1877 to study marine brachiopods, and became fascinated with Japanese ceramics, which he collected systematically by region, city, and kiln, garnering a collection of some six thousand. Fenollosa went to Japan to teach philosophy and political economy at Tokyo University in 1879 on Morse's recommendation, and quickly amassed a collection of around two thousand Japanese paintings. Bigelow first encountered Japanese art in Paris, while studying under Louis Pasteur. He subsequently heard Morse lecture in Boston, traveled with him to Japan in 1882, and began to build a collection that eventually comprised some fifteen thousand paintings, sculptures, and decorative works, as well as tens of thousands of prints, drawings, and illustrated books. As early as 1882, the three men were discussing among themselves their hope that the Museum of Fine Arts would become the eventual repository of their collections. Their dreams were realized in 1890 when the Museum opened a wing to house their collections, which were subsequently acquired by purchase and gift.

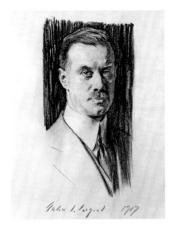

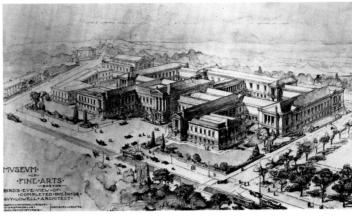

The Museum's collection of Egyptian art is the result of systematic archaeological excavations by the joint Harvard University–Boston Museum of Fine Arts Expedition between 1905 and 1942. The key figure in this was George Reisner, who in 1903, while working for a University of California expedition funded by Phoebe Apperson Hearst (the mother of William Randolph Hearst), was granted a concession to excavate the Third Pyramid and funerary temple of Mycerinus at Giza, and the northern third of the west cemetery. When Mrs. Hearst withdrew her support, Harvard and the MFA joined forces to continue funding Reisner's work. His finds at sites throughout Egypt and the Sudan were shared between the Museum and the Egyptian government.

By the early 1890s, the growing size of the art collection, along with concerns over danger of fire and loss of light caused by the buildings that had grown up around Copley Square, prompted the trustees to search for a larger site, one close to the downtown area but safe from encroachment. In 1899, they purchased twelve acres on Huntington Avenue for \$703,000.

The trustees, who had looked to European models when designing the building in Copley Square, were keenly aware of their opportunity to conceive and construct a building that would not only be ideal for their own collections, but also would establish a model for future museum structures. They explored contemporary theories of museum design, visited more than one hundred European museums, and built an experimental gallery on the Huntington site in order to test a range of methods of gallery illumination.

The design of the building was entrusted to the Boston architect Guy Lowell, whose 1907 master plan evokes his formal training in the Beaux-Arts tradition. His design is a remarkable realization of the committee's guiding principles, and provided a flexible framework for future growth. This proved fortunate, for very

fig. 5 Boston architect Guy Lowell, sketched by John Singer Sargent in 1917, designed the first section of the MFA's Huntington Avenue building.

fig. 6 Lowell's 1907 master plan both suited the MFA's immediate needs and was flexible enough that the building could be added to when funds were raised.

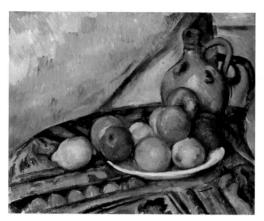

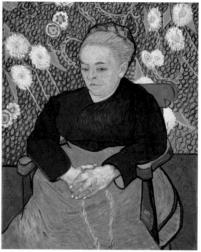

soon after the first section of the Huntington Avenue building opened in November 1909, Mrs. Robert Dawson Evans donated one million dollars for the construction of a second section in honor of her late husband. The Robert Dawson Evans Memorial Galleries for Paintings, built along the Fenway portion of the MFA property, opened in 1915. The Evans wing increased the size of the Museum by more than 40 percent, and provided remarkable new galleries for the display of paintings and prints.

Subsequent additions to the building furthered Lowell's plan. In 1928, a wing for the display of the decorative arts of Europe and America was opened on the east side of the Museum. The decorative arts wing provided a second link between the two existing sections of the building, and created the first of Lowell's two planned internal garden courtyards.

The Museum's Japanese collections continued to grow in the new Museum. The brothers John T. and William S. Spaulding were entranced by a Japanese print by Hiroshige given to them at the end of a visit to Japan in 1909. In 1913. they commissioned Frank Lloyd Wright to travel to Japan in search of prints to build their collection, which came to number about six thousand impressions, notable for their superb state of preservation. The Spauldings donated the collection in 1921. John T. Spaulding went on to acquire a splendid group of Impressionist paintings, including still lifes by Manet and Cézanne, six Renoirs, and two van Goghs, which he bequeathed to the Museum in 1948.

While many of the Museum's collections derived their overall shape and character from the vision of one or a handful of collectors, the European paintings collection represents a broader spectrum of differing viewpoints. A large num-

figs. 7 and 8 Collector John T. Spaulding became closely associated with the MFA in the 1920s and 1930s, loaning paintings for exhibitions and corresponding with curators. On his death in 1948, Spaulding bequeathed his entire art collection to the MFA, including this still life by Cézanne and this portrait of Augustine Roulin by van Gogh.

ber of individual donors have had a significant influence on various aspects of the collection—Quincy Adams Shaw, for example, who gave sixty-five paintings and pastels by Jean François Millet, and the Edwards, Paine, Tompkins, and Spaulding collections of French Impressionism and Post-Impressionism, to name only a few. And all but two of the Museum's thirty-eight paintings and pastels by Claude Monet were gifts from collectors—no fewer than twenty of them, some of whom had acquired the works directly from the artist in Giverny.

By contrast, just two collectors, the remarkable husband-and-wife team of Maxim and Martha Karolik, transformed our holdings of the arts of the Americas. The donation of their collections—eighteenth-century American art in 1939, nineteenth-century American paintings in 1945, and nineteenth-century American watercolors and drawings in 1962—helped give the Museum's remarkable holdings of American art their breadth and depth. The Karolik collections were formed in sequence, in consultation with the Museum's curators, and were earmarked for the Museum from the start. In a letter of 1945 announcing the gift of the paintings collection, the Karoliks noted, "We discarded the motto of the fashionable connoisseur: 'Tell me who the painter is and I will tell you whether the painting is good.' Our motto was: 'Tell me whether the painting is good and I will not care who the painter is.'"

What the Karoliks were to American art, the New York attorney Forsyth Wickes was to French art of the eighteenth century. Although his collection was installed at his home in Newport, he had never visited Boston. Perry Rathbone, then director of the Museum, fondly recalled a conversation in which Wickes asked if the Museum had any columns. Rathbone assured him that, indeed, the Fenway facade of the Museum featured twenty-two Ionic columns. Evidently reassured, Wickes bequeathed his collection of some eight hundred works of art to the Museum in 1965. The Museum, in turn, undertook its first expansion in more than forty years, to provide space in which to house the Wickes collection.

Forsyth Wickes was not the only non-Bostonian to enrich the collections of the MFA. Theodora Wilbour, who, like Wickes, never visited the Museum, in 1933 began a series of anonymous gifts of English silver in memory of her mother, and of coins and medallions in memory of her sister. These gifts continued until her death in 1947, upon which she bequeathed some \$700,000 to establish two endowed funds that continue to bear her name and to permit significant acquisitions of her beloved English silver and Classical coins. In 1943, Elizabeth Day McCormick of Chicago gave the Museum her splendid collection of textiles and costumes, with its unique strength in English embroidery of the Elizabethan and Stuart periods.

An important moment in the history of photography was the acquisition in 1924 of a gift of twenty-seven photographs by Alfred Stieglitz. Ananda Coomaraswamy, then Keeper of Indian and Muhammedan Art at the Museum, was a friend of Stieglitz and an amateur photographer himself. Coomaraswamy solicited the gift and convinced the trustees, not without some difficulty, that photography belonged among the Museum's collections. Stieglitz personally selected the photographs, which were augmented after his death by forty-two additional prints selected by his wife Georgia O'Keeffe. These were the first photographs accepted as works of art by a major American museum.

Some dominant personalities in the history of the Museum's collections spanned more than a single department or collection. For instance, Denman Waldo Ross, who is primarily associated with the Asian and textile collections, has the distinction of having been a significant donor to every department in the Museum. His wide-ranging gifts include the seventh-century Chinese Thirteen Emperors scroll; inlays for the eyes of a mummy case; three paintings by Claude Monet; and two spectacular pastels over monotype by Edgar Degas, acquired as contemporary art and given during the artist's lifetime. Ross taught theory of design at Harvard and was a trustee of the MFA for four decades. His donations to the Museum, amounting to over eleven thousand objects, range across geography, culture, and time period, exemplifying his sole collecting criterion: visual quality. He expressed his goals in a 1913 essay: "We were not archaeologists. We were not historians. We were simply lovers of order and the beautiful as they come to pass in the works of man supplementing the works of Nature.... Our aim was to select and collect the best."

This sentiment has continued to inspire benefactors, too numerous to mention here, throughout the late twentieth century and into the twenty-first. The Museum of Fine Arts was founded by public-spirited Bostonians dedicated to

fig. 9 The Fenway entrance to the MFA, part of Guy Lowell's original design, opened in 1915. It was closed in the 1970s but was reopened after extensive renovations on June 20, 2008, as the State Street Corporation Fenway Entrance.

fig. 10 The MFA's Huntington Avenue Entrance opened to the public in 1909. Cyrus E. Dallin's 1909 bronze sculpture Appeal to the Great Spirit was lent to the Museum in 1912 by the artist and purchased the next year by subscription.

acquiring great works of art and giving them a permanent home, where they would be accessible to everyone. As it has from the beginning, the Museum continues to hold its collections in trust, so that visitors today and for years to come may appreciate and benefit from the generosity of the many donors—past, present, and future—who help us build and maintain that trust.

Along with new avenues of collecting, new strategies were developed to guide the Museum's future. The Museum building was expanded several times in the later half of the twentieth century. In 1970, an addition on the west side of the building fulfilled Lowell's initial concept of enclosing internal courtyards on the east and west with a complete circuit of galleries. And in 1981, the renowned architect I. M. Pei created a landmark addition, also on the west side of the building. The new West Wing brought architectural variation and excitement, with a modernist flair, to the MFA. More recently, the firm of Foster and Partners was chosen to create a plan that would turn our strategic goals for the new century into architectural reality.

The highlights of the Foster and Partners master plan are a spectacular new wing for Art of the Americas, a dramatic glass-enclosed courtyard, a vibrant new visitor center, and expanded and renovated facilities for special exhibitions, as well as for our European, contemporary, and ancient world collections. Referring back to Guy Lowell's original architectural intent, Foster has brought new life to our historic building by reorienting the visitor experience along its north-south axis, from the Huntington Avenue Entrance to the State Street Corporation Fenway Entrance.

In 2007, a further, unexpected opportunity arose for the Museum. The Forsyth Institute, the MFA's neighbor directly to the east, decided to relocate and sell its landmark building. Recognizing this as a singular opportunity to preserve an historic landmark while acquiring a space for much needed future expansion, the Museum purchased the Forsyth building in September of that year. As of this writing, an extensive study is under way to determine how best to transform this sister architectural gem of the Fenway into a vital part of the Museum and of the community.

The Museum of Fine Arts is a rich whole comprising many parts. This brief introduction has focused on pioneering and formative donations, but there are countless other gifts, both of individual works of art and of entire collections, that have enriched our holdings and led us into new territories. The Museum's physical home and its relationship with its neighboring communities have developed too. In the pages that follow, you will learn more about some of the fascinating individuals, objects, and events that have made the Museum what it is today.

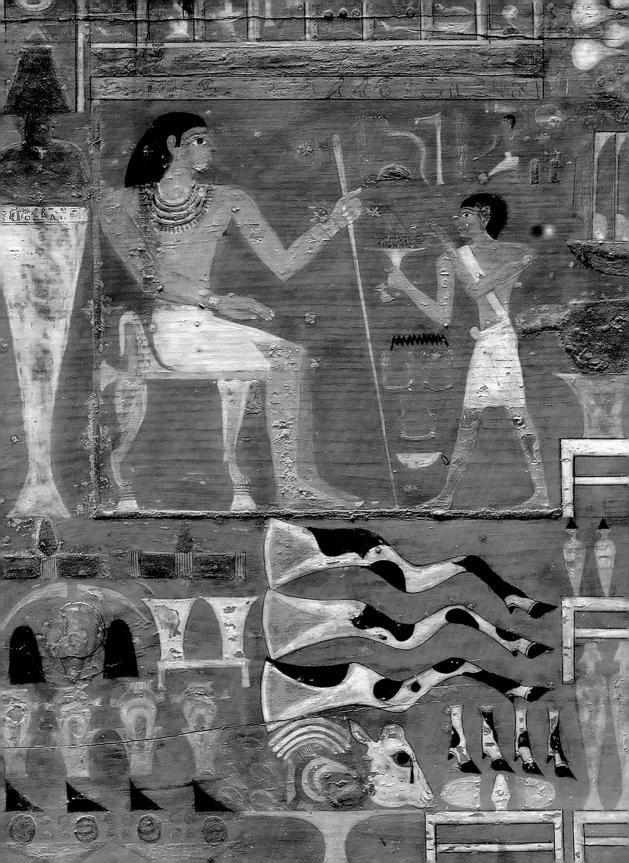

art of EGYPT, NUBIA, AND THE ANCIENT NEAR EAST

King Menkaure (Mycerinus) and queen

Egypt (Giza, Valley Temple of Menkaure) Old Kingdom, Dynasty 4, reign of Menkaure, 2490-2472 B.C.

The Valley Temple at Giza, just outside Cairo, was part of the pyramid complex of King Menkaure (Mycerinus), which also included one of the three great pyramids. It was excavated by George Andrew Reisner and the Harvard University–Boston Museum of Fine Arts Expedition between 1908 and 1910, and as Reisner noted in his journal, it was here that the extraordinary statue of Menkaure and his gueen was unearthed on January 18, 1910: "In the evening, just before work stopped, a small boy . . . appeared suddenly at my side and said 'come.' . . . the female head of a statue (% life size) of bluish slate had just come into view in the sand . . . immediately afterward a block of dirt fell away and showed a male head on the right—a pair statue of a king and queen. A photograph was taken in failing light and an armed guard of 20 men put on for the night."

This serene and idealized royal image is one of the finest pieces of Egyptian sculpture known. Made of stone, its surface is subtly modeled and gives a very real sense of bodily form and structure. Menkaure assumes the classic pose for men in Egyptian art, striding forward, his left leg advanced, arms rigid by his sides. He wears the royal headcloth (nemes), kilt. and false beard. The queen also steps forward, clasping Menkaure in a traditional gesture of intimacy and

Working with ancient texts and archaeological evidence, scholars have constructed a chronology from about 3100 B.C. to the country's conquest by Alexander the Great in 332 B.C. Egyptian history is subdivided into Kingdoms (times of strong central government and political stability) and Intermediate Periods (times when central authority collapsed). These divisions are further broken down into thirtyone dynasties, each comprising a series of reigning pharaohs. Menkaure reigned between 2490 and 2472 B.C., in Dynasty 4 of the Old Kingdom.

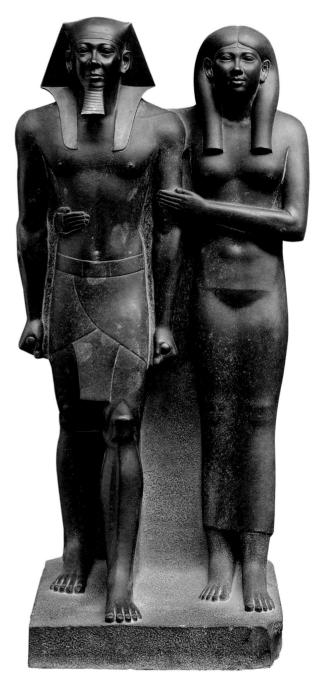

Greywacke H. 56 in. [142.2 cm] Harvard University-Boston Museum of Fine Arts Expedition 11.1738

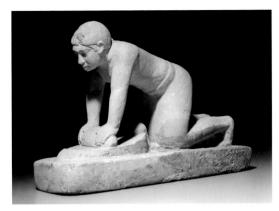

Woman grinding grain Egypt (Giza, tomb G 2185) Old Kingdom, Dynasty 5, 2500–2350 B.C.

Statuettes of people engaged in such domestic tasks as baking, weaving, and brewing were occasionally placed in tombs in the belief that they would magically become real to provide for the ka (that part of the human spirit that needed to be fed and sheltered) and to ensure the well-being of the deceased in the afterlife. This kneeling woman grinding grain for bread wears a kilt tied up at the side and a cloth to cover her hair. Flour spills over the front of the grindstone, while behind the stone is a part-empty sack of grain. Carved from limestone, this figure would originally have been covered with a fine layer of plaster and then painted.

Limestone
L. 12¼ in. (30.9 cm)
Harvard University-Boston Museum of Fine Arts Expedition
12.1486

Ptahkhenuwy and his wife

Egypt (Giza, tomb G 2004)

Old Kingdom, mid- to late Dynasty 5, 2465-2323 B.C.

Although most Egyptian sculptures were originally painted, the color rarely survives. However, this statue is exceptionally well preserved. Ptahkhenuwy and his wife, wearing wigs and beaded collars, are painted in colors standard in Egyptian art: red for the skin of men and yellow for that of women. They stand in a pose very similar to that of King Menkaure (Mycerinus) and his queen, but they are not royal: the inscription on the statue's base identifies Ptahkhenuwy as "supervisor of palace retainers"; his spouse (whose name is indecipherable) is termed "his beloved wife." This statue was found in a *serdab*, a hidden chamber within the tomb that had a window through which the figures could "see" into the adjacent chapel, where gifts of food and drink were left for them.

Painted limestone H. 27% in. [70.1 cm] Harvard University– Boston Museum of Fine Arts Expedition 06.1876

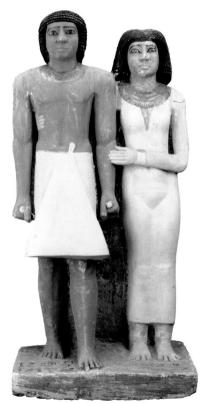

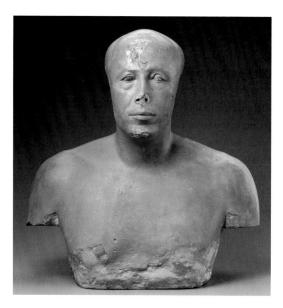

Bust of Prince Ankhhaf Egypt (Giza, tomb G 7510) Old Kingdom, Dynasty 4, reign of Khafre (Chephren), 2520-2494 B.C.

This portrait bust is one of the most remarkable creations in all Egyptian art. It is a true likeness, more naturalistic than the simplified and summarizing "reserve heads." Here the sculptor has captured the irregularities of Ankhhaf's skull, the lines beside his nose, the soft bags under his eyes, creating an indelible and very specific impression of maturity and intelligence. These telling details are modeled in a coat of plaster that covers the limestone core.

Ankhhaf was among the most important men of his time, serving as vizier, or senior administrative official, under King Khafre. The bust was found in Ankhhaf's tomb chapel, but its function is unknown. Although it was never part of a larger statue, it may have stood on a separately carved base that included arms stretched forward to receive offerings.

Limestone and plaster H. 19% in. (50.6 cm) Harvard University-Boston Museum of Fine Arts Expedition 27.442

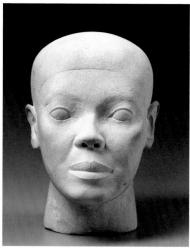

"Reserve head" of a woman Egypt (Giza, tomb G 4440) Old Kingdom, early Dynasty 4, 2551-2494 B.C.

The purpose of the "reserve heads" that were placed in Egyptian tombs remains a mystery, although many scholars believe they were regarded as potential substitutes for the mummy. If the mummy or its head (essential for continued existence in the afterlife) was damaged, the spirit of the deceased could inhabit the "reserve head" and live on. Most of the thirty surviving "reserve heads" were discovered at Giza in the vast cemetery used for courtiers and high officials of the Fourth Dynasty. Six of these sculptures are in the Museum, and no two are alike. They are modeled in broad, simplified forms, but in each case the sculptor has captured the individual's essential, identifying features. Such naturalism is rare in Egyptian art, where figures tend to be generalized and the subjects identified by inscriptions.

Limestone H. 11³/₄ in. [30 cm] Harvard University-Boston Museum of Fine Arts Expedition 14 719

Triad of King Menkaure (Mycerinus) with the goddess Hathor and the deified Hare nome

Egypt (Giza, Valley Temple of Menkaure) Old Kingdom, Dynasty 4, reign of Menkaure, 2490–2472 R.C.

Found in one of the temples dedicated to the cult of Menkaure (Mycerinus), this magnificent sculpture of gray stone demonstrates the close relationship that the Egyptians perceived between their gods and their kings, whom they also believed to be divine. The central figure is the cow goddess Hathor, identified by the horns surrounding a sun disk on her head. Expressing her devotion to the pharaoh (on her left, wearing the crown of Upper Egypt), Hathor circles his waist with one hand and lightly touches his arm with the other. The third figure personifies a nome, or province, and her symbol, the hare, rises above her head. In her left hand she carries the ankh, symbol of life, as a gift to the king. On the base of the sculpture, an inscription reads: "The Horus (Ka-khet) King of Upper and Lower Egypt, Menkaure, beloved of Hathor, Mistress of the Sycamore. Recitation: I have given you all good things, all offerings, and all provisions in Upper Egypt, forever."

Greywacke
H. 33½ in. [84.5 cm]
Harvard University-Boston Museum of Fine
Arts Expedition 09.200

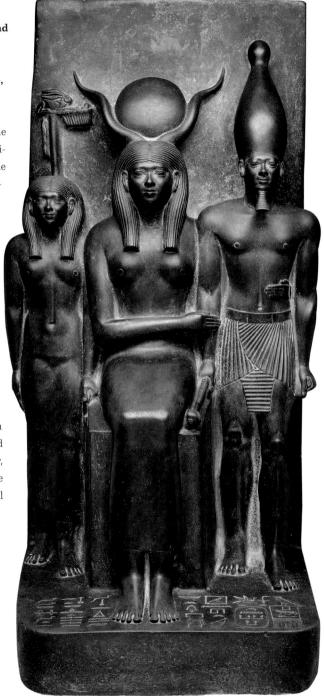

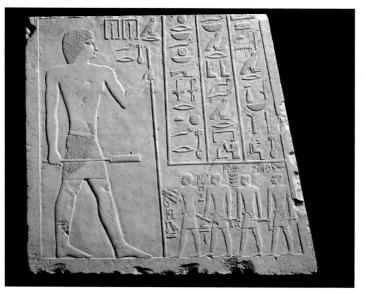

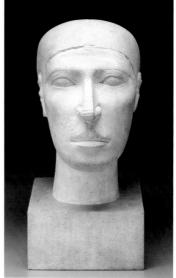

Relief of Nofer

Egypt (Giza, tomb G 2110) Old Kingdom, early Dynasty 4, 2540-2465 B.C.

The stone walls of Egyptian tombs were often decorated with carvings that provide much fascinating information about the life of the deceased and about Egyptian society in general. This relief was placed just inside the entrance to the tomb chapel of Nofer, a government official who was

buried near the great royal pyramids at Giza. Nofer is depicted on a scale befitting his importance; his distinctive aquiline nose and firmly set lips are also evident in the "reserve head" that was found in his tomb. To the right of Nofer, three columns of hieroglyphs list his administrative duties and titles, which included overseer of the treasury. Below the hieroglyphic inscription is a procession of four scribes, the first one taking dictation. Civil servants, like Nofer, and scribes, who recorded the details of governmental affairs, were crucial to the complex, centralized administration of the Egyptian state.

37% x 43% in. (95 x 109.5 cm) Harvard University-Boston Museum of Fine Arts Expedition 07.1002

"Reserve head" of Nofer Egypt (Giza, tomb G 2110) Old Kingdom, early Dynasty 4, 2540-2465 B.C.

Limestone H. 10 1/8 in. (27.1 cm) Harvard University-Boston Museum of Fine Arts Expedition 06.1886

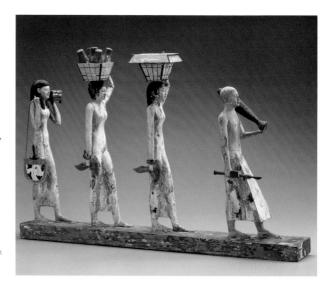

Limestone

facing page, bottom

Procession of offering bearers Egypt (Deir el-Bersha, tomb of Djehutynakht)

Middle Kingdom, late Dynasty 11 or early Dynasty 12, 2040–1926 B.C.

In antiquity, Djehutynakht's tomb was plundered by thieves searching for jewelry and precious materials. When Museum archaeologists opened the tomb in 1915, they found complete chaos-the coffins disassembled, the mummies torn apart, and more than one hundred wooden models violently thrown aside and shattered. These models, like the coffin paintings and texts, were meant to ensure that the deceased would enjoy for eternity the comforts of his earthly life. Most such models are crudely made, but this is one of the finest wood carvings from any period of Egyptian history. It represents a procession, led by a priest carrying an incense burner and a ritual vase. Behind him, two women bring ducks and baskets of provisions, and a third carries a small chest and a mirror in a patterned case. In this small sculpture, ancient Egypt comes vividly to life.

Painted wood L. 26% in. (66.4 cm) Harvard University-Boston Museum of Fine Arts Expedition 21.326

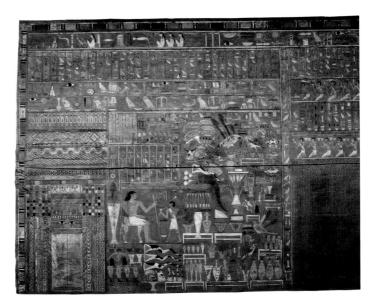

Interior face of the outer coffin of Djehutynakht (detail)

Egypt (Deir el-Bersha, tomb of Djehutynakht) Middle Kingdom, late Dynasty 11 or early Dynasty 12, 2040–1926 B.C.

Four thousand years ago, a provincial ruler named Djehutynakht was buried in a tomb cut into dry limestone cliffs on the east bank of the Nile. His mummified body was placed within two nested coffins made of thick, cedar boards covered on both sides with paintings and inscriptions that would through magic provide for his needs and protection in the afterlife. Exquisitely adorned with vibrant color and a wealth of detail, the interior of the outer coffin is perhaps the finest surviving example of Middle Kingdom painting. It depicts Djehutynakht seated before an attendant who brings a dish of incense. Neat rows of offerings, including the legs of spotted cows, are arranged below. Behind Djehutynakht is a representation of the "false door" through which his spirit could leave the coffin and come into the tomb chapel to receive the food and drink left there for him. The eyes on the door were painted so that the mummy, laid on its side to face them, could look out of the coffin.

Painted cedar 45 ½ x 103 ½ in. [115 x 263 cm]

Harvard University-Boston Museum of Fine Arts Expedition 20.1822

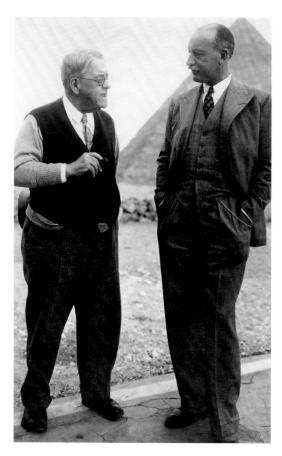

fig. 11 George Reisner with George Edgell, the Museum's director, at Giza (Egypt) in 1938.

The Museum's first Egyptian artifacts were accessioned in 1872, giving the collection an early start. By the turn of the century, however, high prices and the limited supply of artifacts made it clear that the only way to build an important collection was to dig. So the Museum's trustees decided to sponsor an expedition to Egypt.

Their timing was good. Unregulated digging had flourished during the nineteenth century, and in the 1890s an alarmed Egyptian government decided to monitor the excavations, authorizing teams and allowing them to keep a portion of their finds. In 1903 the government opened for excavation Giza, site of the three great pyramids. Sponsored initially by the University of California at Berkeley, an American expedition was led by George Andrew Reisner (1867–1942), who explained the compromise reached: "The division of the pyramids was easily arranged, as the Italians wanted the First pyramid, the Germans wanted the Second, and I was willing to accept the Third. But we all wanted the great cemetery west of the First pyramid. So that was divided into three strips, . . . for which we drew lots." In 1905 Berkeley ended its sponsorship, and the Museum allied with Harvard University to support Reisner. Over the next thirty years Reisner's team rarely stopped digging, and many of the Museum's most famous objects, including the statue of the pharaoh Menkaure (Mycerinus) and his wife (see page 18) and the bust of Prince Ankhhaf (see page 20), were uncovered during those years.

A man of formidable energy, Reisner did not restrict himself to Giza. He dug his way up and down the Nile, from the Mediterranean coast to the Sudan. excavating sites from nearly every period of Egyptian history. His work in the Sudan was particularly important as it revealed for the first time the history and culture of Nubia, ancient Egypt's rival, imitator, and sometime conqueror.

Reisner was an exceptionally careful archaeologist: his methods—particularly his use of photography to document the excavations—helped revolutionize the profession, and the expedition's published reports are unmatched in their thoroughness.

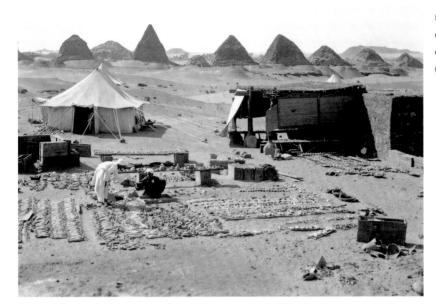

fig. 12 Sudanese workmen organizing the *shawabtys* of King Taharqa at Nuri (Sudan) in 1917.

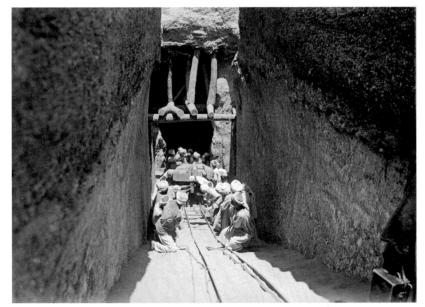

fig. 13 Removing the Anlamani sarcophagus at Nuri in 1917.

Seated Sekhmet

Egypt (Thebes, Karnak, temple of Mut) New Kingdom, Dynasty 18, reign of Amenhotep III, 1390-1352 B.C.

Ancient Egyptians identified the lion-headed goddess Sekhmet (her name means "The Powerful One") with tempestuous weather, scorching heat, pestilence, and war. Priests constantly strove to calm her destructive and unpredictable nature with ceremonies and offerings. Sekhmet was believed to be especially threaten-

ing at the time of New Year

(mid-July), because if she was not pacified, the Nile might not rise, the new year could not begin, and the cycle of life would cease. This image of the

> goddess, brought to Boston from Egypt in 1835, is probably one of 730 erected by King Amenhotep III in his temple at Thebes.

Granodiorite H. 49³/₄ in. [126.6 cm] Gift of John A. Lowell and Miss Lowell 75.7

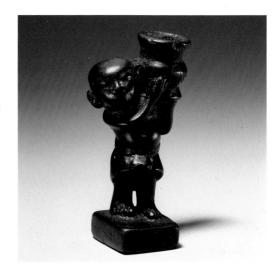

Dwarf holding a jar

Egyptian

New Kingdom, Dynasty 18, 1349-1336 B.C.

In ancient Egypt, most monumental sculptures were formal and idealized, destined for tombs or temples. But sculptors had a freer hand with objects made for daily life. This pot-bellied figure, hoisting a huge storage jar, was a container for cosmetics. This is not a timeless, frozen figure but one full of life and movement as he leans to balance the weight of the jar and keep it upright. Skillfully carved from a single piece of boxwood, the image speaks of the luxury and refinement that prevailed during Dynasty 18. Cosmopolitan men and women both used expensive cosmetics and lotions, which they kept in precious, small containers such as this one. On the jar, tiny hieroglyphs spell out the names of Akhenaten and Nefertiti, the period's famous rulers, who probably gave the piece as a gift to a favorite courtier.

Boxwood 25/16 x 11/16 x 1 in. [5.9 x 1.8 x 2.6 cm] Helen and Alice Colburn Fund 48.296

Statue of Lady Sennuwy

Made in Egypt, found in Sudan (Kerma, royal tumulus K III) Middle Kingdom, Dynasty 12, reign of Senwosret I, 1971–1926 B.C.

This serene image of Sennuwy, the wife of a provincial governor, is a masterpiece of Egyptian sculpture. Worked in hard, black granodiorite, the rounded forms of Sennuwy's body are beautifully proportioned, and the smooth planes of her face are strikingly framed by the ribbed patterning of her heavy wig. Sennuwy and her husband were buried at Assiut, in central Egypt, in an elaborate tomb for which this funerary statue was probably made. However, the statue was found far to the south of Egypt, in the burial of a Nubian ruler of Kerma. Apparently, the statue was removed from the tomb in Egypt and taken to Nubia several hundred years after Sennuwy's death.

Granodiorite

H. 67 1/4 in. [172 cm]

Harvard University-Boston Museum of Fine Arts Expedition 14,720

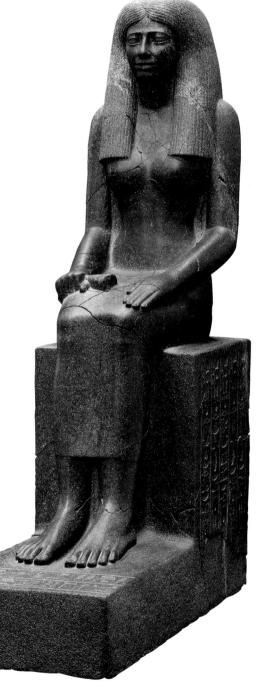

Head of a nobleman (The Josephson Head) Egyptian

Middle Kingdom, late Dynasty 12, 1878-1841 B.C.

This head—once part of a complete body—is a supreme example of the animated, distinctively realistic images that appeared for a brief period in the Middle Kingdom and were never surpassed in Egyptian art. In striking contrast to the idealization and abstract generalization of most Egyptian images, this expressive, emotional face, beneath a smooth wig, is sensitively modeled and arrestingly individualized. The red stone-which echoes the color traditionally used for male skin in painted representations—is fine, polished quartzite, expensive and extremely difficult to work. Egyptians referred to quartzite as "a noble stone" associated with the sun. This portrait bears a strong resemblance to known images of Senwosret III. The extraordinary workmanship and the use of quartzite suggest that the head was made in a royal workshop by a master sculptor. The sitter was almost certainly a high official, perhaps a vizier, whose importance was surpassed only by that of the king.

Quartzite

75/16 x 97/16 x 81/4 in. [18.5 x 24 x 21 cm]

Partial gift of Magda Saleh and Jack A. Josephson and Museum purchase with funds donated by the Florence E. and Horace L. Mayer Funds, Norma Jean and Stanford Calderwood Discretionary Fund, Norma Jean Calderwood Acquisition Fund, Marilyn M. Simpson Fund, Otis Norcross Fund, Helen and Alice Colburn Fund, William E. Nickerson Fund, Egyptian Curator's Fund, Frederick Brown Fund, Elizabeth Marie Paramino Fund in memory of John F. Paramino, Boston Sculptor, Morris and Louise Rosenthal Fund, Arthur Tracy Cabot Fund, Walter and Celia Gilbert Acquisition Fund, Marshall H. Gould Fund, Arthur Mason Knapp Fund, John Wheelock Elliot and John Morse Elliot Fund, de Bragança Egyptian Purchase Fund, Brian J. Brille Acquisition Fund. Barbara W. and Joanne A. Herman Fund, MFA Senior Associates and MFA Associates Fund for Egyptian Acquisitions, and by exchange from an anonymous gift 2003.244

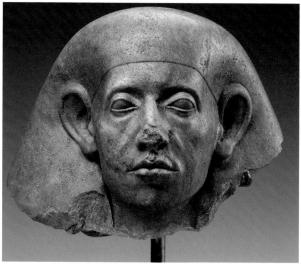

facing page, top

Pectoral

Egyptian

Second Intermediate Period, about 1783-1550 B.C.

Avid for the great wealth buried with the pharaohs, tomb robbers systematically and thoroughly plundered the royal tombs of Egypt-often, very soon after they were closed. Thus, few pieces of ancient jewelry have survived into modern times; this pectoral (chest ornament) is not only extremely rare but a splendid, skillfully crafted work of art. Composed of more than four hundred pieces of inlaid glass and carnelian (a reddish stone), the pectoral was probably made for a royal burial and attached to a gilded mummy case. It represents a vulture grasping two coils of rope, symbols of the universal power of the king. To the left of the bird's body is the stylized representation of a cobra, rearing up as if to strike. Together, the vulture and the cobra signify the union of Upper and Lower Egypt and were standard symbolic attributes of the pharaoh.

Gold and silver with inlays of carnelian and glass W. 14% in. [36.5 cm]

Egyptian Special Purchase Fund, William Francis Warden Fund, Florence E. and Horace L. Mayer Fund 1981.159

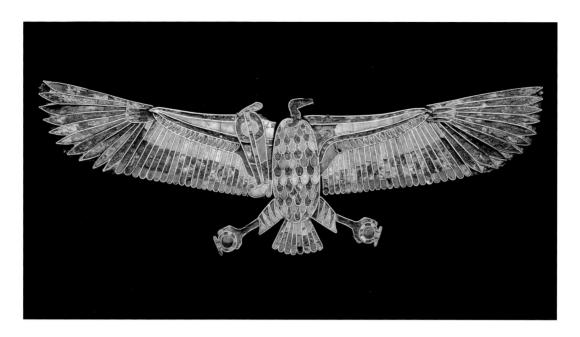

Sarcophagus of Queen Hatshepsut, recut for her father, Thutmosis I

Egypt (Thebes, Valley of the Kings, tomb 20)

New Kingdom, Dynasty 18, reign of Hatshepsut, 1473-1458 B.C.

The powerful Hatshepsut, who ruled for more than twenty years, was one of very few women in Egyptian history to become "king," and ultimately pharaoh. She even had herself represented in sculpture with a male torso.

This sarcophagus, originally designed for Hatshepsut, was reinscribed for her father, Thutmosis I, with the interior enlarged to hold his mummy and coffin. (Hatshepsut then ordered a matching sarcophagus, inscribed for herself as "king.") Made of a very hard stone, the sarcophagus is a fascinating historical document as well as an object of high artistic quality.

Painted quartzite 32 ½ x 34 ½ x 88 % in. [82 x 87 x 225 cm] Gift of Theodore M. Davis 04.278.1–2

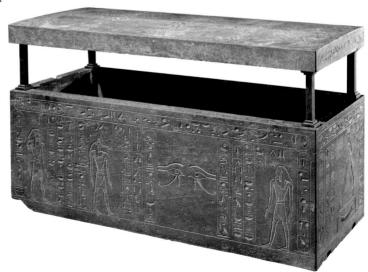

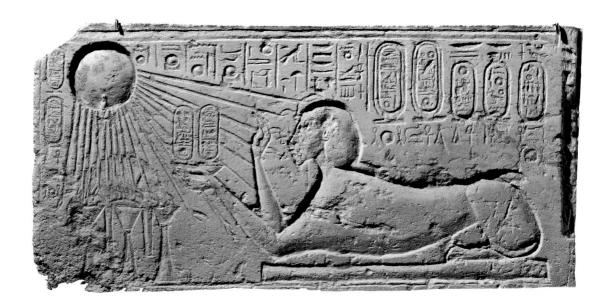

Relief of Akhenaten as a sphinx

Egyptian (probably from el-Amarna) New Kingdom, Dynasty 18, reign of Akhenaten, 1349-1336 B.C.

A true individualist among the pharaohs, for seventeen years, Akhenaten established his own, essentially monotheistic, religion, something previously unknown in the ancient world. He rejected not only the supreme state god, Amen, but the whole, age-old pantheon of Egyptian gods-ordering their images to be smashed, their temples closed, and even suppressing the plural form of the word for god. Akhenaten's one god was a manifestation of the sun called the Aten ("Disk"), and in Middle Egypt, he built a new capital named Akhetaten, the "Horizon of the Aten" (modern el-Amarna). This relief, probably from a palace wall at Akhetaten, depicts the king as a sphinx lying before a table of offerings and presenting to the Aten oval tablets inscribed with the god's names. Overhead, the disk of the Aten sends down its lifegiving rays. The Great Hymn to the Aten, inscribed on the

wall of a tomb at Akhetaten, sings praises to the god-king:

> Earth brightens when you dawn in lightland, When you shine as Aten of daytime; As you dispel the dark, As you cast your rays, The Two Lands are in festivity. Awake they stand on their feet, You have roused them; Bodies cleansed, clothed, Their arms adore your appearance.

After Akhenaten's death, one of his successors, Tutankhamen, returned the royal residence to Memphis and reinstated the old religion. The richly decorated temples, palaces, public buildings, and homes of Akhetaten were razed, and the city returned to the desert.

Limestone 201/6 x 411/6 x 21/6 in. [51 x 105.5 x 5.2 cm] Egyptian Curator's Fund 64.1944

Mummy mask

Egypt (possibly from Meir)

Roman Imperial period, first half of 1st century A.D.

To help preserve the features of the mummified head and upper body of the deceased, ancient Egyptians often covered these parts with a separate wooden mask. Long after the Romans conquered Egypt in the first century A.D., traditional Egyptian religious beliefs and funerary rituals persisted. This mask, from the Roman period, is constructed of car-

tonnage—a material, similar to

papier-mâché, made of layers of linen coated with plaster. Its rich gilding signifies the status of its owner and also evokes the golden flesh of the gods with whom the deceased hoped to be united. The mask is painted with mourning and protective figures. Across the bottom, the god Osiris, reclining on a funerary bier above the crowns of Egypt, is shown being brought back to life by the goddess Isis in the form of a bird holding a feather and the shen-ring of eternity.

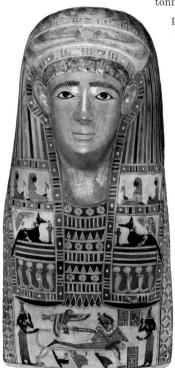

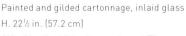

Gift of Lucien Viola, Horace L. and Florence E. Mayer Fund,
Helen and Alice Colburn Fund, Marilyn M. Simpson Fund, William
Francis Warden Fund, and William Stevenson Smith Fund 1993.555.1

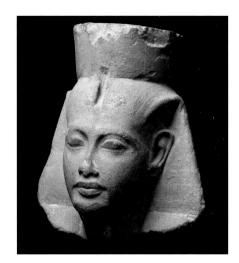

King Tutankhamen
Egyptian

New Kingdom, Dynasty 18, reign of Tutankhamen, 1336–1327 B.C.

Tutankhamen, possibly the son of Akhenaten, reigned only from his ninth to his nineteenth year, but the discovery in 1922 of his largely undisturbed tomb caused a sensation throughout the world. Although hastily assembled following the unexpected death of the young king, the vast array of sumptuous gold and jeweled objects that accompanied Tutankhamen's burial gave archaeologists a realization of just how magnificent must have been the funerary treasures of the royal tombs that had been plundered. This sandstone head, although not inscribed with his name, almost certainly represents Tutankhamen, its sensuous features strikingly similar to those on the famous gold mummy mask from his tomb.

Sandstone H. 11% in. [29.6 cm] Gift of Miss Mary S. Ames 11.1533

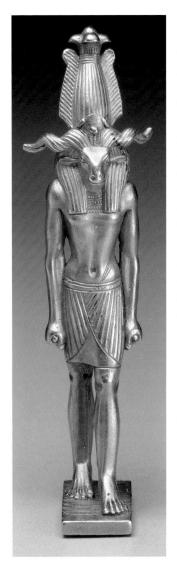

Amulet of Harsaphes Egypt (Herakleopolis) Third Intermediate Period, Dynasty 23, 740-725 B.C.

This tiny amulet of solid cast gold represents the fertility god Harsaphes, depicted as a man with the head of a long-horned ram. He wears a royal kilt, and on his head is the Atef crown that associates him with the powerful Osiris, god of the Underworld. In hieroglyphs on the underside of the base, the statuette is inscribed with the name of Neferkare Peftjauawybast, ruler of the city of Herakleopolis (present-day Ehnasya, Egypt). Neferkare is recorded as a subject prince on the victory stela of the Nubian king Piankhy (Piye) who, "raging like a panther," conquered Egypt "like a cloudburst" about 724 B.C. With its delicate sculpting of muscles and bone and its fine, linear patterning of kilt, horns, and crown, this image of Harsaphes is a superb example of the goldsmith's art.

Gold H. 2% in. [6 cm] Egypt Exploration Fund by subscription

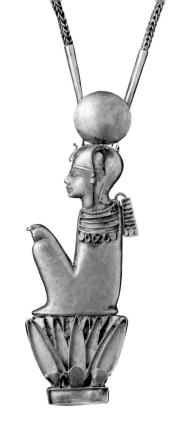

Pendant on a chain

Egyptian

Third Intermediate Period, Dynasty 21-24, 1070-712 B.C.

An Egyptian creation story tells of the emergence of the sun god-the first living being-from a lotus flower growing in the receding waters of the primeval ocean called Nun. This pendant illustrates that story and shows the newborn sun god in the form of the pharaoh as a child. It is made of hammered sheet gold, is carefully worked on both sides, and still retains its chain of interlocking gold loops. The front was originally inlaid with colored glass.

Gold with glass inlays H. 2³/₄ in. [7.2 cm] Gift of Mrs. Horace L. Mayer 68.836

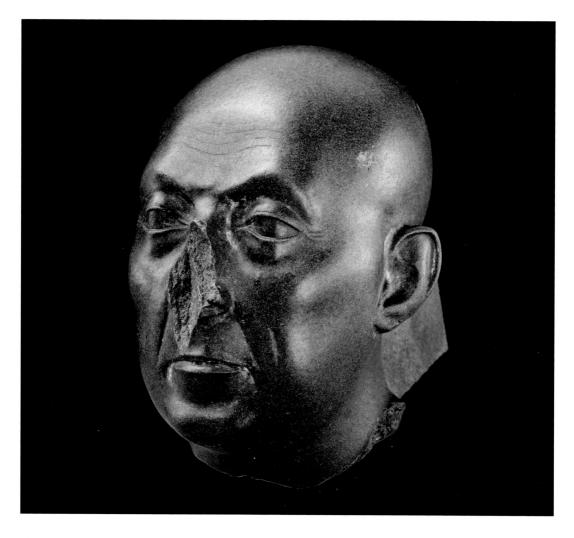

Head of a priest (The Boston Green Head) Egyptian

Late Period, Dynasty 30, 380-332 B.C.

Only four inches high, the so-called Boston Green Head is admired throughout the world as one of the finest of all portrait sculptures from ancient Egypt. It is a masterpiece of naturalism—rare in Egyptian art, which tends to idealize—and is stamped with a remarkable humanity. Note the wrinkled forehead, the deep lines around nose and mouth, the crow'sfeet, and such individualizing details as the mole on

the left cheekbone. The subject is probably a priest, identified by his shaven head. On the back of the head is an inscription with the name of the Memphite funerary deity Ptah-Sokar, suggesting that the statue (of which this head is a fragment) was originally placed in a temple dedicated to that god. This agrees with the alleged findspot of the head: Saqqara, the cemetery of Memphis.

Greywacke

H. 4% in. (10.5 cm)

Purchased of Edward P. Warren, Pierce Fund 04,1749

Tomb group of Nesmutaatneru

Egypt (Thebes, Deir el-Bahari) Late Period, Dynasty 25, about 760-660 B.C.

Nesmutaatneru, the wife of a high-ranking Theban priest, died sometime around 700 B.C., and her tomb remained undisturbed for over 2,500 years until it was excavated in 1894. Her mummy was contained within three wooden coffins, all decorated with inscriptions and depictions of the gods and goddesses who guaranteed protection in the afterlife. The vaulted lid and four corner posts of the outermost, rectangular coffin are meant to imitate the tomb of Osiris, god of the Underworld. This first coffin held the smaller one shaped roughly like a human body and painted with a face and wig. Within this lay a third coffin in the shape of the mummy itself, every inch covered with inscriptions and devotional images, including one of Nesmutaatneru worshipping Osiris as he lay on his funeral bed.

This elaborate housing was designed to protect the mummy—the preserved body of the deceased because the ancient Egyptians believed that

in the afterlife the spirit, or ba, continued to use the body as a home, and that the dead had the same physical needs as the living. To ensure the integrity of the body, they employed the process of mummification removing the internal organs of the deceased (which were preserved and stored separately), dehydrating the corpse with salts, and wrapping it in linen cloth. These procedures were accompanied by elaborate rituals and took nearly three months. Central as mummification was to the afterlife, it was only one way in which care was taken to provide for the next world. Indeed, the majority of the objects in the Museum's Egyptian collection were buried in tombs for the comfort of the deceased. Many others were ritual objects used by the living on behalf of the dead.

Wood, plaster, linen, pigment L. of outer coffin (95.1407d): 80 1/4 in. (204 cm) L. of middle coffin (95.1407c): 731/4 in. (186 cm) L. of inner coffin (95.1407b): 66½ in. (169 cm) L. of mummy [95.1407a]: 59½ in. (151 cm) Egypt Exploration Fund by subscription 95.1407a-d

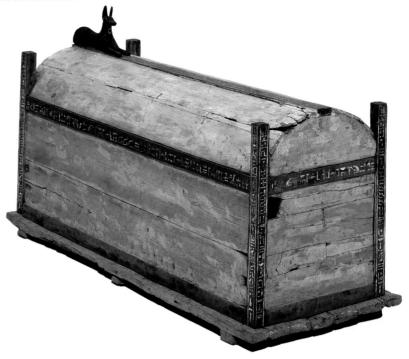

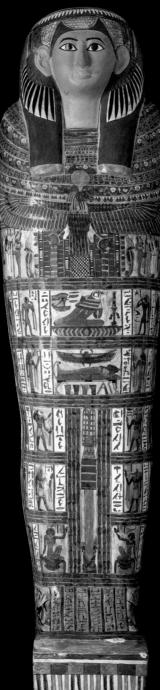

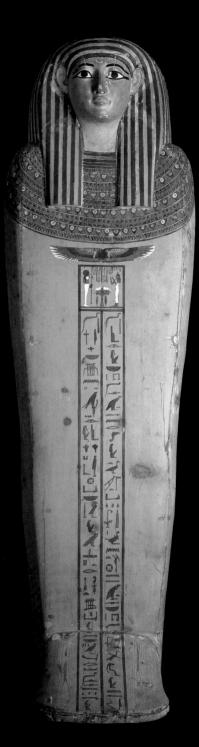

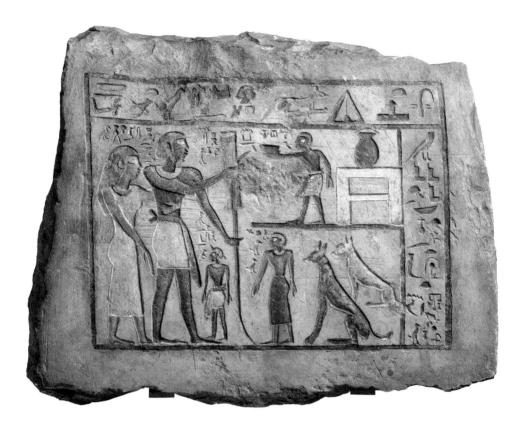

Stele of the Nubian soldier Nenu

Egyptian (said to be from el-Rizeigat) First Intermediate Period to Middle Kingdom, 2100-2040 B.C.

Ancient Nubia-a region encompassing modern-day southern Egypt and northern Sudan-provided a major trade route over which gold, ivory, ebony, incense, and spices traveled between central Africa and the lands around the Mediterranean. Nubia's history was closely intertwined with that of its neighbor, Egypt: social, political, religious, and artistic ideas moved back and forth as each country conquered or was conquered by the other. The ancient Egyptians called Nubia Ta-Sety ("Land of the Bow"), and Egyptian kings often hired the renowned archers of Nubia for their armies. Many of these mercenary soldiers

settled in Egypt, married Egyptian women, and were buried in the Egyptian manner, but they still proudly maintained their Nubian identity. This limestone grave marker depicts a Nubian soldier named Nenu holding his bow and arrows; beside him is his wife, wearing the close-fitting linen dress typical of Egyptian women. Nenu has a short, curly, Nubian hairstyle and close-cropped beard and wears a kilt tied with a characteristically Nubian leather sash. In the upper right, an Egyptian servant presents a bowl of beer. Dogs are often included on the stelai of Nubian soldiers, suggesting the great affection they had for these pets.

Painted limestone 14% x 17¾ in. [37 x 45 cm] Purchased by A. M. Lythgoe 03.1848

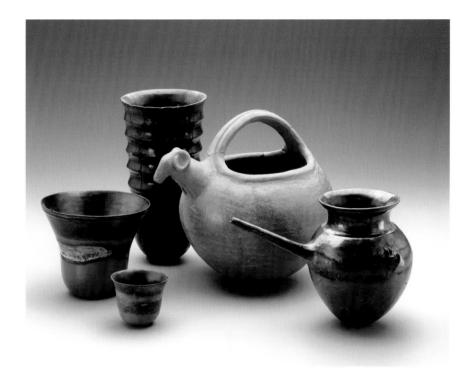

Beakers

Nubian Sudan (Kerma) Classic Kerma period, 1700-1550 B.C.

Despite close ties, both Egypt and Nubia retained their unique characteristics, and with intensified archaeological exploration of Nubia over the past decades, scholars have recognized its importance as a distinct culture. This recognition of culture has greatly enhanced our understanding of ancient Africa as a complex community of nations. Nubian ceramics are among the earliest and most sophisticated of the ancient world. About 1700 B.C., as Egypt declined, the great Nubian kingdom of Kush rose to power, its capital built on a fertile bend of the Nile where the modern town of Kerma now stands. A hallmark of the

Kerma period is its extraordinarily fine black-topped red-polished pottery, which came in a variety of elegant, inventive shapes. Remarkably thin and delicate, this pottery was not thrown on a wheel but made entirely by hand. Much of it was produced to be included in burials along with furniture, household equipment, dress, and jewelry. The unusual shape of the tall ribbed, or rilled, beaker here suggests the nested stacks of individual cups that were often placed in Kerma tombs so that the thirst of the dead might be satisfied in the afterlife.

Ceramic

H. of rilled beaker: 8% in. (22.5 cm)

Harvard University-Boston Museum of Fine Arts Expedition
13.4080, 13.4075, 20.2006, 20.1714, 13.4102

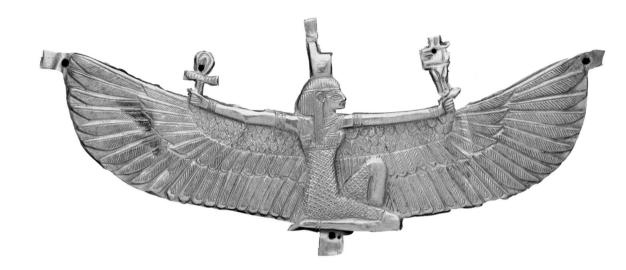

Winged Isis pectoral

Nubian

Sudan (Nuri, pyramid of King Amaninatakilebte) Napatan period, reign of Amaninatakilebte, 538-519 B.C.

This gold pectoral, overlooked by the thieves who plundered the royal tombs at Nuri, represents the winged goddess Isis, holding an ankh (symbol of life) in her right hand and what may represent the hieroglyph for a sail (symbol of the breath of life) in her left. Twenty Nubian kings and fifty-four queens were buried at Nuri between the mid-seventh and the late fourth centuries B.C. The mummified bodies were

placed within nested sets of gilded wooden coffins inlaid with colored stones. The mummies wore gold amulets, gold finger and toe caps, and probably gold face masks. This pendant would have been sewn onto a bead net draped over a king's mummy. Cut into the bedrock beneath the pyramids, the royal tombs were excavated by the Museum expedition between 1917 and 1920.

Gold

W. 6% in. [16.7 cm]

Harvard University-Boston Museum of Fine Arts Expedition 20.276

Miniature dagger

Nubian Sudan (Kerma, cemetery M, grave 48) Classic Kerma period, 1700–1550 B.C.

In 1913 George Andrew Reisner and the Harvard University–Boston Museum of Fine Arts Expedition began a twenty-year excavation of major Nubian sites

in the northern Sudan, among them

the walled city and cemetery of ancient Kerma, capital of the kingdom of Kush. Sudanese authorities allowed the expedition to keep many of the objects found, and the Museum of Fine Arts now houses the finest and most extensive collection of Nubian art outside Sudan. Although many objects discovered in Kerma burials were either influenced by Egyptian art or were Egyptian in origin (see the statue of Sennuwy, page 27), exquisitely crafted miniature daggers like this one, found in the grave of a young boy, are entirely Nubian.

Gold, bronze, and ivory
H. 611/16 in. (17 cm)
Harvard University-Boston Museum of
Fine Arts Expedition 21.11796b

Crystal pendant with head of Hathor

Made in Egypt, found in Sudan (el Kurru) Napatan period, reign of Piankhy (Piye), 743-712 B.C.

Surmounted by a gold head of the goddess Hathor, this rock-crystal pendant served as a protective amulet. Worn by the living and buried with the dead, amulets were believed to have special powers, embodied both in their sacred imagery and in the precious materials of which they were made. This example has a gold cylinder enclosed within the crystal globe. Comparable cylinders have been found containing sheets of papyrus or metal inscribed with magical texts; however, X-rays have shown that this one is empty. The pendant was found in the tomb of a queen of the Nubian king Piankhy

Rock crystal and gold
H. 2% in. [5.3 cm]
Harvard University-Boston Museum of Fine Arts Expedition
21.321

(Piye), ruler of both Nubia

and Egypt. The head of Hathor is Egyptian in

style, and the pen-

dant was probably

part of the tribute paid to King Piankhy

by Egyptian princes.

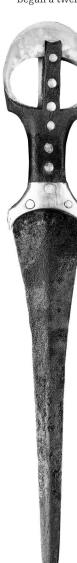

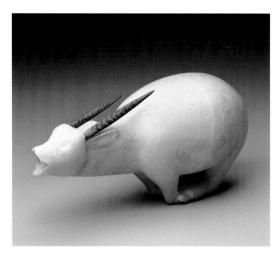

Vessel in the shape of a bound oryx Nubian Sudan (Meroe, tomb W 609) Napatan period, early 7th century B.C.

In a grave excavated at Meroe, a hundred miles from the modern city of Khartoum, the body of a young woman was found surrounded by jewelry, amulets, mirrors, pottery, bronze vessels, and three alabaster jars in the form of bound oryxes. At once lifelike and ingeniously functional, these elegant jars were containers for expensive perfume and ointments, which could be poured out through the open mouth. The travertine bound legs made a practical handle. The wooden horns are modern reproductions of the original slate ones.

Travertine (Egyptian alabaster) L. 6³/₄ in. [17.2 cm] Harvard University-Boston Museum of Fine Arts Expedition 24.879

Leg from a funerary bed Nubian

Sudan (el-Kurru)

Napatan period, reign of Shebitka, 698-690 B.C.

In traditional Nubian burials, the unmummified body of the deceased was laid out on a wooden bed. Later, in the period when Nubian kings ruled Egypt, mummification in the Egyptian fashion was introduced although the wooden funerary beds were retained. This bronze leg from such a wooden bed (long since decayed) incorporates the figure of a goose. In funerary texts from Old Kingdom Egypt, the deceased expresses his desire to rise to heaven as a goose, and, from the time of the New Kingdom, the goose was one of many forms taken by Amen, the principal Egyptian god.

Bronze H. 22% in. [56.1 cm] Harvard University-Boston Museum of Fine Arts Expedition 21.2815

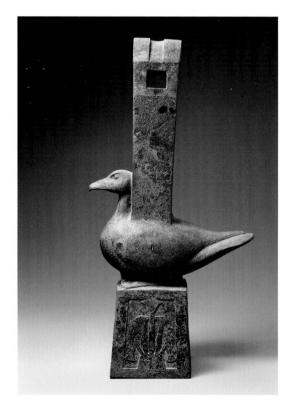

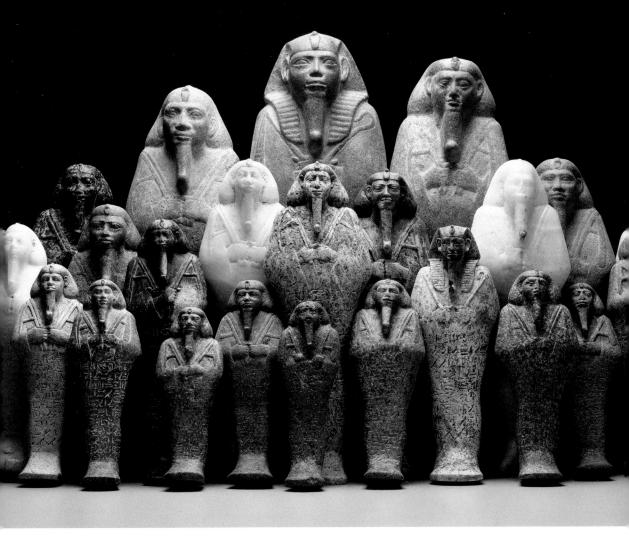

Shawabty figures of King Taharqa

Nubian

Sudan (Nuri, pyramid of Taharqa) Napatan period, reign of Taharqa, 690-664 B.C.

About 740 B.C. the Nubian king Piankhy (Piye) invaded Egypt and established his family as Egypt's Twenty-fifth Dynasty. Many Egyptian practices were adopted in Nubia during this period, including the construction of pyramids for royal tombs that contained *shawabty* figures intended to perform manual labor for the deceased in the afterlife. These

shawabtys are some of more than one thousand that were discovered standing in neat rows in the burial chamber of King Taharqa's pyramid tomb at Nuri.

Taharqa, a son and third successor of King Piankhy, was the greatest of the Nubian pharaohs. His empire stretched from Palestine to the confluence of the Blue and White Niles. In 667 B.C., Nubia lost control of Egypt to the Assyrians.

Granite, alabaster, and other stones
H. 4-13¾ in. (10-35 cm)
Harvard University-Boston Museum of Fine Arts Expedition

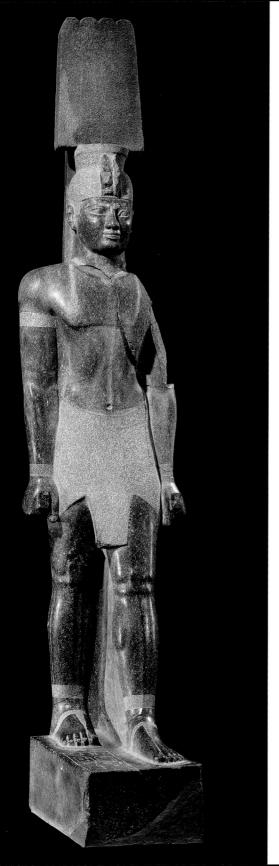

King Aspelta

Nubian

Sudan (Gebel Barkal)

Napatan period, reign of Aspelta, 593-568 B.C.

This monumental striding statue of King Aspelta, wearing the royal Nubian headdress, originally stood in the Great Temple of Amen at Gebel Barkal, the foremost religious center of Nubia. Eleven feet tall and weighing eight tons, the colossal image is smoothly polished except for the surfaces representing dress and jewelry, which were left rough to hold a thin layer of gold leaf. In 1916 this statue, which had probably been broken in 598 B.C. by members of an invading Egyptian army, was discovered in pieces by Museum archaeologists in a pit outside the temple entrance. The statue was reassembled at the Museum in 1924.

Granite gneiss

H. 130³/₄ in. (332 cm)

Harvard University-Boston Museum of Fine Arts Expedition 23.730

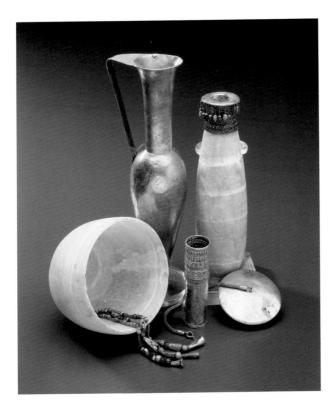

Tomb treasure of King Aspelta Nubian Sudan (Nuri, pyramid of Aspelta) Napatan period, reign of Aspelta, 593-568 B.C.

The splendid pyramid tomb of King Aspelta (probably the great-grandson of King Taharqa) was the least plundered of all the royal burials at Nuri. Within it, Museum archaeologists discovered a wide array of precious grave goods buried in soil littered with gold beads and pieces of gold foil (in which the objects

may originally have been wrapped). Included in the treasure were the objects illustrated here, among them a graceful gold vase and an alabaster perfume or ointment jar from whose gold cap beads of semi-precious stones hang on woven gold-wire chains.

Silver, gold, travertine (Egyptian alabaster), carnelian, turquoise, and steatite

H. of gold vase: 12% in. (31.5 cm)

Harvard University-Boston Museum of Fine Arts Expedition 20.340, 20.1070, 20.334, 21.339a-b, 20.339, 20.1072

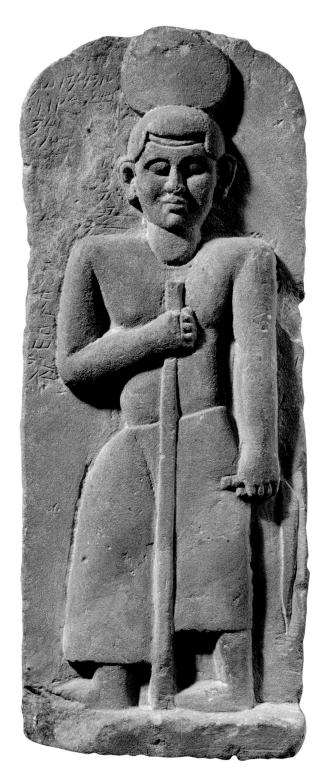

Funerary stele

Nubian

Meroitic period, 2nd-3rd centuries A.D.

This fine stele, or grave marker, represents a high-ranking Meroitic official with his characteristic long skirt, fly whisk, and staff. The cut in his forehead represents a decorative scar that some Sudanese still wear today to identify their community affiliation, and the sun disk above his head indicates that he has died and become divine. To the left of the figure, a Meroitic inscription probably gives his name and title. However, scholars are still unable to decipher this ancient language (composed of an alphabet of twenty-three letters), which appeared in the second century B.C.

Sandstone H. 21% in. (55 cm) Gift of Horace L. and Florence E. Mayer, C. Granville Way, Denman Ross, the Hon. Mrs. Fredrick Guest, Bequest from Charles H. Parker, and Anonymous Gift, by exchange 1992.257

Shrine

Nubian

Sudan (Gebel Barkal, Great Temple of Amen) Meroitic period, 2nd century B.C. or later

This sandstone shrine, found in the Great Temple of Amen at Gebel Barkal, originally housed a statue of the god Amen hidden behind a sealed doorway. Once thought to imitate the form of a traditional African house, the shrine actually is a model of Gebel Barkal itself, the three-hundred-foot sacred "Pure Mountain" behind whose cliff Amen was believed to dwell. On either side of the opening of the shrine are carved images of a Nubian king and a winged goddess, standing above a stylized papyrus swamp. Nubians believed that Gebel Barkal was the "primeval hill" of Egyptian mythology, where the creator god first gave himself form and, amid the primordial swamp, caused the sun to rise on the first day of time.

Stuccoed and painted sandstone
H. 24% in. [62.5 cm]
Harvard University-Boston Museum of Fine Arts Expedition
21.3234

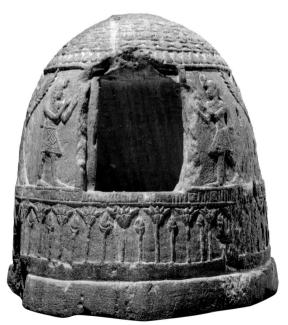

Decorated spheroid jar
Nubian
Sudan (Kerma, tomb 18/2)
Meroitic period, 2nd century A.D.

About 270 B.C. the royal court of Nubia was established at Meroe, a manufacturing center that traded objects of copper, ivory, glass, and ceramic as far away as Italy and Greece. Influences from central Africa, Egypt, and the Greco-Roman world combine in the distinctive art and culture of this period, and Meroitic ceramics are renowned for their quality and variety. This vessel for wine or beer is decorated with both indigenous and imported motifs—native crocodiles and twining grapevines derived from Greek art.

Pottery
H. 11 in. (28 cm)
Harvard University-Boston Museum of Fine Arts Expedition
13. 4038

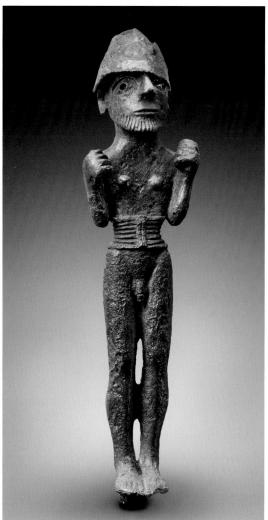

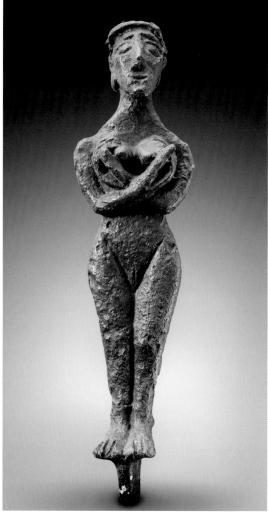

Male and female figurines Syria (Tell Judeideh) Early Bronze Age, 3200-2800 B.C.

Among the oldest surviving metal sculptures from the ancient Near East, these figurines were excavated at an Early Bronze Age site in northern Syria, along with four similar figures that all appeared to have been wrapped in cloth before burial. Cast in an unusual bronze alloy, these lively figures are nude; the woman (who once had silver jewels and curls) holds her breasts, and the man, who wears only a wide belt and a silver helmet, originally grasped small bronze weapons. Such figures may have been intended to magically enhance fertility and virility.

Low-tin bronze with silver
H. of male figure: 7 in. [17.8 cm]
H. of female figure: 7½ in. [19 cm]
Gift of the Marriner Memorial Syrian Expedition
49.118, 49.119

Mountain goat

Elamite

Proto-Elamite period, 3500-2700 B.C.

The artist who made this exquisite miniature mountain goat created an image of great dignity and naturalism, even incising its rear leg and tufted tail on the bottom of the sculpture. A fragmentary loop on the animal's back suggests that it may have been worn as an amulet. The sculpture dates from the brilliant Proto-Elamite period that saw the dawn of literacy in Iranian civilization.

Silver and sheet gold
L. 2% in. [7 cm]
John H. and Ernestine A. Payne Fund 59.14

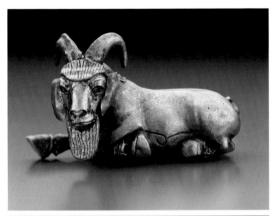

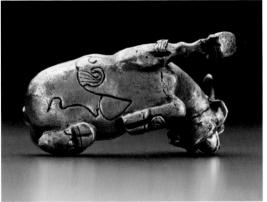

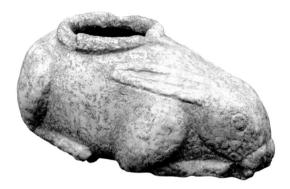

Vessel in the form of a hare Syrian Neolithic period, 6400-5900 B.C.

Carved about eight thousand years ago, this amazingly well-preserved vessel in the form of a hare is among the oldest works of art on view in the Museum. Simply shaped and economically detailed, the hollow vessel nevertheless vividly captures the essential hare—its round-eyed face resting on its paws and its long ears laid tightly against the body. An almost identical vessel was discovered in the 1970s at the Neolithic village site of Bouqras, on the Euphrates River in northern Syria.

Gypsum L. 7¼ in. (18.5 cm) Egyptian Curator's Fund and Partial Gift of Emmanuel Tiliakos 1995.739

Fragment of a victory stele Akkadian Akkadian period, 2334-2154 B.C.

During the Akkadian dynasty, established by Sargon the Great about 2350 B.C., all of Mesopotamia and even parts of Anatolia (modern-day Turkey) were united under one ruler for the first time. The commemorative relief of which this is a fragment most likely dates from the reign of Naram-Sin, mightiest of Sargon's successors, and was originally composed of several registers carved with scenes of Akkadian soldiers leading prisoners and carrying away booty. The warrior in this fragment wears a ribbed or quilted helmet, a fringed sash, and a long skirt. He holds a battle ax and rests his right arm on the shoulder of the last man in a line of bound, nude captives (preserved in fragments in the Iraq Museum in Baghdad).

Alabaster H. 13 ¼ in. [33.5 cm] Gift of the Guide Foundation and Mrs. Hilary Barrat-Brown 66.893

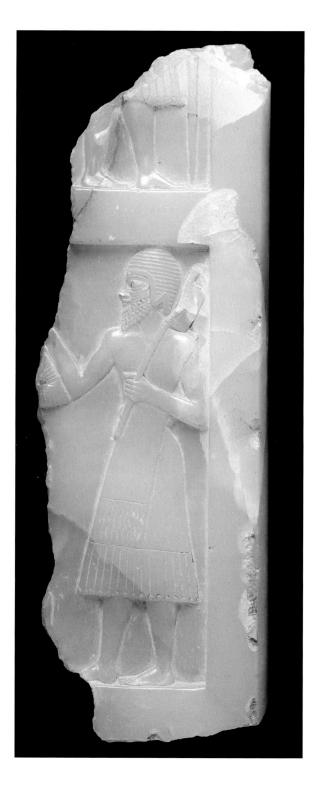

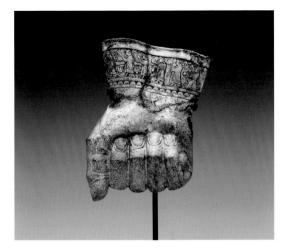

Drinking vessel

Hittite Hittite New Kingdom, reign of Tudhaliya III, 14th century B.C.

This is one of few surviving objects in precious metal made by the ancient Hittites, whose kingdom lay in north-central Anatolia (part of present-day Turkey). The strikingly lifelike and detailed cup was made from a single sheet of silver to which a handle (now lost) was attached. The frieze around the rim shows a Hittite king pouring out a libation; to the left of his head are the hieroglyphs of "Tudhaliya, Great King." The king, followed by a procession of priests and musicians, performs an offering ceremony to the storm god, Tarhuna, who appears before him leading a bull. Stylistic evidence indicates that this cup, most likely employed in the service of Tarhuna, was made for the third of three known Hittite kings named Tudhaliya. The fist shape evokes a Hittite hieroglyph meaning strength, and hands clenched into fists and held before the chest is a reverential gesture often seen in Hittite art.

Silver $3^{15}\!\!\% \times 6\% \text{ in. } \{10 \times 15.5 \text{ cm}\}$ Gift of Landon T. and Lavinia Clay in honor of Malcolm Rogers 2004.2230

Head of Gudea

Sumerian (probably Tello)

Neo-Sumerian period, reign of Gudea, 2144-2124 B.C.

During the turbulent era following the collapse of the Akkadian empire, Gudea governed the small state of Lagash (modern Tello) in southern Iraq. Ironically, most major known pieces of late-Sumerian art represent this minor ruler, who filled the temples of his local gods with statues of himself. These images are mostly carved from diorite—a hard, black stone that Gudea claimed to have brought by sea from "Magan," a distant land now believed to be somewhere on the Arabian coast. Like the majority of surviving images of Gudea, this one was vandalized in antiquity, the head lopped from the body and the nose broken. Nevertheless, it remains a superb work of art, the remarkable surfaces of smooth, polished stone emphasizing dramatically large eyes beneath sweeping eyebrows and a wool crown formed of tight, stylized curls.

Diorite H. 9% in. [23 cm] Francis Bartlett Donation of 1912 26.289

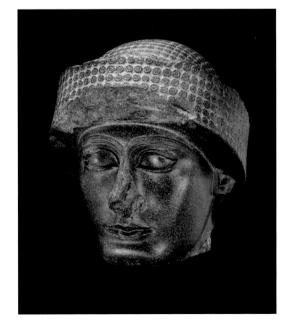

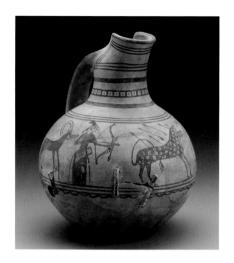

Pitcher Phrygian Late Phrygian period, 699-600 B.C.

Most ceramics from the ancient kingdom of Phrygia in Anatolia (present-day Turkey) were painted with geometric designs. This highly unusual pitcher, however, was decorated with figures, probably reflecting the influence of Greek art. Many scholars consider it the most important surviving late-Phrygian ceramic. It seems to have been equally valued in antiquity, when it was carefully repaired with lead clamps (visible here). The decoration shows a huntress shooting at a leopard; an ibex stands behind her. The huntress is Kubaba or Cybele (known as Artemis to the Greeks), the powerful Anatolian mother goddess and mistress of the animals. This vessel may have been used in rituals at one of the goddess's shrines.

Painted pottery H. 11³/₄ in. (30 cm) Edward J. and Mary S. Holmes Fund 1971.297 facing page, top

Lion

Iraq (Babylonian)

Neo-Babylonian period, reign of Nebuchadnezzar II, 604-561 B.C.

In 1899 German archaeologists excavating the ancient site of Babylon found hundreds of thousands of glazed brick fragments—all that was left of the massive Ishtar Gate and the Processional Way that once led to the Great Temple of Marduk, chief deity of the city. The lion was sacred to the goddess Ishtar and on both sides of the Processional Way, the walls were adorned with multicolored tiles depicting some 120 lifesized lions striding toward the temple in what must have been one of the most spectacular ensembles in antiquity.

Glazed bricks 41³/₄ x 91 in [106 x 232 cm] Maria Antoinette Evans Fund 31.898

facing page, bottom

Protective spirit

Assyrian

Iraq (Nimrud, Northwest Palace)

Neo-Assyrian period, reign of Assurnasirpal II, 883-859 B.C.

In the belief that they were constantly threatened by a host of malignant supernatural forces, the Assyrians surrounded themselves with images of protective deities, often represented as mighty, winged men. In the palace of Assurnasirpal II at Calah (present-day Nimrud), huge carved reliefs such as this one covered the walls of throne rooms, banquet halls, bedrooms, and even lavatories. The deity depicted in this sculpture pollinates a sacred tree with a cone and situla, or pail. Across the middle of this and every similar relief—all of which were once painted—is the "standard inscription" of Assurnasirpal II, in which he describes himself as "the strong man who treads on the necks of his foes ... who shatters the alliance of the rebels: the king who with the help of the great gods . . . has mastered all the mountain regions and has received their tribute."

Gypsum 87½ x 69% in. [221.7 x 176.3 cm] Charles Amos Cummings Fund 35.731

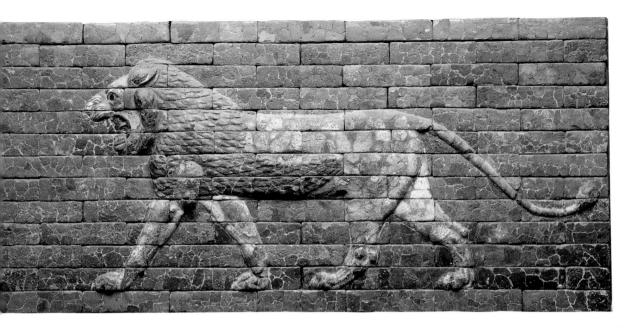

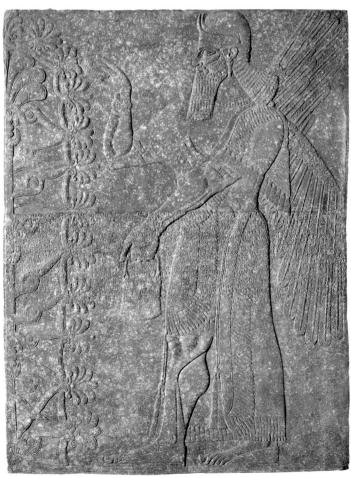

A Persian guard

Persian

Iran (Persepolis, Palace of Xerxes) Achaemenid period, reign of Xerxes, 486-464 B.C.

This noble figure was a member of the elite guard of the Persian kings called the "Ten Thousand Immortals" because if one fell in battle another would immediately step forward to take his place. The Greek historian Herodotus described the Ten Thousand Immortals in his chronicle of the wars between the Persians and the Greeks, written about the time this relief was carved.

Of all the troops, these were adorned with the greatest magnificence, and they were likewise the most valiant. Besides their arms, they glittered all over with gold, vast quantities of which they wore about their persons. They were followed by litters. carrying their concubines, and a numerous train of attendants handsomely dressed. Camels and pack animals carried their provisions apart from those of the other soldiers.

The fragment shown here was once part of a long frieze, portraying a single file of the Immortals, that decorated the palace of Xerxes at Persepolis, a royal

> residence of the Achaemenid Persian kings. With a guiver and bow case over his shoulder, the soldier wears a high, fluted helmet, and his beard and hair are rendered in rows of tight, spiraling curls. Traces of pigment on similar reliefs suggest that the figure was once painted in shades of yellow, blue, and purple.

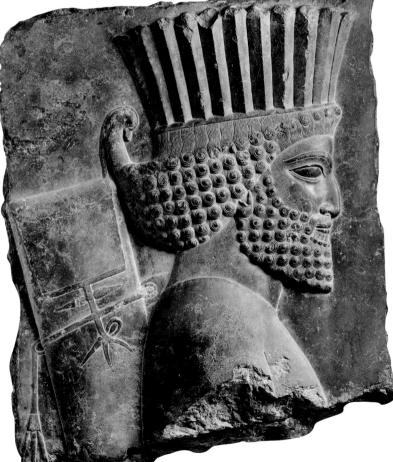

Limestone 20 % x 18 ¼ in. [53 x 46.5 cm] Archibald Cary Coolidge Fund 40.170

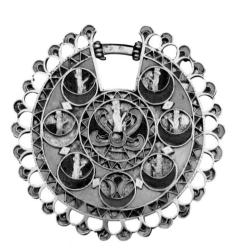

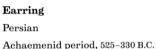

This sumptuous gold earring is decorated on both sides with a dense web of inlaid semiprecious stones (originally 460 individual pieces) that create a brilliant and complex composition. Around a central roundel featuring a bearded regal figure, seven smaller roundels contain six male figures and a lotus blossom. The design closely parallels one carved over the royal tombs at Persepolis, and it probably represents simultaneously the king revered by the six Great Houses of the empire, the land of Persia (present-day Iran) surrounded by the six world regions, and the god Ahuramazda surrounded by the six Bounteous Immortals. The lotus blossom may identify the king as the sun, as it does in Egypt, or it may symbolize a seventh world region, the ocean.

Gold with inlays of turquoise, carnelian, and lapis lazuli Diam. 2 in. (5 cm) Edward J. and Mary S. Holmes Fund 1971.256

Plate Persian Sasanian period, A.D. 400-699

The nimble mountain sheep on this silver bowl picks his way daintily across flower-covered peaks to sniff a magical blossom. A symbol of royalty, and more specifically of Ardashir, founder of the Sasanian dynasty—the last to rule Persia (present-day Iran) before the empire fell to the Arabs in the mid-seventh century—the sheep wears a studded bell collar with the fluttering ribbons often depicted streaming from the king's crown and royal vestments. On this exquisite plate, the blossom and the animal's body, head, and horns were made separately, attached to the surface, and then gilded.

Silver with mercury-gilded details

Diam. 8½ in. (21.2 cm)

John H. and Ernestine A. Payne Fund 1971.52

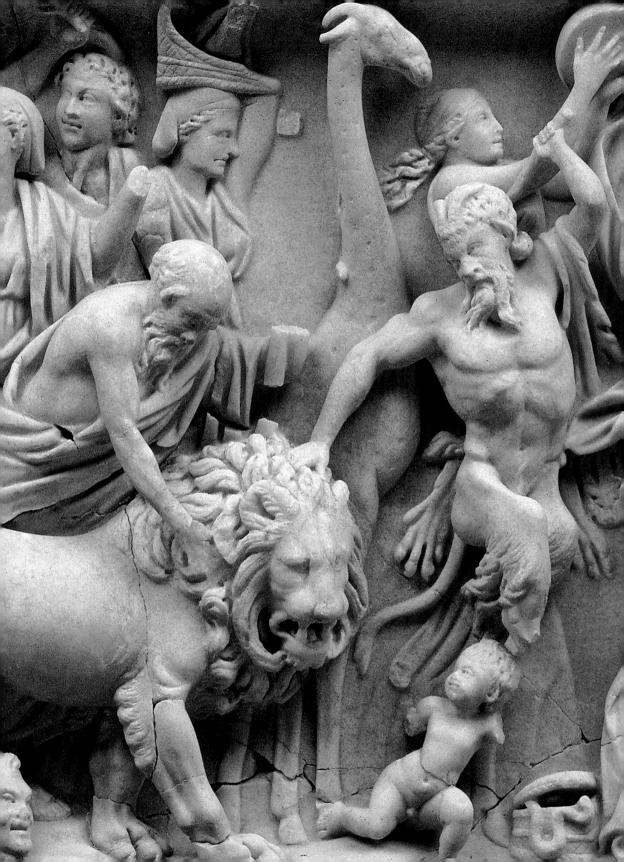

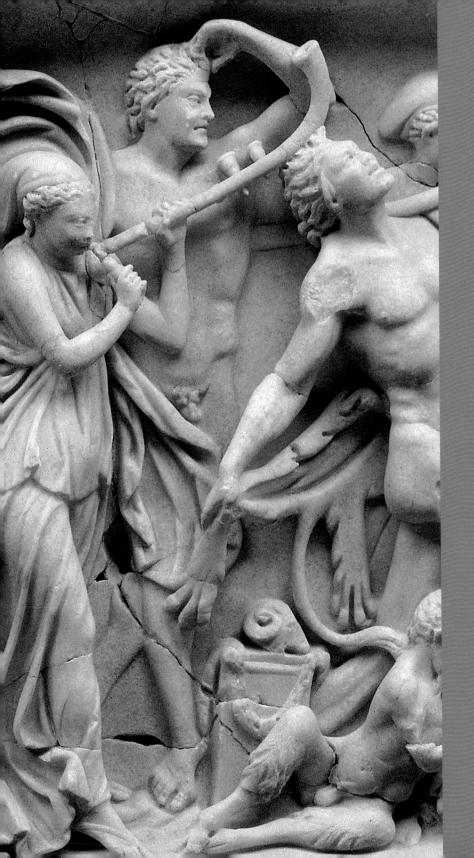

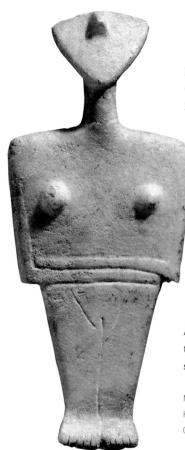

Female figurine

Cycladic

Early Cycladic period, about 2300-2000 B.C.

The first of the remarkable Bronze Age civilizations that flourished in what is now Greece and the Aegean developed on the islands called the Cyclades. Skilled artisans created fine vessels and sculptures from white marble that was cut, incised, and probably smoothed with emery (a hard, abrasive mineral). The most characteristic Cycladic sculptures are stylized human figures whose abstracted forms and timeless serenity are particularly attractive to the modern eye. Most of the figures represent women and were found in tombs; this one belongs stylistically with those from Chalandriani on the island of Syros. Were they intended as images of a deity? Portraits of the deceased? Fertility symbols?

Although their meaning remains a mystery, Cycladic figurines stand as the earliest examples of the classical world's extraordinary tradition of shaping stone into works of art.

Marble H. 7³/₄ in. (20 cm) Gift of Mr. and Mrs. J. J. Klejman 61.1089

Votive double ax Minoan Late Minoan period, about 1550-1500 B.C.

Only three inches high, this delicate and exquisitely worked miniature ax is said to have been found in the sacred cave of Arkalokhori on Crete. The cave was first discovered in 1912 by local residents who collected and sold for scrap metal the many pounds of ancient bronze weapons they found there. Alerted to the find, archaeologists excavated hundreds of bronze, gold, and silver weapons from the site. This ax, made of thin sheet gold mounted on a hollow gold shaft, seems to have been a religious offering, although its precise significance is unknown. On the left blade is a rare inscription in the early, still-undeciphered script called Linear A

Gold

H. 3½ in. [9 cm]

Theodora Wilbour Fund in memory of Zoë Wilbour 58.1009

Vessel for mixing wine and water (krater) Cypriote

Late Cypriote period, 1350-1250 B.C.

Large ceramic vases painted with scenes of aristocratic pursuits testified to their owner's wealth and status and were often placed in tombs. This vase is decorated with horse-drawn chariots and an unusual representation of an athletic contest: the two men standing in front of the horse are belt-wrestling, trying to pull each other off balance while bound together at the waist. The abstract and exaggerated painting style is typical of the art associated with Mycenae, the brilliant Bronze Age civilization of Greece whose influence spread throughout the Aegean and into the eastern Mediterranean.

Ceramic H. 17¼ in. [43.6 cm] Henry Lillie Pierce Fund 01.8044

Spouted jar

Minoan

Early Minoan period, about 2600-2000 B.C.

The prosperous and sophisticated Bronze Age civilization on the island of Crete is called Minoan after the legendary King Minos, who ruled a mighty, seafaring empire. More than four thousand years ago, highranking families on the island of Mochlos, off Crete, where this jar was found, built tombs in the shape of simple houses as eternal dwellings for the deceased. Graceful containers worked from local stone—perhaps inspired by vessels imported from Egypt and the Cyclades—were symbols of wealth and status, buried with the dead as offerings or for use in the afterlife. The basic form of this thin-walled jar, shaped to take advantage of the travertine's color and swirling pattern, was painstakingly worked with a bronze chisel or stone hammer, then drilled out using hollow reeds and emery powder.

Banded travertine
H. 4% in. [11 cm]
Gift of Mrs. T. James Bowlker 09.18

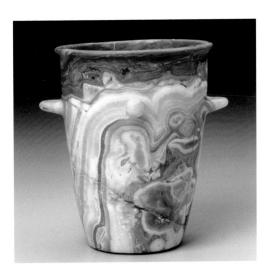

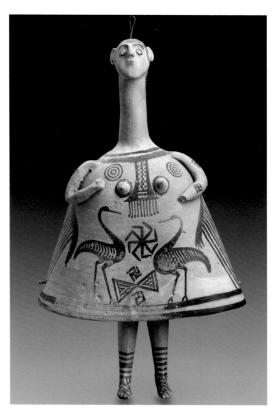

Figurine

Greek

Geometric period, 720-690 B.C.

This is one of a small group of similar objects that most likely came from Boiotia on mainland Greece. The context in which they were found is unknown, and their original purpose and use remain a mystery. However, it has been suggested that this doll-like figure may have served as an offering to a deity and been hung from a tree at one of the outdoor sanctuaries typical of this early period. Because the legs were made separately and attached beneath the skirt, the figure might have appeared to "dance" in the wind and ring like a chime.

Ceramic H. 11³/₄ in. (30 cm) Henry Lillie Pierce Fund 98.891

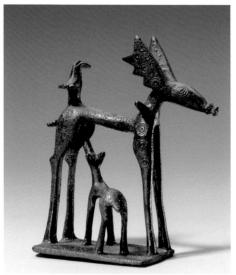

Deer nursing her fawn

Geometric period, 8th century B.C.

Fragile legs braced, this slender doe stands nursing her fawn. A bird perches on her rump, and her body is decorated with concentric circles. Her antlers are those of a male deer, and, although inaccurate, these give added weight to the upper portion of the sculpture and enhance its distinctive silhouette. This tiny and appealing cast-bronze figure is among the most accomplished early Greek sculptures both in design and technique. Like the ceramic "doll" (left), it was probably made as an offering to a deity and placed in an outdoor sanctuary in Boiotia-perhaps by a hunter hoping that the deer on whom his livelihood depended would thrive and multiply.

Bronze H. 21/8 in. [7.2 cm] Henry Lillie Pierce Fund 98.650

Apollo

Greek

Geometric period, about 700-675 B.C.

This powerfully expressive figure comes from an important transitional moment in the development of Western art. The simplified, elongated forms and emphatic symmetry (the torso is even bisected with an incised line) typify the conventions for depicting the human figure in this period. However, the artist reached beyond this tradition toward a greater naturalism, and the figure projects a striking new sense of mass and volume, particularly in the heavy coils of hair and the rounded curves of shoulders, thighs, and chest. It almost certainly portrays Apollo and possibly once held a silver bow in the left hand. On the thighs, a metrical inscription in ancient Boiotian script states that the statuette was dedicated to Phoibos (Apollo) by a man named Mantiklos: "Mantiklos donated me as a tithe to the far-shooter, the bearer of the Silver Bow. You, Phoibos, give something pleasing in return."

Bronze
H. 8 in. [20.3 cm]
Francis Bartlett Donation of 1900 03.997

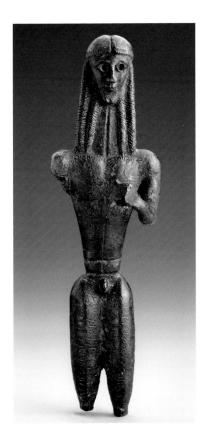

Oil flask (aryballos)

Greek

Orientalizing period, 690-675 B.C.

Vase painters in the port city of Corinth were celebrated for their decoration of tiny *aryballoi*, containers for the precious perfumes and oils that were exported from Corinth throughout the Greek world. Corinthian painters invented a technique, now called "black-figure" (see page 66), that was well suited to the rendering of detail on a miniature scale. First, the artist painted black, sil-

houetted forms on the unfired vessel, then incised anatomical or decorative details so that the light-colored clay beneath showed through. Influenced by the art of the Near East, Corinthian painters developed a repertoire of animals and human figures; the latter had rarely been seen in Greek art before this time. This aryballos is a very early example of Greek narrative painting.

Ceramic H. 2¾ in. (7.4 cm) Catharine Page Perkins Fund 95.12

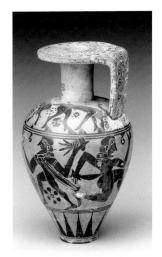

Libation bowl Greek Late Orientalizing period, about 625-600 B.C.

This hammered bowl—marks of the hammer are still visible on the surface—is a unique example of the work of early Greek goldsmiths. Under the rim an inscription in the Corinthian alphabet reads: "The sons of Kypselos dedicated [this bowl] from Heraclea." In the late seventh century, Kypselos was the ruler of Corinth, the richest city on the Greek mainland. Reportedly found at Olympia, the bowl was probably offered as a thanksgiving after a successful battle at Heraclea. Only the extremely wealthy could make such a lavish offering, and the bowl is evidence both of the opulent lifestyle of early Greek rulers and of the skill of its maker-although the gift was valued at the time only for its quantity of precious metal. Unusually, the inscription does not name the god to whom the bowl was dedicated, but very likely it was Zeus.

Gold Diam. 5% in. [15 cm] Francis Bartlett Donation of 1912 21.1843

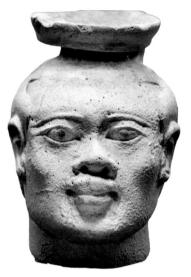

Oil flask (aryballos) East Greek Archaic period, 6th century B.C.

Less than two inches high and made of faience (a synthetic substance related to glass), this vessel was intended to contain perfume or precious oil. It represents an African man, and—probably because it is a representation of a "foreigner"—exhibits an attention to realistic detail that is striking among Greek images of this period, which were usually idealized. The naturalistic representation suggests that the artist worked from the direct observation of a live model. Ancient Greeks took great interest in representing the different cultures and peoples they encountered through travel, warfare, and commerce.

Glazed ceramic (faience) H. 13/4 in. [4.6 cm] Francis Bartlett Donation of 1900 03.835

Two-handled iar (amphora)

Greek

Archaic period, about 540-530 B.C.

Dionysos was the Greek god of wine and its attendant pleasures—intoxication, physical delight, and the banishment of care. In the sixth century B.C. the cult of Dionysos became extremely popular at all levels of society, and in Athenian art representations of this god outnumber those of any other. Dionysos was, of course, a natural subject for the decoration of vessels used in the production, storage, and drinking of wine. On this black-figure storage jar-made in Athens, and painted by an artist whose style resembles that of the master Exekias—the god sits on a folding stool sipping wine from a kantharos. In the huge, laden grapevine, diminutive satyrs appear to be diligently harvesting the fruit (closer inspection reveals that they are all at play). The satyr above Dionysos's head, lolling back with his arm hooked around a vine, leisurely examines the ornamental border. The scene is idvllic, humorous, and masterfully organized. The ivy that trails over Dionysos's shoulder is echoed on the handles

of the vase, and the whole image is energized by the rhythm

> of the vine that twists across the surface.

> > Ceramic H. 201/4 in. [51.4 cm] Henry Lillie Pierce Residuary Fund and Francis Bartlett Donation of 1900 63 952

Greek

Archaic period, 520-500 B.C.

In Greek mythology, the god Hermes takes many guises: protector of travelers and thieves, quick-witted trickster, and messenger for the gods who dwelt on Mount Olympus. Here, however, he is represented as Hermes Kriophoros (the ram-bearer), guardian of shepherds and their flocks. He wears the short tunic, brimmed hat, and low boots of a herdsman, and with one hand supports the front legs of the lamb tucked under his arm. In his other hand, Hermes probably once held the snake-entwined staff (kerykeion in Greek, caduceus in Latin) that identifies him as the emissary of the gods. With its huge eyes, taut contours, and lively surface patterning, this cast bronze statuette (probably created as an offering to the god) captures Hermes'

Bronze H. 6% in. [16.7 cm] Henry Lillie Pierce Fund 04.6

intensity.

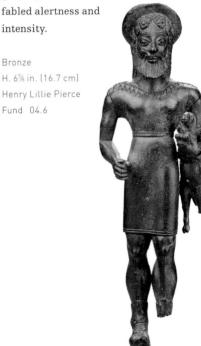

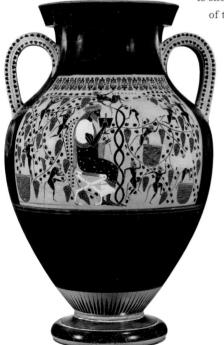

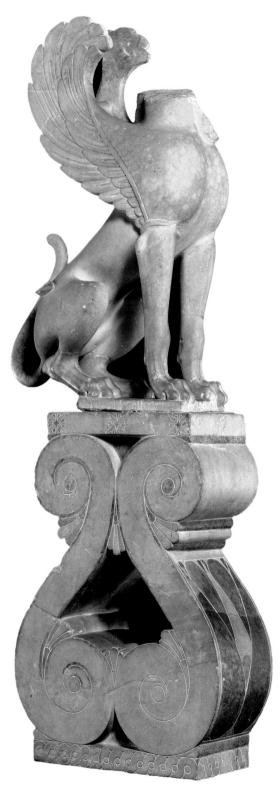

Upper part of a grave stele Greek

Archaic period, about 530 B.C.

The sphinx, like the lion, was favored as a guardian figure and often placed on grave monuments to protect the deceased from malevolent forces in this world and the next. This sphinx, crouching on a capital that originally surmounted a tall shaft, is all taut curves; her wings and haunches are lifted, her body ready to spring. The sculpture is expertly carved of warm, golden marble and traces remain of its original painted decoration—the hair was black, for example, and the wing feathers alternately green, black, red, and blue. Grave monuments of this quality and complexity could only have been afforded by the rich, and sometime after the mid-sixth century B.C., laws against ostentatious display put an end to their production. Almost every surviving example was deliberately broken in antiquity, possibly during a period of civil unrest; the Museum's sculpture is in unusually good condition.

Marble H. 55% in. [141.7 cm] 1931 and 1939 Purchase Funds 40.576

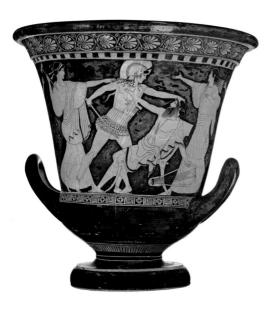

Early Classical period, about 460 B.C.

The Dokimasia Painter

On his return from the Trojan War, Agamemnon, commander of the victorious Greek army, was murdered by his wife, Clytemnestra, and her lover, Aegisthus. On this Athenian *krater*, Aegisthus, grasping Agamemnon's head, has plunged his sword into his victim's body and prepares to strike again. Clytemnestra, bearing an ax, is close behind. The sense of urgency and drama is conveyed in the swing of draperies and the bold gestures that resonate against the empty spaces of the background. The figure of Agamemnon is extraordinary, naked and helpless in a snare made of sheer and costly fabric. In Aeschylus's play *Agamemnon* (first presented in 458 B.C., soon after this vase was painted), Clytemnestra describes this moment:

He had no way to flee or fight his destiny our never-ending, all embracing net, I cast it wide for the royal haul, I coil him round and round in the wealth, the robes of doom. . . .

Ceramic H. 20% in. (51 cm) William Francis Warden Fund 63,1246

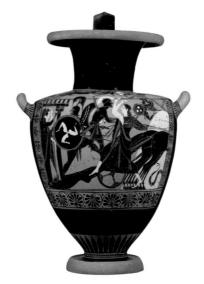

Water jar (hydria) Greek Archaic period, about 520-510 B.C.

Attributed to the Antiope Group

The Trojan War was a favorite subject among Greek vase painters. This Athenian hydria depicts the harrowing story of the Greek hero Achilles, whose best friend Patroklos was killed in battle by the Trojan prince Hector. Distraught and thirsting for revenge, Achilles killed Hector and defiled the body by dragging it behind his chariot. The painter has abridged the story, compressing two locations and the events of three days into a single image. Achilles (holding a round shield) mounts the chariot to which Hector's body is bound. Hector's grieving parents stand in a portico at left. At the far right, beyond the horses, is Patroklos's tomb. The winged female figure is Iris, sent by the gods to urge Hector's father to offer ransom for his son's body and so end its brutal violation. The whole composition—packed with detail and the vigorous movement of overlapping forms—is anchored in the center by the stern, anonymous figure of the charioteer.

Ceramic H. 19¾ in. (50 cm) William Francis Warden Fund 63.473

Bowl for mixing wine and water (krater)

Greek

Early Classical period, about 470 B.C.

The Pan Painter

This *krater* is among the greatest of all Athenian painted vessels. One side of the krater shows one of the first representations in Greek art of Pan, the goat god. Across the ves-

sel's broad surface, Pan

pursues a frightened young shepherd; the god's impressive erection is echoed in the herm, a kind of pillar with the head of the god Hermes that marked the intersections of roads.

The image on the other side of the *krater*, although inherently more brutal, is as lyrical as the depiction of Pan and the shepherd is explosively

energetic. It shows the death of Aktaion at the hands of Artemis, goddess of the hunt. Aktaion had angered Artemis, and she caused his own hounds to turn on him and tear him to pieces. As Artemis leans back to draw the arrow she will not need, Aktaion falls before the onslaught of the dogs.

Ceramic H. 14% in. [37 cm] James Fund and Museum purchase with funds donated by subscription 10.185

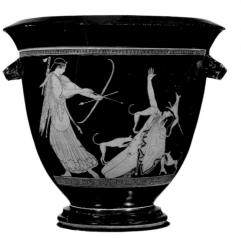

facing page, top

Three-sided relief

Greek

Classical period, about 450-440 B.C.

This monumental sculpture forms the front of a three-sided marble structure that probably served as a windbreak to protect sacrifices being burned on an altar. It depicts Eros, god of love, weighing two small spirits on a balance (the lost arm of which was secured in the three rectangular holes). On the right is Demeter, goddess of agriculture, and on the left is Aphrodite, goddess of love, fertility, and

The sculpture is closely related to the so-called Ludovisi relief, found in Rome in 1887, and it has been challenged as a forgery inspired by the Ludovisi sculpture. However, recent scientific examination has shown that both reliefs are made of the same rather rare marble, and that the Boston relief shows evidence of ancient weathering. It is possible that both sculptures were brought to Rome years after they were carved and placed in a sanctuary.

Marble 32% x 63% in. [82 x 161 cm] Henry Lillie Pierce Fund 08.205

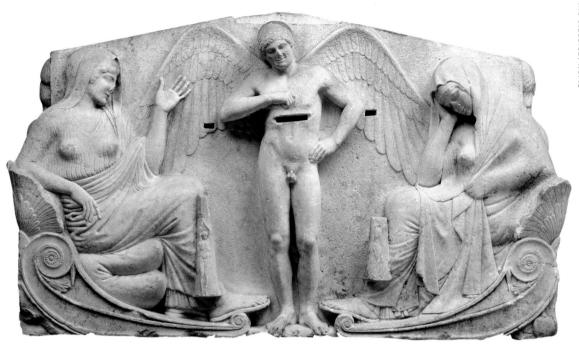

right

Covered drinking cup (kylix)

Greek

Classical period, about $460\,\mathrm{B.C.}$

Possibly by the Carlsruhe Painter

Both the form and decoration of this Athenian cup are extremely unusual. The cover, seen here from above, was not designed to open. The cup was filled through a hollow in its stemmed base, and libations were poured out through the opening in the cover. Most Greek vessels were painted either in the black-figure or red-figure technique. This cup, however, is decorated with the white-ground technique, in which a layer of white slip (a thin mixture of fine clay and water) was applied to all or part of a vessel. The figures were drawn in outline on the unfired clay and painted with a range of delicate colors. Because many of these colors were subject to deterioration, white-ground vessels were primarily reserved for ritual or

funerary use. This one depicts the god Apollo opening his cloak to reveal himself (both actually and metaphorically) to one of the nine Muses, goddesses of the arts, whom he led and inspired.

Ceramic Diam. 6½ in. [16.6 cm] Henry Lillie Pierce Fund 00.356

Two-handled jar (amphora)

Greek

Archaic period, about 525-520 B.C.

The Andokides Painter and the Lysippides Painter

Both sides of this Athenian vase depict the legendary strong man Herakles driving a bull. In design the scenes are almost identical, but in other ways they are completely different. Their differences illustrate the two main styles of Greek vase painting known, appropriately enough, as blackfigure and red-figure. Black-figure vases were made by painting a design on an unfired pot with slip (a thin, paintlike mixture of clay and water). The artist then scratched in the details of the design, such as the ribs on the bull's flank, revealing the main body of the vase underneath. Although they were the same color when wet, the slip and the clay of the vase took on different colors (red and black) when

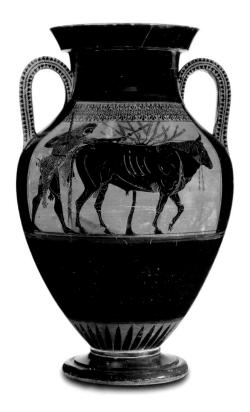

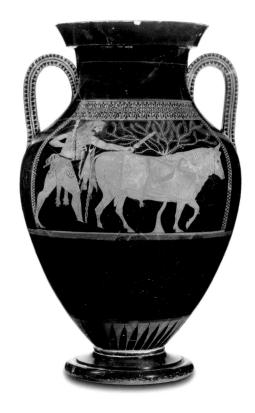

baked in the kiln. Red-figure vases were made in exactly the opposite way. The artists painted the whole vase with slip except for the design, which was left unpainted. Details such as Herakles' lion skin were then drawn with slip.

This vase was painted by two different artists in two different styles. By law, potters and painters all worked in the same part of Athens, creating ample opportunity for artistic exchange. "Bilingual" vases such as this one, featuring both red- and black-figure paintings, date from about the time of the introduction of the red-figure technique. They were most likely made to show the strengths of each style, the old and the new, perhaps as an advertisement to potential customers.

Ceramic H. 20% in. (53.2 cm) Henry Lillie Pierce Fund 99.538

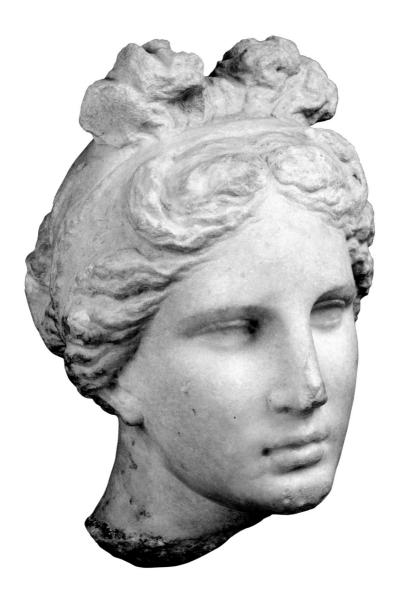

Head of Aphrodite

Greek

Late Classical or Early Hellenistic period, about 330-300 B.C.

This sensuous and beautiful head is one of the finest surviving Greek sculptures of the late Classical period. It represents Aphrodite, goddess of love, and was originally set into a full-length statue. The sculpture's idealized grace, subtle modeling, and

contrasting textures of skin and hair recall the workmanship and revolutionary style of Praxiteles, among the most celebrated of all classical sculptors. Greek sculptures of this period and quality are very rare, and most are known today primarily through later Roman copies.

Marble
H. 11¼ in. [28.8 cm]
Francis Bartlett Donation of 1900 03.743

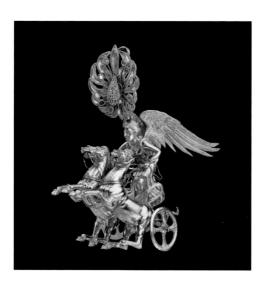

Earring

Greek

Late Classical or Early Hellenistic period, about 350-325 B.C.

Two inches high, this earring was perhaps created to adorn the statue of a deity. It represents Nike, goddess of victory, a symbol of success in war and other contests. She is depicted driving a chariot, her face focused and determined, her wings sweeping behind her. She holds her horses on a tight rein, and they rear sharply, muscles tensed. Every detail of Nike's costume and the harness of her horses is minutely rendered—hundreds of tiny pieces of gold soldered together with marvelous precision to create a harmonious whole.

Gold H. 2 in. (5 cm) Henry Lillie Pierce Fund 98.788

Jar (pelike)

Greek

Classical period, about 440 B.C.

The Lykaon Painter

After a year of dalliance with the beautiful sorceress Circe on the island of Aeaea, Odysseus, hero of Homer's *Odyssey*, journeyed to the Underworld to consult the spirit of the prophet Teiresias. There, Odysseus sacrificed two rams so that their blood would call forth the spirits of the dead. Many spirits came, including that of Odysseus's young companion Elpenor, who had broken his neck in a drunken fall from Circe's roof and had been left unmourned and unburied in the haste of departure. The central figure on this elegantly painted Athenian jar is Odysseus, solemn and unafraid. Beyond the dead rams, Elpenor climbs up out of the black background (evidence of a new interest in illusionistic effects in vase painting of this period). According to Homer, Elpenor begged Odysseus to bury him properly, and Odysseus promised, reflecting: "So we two sat there, exchanging regrets, I with my sword held out stiffly across the blood-pool and the wraith of my follower beyond it. telling his tale."

Ceramic H. 18¾ in. [47.4 cm] William Amory Gardner Fund 34.79

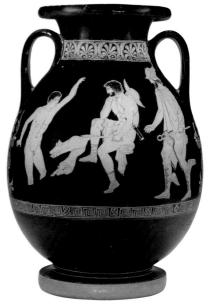

Vessel for mixing wine and water (krater)

Greek, South Italian

Late Classical period, about 340 B.C.

The Greek colonists who settled on the coast of Italy maintained close contact with their homeland, and South Italian vases derive from Greek models. Indeed, early examples were often made by immigrant Greek craftsmen. This sumptuously ornamented krater is among the finest (and largest) South Italian vases from the area of Apulia and is painted with a complex, multifigured composition that emphasizes dramatic expression and gesture. The subject is an event of the Trojan War. The Greek hero Achilles, seated within a pavilion, has just beheaded Thersites, the Greek soldier whom Homer called "the most obnoxious rogue who ever went to Troy." All around, mortals and deities are identified by neat inscriptions. The large size of this krater suggests that it was probably made for burial in the tomb of an important person rather than for actual use.

Ceramic
H. 49% in. (124.6 cm)
Francis Bartlett Donation of 1900 03.804

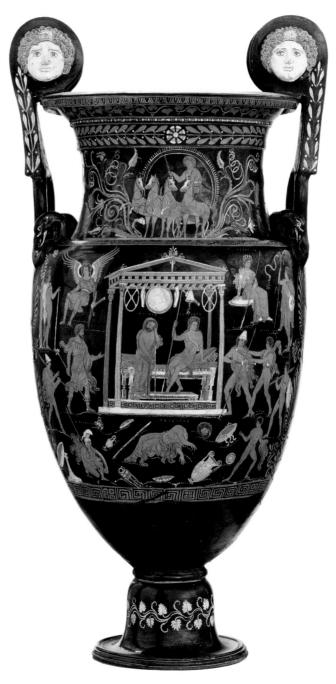

Oil bottle (lekythos) Greek Late Classical period, mid-4th century B.C.

The body of this Athenian vessel depicts the birth of the goddess Aphrodite from the sea. Framed by the scallop shell in which, according to legend, she sailed to the island of Cyprus, she is accompanied by two erotes, their wings lifted to catch the ocean breezes. At once delicate and extravagant, this vessel-appropriately decorated with the goddess of love and beauty-probably held precious perfumes or oils.

Ceramic H. 7½ in. [19 cm] Museum purchase with funds donated by Mrs. Samuel Torrey Morse 00.629

Dancer Etruscan Late Archaic period, about 500 B.C.

Long veiled in mystery because no literary or religious documents survive, the Etruscans are now believed to have been indigenous people of the central Italian peninsula. Their civilization lasted from 900 to 89 B.C., when they were absorbed by the Roman Republic. The Etruscans were a wealthy and powerful seafaring people living in politically independent, densely populated cities. The region's "metal-bearing hills" were mentioned frequently by ancient writers, and Etruscan bronzes were traded throughout the Mediterranean world and as far as northern Europe and Russia. In their sculptures, the Etruscans often exaggerated and distorted the human form for decorative and expressive effect. The artist who created this charming bronze dancer emphasized her delicate and lively silhouette. The curves of her elongated hands and the sharp points of her swinging sleeves and flaring hem provide a counterpoint to the softer lines of her body, which shows clearly beneath a clinging dress sprinkled with incised patterns. This statuette was probably placed in a tomb.

Bronze H. 5¼ in. [13,3 cm] Museum purchase with funds donated by contribution 01.7482

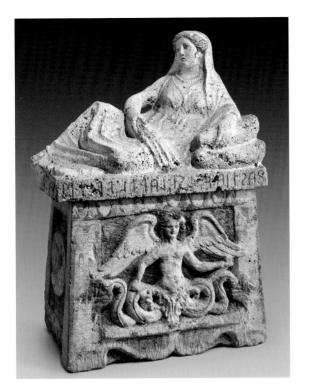

Sarcophagus or cinerary urn Etruscan

Hellenistic period, late 3rd century B.C.

This urn contained the ashes of Fastia Velsi, wife of Larza Velu; her name is inscribed on the rim of the cover, and her idealized portrait reclines on top. On the front of the urn is an image of Scylla, a marine monster with the body of a woman and fishtails for legs. It was probably placed there to protect Fastia Velsi's remains, as many Etruscans believed the journey to the Underworld included a perilous sea voyage. The urn is said to have been found in Chiusi, in a chamber tomb with those of four other upper-class women of the Velsi family, surrounded by gaming pieces, mirrors, jewelry, and other luxury goods for use in the afterlife. The urn originally was painted, and the many traces of pigment are a rare survival.

Limestone (possibly travertine)
41 x 29½ in. (104 x 75 cm)
Francis Bartlett Donation of 1912 13.2860

Portrait of a man

Roman

Republican period, about 50 B.C.

The striking naturalism that emerged in Roman portrait sculpture of the late Republican period is unparalleled in the ancient world. Nevertheless, it does reflect the influence of other civilizations, particularly that of the Etruscans, whose impact on Roman culture ranged from funerary customs to architecture and city planning. Such portraits as this one expressed the Roman conviction that a person's individuality was seen solely in the face. Possibly a preparatory study for a sculpture in bronze or marble, this terra-cotta bust unflinchingly records signs of aging that would have been appreciated as marks of experience and wisdom. Interestingly, only mature individuals seem to have been considered subjects worthy of major portraiture in this period.

Terra-cotta
H. 14% in. (35.7 cm)
Museum purchase
with funds
donated by
contribution
01.8008

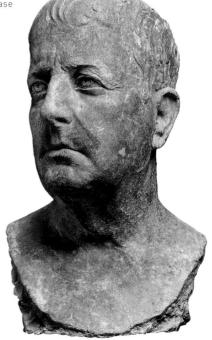

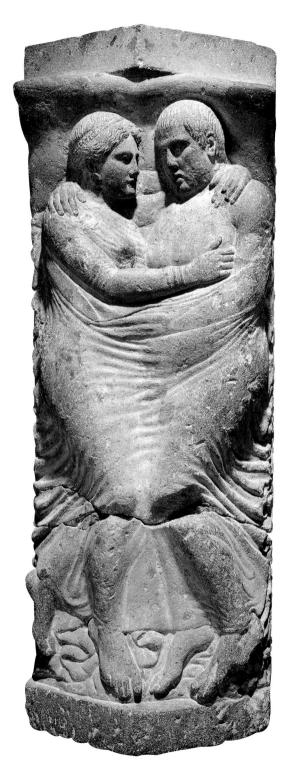

Sarcophagus lid

Etruscan

Late Classical or Hellenistic period, late 4th or early 3rd century B.C.

This stone sarcophagus lid, found in the cemetery of Vulci, is carved with the image of a married couple whose affectionate embrace conveys the continuation of their love for all eternity. Only the woman's name, Ramtha Visnai, is inscribed on the sarcophagus, and she may have been buried alone in it. However, it is possible that the body of her husband was interred later and his name added in paint that has since worn away. This type of sarcophagus lid, which originally would have been painted, is uniquely Etruscan, and very few examples survive. Two are in the Museum collection; the other was apparently made for this couple's son, Larth Tetnies, and his wife.

Peperino (volcanic stone)
82¾ x 28¾ in. [210 x 73 cm]
Museum purchase with funds by exchange from a Gift of
Mr. and Mrs. Cornelius C. Vermeule III 1975.799

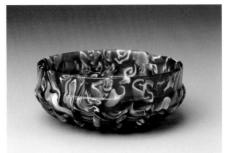

Bracelets

Greek or Roman Late Hellenistic or early Imperial period, about 40-20 B.C.

Although it is not known where these opulent bracelets were made, they may be from Egypt; similar examples are painted on representations of the deceased on mummy shrouds of Egypt's early Roman period. The gold bands are studded with two rows of pearls and hinged to a central projecting ornament surrounded with emeralds and coiling snakes crowned with pearls. In the classical imagination, snakes were beneficent creatures associated with Asklepios, god of health, and with the revels of Bacchus (Dionysos), god of wine and nature. In Egypt, the snake was an emblem of the creator god. Atum, and the green color of emeralds was associated with Osiris, god of the Underworld, and with the concept of rebirth.

Gold, emeralds, and pearls (modern) H. 2³/₄ in. (6.4 cm) Classical Department Exchange Fund 1981.287–288

Mosaic bowl

Roman

Late Republican or Imperial period, late 1st century B.C. or early 1st century A.D.

Roman glass was widely produced and universally admired in ancient times. Many richly colored glass objects were made in the city of Alexandria, in Egypt, which was a major center for the production of luxury goods during the Roman Empire. This bowl was made by assembling slices or spirals of multicolored glass canes into molds that were then placed into a furnace for slow fusing. After the discovery of the technique of glassblowing in the mid-first century B.C., glass became readily available and affordable. Nevertheless, objects made by such complex and labor-intensive techniques continued to be highly prized. Very little ancient glass has survived unaffected by the moisture and acids of the soil in which it was buried.

Glass H. 1¾ in. (4.4 cm) Henry Lillie Pierce Fund 99.442

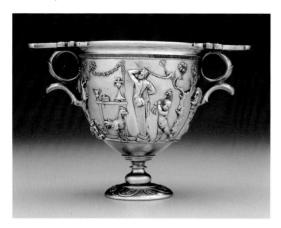

Two-handled cup (skyphos) Roman Early Imperial period, A.D. 1-30

This silver wine cup was probably made during one of the most extravagant periods of Roman history—the reigns of the emperors Augustus and Tiberius. Such superbly made and expensive objects were avidly collected, and this taste for luxury could be carried to excess; the historian Pliny noted that the Roman governor of Lower Germany carried "12,000 pounds weight of silver plate with him when on service with an army confronted by tribes of the greatest ferocity."

The cup is decorated with scenes showing the preparations for a sacrifice in honor of Bacchus (Dionysos), god of wine, fertility, and good times. The plain background sets off the poses of the figures, and the outdoor setting is filled with sacrificial equipment—a portable altar and offering table, an incense burner, cups for wine—all rendered with precision and delicate detail. Two thousand years after its creation, the cup is in remarkable condition.

Silver with traces of gold leaf H. 4% in. [11.1 cm] William Francis Warden Fund, Frank B. Bemis Fund, John H. and Ernestine Payne Fund and William E. Nickerson Fund 1997.83

The playwright Menander

Roman

Imperial period, late 1st century B.C. or early 1st century A.D.

The Roman conquest of Greek colonies in southern Italy and ultimately of Greece itself led to a passionate appreciation and emulation of Greek culture, of which this bust is evidence. It represents the playwright Menander and was probably modeled after a statue that stood in or near a theater in Athens. The Greek sculptures that Roman armies brought back to Rome were set up in public places throughout the city, and wealthy Romans commissioned local artists to make the copies and adaptations to which we owe much of our knowledge of lost Greek masterworks.

This idealized image of a somber, handsome man takes the form of a herm—a roadside marker often found in the Greek countryside—and has holes in the sides of the shoulders for wooden

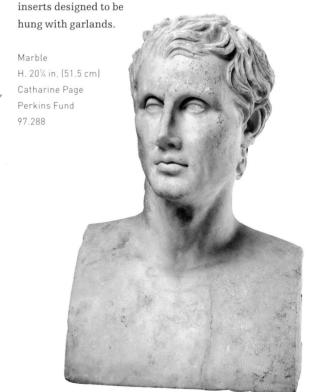

Wall painting

Roman

Imperial period, about A.D. 14-62

This is one of an extraordinary group of Roman wall paintings in the Museum's collection that was excavated in the early twentieth century from the Contrada Bottaro Villa, near Pompeii. The villa and the paintings on its walls were superbly preserved when buried in molten lava by the eruption of Mount Vesuvius in A.D. 79. Known as the Third Style of Campanian wall painting, the decoration of this image incorporates delicate and fanciful architectural ele-

ments and floral and figural details, all silhouetted against an expanse of color that respects and emphasizes the flat, solid surface of the wall. In Herculaneum and Pompeii, where middle-class Romans had second homes, almost every room in every house was painted. In no other society was so much effort bestowed on decorating ordinary living spaces, and such painting attracted the most talented artists of the period.

Fresco 38½ x 46 in. (97 x 117 cm) Richard Norton Memorial Fund 25.45

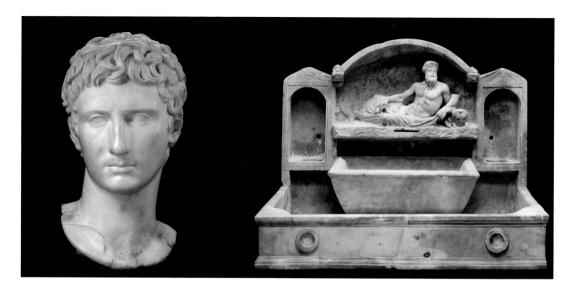

The emperor Augustus Roman Imperial period, 1st or 2nd century A.D.

Augustus (63 B.C.-A.D. 14), the designated heir of his great-uncle Julius Caesar, was Rome's first emperor and began a long imperial tradition of commissioning art as a form of political propaganda. In the previous, late Republican period, young people were seldom considered deserving of political or artistic consideration. Therefore, when Augustus became emperor at the age of thirty-two, artists looked for inspiration to fifth-century Greece, a time when youthful beauty was much admired. Until his death at seventy-six, Augustus was always represented as a handsome young man with a full head of thick curls. As imperial icons, these idealized portraits continued to be made long after the emperor's death. This superb example, which was probably inserted into a full-length statue, may have been created for a private villa near Rome.

Marble H. 17 in. [43.3 cm] Henry Lillie Pierce Fund 99.344

Fountain basin Roman Imperial period, about A.D. 98-138

This unique and complex fountain, which reflects ancient Roman fascination with Egypt, probably came from the courtyard of a private villa near Rome. It is highly unusual among surviving objects of its type in that it creates an architectural setting for water, a sophisticated arrangement of boxes within boxes, each a different shape. Water splashed into the basins from the niches in the back, flowing out through holes in the front. The delicately modeled figure is Nilus, god of the Nile, identified by the sphinx on which he leans. He holds a cornucopia in one hand and may have held a sheaf of grain in the other-both symbolic of the agricultural prosperity that the Nile brings to Egypt. The side niches once contained statuettes of water nymphs, perhaps representing the daughters of Nilus.

Marble

26 x 34 % x 29 % in. [66 x 88 x 74 cm] Museum purchase with funds by exchange from a Gift of Mr. and Mrs. Henry P. Kidder, a Gift of Thomas Gold Appleton, a Gift of Edward Jackson Holmes, a Gift of Mrs. Francis C. Lowell, Otis Norcross Fund, and a Gift of Edward Perry Warren 2002.21

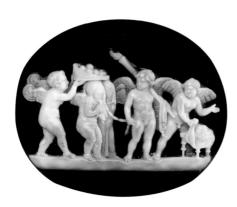

Cameo

Roman

Late Republican or early Imperial period, mid- to late 1st century B.C.

Signed by Tryphon

The carving of tiny images on precious stones was a Greek art form that was later enthusiastically adopted by the Romans. In the first century, the Roman scholar Pliny wrote in his *Natural History*: "Very many people find that a single gemstone alone is enough to provide them with a supreme and perfect aesthetic experience of the wonders of Nature." This cameo—a stone carved in relief on one layer against the background of a lower, contrasting layer—depicts the marriage of Cupid and Psyche. Venus, goddess of love and beauty, was so jealous of the beautiful Psyche that she sent Cupid to make Psyche fall in love with some insignificant man. Predictably, Cupid fell in love with Psyche himself, and after many tribulations the enamored couple was brought to heaven and married. This cameo, which bears a signature ("Tryphon made it"), once belonged to the celebrated Flemish artist Peter Paul Rubens, a selfproclaimed "lover of antiquities."

Onyx $1\frac{1}{2}\times1\frac{3}{4}\text{ in. } (3.7\times4.5\text{ cm})$ Henry Lillie Pierce Fund ~99.101

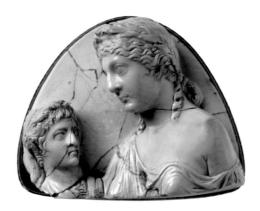

Cameo

Roman

Imperial period, A.D. 14-37

In Roman times, high officials and members of the imperial family often commissioned carved gemstones as private or official gifts. To promote imperial power and political ideology, images of the emperor Augustus and his family were disseminated throughout the vast Roman Empire. Coins placed such images in the hands of Roman citizens of every class, but precious cameos were special gifts. This exquisite example, made of turquoise, depicts Augustus's widow, Livia, holding a bust of her deceased husband. Although created late in her life, the cameo shows the empress as a lovely young woman; indeed, she is represented as Venus—an acknowledgment of the fact that, in his will, Augustus declared his wife a member of the family of Julius Caesar, whose patron goddess was Venus.

Turquoise

1½ x 1½ in. (3.1 x 3.8 cm)

Henry Lillie Pierce Fund 99.109

Portrait of a man

Roman

Imperial period, about A.D. 200-230

This remarkable head once belonged to a painted, life-sized statue made of costly bronze. The portrait is a private one, very different from the idealized images created for public display, with politics and propaganda in mind (see page 76). Portraits such as this one were not serially produced; the sculptor studied the sitter in person and worked directly on a wax cast of his clay model. Here, the tool marks are still evident, giving the work a fresh immediacy—the wrinkled brow, sunken eyes, and creased forehead of an individual. The realistic style of portraiture was popular in the Roman Republic (see page 71) this work reflects its revival three hundred years later. This sculpture may have been reused on a triumphal arch erected on a bridge over Rome's Tiber River. It is believed to have been recovered from the river in the late nineteenth century.

Bronze H. 121/4 in. [31 cm] Catharine Page Perkins Fund 96.703

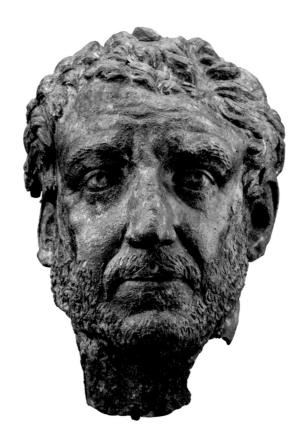

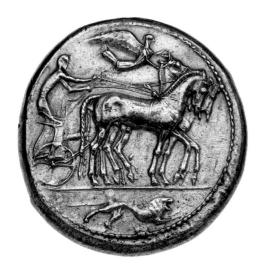

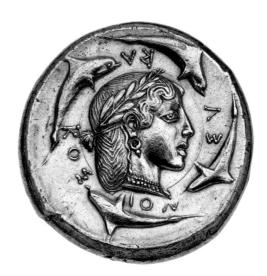

Ten drachma coin

Greek, mint of Syracuse (Sicily)
Early Classical period, about 465 B.C.

Silver

Diam. 1% in. (3.5 cm)

Theodora Wilbour Fund in memory of Zoë Wilbour 35.21

$egin{array}{ll} egin{array}{ll} egi$

Roman, northern Greek mint Late Republican period, 43-42 B.C.

Silver

Diam. ¾ in. (2 cm)

Theodora Wilbour Fund in memory of Zoë Wilbour 2002.129

Coins throughout their history have always been more than money: if these little pieces of metal were simply currency, they could be blank (or nearly so). However, coins are ambassadors, and the symbols they bear matter. Greek city-states began issuing coins decorated with local gods and symbols as early as the seventh century B.C. The Syracusan tendrachma piece illustrates a format still seen on most modern coins: a head on one side (the nymph Arethusa, associated with a famous spring in Syracuse) with a more complicated scene on the other

(Nike, goddess of victory, crowning the horses of a victorious racing team).

About the time of Alexander the Great (356–323 B.C.), kings and emperors began celebrating their reigns by issuing coins bearing their own images. The Romans took up the habit with enthusiasm. This silver coin (denarius) commemorates the Ides of March, the day in 44 B.C. on which Julius Caesar was assassinated by a group of senators led by Brutus, whose portrait appears on the obverse of the coin. On the reverse is a pileus (a felt cap symbolizing the liberty that Caesar's murder was designed to obtain), flanked by two daggers and the inscription EID.MAR (Ides of March). Perhaps inspired by Shakespeare's play Julius Caesar, March 15 remains an unlucky day in the popular imagination.

Athena Parthenos

Roman

Imperial period, 2nd or 3rd century A.D.

A monumental figure of Athena Parthenos, the masterpiece of the sculptor Phidias, was the principal image in the Parthenon, the temple dedicated to Athena that still crowns the Acropolis in Athens. Made between 447 and 438 B.C., Phidias's statue of the goddess of wisdom was sheathed in ivory and gold and stood almost forty feet high. It was gone from the Acropolis by about A.D. 450 (possibly destroyed by fire), but before that time numerous copies had been made for export throughout the Mediterranean world.

This small replica is one of the most accurate known, preserving details—found in no other copy-that match a description of the original written about A.D. 150 by the Greek traveler and writer Pausanias. Athena's aegis—a breastplate emblematic of majesty is adorned with twining snakes and an image of one of the Gorgons, fearsome sisters of Greek mythology whose glance had the power to turn people to stone.

Marble H. 60% in. (154 cm) Classical Department Exchange Fund 1980.196

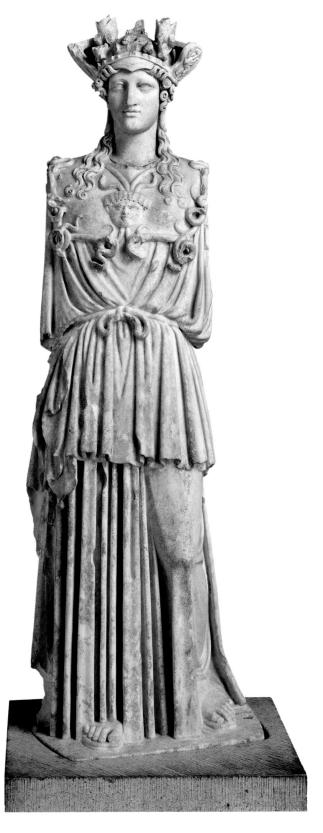

Homer

Roman

Late Republican or Imperial period, late 1st century B.C. or 1st century A.D.

Although the ancient Greeks believed that the great epics the *Iliad* and the *Odyssey* were the work of the poet Homer, reliable information about the poet's life was as elusive then as it is today. This sculpture, therefore, is not a real portrait but a conceptual image of creative genius: the unruly hair and knitted brow suggest intensity and passion; the worn, furrowed face reflects experience; the eyes, sightless in accordance with ancient tradition, reflect the belief that Homer and other great bards saw into the future and beyond this world.

Probably once set into a seated statue, this head is the best of many Roman copies of a lost Greek sculpture from the Hellenistic period, a time in which art was characterized by an interest in expressiveness, naturalistic detail, and technical virtuosity.

Marble
H. 16% in. [41 cm]
Henry Lillie Pierce Fund 04.13

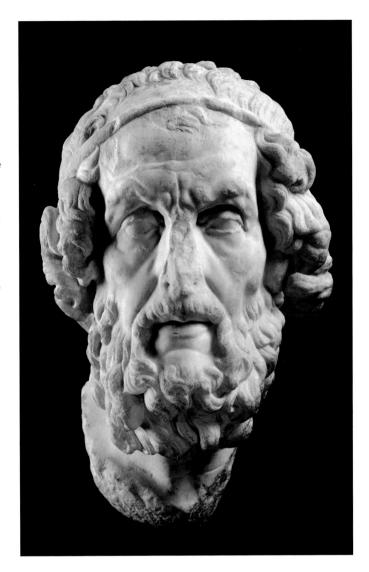

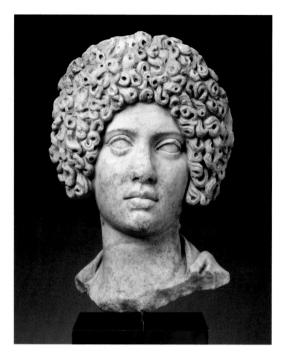

Portrait of a woman Roman Imperial period, A.D. 100-125

This unknown woman's full lips and sweet expression suggest portraiture, but the sculpture is really about the extravagant hairstyle, made up of tight curls twisted into a great crest. Behind this "facade" the hair is wound into a wide, flat bun. Such a coiffure may have been inspired by the masks worn by actors although, in a more subdued form, it had been made popular decades earlier by women of the imperial family. With great skill, the artist used a drill to create the strong contrasts of light and shadow that give substance and vitality to the marble curls.

Marble

H. 13³/₄ in. [35 cm]

Gift of Samuel and Edward Merrin and Museum purchase with funds by exchange from the Benjamin and Lucy Rowland Collection and a Gift of Barbara Deering Danielson, and the William Francis Warden Fund 1992.575

Funerary relief

Roman

Imperial period, about A.D. 150-200

The Syrian city of Palmyra was a major commercial hub for the merchants that traded between the Persian Gulf and the Mediterranean. There the cultures of east and west met and fused, creating an artistic style unique in the Roman world. This Palmyrene funerary monument is inscribed in Greek: "Aththaia, daugher of Malchos, Happy One, Farewell." Adorned for eternity, Aththaia wears jewelry that reflects the taste and craftsmanship of the Greek, Roman, and Near Eastern cultures that shaped her city-elaborate pendant earrings, a large circular pin, two signet rings on her left hand, a betrothal or wedding ring on her right, bracelets made of twisted gold or silver, and two necklaces. All this jewelry has been rendered with such precision that this relief and others like it are invaluable resources for charting the fluctuations of fashion among the prosperous residents of ancient Palmyra.

Limestone 21% x 16½ in. [55 x 42 cm] Museum purchase with funds donated by Edward Perry Warren in memory of his sister 22.659

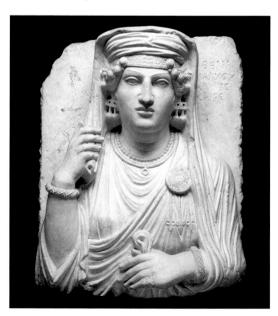

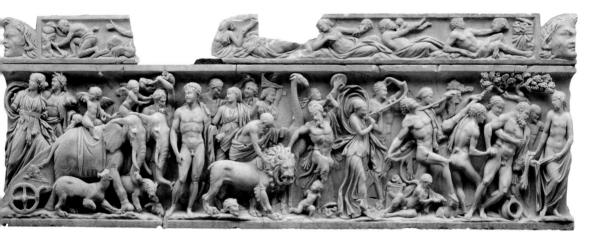

Sarcophagus

Roman

Imperial period, about A.D. 215-25

The scene that sweeps along the side of this sarcophagus depicts the triumphant return of the god Bacchus (Dionysos) from India, where he had been spreading his cult of joyous physical abandon. On the left edge, Bacchus steps into a chariot drawn by two Indian elephants. Before him, his merry-making attendants (many part-human, part-beast) celebrate with wine, dance, and music. At the far right is Hercules, who has lost a drinking contest to Bacchus and staggers toward a coyly welcoming maenad, one of Bacchus's lustful female followers. Almost every inch of the relief is covered with figures of astonishing variety and vitality, carved in such high relief that some are almost free of the block.

Marble 30½ x 81¾ in. (77.5 x 208 cm) William Francis Warden Fund 1972.650

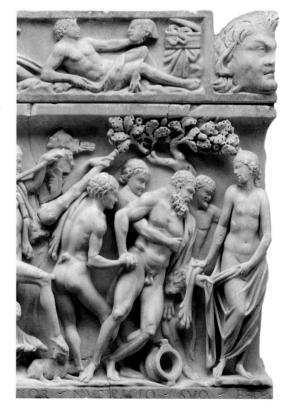

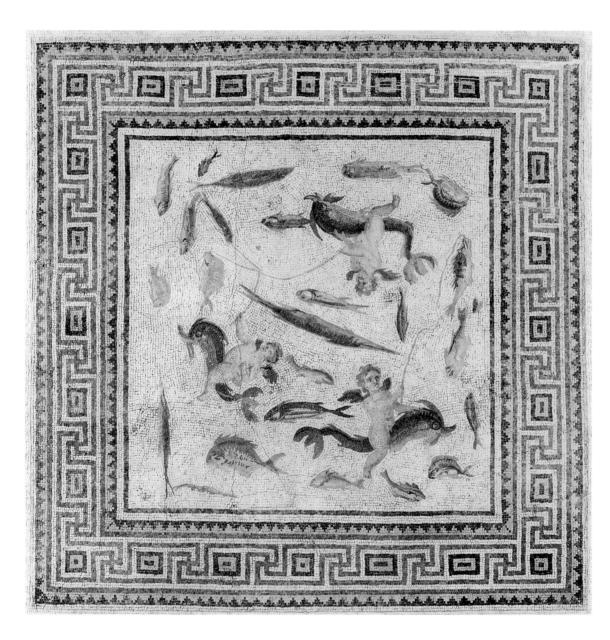

Mosaic

Roman

Imperial period, A.D. 200-30

About nine feet square, this mosaic was excavated in the 1930s in Seleucia Pieria, the port of Antioch (present-day Antakya, Turkey). It once paved the courtyard of an early-third-century Roman house where diners reclined on couches and enjoyed spectacular views of the Mediterranean Sea and the mountains of Syria. At one end of the courtvard, a fountain provided the refreshing sound of water. The preeminent pictorial medium of the time, mosaics are made of tesserae, small cubes of stone or glass, skillfully set into lime mortar to create painterly effects of shading and modeling. In this mosaic, cupids riding on dolphins fish in the sea, with twenty-five varieties of saltwater fish (expensive, and symbols of status) are recognizably depicted. Evocative of its now-lost domestic setting, this mosaic is particularly valuable for its documented architectural and archeological setting. Beginning in 2004, the Museum spent two years cleaning, stabilizing, and restoring the mosaic for display.

Stone and glass tesserae 114³/₄ x 113 in. [291.5 x 287 cm]

Museum purchase and conservation with funds donated by George D. and Margo Behrakis, The Getty Foundation, Jane's Trust, John F. Cogan, Jr. and Mary L. Cornille, Daphne and George Hatsopoulos, the Estate of Dr. Harold Amos, Peter and Widgie Aldrich, Mrs. I. W. Colburn, Mary B. Comstock, The Hellenic Women's Club, Inc., an anonymous donor, Katherine R. Kirk, Peter Vlachos, Mrs. James Evans Ladd, Irene and Grier Merwin, Suzanne R. Dworsky, Mr. and Mrs. Robert K. Faulkner, Francis J. Jackson and Nancy M. McMahon, Meg Holmes Robbins, Otis Norcross Fund, Helen and Alice Colburn Fund, Arthur Tracy Cabot Fund, Charles Amos Cummings Fund, and by exchange from the John Wheelock Elliot Fund, Henry Lillie Pierce Fund, Benjamin Pierce Cheney Donation, Bequest of Benjamin Rowland, Jr., Gift of a "class of young ladies," Museum purchase by contribution, Gift of Barbara Deering Danielson, General Funds, William Sturgis Bigelow Collection, Gift of Mr. and Mrs. G. W. Wales, Gift of Paul E. Manheim, Bequest of Mrs. May Sheppard Jordan, Gift of Mr. and Mrs. William de Forest Thomson, Francis Bartlett Donation. Gift of James Howe Proctor, Gift of Benjamin W. Crowninshield. Gift of the Estate of Dana Estes, Gift of Thomas Gold Appleton. Gift of Edward Perry Warren, Gift of an anonymous donor, Gift of Francis Amory, Gift of J. J. Dixwell, Gift of Edward Austin, Gift of Edward Robinson, Gift of Horace L. Mayer, Everett Fund, Gift of the Misses Norton, Gift of the Misses Amy and Clara Curtis, Gift of Charles C. Perkins, Gift of Mrs. Walter Scott Fitz. Gift of Harold Murdock in memory of his brother, Rear-Admiral J. B. Murdock, Gift of the Estate of Alfred Greenough, and Gift of Edward Southworth Hawes 2002.128.1

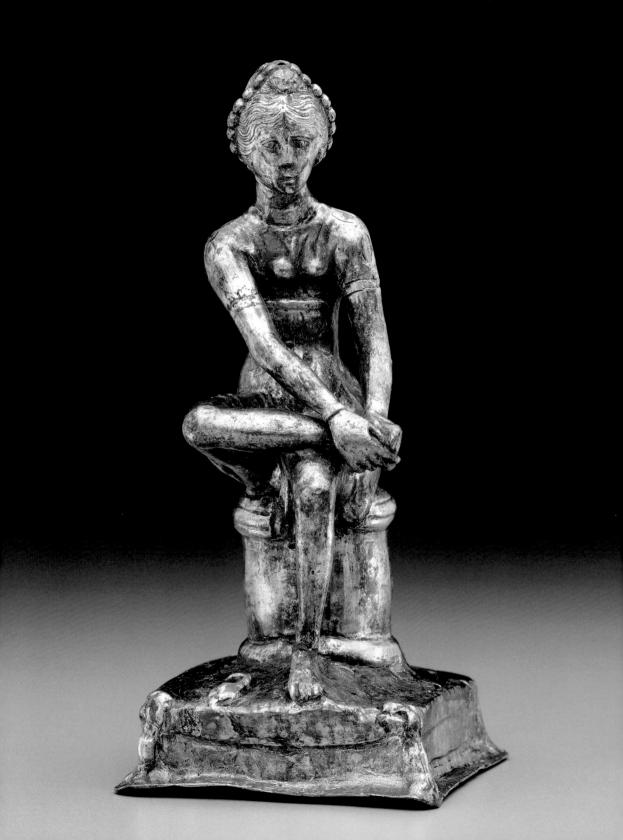

facing page

Seated dancer

Roman

Late Imperial period, late 4th century A.D.

A dancer sits on a stool, massaging her tired foot and perhaps preparing to put on the slipper that rests on the sculpture's rectangular base. Images of seated figures adjusting a sandal or slipper had a long history in ancient Greek sculpture. The artist who created this figurine hundreds of years later, in the late Roman Imperial period, clearly was still attracted by classical ideals of grace and beauty. The sculpture is exquisitely worked, cast in silver with lion-headed supports at the corners of the base and details of hair, costume, and jewelry picked out in gold.

Silver with gold details
H. 4% in. (12 cm)
Frederick Brown Fund 69.72

Neck ornament

Eastern Mediterranean Late Antique period, 4th century A.D.

This tapestry-woven neck ornament with a jeweled neck band and end panels decorated with mythological figures on a purple ground illustrates the richness of clothing decoration. Originally part of a linen tunic, the ornament is woven in fine wool, linen, and gold-wrapped silk yarns. The tapestry weaver enhanced the richness of the design by using gold-wrapped thread as well as vividly dyed wool yarns. The purple wool of the ground could be Tyrian purple, the finest and most expensive dye of antiquity, which was extracted from a species of eastern Mediterranean mollusk and was originally made famous by the Phoenicians of Tyre, in present-day Lebanon. The figural motifs are woven in an illusionistic style widespread in figural representations of the third and fourth centuries.

Linen, wool, silk, and gold-wrapped yarns; tapestry weave $22\% \times 6\%$ in. [56.9 x 15.8 cm] Charles Potter Kling Fund 46.401

opposite

Fragment of a curtain

Roman

Late Roman period, 4th-6th century A.D.

Ancient Egyptian culture changed course dramatically when Alexander the Great conquered the country in 332 B.C. and founded the city of Alexandria—a magnet for thousands of Greek immigrants. Three hundred years later, in 31 B.C., Egypt became a Roman province and, along with the rest of the Roman Empire, eventually adopted Christianity as its official religion. Gradually a new and original civilization known as Coptic (a word derived from the Greek for "Egyptian") developed in Egypt, incorporating Greek, Roman, and Christian influences. This curtain fragment (like the neck ornament on page 87) is a highlight of one of the most extensive American collections (some twelve hundred pieces) of Eastern Mediterranean weavings from the Early Christian period. Woven in loops of warm, rich colors, it features a man—perhaps a temple acolyte—holding a staff and raising a libation bowl. Roses are scattered on the ground around him.

Linen plain weave with weft wool pile loops $38\% \times 51\%$ in. [97.5 x 131 cm] Charles Potter Kling Fund 49.313

Chalice Byzantine Early Byzantine period, 6th century A.D.

The chalice was among the most precious objects employed in the liturgy of the Byzantine Orthodox Christian church, all of which had a symbolic meaning as well as a practical function. The chalice was, symbolically, the bowl that collected the blood of the crucified Christ and also the cup used in the church for Holy Communion. The hammered bowl of this chalice is inscribed, in Greek, "Having vowed, Sarah offered [this chalice] to the First Martyr," who was Saint Stephen. The chalice was probably Sarah's gift to her church in Syria. On each side of the body of the bowl is a chrismon (monogram of Christ), a Chi-Rho formed from the first two letters of Christ's name in Greek. The small alpha and omega, first and last letters of the Greek alphabet, refer to Jesus's statement in the New Testament: "I am alpha and omega, the beginning and the end."

Silver and niello with gilding
7 x 10½ in. (18 x 26.6 cm)
Edward J. and Mary S. Holmes Fund 1971.633

Bodhisattva

Northwestern Pakistan (Gandhara), late 2nd century A.D.

Bodhisattvas are enlightened beings who postpone their own entry into nirvana and remain on earth to assist other beings in their quest for salvation. This is an extremely important concept in Buddhism, a religion that stresses altruism and compassion. Reflecting the origins of the historic Buddha, who was born a prince, bodhisattvas wear elaborate jewelry and layers of rich garments. Details of this sculpture, such as the stiff folds and ridges of the heavy drapery, reflect the Gandharan region's contacts with the contemporary Greco-Roman world and Gandharan artists' knowledge of Western sculptural traditions.

Gray schist H. 43 % in. [109.5 cm] Helen and Alice Colburn Fund 37.99

Male spear thrower or dancer
Pakistan (Sindh, Chanhudaro)
Indus Valley civilization, 2600-1900 B.C.

The pose of this tiny, fragmentary figure suggests that he is either dancing or throwing a spear. Many similar male figurines with their hair tied back in buns have been found at Indus Valley sites in present-day Pakistan, but their function and meaning are unknown. The metalworking techniques of this early civilization, however, were remarkably sophisticated, and this sculpture was probably cast using the lostwax process. In this process, a wax model is encased in clay that is heated until the wax melts: the wax is then poured out and replaced with molten bronze or copper. When cool, the clay casing is broken away from the metal cast, which is then smoothed and finished.

Copper H. 1% in. [4.1 cm] Joint Expedition of the American School of Indic and Iranian Studies and the Museum of Fine Arts, 1935–1936 Season 36.2236

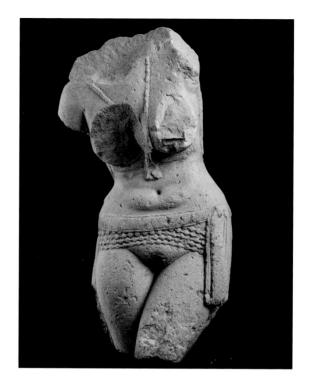

Torso of a fertility goddess (yakshi) Central India (Sanchi, from a gateway of the Great Stupa), 25 B.C-A.D. 25

Prior to the development of Buddhism in India, yakshis were honored as semidivine nature spirits believed to bring good luck, wealth, and other blessings such as the birth of children. Incorporated into the early imagery of Buddhism, yakshis and their male counterparts, yakshas, were placed at the entrances to religious monuments to provide protection and welcome the faithful. This sensuous sculpture comes from a gateway at one of the oldest and most important Buddhist monuments in India, the Great Stupa at Sanchi. Like figures still found on gateways at the site, this yakshi stood beneath a tree, her left arm raised to hold a branch. Since it was believed that the touch of a beautiful woman would cause a tree's sap to run, making that tree flower and bear fruit, such figures were powerful symbols of fertility and abundance.

Sandstone H. 28% in. (72 cm) Denman Waldo Ross Collection 29,999

Ganesha with His Consorts

Northern India (Madhya Pradesh or Rajasthan), early 11th century

Ganesha is a Hindu god represented with the body of a boy and the head of an elephant. Elephants are symbols of royalty and very auspicious animals in Indian culture, and part of Ganesha's function is to help clear obstacles from the worshiper's path to enlightenment. Sculptures of Ganesha, like this one, are often placed on the exterior wall of temples so that they are the first images encountered by the reverent visitor, who circles the temple before entering. In this lively sculpture, Ganesha is shown with his consorts, Siddhi (Success) and Riddhi (Prosperity). Below him is a rat, his traditional means of transportation.

Sandstone H. 41% in. [105.2 cm] John H. and Ernestine A. Payne Fund, Helen S. Coolidge Fund, Asiatic Curator's Fund. John Ware Willard Fund, and Marshall H. Gould Fund 1989.312

Lovers (mithuna) Eastern India (Orissa). 13th century

This exquisitely carved ivory sculpture may have been designed to ornament a piece of furniture-perhaps the throne of a king or a deity. The sensual interplay of intricate jewelry and softly rounded flesh reflects the eastern Indian origin of the sculpture. Such images of lovers (mithuna) are often found in

> Indian art as part of the decoration on both Buddhist and

> > Hindu monuments; they symbolize the union between the male and female principles—the equal yet opposing forces of nature. With

the sense they convey of fertile energy and infectious optimism, they are also prized as good luck charms. Stylistically, this object is very close to the erotic stone sculptures on the sun temple at Konarak in Orissa, built in the thirteenth century.

H. 6¼ in. [15.9 cm] Keith McLeod Fund 1987.622

Southern India (Tamilnadu region), late 10th century

Hindu gods are often depicted in human form but with superhuman attributes such as multiple heads and eyes that symbolize enhanced knowledge and vision. This

figure's many heads are associated with Brahma, the god of creation, but the third eye in the forehead and the tall, matted hair indicate that he is, in fact, Shiva—the god of destruction who also embodies the life force. With five faces (a fifth, looking

upward, is implied), this image repre-

sents the god as supremely powerful and would probably have been placed in a niche on the outside of a temple wall. Hindu temple sculptures function both as representations and physical embodiments of the gods; they are there to be seen by and also to see the worshipers.

Green schist
H. 63¾ in. (162 cm)
Gift of Mrs. John D. Rockefeller, Jr. 42.120

Pictorial carpet

Northern India (Lahore), about 1590-1600

This carpet brilliantly translates into knotted pile the lively painting style of the court of the Mughal emperor Akbar, where it was probably made. The wealth of imagery includes scenes of palace life, hunting, and fabulous beasts in combat and a border filled with glowering monster masks. The celebrated nineteenth-century American architect Henry Hobson Richardson selected this carpet for the house of an important client, Boston businessman Frederick L. Ames.

Cotton warp and weft, wool knotted pile 95% x 60% in. [243 x 154 cm] Gift of Mrs. Frederick L. Ames, in the name of Frederick L. Ames 93.1480

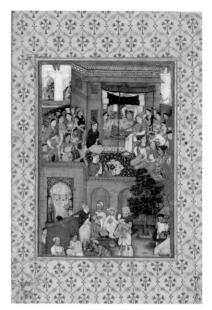

Bishandas Indian, active about 1590-1650 Birth of a Prince, about 1620

Seventeenth-century Mughal painting is one of the great glories of Indian art. This vivid, meticulously executed image of courtly life is probably a page from a manuscript illustrating the life of the Mughal emperor Jahangir, son of the great emperor Akbar, and may depict his birth. The infant's jewel-encrusted crib is placed near the bed of his mother, who is surrounded by female attendants, musicians, eunuchs, and Akbar's other wives. Male attendants bring platters of presents, the court astrologers (at bottom center) forecast the child's future, and the entrance to the harem (at left) is garlanded with flowers in honor of the festive occasion. The painting is attributed to Bishandas, one of the most celebrated Mughal painters, whom Jahangir called "unequaled in his age for making likenesses."

Opaque watercolor on paper 10 % x 6 ½ in. [26.4 x 16.4 cm] Francis Bartlett Donation of 1912 and Picture Fund 14.657

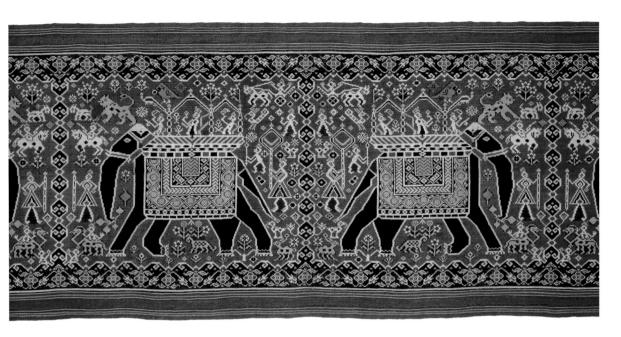

Ceremonial hanging (patola)

Western India (Gujarat), late 18th or early 19th century

Ikat is a Malay-Indonesian word for an intricate clothmaking process in which threads are patterned by repeated binding and dyeing before they are placed on the loom and woven. Patola—Indian silk textiles richly patterned in the exacting double-ikat technique—were prized as heirlooms and luxury trade goods. Valued also for their spiritual potency, fragments of patola were even powdered and mixed with medicines. Many of these textiles were made for

the Indonesian export market and have survived in excellent condition because their use was reserved for religious and ritual functions. Their superb quality and vibrant color inspired the Indonesian name patola, which means "gifts from the sky." This example was probably given to an Indonesian ruler by officials of the Dutch East India Company as a mark of special esteem.

Silk; double ikat (resist-dyed warp and weft yarns) 43 x 191 in. [109.2 x 485 cm] Marshall H. Gould Fund 1985.709

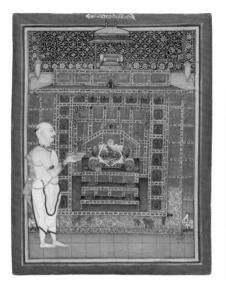

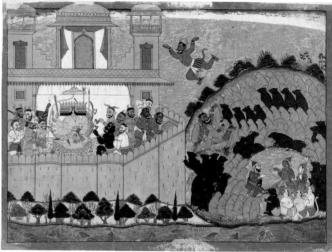

Maharao Kishor Singh of Kota Worshiping Brijrajji

India (Rajasthan, Kota), about 1830

The rulers of Kota, in Rajasthan, put special emphasis on the worship of icons. The small metal icon called Brijrajji (a form of the god Krishna) was housed in the palace compound at Kota, where it played a major role in numerous elaborate rituals. This painting commemorates a specific puja (the act of showing reverence through prayers, songs, and rituals) in which the icon was placed on a couch in an elaborate shrine made of silver panels. The maharao ("great king") stands at left; he has shaved his head and put on simple clothing to demonstrate his humility. By keeping a revered and powerful icon in the palace and by treating it as the true ruler of Kota, the maharaos sought to protect their state as well as to exhibit their own humility before the divine.

Opaque watercolor, silver, and gold on paper 10³/₄ x 8¹/₂ in. [27.1 x 21.5 cm] Gift of John Goelet 66, 159

Attributed to Manaku

Indian, about 1700-1760

Rama and His Armies Encamped; One Spy Returns to Ravana

Northern India (Punjab Hills, probably Guler),

about 1725

Remarkable for its vivacious draftsmanship and flat expanses of intense color, this page is from an oversized manuscript of the Ramavana, the Indian epic that recounts the life of the warrior-king Rama. A reincarnation of the god Vishnu, Rama descends to earth to vanquish Ravana, the multiheaded, multiarmed king of the demons, and restore the balance of the universe. Having been roughed up and warned of impending conflict by Rama's army, a demon returns to report to Ravana. Throughout the series, demons appear as a diverse group of misshapen characters, many of them more humorous than frightening. Ravana's palace is usually described as outrageously opulent and stands in stark contrast to the forested areas inhabited by Rama and his woodland allies.

Opaque watercolor and gold on paper 241/4 x 33 in. [61.5 x 83.6 cm] Ross-Coomaraswamy Collection 17.2746

Cloth painting (pechhavai) India (Rajasthan, Jodphur or Bikaner), late 18th century

A pechhavai ("that which hangs at the back") is a painted wall hanging created as a backdrop for sacred icons in temple shrines. These shrines are usually dedicated to Krishna, the Hindu god who embodies love and the divine joy that destroys pain and sin. Krishna grew up in a family of cow herders, and this pechhavai shows six gopis (cow-herding girls devoted to Krishna) carrying flywhisks and dishes of offerings. At the sides are mango trees, heavy with fruit, and the background

is filled with a shower of blossoms, perhaps signifying nourishing rain. Below the *gopis* is a row of cows above a lotus pond, and six Hindu deities appear in a band of clouds at the top. Like so many works of art in museums, we must imagine this rich vision of fruition in its original context—behind an altar bearing images and offerings of sweets and spices.

Opaque watercolor, gold, and silver on painted cotton plain weave 96 x 100 in. (244 x 254 cm) Gift of John Goelet 67.837

Lute (tambura) Northern India, 19th century

An essential component of classical Indian music, the *tambura* provides a drone accompaniment to the human voice or solo instruments such as the sitar. The strings are plucked slowly in repeated sequence, and a prolonged buzzing tone

they make contact with a wide bridge. In this splendid example, the bridge is ivory and the instrument, undoubtedly created for a wealthy patron, is finely decorated with ivory inlay.

Tun wood, calabash gourd, ivory,
black mastic
H. 53 ½ in. [135 cm]
Mary L. Smith Fund 1992.259

Heroine Rushing to Her Lover (Abhisarika nayika)

Northern India (Punjab Hills, Kangra), late 18th century

Paintings from the state of Kangra are celebrated for their delicacy of detail, juxtapositions of brilliant and muted colors, and evocation of complex emotions. The word nayika in the title of this page refers to the female personification of the notion of human love. Here, the heroine ignores the perils of the night—darkness, lightning, beating rain, snakes—as she hurries to meet her lover. The storm symbolizes her passion, and the trees represent intertwined lovers. Paintings of such secular subjects were popular among painters at the Hindu Rajput courts of Rajasthan and the Punjab Hills, which prospered in close proximity to the Muslim Mughal courts of northern India.

Opaque watercolor and gold on paper $6\% \times 9\%$ in. (16.2 x 25 cm) Ross-Coomaraswamy Collection 17.2612

Dancing celestial figure (apsaras)

Cambodia, late 11th century

Sprightly female apsarases appear on temples throughout southern Asia. Heavenly beings, they are usually shown dancing or playing musical instruments as they entertain and pay homage to the gods. In this example, the elegant figure is framed by a flamelike arch and dances on a lotus flower whose branch sprouts two additional buds. The sculpture was originally part of an incense burner or a hanging lamp whose flickering light would have enhanced its sense of graceful movement. This is one of the most exquisitely worked and best preserved of the very few fragments of such fragile bronzes that have survived from Cambodia.

Bronze H. 15½ in. [39.3 cm] Denman Waldo Ross Collection 22.686

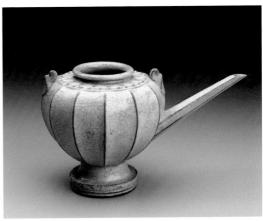

Ewer Vietnam, 11th-12th century

Ceramics from Vietnam often reflect that region's role as a bridge between eastern and southern Asia. This ewer was probably made for royal patrons or temple officials in Thang Long (present-day Hanoi). The vessel's rolled lip and collar of modeled lotus petals are typical of Vietnamese ceramics, but the creamy, crackled glaze recalls Chinese wares. The ewer's dramatic silhouette may have been inspired by metal vessels that originated in India but were used in Buddhist and Hindu rituals throughout southern Asia.

Stoneware with white slip and light green glaze, carved lotus petals, molded and applied handles

H. 4% in. (12.5 cm)

Anonymous gift 1991.969

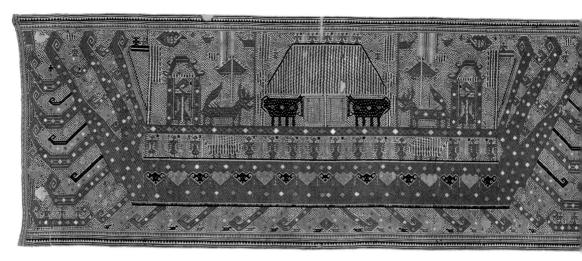

Bhairava or Mahakala Indonesia (eastern Java), 14th century

Striking a pose from traditional Javanese dance, this large, stone sculpture may represent either Bhairava (a Hindu deity) or Mahakala (a Buddhist deity); Hinduism and Buddhism coexisted in Javanese culture and often shared imagery. Wearing royal attire-an ornate crown, belts, necklaces, earrings, and armbands—this figure may have been intended as an idealized portrait, combining the representation of a deceased royal personage with that of a deity. The rope of skulls indicates that this is a wrathful deity, representing the power to overcome fears and frightening only to those who are not part of the faith.

Volcanic stone (andesite) H. 78 in. (198 cm) Frederick L. Jack Fund 1972.951

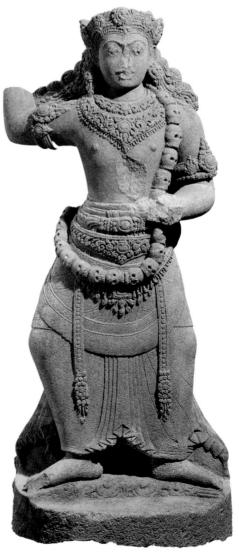

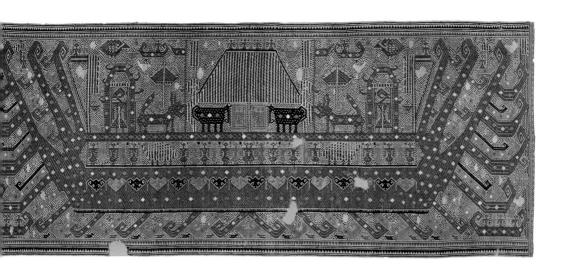

Ceremonial hanging (palepai)

Indonesia (Sumatra, southern Lampong region), 1825-75

Depictions of ships have appeared on Southeast Asian artifacts for millennia; long associated with funeral rites, ship imagery in the culture of Sumatra stands not only for death but also for the transition from one social or spiritual state to another. Owned and displayed only by the aristocracy, large *palepai* or "ship cloths" of Sumatra, like this one, were hung as backdrops for the important ceremonies of initiation into adulthood, marriage, and the attainment of rank. The fabulous sailing vessels depicted on *palepai* have elaborately curled bows and sterns, multiple decks with royal pavilions and banners, and cargos that include elephants—creatures associated with royal power.

Cotton; discontinuous supplementary patterning wefts on plain-weave ground $29 \times 1501\% \, in. \, (74 \times 382 \, cm)$ The William E. Nickerson Fund No. 2 1980.172

Crown

Indonesia (eastern Java), 13th century

This delicate golden crown, which would have been attached to a cloth cap, is formed in the shape of a lotus pond. Lotuses are found at the center of the crown and at the base of the wired spangles, which themselves suggest flowers emerging from the pond. Made of very thin, beaten gold, the spangles would have shimmered as the wearer moved. The flowers, water creatures, and snakes that also decorate the crown are auspicious symbols that appear frequently in the religious and courtly arts of Southeast Asia.

Gold H. 5 in. (12.7 cm) Keith McLeod Fund 1982.141

Dainichi, the Buddha of Infinite Illumination Japan

Late Heian period, 1149

The central deity of Esoteric Buddhism and the generative principle of the universe. Dainichi sits here in a meditative posture. He holds his hands in the distinctive wisdom-fist gesture (chiken-in), symbolizing his infinite knowledge. Unlike other Buddhas, who have an extracranial protuberance and wear monastic garb, Dainichi wears a crown, an elaborate topknot, and princely robes—symbols of his dominion over all.

This image was created in the "true style," characterized by an extreme idealization of the face and body, an introspective expression, and a fluid vet linear treatment of the drapery. The style is associated with the eleventh-century master sculptor Jocho, who provided statues for most of the important aristocratic temple commissions in and around Kyoto (then

Japan's capital) during the eleventh century. His celebrated image of Amida at Byodo-in, a temple just to the south of Kyoto, was widely copied for patrons throughout Japan who wished to emphasize their noble status.

Fashioned from camphor wood rather than the more typical cypress, this statue was definitely created for a provincial temple. An inscription on the interior of the image details the circumstances and date of its production; the sculptors required a little more than two months to complete the statue on the twenty-fourth day of the first month of Kyūan 5 (1149). Its place of origin, however, still remains a mystery.

Camphor wood with gold; joined woodblock construction

H. of figure: 553/4 in. [141.6 cm]

Denman Waldo Ross Collection 09.531a-c

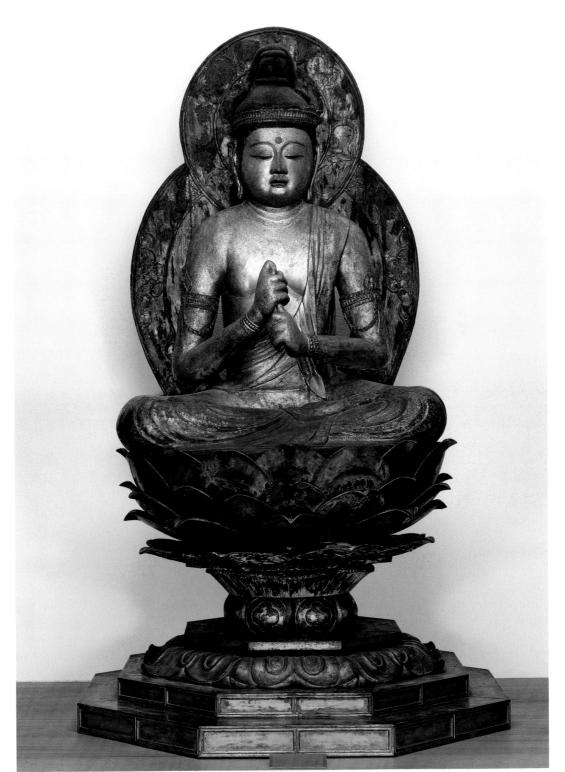

The Fifth King of Shambhala

Tibet or China, second half of the 17th century

This painting is one of a set portraying the pious kings of Shambhala, a mythical region in Central Asia. These kings were believed to have transmitted from one generation to the next an esoteric spiritual system that is an essential part of Lamaism, the Tibetan form of Buddhism. Although the brilliant colors of this painting are characteristically Tibetan, the work may have been created in neighboring China—the scrolling clouds are Chinese in style and the oversized fan held by the servant at right is decorated with a Chinese landscape that echoes the painting's mountainous setting.

Opaque watercolor on cotton 17 x 13 % in. [43.2 x 35.2 cm] Denman Waldo Ross Collection 06.324

Avalokiteshvara

Tibet, about 12th-13th century

Avalokiteshvara is the most compassionate and beloved of all Buddhist bodhisattvas—spiritually enlightened beings that postpone their entry into nirvana to help others in their guest for salvation. This Tibetan image, with its open stance and lively, fluid pose, is unusually approachable and graceful. Cast in one piece—an amazing feat considering the very large size—the figure holds a lotus flower, symbol of spiritual purity, and extends the other hand in the mudra (gesture) of wish granting. He wears elaborate jewelry, reflecting the historical Buddha's origins as a prince; a remarkable, sinuous garland frames his body. After extensive examination, Museum conservators and curators concluded that the sculpture was

made in western Tibet. although most sculptures from that area have more static poses and more surface decoration. This Avalokiteshvara may have been made during the late period. when artists had more access to Western influence.

Bronze H. 36¹³/₁₆ in. (93.5 cm) Keith McLeod Fund 2003.339

Buddha of Eternal Life and Eight Bodhisattvas

Tibet, 11th century

Seated on an elaborate peacock throne with typically Nepalese architectural elements, the Buddha of Eternal Life is encircled by elephants, snakes, lions, flying goats, boys, and—at the peak of the throne the bird deity Garuda. Around the Buddha are eight bodhisattvas, enlightened beings who remain on earth to assist others to achieve salvation. Other Buddhist deities are ranged across the top and bottom of the painting. Known as thangkas, painted textiles such as this were displayed in Buddhist temples throughout the Himalayan region. This extraordinary example, probably painted by a Nepalese artist working in an important Tibetan monastery, belonged to a set of five; each depicted one of the Five Transcendental Buddhas, representations of the qualities of the Buddha that comprise a central tenet of tantric Buddhism.

Opaque watercolor on cotton 16 ½ x 13 in. [41.3 x 33 cm] Gift of John Goelet 67.818

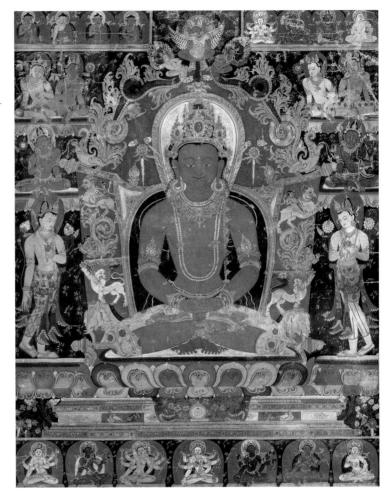

Granary jar

China Neolithic period, Machang type, late 3rd millennium B.C.

Human images seldom appear on ancient Chinese ceramics, and this vessel is extremely unusual in that its decoration includes a three-dimensional human head with a painted body below. The tattooed face and elaborate hairstyle make us wonder what sort of special role the figure depicted might have played in this prehistoric society—perhaps a shaman or official who communicated with the spirit world? Made to hold grain, the jar may have been buried in the tomb of a chieftain or a high priest. Its painted decoration represents one of the earliest surviving examples of the Chinese tradition of brush painting.

Earthenware with painted and applied decoration over slip H. 15½ in. (39.5 cm) E. Rhodes and Leona B. Carpenter Foundation Grant and

Edwin E. Jack Fund 1988.29

Standing youth

Bronze: Eastern Zhou dynasty, Warring States period, early 4th century B.C.

Jade: Shang dynasty, 1600-1045 B.C.

The Eastern Zhou period was marked by a new interest in more accurate and specific portrayals of the human figure. This young man's facial features, braided hair, jewelry, dagger, and boots suggest that he represents a member of a nomadic group that inhabited China's northern border regions until the first century B.C. The jade birds, roughly a millennium older than the bronze figure, were attached to the sticks by a crafty art dealer in the 1930s. Originally, the sticks supported reservoirs for lamp oil, and this figure would have been placed in a tomb to provide eternal light in the afterlife.

Cast bronze with applied jade H. 11³/₄ in. (30 cm) Maria Antoinette Evans Fund 31.976

Ritual vessel with cover (you) China

Western Zhou dynasty, 11th-10th century B.C.

Throughout the Bronze Age in China (about 2000-221 B.C), bronze vessels were prized symbols of power, authority, and wealth. Each of the more than fifty different types of bronze ritual vessels had a specialized function; this you was a ceremonial container for wine. Stylized horned creatures (possibly water buffaloes) dominate the design, and the eight-character inscription on the interior of the body and on the lid indicates the vessel's use in the practice of ancestor worship. It reads: "Dui Cheng had this ritual vessel made for his accomplished late father Ding."

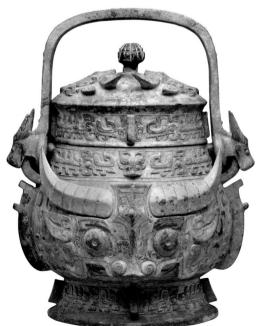

Chinese bronzes of this early period were created by a process quite different from lost-wax casting (see page 93). Sectional clay molds, carved on the inside with designs, were placed around a solid clay core, and molten bronze was poured into the space between them. After the bronze cooled, the mold sections and core were removed, revealing the completed vessel.

Cast bronze
H. 9% in. (25 cm)
Anna Mitchell Richards Fund 34.63

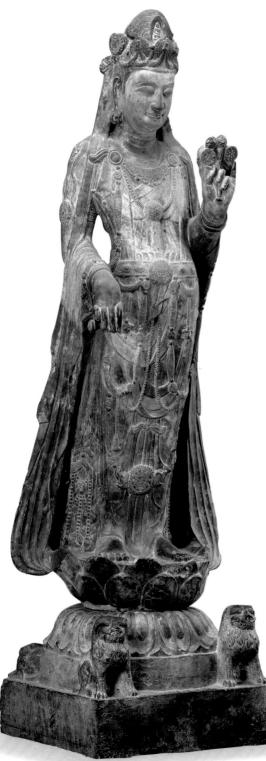

Guanyin

China

Northern Zhou or Sui dynasty, about A.D. 580

Guanyin, the Bodhisattva of Compassion and the divine figure that responds most directly to human prayers, became the most beloved Buddhist deity after the religion reached China from India in the first century A.D. Guanyin stands on a lotus throne and holds a cluster of lotus pods—this plant, which rises from the mud to release a white flower, is a Buddhist symbol of spiritual purity. Surviving traces of paint and gilding indicate that this monumental sculpture was once richly decorated. The figure's lithe, elongated body and flowing garments are characteristic of sculpture in the Xian area during the last decades of the sixth century.

Limestone with traces of paint and gold H. 98 in. (249 cm) Francis Bartlett Donation of 1912 15.254

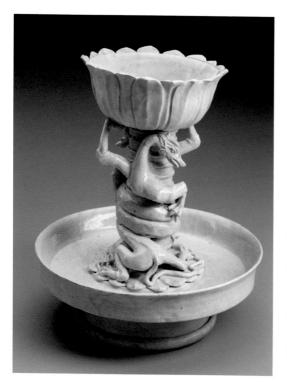

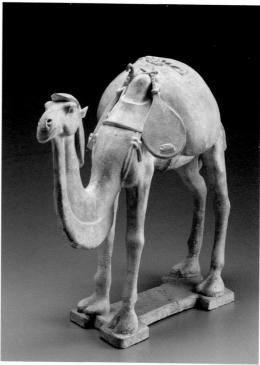

Incense burner

China

Sui-early Tang dynasty, late 6th-7th century A.D.

Originally fitted with a perforated lid in the shape of a lotus bud, this vessel is a Buddhist ritual implement for offering incense to the deities. The lotus was revered throughout Asia as a symbol of purity (see page 134). The object may have been intended as a miniature representation of the Buddhist cosmos, with Mount Meru, axis of the universe, wrapped in intertwined dragons. On the top are the heavenly realms, represented as a lotus blossom with layered petals. At the foot of the mountain are the earthly continents surrounded by oceans enclosed in concentric walls.

Stoneware with clear glaze $10^{13}\%~x~6\% s~in.~[27.5~x~16~cm]$ Bequest of Charles Bain Hoyt ~50.1957

Bactrian camel

China

Sui-early Tang dynasty, late 6th-7th century A.D.

The Bactrian camel is a shaggier, two-humped relative of the more familiar dromedary camel. Native to central Asia, it long has served as a pack animal on the trade routes of the Silk Road. This charming figure's saddlebags are held in place between the two humps by straps passing under the tail, base of neck, and belly. On either side of the front of the bags are pipa (lutelike musical instruments; see page 119) and in back are flasks.

Earthenware with ivory-white glaze and applied motif $13^{11}\% \times 16\%$ in. (34.7 x 42.5 cm) Bequest of Charles Bain Hoyt 50.897

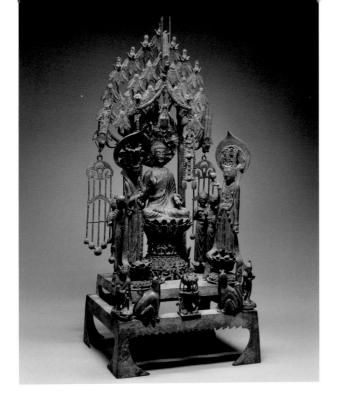

Altarpiece

China

Sui dynasty, A.D. 593

At the center of this serenely beautiful altarpiece sits the Amitabha Buddha, whose good favor ensured rebirth after death into a Western Paradise "full of sweet smells, clouds of music, showers of jewels, and every other beauty and joy." The altarpiece was commissioned by eight women of the Pure Land Buddhist faith to guarantee their own rebirths and those of their children and ancestors. Before the Buddha, surrounded by his attendants, is an incense burner flanked by lions and images of the Guardian Kings. The altarpiece was discovered in a pit in the late nineteenth century. The incense burner, lions, and Guardian Kings, not part of the altarpiece at the time of purchase in 1922, were finally reunited with the altar twenty-five years after it came to the Museum.

Cast bronze H. 30 % in. (76.5 cm) Gift of Mrs. W. Scott Fitz 22.407 Gift of Edward Jackson Holmes in memory of his mother, Mrs. W. Scott Fitz 47.1407-1412

Bottle

China

Tang dynasty, about 8th century A.D.

This is a rare survival—an eighth-century example of a kind of bottle produced in ceramic and metal beginning in the sixth century. It reflects a technique common in the Tang dynasty of fashioning objects from sheets of silver. Four hammered sheets were soldered together to make this bottle, with bands of gilding both concealing the soldering and emphasizing the form. The decoration is exceptionally fine, with a vine bearing grapes winding around the body and a phoenix surrounded by a variety of gilded birds. A network of tiny, hammered circles forms an exquisite background to the design.

Hammered silver with chased and parcel-gilt design 7½ x 2½ in. [20 x 7.3 cm] William Francis Warden Fund 47.1436

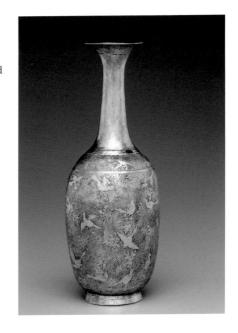

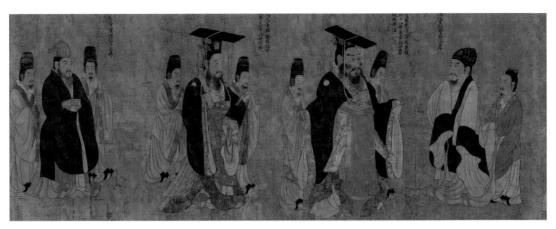

Attributed to Yan Liben
Chinese, about 600–673 A.D.

The Thirteen Emperors (detail)
Tang dynasty, second half of the 7th century A.D.
(with later replacement)

This is the oldest Chinese handscroll in an American collection. Although Tang-dynasty figure painting was a high point of Chinese art, few non-religious images remain; this is the only surviving example of its subject. The scroll depicts thirteen emperors who reigned from the second century B.C. to the seventh century A.D. Each individually characterized figure is identified by an inscription and accompanied by attendants. From the twelfth century, the scroll has been attributed to Yan Liben, a court artist and prime minister who was the most celebrated painter of the period. His painting demonstrates a profound sense of volume, grandeur, and movement, with exquisite drawing, forceful brushstrokes, and strong, simple coloring. The scroll was most likely painted for didactic purposes, with the historical serving as moral and political examples to the nobility.

Handscroll; ink and color on silk 20% x 209% in. (51.3 x 531 cm)

Denman Waldo Ross Collection 31.643

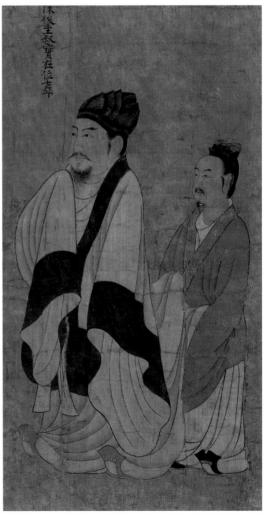

Zhao Lingrang

Chinese, active late 11th-early 12th century Summer Mist along the Lakeshore (detail) Northern Song dynasty, 1100

A handscroll (this one is more than five feet long) was slowly unrolled so that the viewer studied and appreciated only one part at a time, like the details you see here. Striking for its elegant brushwork and naturalistic effects, this handscroll depicts a lakeshore during summer, with bands of mist winding among the trees. Unlike traditional compositions—which captured

the grandeur of nature through scale and dazzling detail—Zhao's paintings are quiet, lyrical, and more intimate in their observation of nature. Nonetheless, small, low-perspective compositions such as this one later became a highly popular painting style. Signed, dated, and including two seals by his hand, this is one of few paintings known to be by Zhao Lingrang.

Handscroll; ink and color on silk 7½ x 63½ in. [19.1 x 161.3 cm] Keith McLeod Fund 57,724

Emperor Huizong Chinese, 1082-1135

The Five-Colored Parakeet (detail) Northern Song dynasty, early 12th century

Handscroll; ink and color on silk 21 x 49 1/4 in. (53.3 x 125.1 cm) Maria Antoinette Evans Fund 33.364

This handscroll by Emperor Huizong (reigned 1101–1125) may have originally been part of a large album that he compiled to record rare birds and flowers, exquisite objects, and important events. In the poem inscribed on it, the emperor describes the exotic parakeet that perched one spring day on an apricot branch in the imperial garden. He depicted each feather of the bird and every petal of the apricot blossoms in the meticulous style of academic court painting he established. Huizong's paintings were often copied by court painters; this is one of few surviving works in which the distinctive style of the calligraphy and painting makes it likely to have come from the emperor's own hand.

Attributed to Emperor Huizong
Chinese, 1082-1135

Ladies Preparing Newly Woven Silk
Northern Song dynasty, early 12th century

Handscroll; ink, color, and gold on silk $14\% \times 57\%$ in. [37 x 145.3 cm] Special Chinese and Japanese Fund 12.886

This celebrated handscroll—one of the great master-pieces of Chinese painting—depicts three scenes of elegant court ladies beating, sewing, and ironing new silk. The engagement of these aristocratic women in domestic labor may reflect a traditional, springtime event in which the empress led her attendants through the ancient ritual of producing silk. In the detail above, the women stretch a long piece of newly woven silk near a charcoal fire kindled to heat the iron.

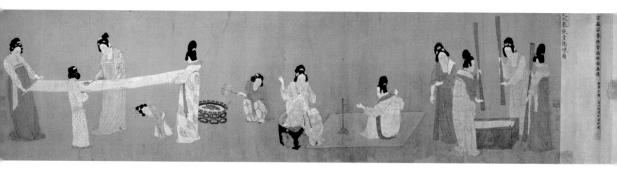

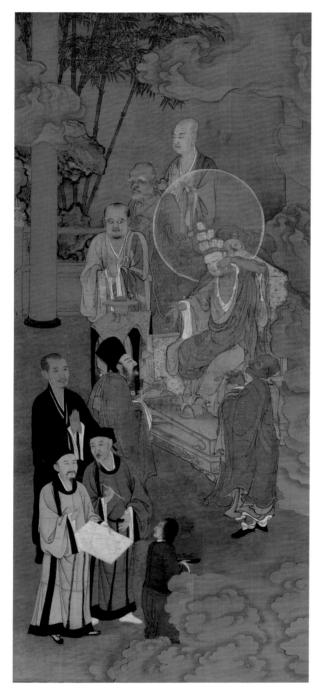

Zhou Jichang

Chinese, active late 12th century

Lohan Manifesting Himself as an Eleven-Headed Guanyin

Southern Song dynasty, about A.D. 1178

In Buddhism, lohans are disciples of the Buddha who have achieved enlightenment and gained release from their earthly existence. Known for their wisdom and courage, lohans are worshipped in many Buddhist temples. In this enigmatic painting, an enthroned lohan seems to be either putting on a mask or pulling aside his skin to reveal the features of the eleven-headed Guanyin, Bodhisattva of Compassion. This painting is unique in its inclusion of portraiture in a religious composition—figures representing the artist Zhou Jichang and his colleague Lin Tinggui stand rapt in discussion over a sketch in the foreground. Behind them stands the monk Yishao, from the Huian Monastery, who raised funds to commission an ambitious set of one hundred lohan paintings, of which this is one. Ten of these paintings now reside in the Museum's collection.

Hanging scroll mounted on panel; ink and colors

43% x 20% in. [111.5 x 53.1 cm] Gift of Denman Waldo Ross 06.289

Tea bowl China Southern Song dynasty, 12th–13th century

Elegantly simple ceramic tea bowls such as this one are unique to the kilns of Jizhou in the southern Chinese province of Jiangxi. To create them, potters placed a leaf in the tea bowl before applying the glaze. The leaf itself was consumed in the heat of firing, leaving behind a delicate, yellow-ochre pattern of the leaf's structure. When the bowl is filled with green tea, the leaf design seems to float within the liquid.

Jizhou ware; stoneware Diam. 5% in. (14.9 cm) Charles Bain Hoyt Collection 50.2014

Lute (pipa)

China

Qing dynasty, 1891

Probably originating in Central Asia, the fourstringed *pipa* was a favorite instrument at Chinese court banquets since the Tang dynasty (A.D. 618–906). The *pipa* was originally played with a pick, but in later periods performers plucked the

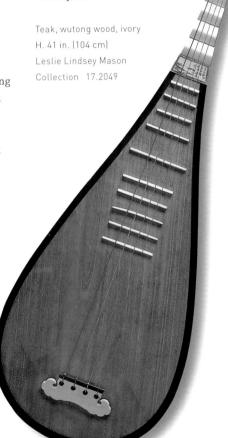

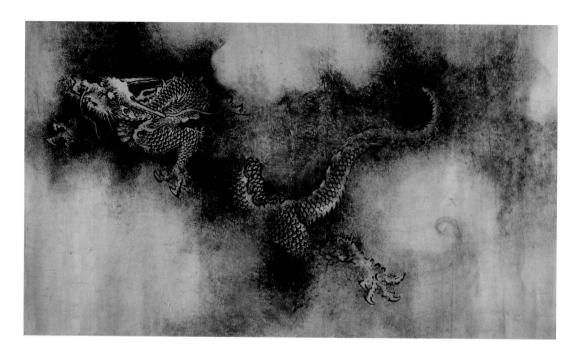

Chen Rong Chinese, first half of the 13th century Nine Dragons (detail) Southern Song dynasty, 1244

Arguably the greatest of all Chinese dragon paintings, this handscroll—almost thirty-six feet long in its entirety—is the work of Chen Rong, an impoverished painter, poet, and scholar from south China's Fujian province. He treats the dragon as a manifestation of the principles of Daoism, a Chinese philosophy that explores the relationship of people and the natural world. The dragons in his painting, hidden and then revealed amid mist, waves, and clouds, may symbolize the Great Dao itself—a mysterious, natural force.

Handscroll; ink with touches of red on paper Entire scroll: 18¼ x 431% in. (46.3 x 1096.4 cm) Francis Gardner Curtis Fund 17.1697

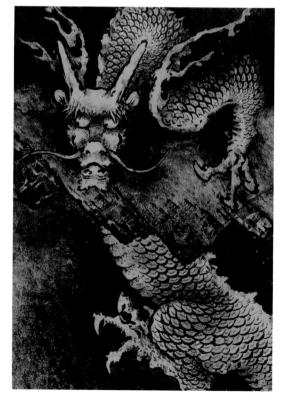

Jar

China

Yuan dynasty, 14th century

Few ceramic wares have been as widely admired as the porcelain commonly known as Chinese blue-and-white. It was traded throughout the Near and Far East and to Europe, where it was imitated widely. This jar is an early example of Jingdezhen porcelain, decorated in underglaze cobalt blue, from the Yuan period (1279–1368). It is decorated with a scene from Yuchi Gong Defeats Shan Xiongxin with His Iron Whip, a historical event frequently reenacted in the popular theater of the Yuan period. The jar's robust form, the brilliance of the cobalt blue, and the vigorous brushwork all contribute to its exuberance and vitality.

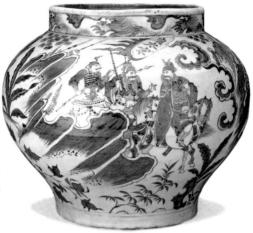

Jingdezhen ware; porcelain with underglaze blue decoration H. 11 in. (27.8 cm)
Charles Bain Hoyt Collection 50.1339

Lacquer tray

China

Southern Song or Yuan dynasty, 1294 (or possibly 1234)

Carved deeply into the lacquered surface of the tray, two pheasants circle above flowers of the four seasons. Starting from spring, they are peach, peony, gardenia, mallow, chrysanthemum, and camellia blossoms. The artist used pheasants and flowers to create an auspicious rebus that reads, "Adding blossoms to a brocade," meaning heaping splendor upon splendor. It is a clever play on the word jin (brocade), which is the first character of the Chinese word for pheasant. The piece is rare as an early dated example of carved lacquer.

Carved lacquer 81% x 4% x 13% in. (22.4 x 11 x 2.1 cm) Asiatic Curator's Fund 58.689

Kesi tapestry (detail)

China

Qing dynasty, Qianlong period, 1736-96 Calligraphy by Dong Qichang (1555-1636), copying letters from the Four Masters of the Northern Song (960-1126)

Although it closely resembles calligraphy rendered with ink and brush on paper, this work is a textile in which the weaver skillfully captured the fluid motions and marks of an ink-laden brush. The "calligraphy" is that of Dong Qichang, who was paying homage to the calligraphy of four masters of the Song dynasty. Thus, woven into this eighteenth-century kesi are many centuries of admiration for particular examples of calligraphy—considered the most pure and lofty of the arts. The tapestry appears to have been woven in one segment (more than nine feet long),

then adhered to paper and mounted as a handscroll. A work of this astonishing virtuosity and quality undoubtedly was made in the imperial workshops of the Qing palace, where Dong Qichang's original scroll, now lost, was kept.

Kesi tapestry weave; silk yarns 11% x 114 in. (29.5 x 289.5 cm) Charles Bain Hoyt Fund 2005.193

Dong Qichang

Chinese, 1555-1636

Stately Trees Offering Midday Shade

Ming dynasty, about 1616-20

Dong Qichang was a highly influential figure, both for his own paintings and for his theories about the history of Chinese painting, which he divided into two dominant strains: the Northern School, professional painters who painted commissions for money, and the Southern School, scholarartists who painted to express their erudition and creativity. In his own work, Dong focused on the materials of the Chinese scholar-ink, brush, and paper-painting multiple layers of ink on nonabsorbent paper so that other scholar-artists might appreciate each brushstroke. Although this work reflects some inspiration from the natural world, it is equally inspired by earlier paintings. The many red seals are from the hand of an eighteenthcentury Qianlong emperor, who owned and clearly treasured this important work.

Hanging scroll; ink on paper $35\% \times 11\%$ in. [90.8 x 28.8 cm] Frederick L. Jack Fund 55.86

Gong Xian Chinese, 1619-1689 Leaf of a landscape album

Qing dynasty, 1670s

Album leaf; ink on paper 83/4 x 171/6 in. (22.2 x 43.4 cm) Anne Louise Richards Fund, Marianne Brimmer Fund, Frederick L. Jack Fund, Otis Norcross Fund, Harriet Otis Cruft Fund, and Gift of Reverend Z. Charles Beals, by exchange 1986.578.5

"When one learns to paint," Gong Xian once stated, "he should start with trees; learning to paint trees, one should begin with withered ones." Calligrapher, poet, and teacher, the artist led the Jinling (Nanking) school, which played an influential role in shaping later Chinese painting theory and style. He called his innovative technique "Accumulated Ink," working from dark to light to amass layers of ink on the paper, achieving volume, tonality, and subtle gradations from light to dark, wet to dry, airy to solid. As is clear in this masterful album leaf, his highly complex compositions show particular interest in the play of light.

Man's robe (chuba) of Chinese fabric

Tibet, 19th century
Fabric: China, late Ming or early Qing dynasty,
17th century

The dragon—king of the beasts, powerful protector, and symbol of creation—symbolized China. The dynamic, five-clawed dragon that dominates this robe has three eyes, representing the all-seeing eye of the Chinese emperor. It is a dragon robe, probably made for the emperor or a member of his court, where dress was a highly significant symbol of rank and favor. The emperor wore silk to maintain the social hierarchy and his place in it; the silk threads of this rare, tapestrywoven robe are wrapped with metal and peacock

feathers. Such lavish robes were often diplomatic gifts intended to curry favor and forestall aggression; this robe probably was given to a high-ranking official in Tibet, with whom China had close diplomatic and commercial ties. In the nineteenth century it was retailored as a Tibetan *chuba*, but much of the shape and visual impact of the Chinese original remain.

Silk and silk threads wrapped with metal and peacock feathers; slit tapestry H. 57% in. [146.7 cm.]

Museum purchase with funds donated anonymously 2001.145

opposite

Qi Baishi

Chinese, 1863-1957

Gourds, Hibiscus, Chrysanthemums, and Pine Tree, 1920

Admired by individuals as different as Picasso and Chairman Mao (who came from the artist's home county), Qi Baishi was born a farmer, trained as a carpenter, and learned to paint from manuals and from studying the work of old masters. Unlike many of his contemporaries, he knew little of Western art and trained himself in traditional themes and techniques. Eventually, he developed his own style, which favored rustic elegance, directness, and lack of artifice. Created at the very beginning of his artistic breakthrough, these works were painted for Cao Kun, who later became the third president of the Republic of China.

Hanging scroll; ink and color on paper 111½ x 21½ in. [282.5 x 54 cm]

Gift of Madame Fan Tchun-pi and her sons in memory of Dr. Tsen Tson Ming 1980.99–102

Buddha of Medicine

Korea

Unified Silla dynasty, about 8th century A.D.

The Chinese monks who first brought Buddhism to Korea provided medical care as well, and the Buddha of Medicine has always been popular there. Known as Yaksa yeorae, he is identified by the medicine jar in his hand. This small figure of the deity may originally have been placed in a household shrine or it may have been displayed with similar statues at a

temple. It is closely related to a group of more

than fifty gilt bronzes once placed on the branches of an ancient elm tree in a temple in the Diamond Mountains of North Korea. A masterpiece of Korean Buddhist sculpture, it reflects the influence of Tang-dynasty

China, although the rather heavy proportions, large head and hands, and octagonal base are all typically Korean.

Gilt bronze
H. 14½ in. (36 cm)
Gift of Edward Jackson Holmes in

Gift of Edward Jackson Holmes in memory of his mother, Mrs. W. Scott Fitz 32,436

Vase (maebyong) Korea Goryeo dynasty, late 12th century

Korea is well known in the West for its fine ceramics, particularly those with the subtle, grayish-green glaze known as celadon. This vase, with its sensuous shape and delicate design of cranes and other birds in bamboo bushes, is an early example of inlaid celadon, a technique perfected in the course of the twelfth century. No other maebyong of this same design is known.

Glazed stoneware with inlaid decoration H. 121/4 in. (31.1 cm) Charles Bain Hoyt Collection 50.989

below Ewer and basin Korea Goryeo dynasty, 11th-12th century

Although similar in form and decoration to ceramic examples, this sumptuous ewer and basin are made of silver partially covered with gold. Commissioned by a wealthy patron, they were used to serve wine or other liquids in a domestic setting; the ewer was placed inside the basin where hot water kept its contents at the desired temperature. Bamboo inspired the basic shape of both pieces as well as the handle and spout of the ewer. The cover to the ewer consists of three stylized lotuses surmounted by a phoenix both auspicious symbols in Buddhist art.

Silver with parcel gilt and engraved decoration H. 15 in. (38 cm) George Nixon Black Fund 35.646a-b

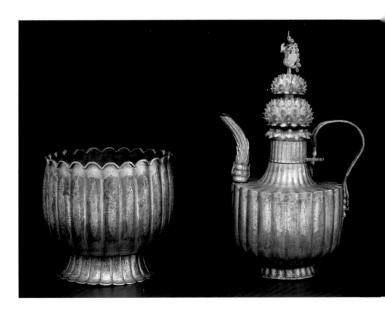

$Sutra\ of\ Perfect\ Enlightenment$ Korea

Goryeo dynasty, about 1300-1350

In the center of this scroll, the Vairocana Buddha (the central member of the Five Buddhas) sits on a lotus throne with his hands raised in the gesture of exposition. Below him are bodhisattvas and other members of the Buddhist pantheon, their names in gold on red cartouches. The Vairocana Buddha is teaching the Sutra of Perfect Enlightenment, one of the discourses of the Buddha that comprise the basic text of Buddhist. scripture. His followers take turns asking questions about some aspect of his teaching, and his responses constitute the substance of the sutra. The bodhisattva who kneels in the lower center—the focal point of the composition-effectively draws the viewer into the scene. Rich in color and gold, this monumental work creates the abstract beauty of the celestial sphere and may have been used as part of a ritual observance. Reflecting the influence of Chinese painting on that of Korea, the work was long thought to be Chinese.

Hanging scroll mounted as a panel; color and gold on silk $64^{1}\%_6 \times 33\%_6$ in. [165 x 85 cm] William Sturgis Bigelow Collection 11.6142

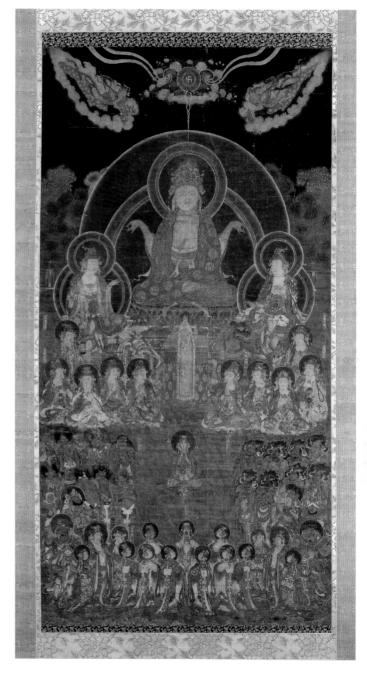

bottom

Mirror

Japan

Tumuli period, 5th century A.D.

Historically, mirrors have had special significance in Japan where, particularly in this early period, they were thought to possess magical properties and were associated with the power of the sun goddess. Mirrors with highly decorated backs, such as this one, were often buried with important officials as emblems of their authority. Here, in the broad band of decoration inside the raised rim, are symbols of the four points of the compass: the Tortoise and the Snake for the North, the Red Bird for the South. the Green Dragon for the East, and the White Tiger for the West.

Bronze Diam 91/4 in [23.5 cm] Museum purchase with funds donated by contribution 08.160

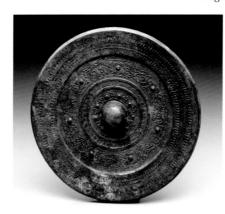

Shitao

Chinese, 1640-1718

Raising the Alms Bowl: Conversion of Hariti to Buddhism (detail)

Qing dynasty, 1683

Terrorized by the ogress Hariti, who stole and devoured children, the populace appealed to the Buddha to stop her. The Buddha-giving Hariti a taste of her own medicine—stole her youngest child and hid him under a large bowl used for receiving alms. Desperate with grief and anxiety, Hariti employed all her powers to recover her son, summoning flying demon-warriors to attack the Buddha and engaging other ogres to try to raise the bowl. But the demon's weapons broke in mid-air, and the bowl could not be moved. At last, recognizing the power and supremacy of the Buddha,

> Hariti converted to Buddhism and became the protector of mothers and newborns. The artist of this whimsical and fantastic work was a Buddhist priest, arguably the most influential painter and theoretician in the history of later Chinese painting.

Handscroll; ink on paper 10¹/₁₆ x 139 ½ in. (27.2 x 353.3 cm) Marshall H. Gould Fund 56.1151

Shaka, the Historical Buddha, Preaching on Vulture Peak

Japan

Nara period, 8th century A.D.

One of few surviving examples of eighth-century Japanese painting, this panel depicts the Historical Buddha surrounded by his disciples and bodhisattvas. He is preaching the *Lotus Sutra*, a highly influential text that promises salvation to both men and women. The painting has suffered greatly over time and was repaired as early as the twelfth century. Despite surface abrasion and other losses, craggy mountain peaks and deep ravines can be discerned in the background and swirling clouds representing mystical

energy at the top. This painting was once installed in the Hokkedō (Lotus Hall) at the celebrated temple Tōdai-ji in Nara. In 1884, at a time when many Buddhist temples were selling their treasures because of financial hardship, it was acquired by Bostonian William Sturgis Bigelow.

Panel; ink, color, and gold on ramie $42\% \times 56\%$ in. [107.1 x 143.5 cm] William Sturgis Bigelow Collection 11.6120

Batō Kannon, the Horse-Headed **Bodhisattva of Compassion**

Japan

Heian period, 12th century

Years of training were required to master the complicated tenets and rituals of the sect known as Esoteric Buddhism, and art was an important means of communicating the complexities of its theology and pantheon of deities. During the Heian period, the Esoteric Buddhist deity Batō Kannon, identified by the horse's head in his

crown, was believed to look after those individuals reborn as animals. He was also revered as the protector of horses,

cattle, and warriors. This painting was executed in the sumptuous style—featuring the lavish use of gold and silver (here darkened with age)—that dominated Japanese art during the twelfth century. Batō sits under a floral canopy festooned with strands of jewels. With some of his hands, the bodhisattva performs the ritual gestures, or mudras, essential to Esoteric Buddhist practice; in others he holds symbolic objects.

Panel; ink, color, gold, and silver on silk 65% x 32% in. [166.1 x 82.7 cm] Fenollosa-Weld Collection 11.4035

Minister Kibi's Trip to China (detail)

Japan

Heian period, late 12th century

This celebrated handscroll depicts the legends that grew up around Kibi no Makibi, a Japanese courtier who served as ambassador to the imperial court of China in A.D. 753. In scene after scene, the scroll illustrates and describes Kibi's progress as he matches wits with Chinese bureaucrats determined to belittle his (and, by extension, Japan's) scholarly accomplishments. Locked into a haunted tower, Kibi impresses the resident ghost-that of the previous Japanese ambassador, Abe no Nakamaro-with his integrity and upright demeanor. Assisted by Abe, Kibi outwits the Chinese using magic, artifice, and his native cunning. Remarkable for its vigorous, often humorous, narrative style and its elegant calligraphy, this scroll was originally over eighty feet long; it has been divided into four sections to facilitate handling and ensure its preservation.

Set of four handscrolls; ink, color, and gold on paper

Entire scroll: 12 % x 961 ½ in. [32.2 x 2442 cm] William Sturgis Bigelow Collection 32.131

Kaikei Japanese, active 1189-1223

Miroku, the Bodhisattva of the Future

Kamakura period, 1189

At the end of the twelfth century in Japan, the military class ascended to power in a series of bloody civil wars. During the rebuilding of temples destroyed in the conflict, the Kei school—of which Kaikei was a founder—produced most of the major sculptural commissions, creating a new, naturalistic style that dominated Japanese sculpture for over five hundred years. In this extraordinary carved and gilded image (Kaikei's

earliest dated work), emerging naturalism is evident in the

proportions of the body,
the fall of the drapery,
and the use of inlaid
crystal for the eyes. The
figure represents Miroku,
the Bodhisattva of the
Future, who will become
the next Buddha. A scroll
found inside the sculpture explains that it
was made in 1189 for
the repose of Kaikei's
deceased parents and
teacher.

Japanese cypress with gold and inlaid crystal; split-andjoined construction H. 42 in. (106.6 cm) Chinese and Japanese Special Fund 20.723a

Bishamonten, the Guardian of the North, with His Retinue

Japan

Kamakura period, late 12th-early 13th century

Possibly because he is guardian of the North, the traditional source of malevolent forces, Bishamonten is the only one of the four celestial guardians of the cardinal directions who is worshiped as an independent Buddhist deity. In this highly dramatic painting, tall flames rise behind the head of Bishamonten, who wears armor embellished with the heads of demons and wields a silver-edged sword. The painting is remarkable for its vivid details and for the range of supernatural beings who surround the deity, including (to his right) his voluptuous consort Kichijōten, the Goddess of Good Fortune.

Panel; ink, color, gold, and silver on silk $46\% \times 26\%$ in. [119.1 x 68.1 cm] Special Chinese and Japanese Fund 05.202

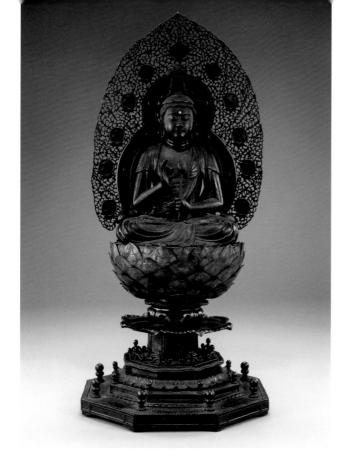

Saichi Japanese, dates unknown Shō Kannon, the Bodhisattva of Compassion Kamakura period, 1269

The white lotus symbolized purity throughout Asia because it perches above the water on its long stem as if growing miraculously out of the mud. Here the Bodhisattva of Compassion is shown holding a lotus bud and seated on a lotus blossom throne that indicates his divinity. His distinctive halo is decorated with floral designs and eleven disks on which appear Sanskrit letters representing his name and that of the Cosmic Buddha. Cast in separable parts, this intricate sculpture is one of the finest surviving examples of thirteenthcentury Japanese bronze work. It was originally enshrined in the main hall of Kongonrin-ji, a Buddhist temple east of Kyoto.

Gilt bronze: cast from piece molds H. 19¹³/₁₆ in. (50.3 cm) William Sturgis Bigelow Collection 11.11447 facing page, top

Takeshiba Toshiteru and others Japanese, dates unknown Set of matched mountings for a long and a short sword (daishō) with design of autumn plants and insects Edo period, mid-19th century

Amid the incessant civil wars that erupted in Japan during the fifteenth and sixteenth centuries, middleranking and senior samurai began to carry two swords: the katana and the shorter wakizashi, a combination known as "large and small" (daishō). During the Edo period, the mountings for these daisho sets grew increasingly elaborate, employing fragile materials such as lacquer, silk, gold, and soft copper alloys. This example features a unified design of autumn grasses and insects, supposedly based on a painting by Kano Tan'yū. The metal fittings include the pommel (kashira) and collar (fuchi) covering each end of the hilt, which were made as a matching set; the menuki, a pair of fittings underneath the hilt's silk wrapping, intended to improve the grip; the hand guard (tsuba) at the beginning of the polished, sharp part of the blade: the handle of a small knife (kozuka) carried in the scabbard: and a skewerlike implement, the kōgai (not visible here), carried in the opposite side of the scabbard.

Scabbards: gold-lacguered wood; hilts: wood covered in ray skin wrapped with silk bands; metal fittings: gold, silver, and copper alloys; tying cords: silk L. 28 % and 39 in. [71.4 and 99.2 cm] William Sturgis Bigelow Collection 11.11291-11292

$\textbf{\textit{Night Attack on the Sanj\"{o} Palace}}~(\text{detail})$

Japan

Kamakura period, third quarter of the 13th century

The bloody civil war between the Taira and Minamoto clans in the twelfth century was a perennial source of inspiration for later artists. The earliest surviving images are three scrolls and some isolated fragments known as *The Illustrated Handscrolls of the Events of the Heiji Era*. First in the series, this scroll powerfully re-creates Minamoto's attack of 1159 on the Sanjō Palace, from which the influential retired emperor

Go-Shirakawa was abducted. The brilliant flames of the burning palace dominate the composition, swirling above crowds of combatants who are rendered in minute and brutal detail. Several artists were probably involved in the production of these paintings, but none of their names is known.

Handscroll; ink and color on paper Entire scroll: $16\% \times 275\%$ in. [41.3 x 699.7 cm] Fenollosa-Weld Collection 11.4000

Kano Shōei Japanese, 1519-1592 Fowl in Spring and Summer Landscape Momoyama period, late 16th century

The delightful painted decoration of this folding screen places meticulously rendered birds and flowers within a soft, evocative landscape. The signature in the lower right corner is that of Kano Tanyū, who attributed this work to his great-grandfather, Kano Shōei, son of Kano Motonobu—one of the early leaders of the highly influential Kano school. In this screen, Shōei achieved a synthesis of kanga (the subtle, monochrome ink painting of China) and yamato-e (the traditional bright and decorative painting of Japan). It is a style well suited to large-scale compositions such as screens and sliding doors and was popular into the modern period.

Six-panel folding screen; ink and light color on paper 59% x 146½ in. [151.5 x 372 cm] Fenollosa-Weld Collection 11.4347

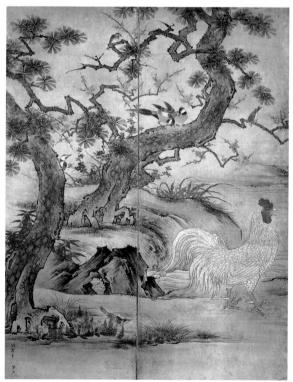

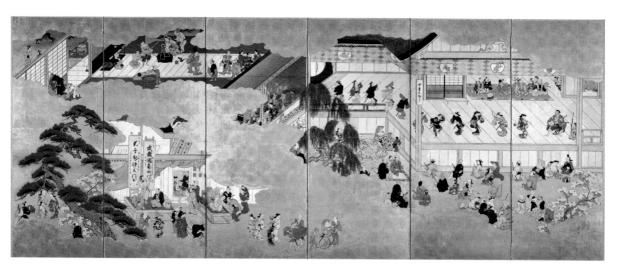

Hishikawa Moronobu

Japanese, died 1694

Scenes from the Nakamura Kabuki Theater and the Yoshiwara Pleasure Quarter

Edo period, about 1684-94

This screen is a vivid, early example of ukiyo-e, "images of the floating world." As a subject for art, the pleasures of the entertainment world became highly popular in the seventeenth century when members of the prosperous middle class increasingly frequented kabuki theaters as well as the brothels and teahouses of "pleasure quarters" such as the Yoshiwara in Edo (presentday Tokyo). This screen shows three areas of the Nakamura-za, a famous kabuki theater. In the lower left, men and women of varied occupations and social levels walk along the street in front of the theater. Depicted above is a backstage area where actors and musicians prepare for a performance. The right half of the screen shows the stage and the area for the audience. On stage, costumed figures dance to the lively rhythms of the shamisen and drums.

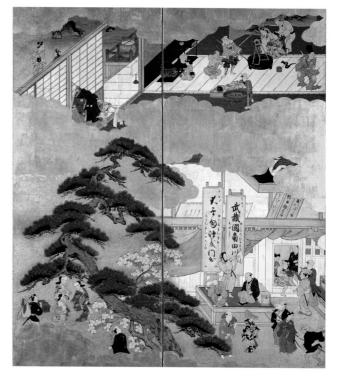

One of a pair of six-panel folding screens; ink and color on gold-leafed paper $55\%_6 \ x \ 139^{13}\%_6 \ in. \ [139.8 \ x \ 355.2 \ cm]$ Gift of Oliver Peabody 79.468

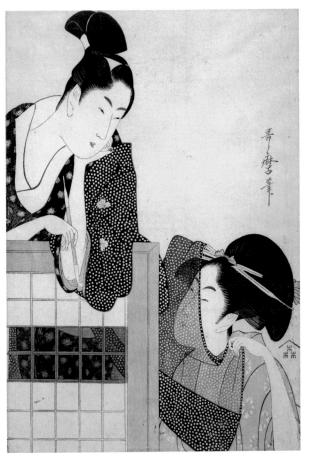

Kitagawa Utamaro

Japanese, 1753-1806

Lovers

Edo period, about 1797

Published by Moriya Jihei

One of the most original and popular forms of ukiyo-e was the woodblock print—an art form that emphasized flowing outlines, simplified forms, and the patterning of flat areas of color. Among ukiyo-e printmakers, Utamaro is most celebrated for his images of women who worked in the brothels and tea houses of the urban pleasure quarters. His imaginative compositions, such as this one, feature idealized figures who are given character and individuality through pose, gesture, and dress. In their time, ukivo-e prints were inexpensive, produced in great numbers, and collected by members of the middle class whose lives and interests they depict. Japanese woodblock prints also profoundly influenced European and American artists of the nineteenth century (see pages 251, 262, and 327).

Color woodblock print 14½ x 10¼ in. [37.2 x 26 cm] Gift of Captain John C. Phillips 18.308

facing page, bottom

Tray with design of shells, weeds, grasses, and family crests

Japan

Momoyama period, late 16th-early 17th century

In lacquerwork, the resin or sap of a lacquer tree is colored with pigments and applied over a wooden understructure in many thin layers—sometimes more than forty. The result of this painstaking process is a smooth, strong, and lustrous surface that was often inlaid with designs in precious metals. This shallow tray made to hold clothing combines bold designs

and naturalistic detail. The tray is a particularly fine, large-scale example of Kōdai-ji ware, the most popular type of lacquerwork of the Momoyama period. The crests of paulownia flowers and chrysanthemums found throughout the tray's decoration associate it with the patronage of the clan of Toyotomi Hideyoshi, one of the three great warlords of Japan during this period.

Lacquered wood with gold and silver overlays 225/16 x 21 x 31/16 in. [56.6 x 53.3 x 7.7 cm] Keith McLeod Fund 1998.58

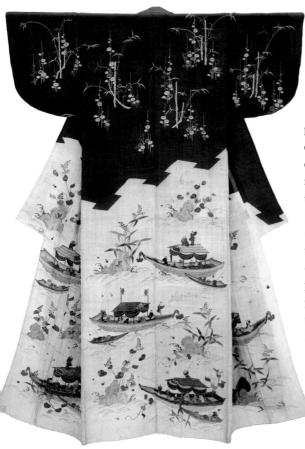

Summer robe (katabira)

Japan

Edo period, 18th century

Unlined robes made from hemp or ramie (an Asian plant fiber) were worn during the summer by upperclass Japanese women. The designs of these luxurious garments often include water motifs appropriate for times of oppressive heat, and the lower section of this robe shows aristocrats enjoying themselves on pleasure boats. The robe was decorated using a technique in which the artist outlined each part of the design with rice paste to prevent bleeding of the dyes. The dyes were applied with a brush and the rice paste washed away when the colors were set. The plum blossoms and bamboo in the upper section of this *katabira* were made by this same method and further embellished with embroidery in colored threads and gold paper.

Ramie; plain weave with resist and stencil dyeing, handpainting, silk and gilt paper, and embroidery H. 64 in. (162.4 cm)

William Sturgis Bigelow Collection 21.1134

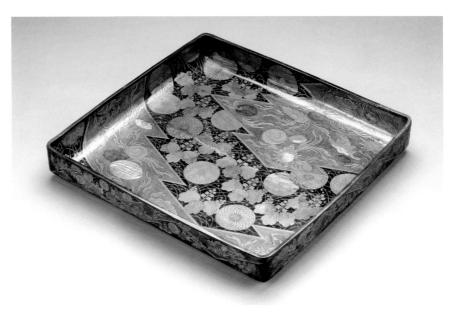

Soga Shōhaku

Japanese, 1730-1781

The Four Sages of Mount Shang

Edo period, about 1768

Shōhaku's career coincided with a remarkable period of artistic innovation in Japanese art, when eccentricity and originality of vision enhanced rather than hindered a painter's reputation. An individualist in both his life and his art. Shohaku worked almost exclusively in monochrome ink, painting in a spontaneous, expressionistic style. The energy and dexterity of his swift, broad brushwork are nowhere more fully realized than in this late work, one of a pair of screens illustrating a popular subject from Chinese legend. The Four Sages were elderly paragons of virtue who retreated to Mount Shang during the political unrest of the third century B.C., remaining there until they felt that moral rectitude had returned to the world of human affairs.

One of a pair of six-panel folding screens; ink and gold on paper 60% x 142% in. [154.7 x 361.2 cm] Fenollosa-Weld Collection 11.4514

Itō Jakuchū

Japanese, 1716-1800

White Cockatoo on a Pine Branch

Edo period, about 1755-57

Like his contemporary Shōhaku, Jakuchū was one of the celebrated "eccentric" painters of the Edo period whose success reflects the diminishing dominance of official styles of art at this time. Of humble origins and primarily self-taught, Jakuchū began by copying Chinese paintings preserved in the temples of Kyoto but soon found his inspiration in shaseiga, or painting from nature. It is said that the artist raised birds himself in order to study more closely their appearance and behavior and to sketch them from life.

15³/₄ x 21⁷/₈ in. (40.1 x 55.6 cm) Hanging scroll; ink, color, and gold on silk Beguest of Charles Bain Hoyt 50.1493

Attributed to Garaku Risuke
Japanese, dates unknown
Toggle (netsuke) in the form of a hare
scratching its chin with its right hind leg
Edo period, early-mid-18th century

Netsuke are toggles used to secure items such as inro (medicine cases) suspended on cords from the wearer's sash. The earliest examples were probably simple ivory rings, but at some point in the seventeenth century, these were replaced first by imported Chinese carvings and then by figurative pieces produced in workshops in Kyoto and Osaka. Although the ivory hare illustrated here is unsigned, its powerfully carved, deeply stained fur, large inlaid horn eyes, and compact form all suggest the work of Garaku Risuke, who worked in Osaka. In the later eighteenth century, netsuke production spread to other urban centers, including both Edo and Nagoya, and wood became increasingly popular as a less expensive alternative to ivory.

Carved and stained ivory with eyes intaid in dark horn $1\% \times 1\% \times 1$ in. [2.7 x 4.8 x 2.5 cm] Gift of Major Henry Lee Higginson 18.221b

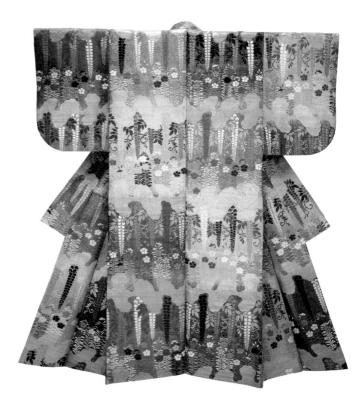

Robe for the No theater (karaori)

Japan

Edo period, late 18th-early 19th century

Silk robes woven with sumptuous floral motifs are worn by actors in the highly stylized performances of the $N\bar{o}$ theater, which integrate speech, music, dancing, and mime. Performing on a spare stage with minimal props, the actors (who are all men) depend upon their robes and wooden masks to communicate their characters to the audience. The red color of this robe indicates that the character portrayed was a young woman. Although seen from a considerable distance by the audience (which in the Edo period was often members of the military elite), karaori are extremely elegant and sophisticated in materials, design, and craft.

Silk; twill weave with pattern-dyed warps and silk and gilt paper supplementary pattern wefts

H. 57% in. [147 cm]

William Sturgis Bigelow Collection 15.1148

Fragment

Iran, 11th or 12th century

Reportedly found near the city of Tabriz, in northwestern Iran, this textile fragment once featured pairs of beautifully rendered falcons encircled by vine scrolls and Arabic inscriptions wishing the owner "lasting glory, allembracing bounty, felicity, good fortune, and abundant ease." Islam's proscription against the depiction of living things usually did not apply to textiles, and roundels enclosing human or animal figures were common designs. Within Islamic cultures, silk weaving was a major art form, and lavishly patterned silks were symbols of authority, rank, and prestige. This small fragment masterfully illustrates the refinement and technical sophistication of Islamic silk weaving and textile design.

Silk, double cloth

7% x 5% in. (20 x 14 cm)

Denman Waldo Ross Collection 04.1621

Alexander Fights the Monster of Habash

Page from a manuscript of the Shahnama Iran (Tabriz)

Mongol period, before 1335

The Shahnama (Book of Kings) is the national epic of Persia (today's Iran) and the most frequently illustrated manuscript in Islamic art. A blend of myth and history numbering nearly sixty thousand rhymed couplets, the Shahnama was written by the poet Firdawsi over a period of thirty years at the turn of the eleventh century. This page shows a historical figure, Alexander the Great, slaying a fantastic, mythological beast. The mountains in the background, rendered in a distinctly Chinese manner, are typical of Eastern stylistic elements often found in fourteenth-century Persian manuscript painting. This superb page was part of a royal commission known as the "Great Mongol Shahnama"—one of the earliest surviving illustrated versions of the epic poem.

Opaque watercolor, gold, and ink on paper 23½ x 15½ in. (59 x 39.6 cm)

Denman Waldo Ross Collection 30.105

1	المحتكا عدا المثان	عاميكات كاذرار	بالمعدك أشادا	اس در خرنه حکواه الله	والمن رادوش راحكشها
مايدرمون	ورتحه ارتك الماددان	ماناد ول زاد سكاد ديلة	والديم دعينا أزردد ٥	نارى عكرى سردناه	Biring in The sind
الميا	تكنيَّ لثكرنائمُ	رسترجين كفتكا عبثانا	والاختم كيكافال		
ا داد جيوب	د وسڪڙي دوو تراکشانه	مترده تشاشته دراغش	الما فالحدرة ان فيالمكن		
ا ڪيار	وتفنشاه جارة مايتاد	المراكاة المركثية	دريم باخت رياحتي و ط		
			المان الران المان		
					FOESTRIP DELLEGISTRE
				* 2018/2018/00/07/07/07/08	
				-	D. Ann
16		CHINAM	- TEN	7	
1		A Contraction			AL VAN
				120	
	SALE.	All a	11.5		
作血			1991		
	Kill Salar	1	-7:3		
		00	-	T TE	
		1			
腦節	10000	D	1 1/	THE RESERVE	
354		W. A.		Al Su	100
(D)	Market Land	4,7	S. M	waes.	
COLUMN E	The same of the same	Sideliche	MI	حكدرون ويدريس	
الماتاس	من المسكون بين موما وال	No belle	IJOS IJOS	المستره والمستورد	واكون من اسياراد
ا ڪيا،	روازه فرامرز ودستانهام			Chon Summer 2	Elisaini in per
		المتعاديم والماركا	الموكفت دورا منالل	المن المناوية	ارزم كون مريدة والأ
		الم الم المراد ا	عانامتهادت وبقال	المنام كديم نشية	وعمرت مناب شنا
		م كانت سو وكانود	المركت الدى لاستنقاء	مع بستيمة اراموكم	دو کن درکنم
		الما من الما الما الما الما الما الما ال	Elicion is	المراجعة المراجعة	عكمتا فالوداثا
	اصاحتها دادبسوبكريد				
باذئويد	مواستها دادسور بكريد المحسنة المعاسقة الد		أد كرد إسكها رآب	المحانات المارة	عكت كر الخلفيد
	مادر الدار	ر الله المالة المالة الله الله الله الله الله الله الله ا	الما الذكر الاستكانا الما الما الما الما الما الما الما ا	الما الما الما الما الما الما الما الما	الماد المن المنافعة

Bowl Iran (Kashan), early 13th century

The karkaddan depicted at the center of this bowl and identifiable by its single horn is among the many fabulous creatures in Islamic art. It is surrounded by large serpents whose scaly, entwined bodies give the design intricacy and strength. The bowl is painted in black under a translucent turquoise glaze and was probably produced in Kashan, a central Persian city famous for its medieval ceramic tiles and vessels.

Composite body (quartz, clay, and glass frit) with black pigment under a translucent alkaline glaze
Diam. 8% in. [22.5 cm]
Gift of the John Goelet Foundation 65.231

Design for a water clock

Egypt (probably Cairo) Mamluk period, 1354

Written in 1206 by the engineer Ibn al-Razzaz al-Jazari, *The Book of Knowledge of Mechanical Devices* detailed the construction of elaborate mechanical devices ranging from clocks and locks to automated vessels for washing hands. This design for a clock is from a manuscript of al-Jazari's text created in 1354 for an official serving the Mamluk sultan of Egypt. Run by water, the clock is operated with a complex system of reservoirs, floats, and pulleys. Every hour of the day, a figure emerges from one of the twelve doorways in the arcade below the signs of the zodiac, and the two falcons on the sides come out and drop balls from their beaks. Hourly during the night, one of the twelve circles in the lower arch lights up. At the sixth, ninth, and twelfth hours, the musicians play their instruments.

Opaque watercolor, gold, and ink on paper $15\% \times 10\%$ in. (39.5 x 27.5 cm) Francis Bartlett Donation of 1912 and Picture Fund 14.533

Possibly by Muzaffar Ali A Young Prince Holding Flowers Persia

Safavid, 16th century

From his round face shown in conventional three-quarter view to his tiny feet in profile, this elegant youth resembles many others depicted in sixteenth-century Persian painting. If this "portrait" once represented a specific individual, the young man's identity is now unknown. His turban, however, establishes that he is a nobleman at the court of Shah Tahmasp I (ruled 1524-1576), whose followers wore a felt cap (taj) with a tall projection around which a length of silk or cotton was wrapped in a graceful, tapering shape. A nobleman could embellish his turban with jewelry and feathers.

Opaque watercolor on paper 19 x 12% in. [48.2 x 31.4 cm] Francis Bartlett Donation of 1912 and Picture Fund 14,590

Woman's coat (munisak)

Uzbekistan (Bukhara region), 1850-1900

The laborious process of ikat—the repeated tying and dyeing of the threads of a cloth before weaving-has long been practiced in many parts of the world. The ikat textiles created in Central Asia during the nineteenth century, however, are unrivaled in their vibrant colors and explosive patterns. In such isolated desert cities as Bukhara and Samarkand (in today's Uzbekistan), sumptuous ikat wall hangings and robes brought vibrant color to life in a stark, barren landscape. Both men and women wore ikat clothing; the munisak, a woman's coat characterized by extra fullness at the hips, was the most costly item of a bride's dowry.

Silk; cut-velvet, resist-dyed (ikat) pile warp H. 46½ in. (118 cm) Gift in memory of Jay Abrams 58.342

Tile panel Turkey (Iznik) Ottoman period, about 1573

Present-day Turkey was once the core of the Ottoman Empire that dominated large areas of the Middle East, North Africa, and southern Europe in the sixteenth century. The city of Iznik in northwestern Turkey was a center for the production of ceramic tiles used to decorate many buildings, including mosques and palaces. This panel was probably placed above a window or doorway in the palace complex at Istanbul of Piyale Pasha, grand

admiral of the Ottoman fleet. Iznik ceramic artists frequently adopted designs from illuminated manuscripts and textiles. Here, the artist employed a vocabulary of Chinese-inspired plant forms known as the *saz* (enchanted forest) style, as well as Chinese cloud bands rendered in a distinctly Turkish iron-oxide red.

Composite body (quartz, clay, and glass frit) with colors painted on white slip under clear glaze W. 57% in. (145.1 cm)
Bequest of Mrs. Martin Brimmer 06.2437

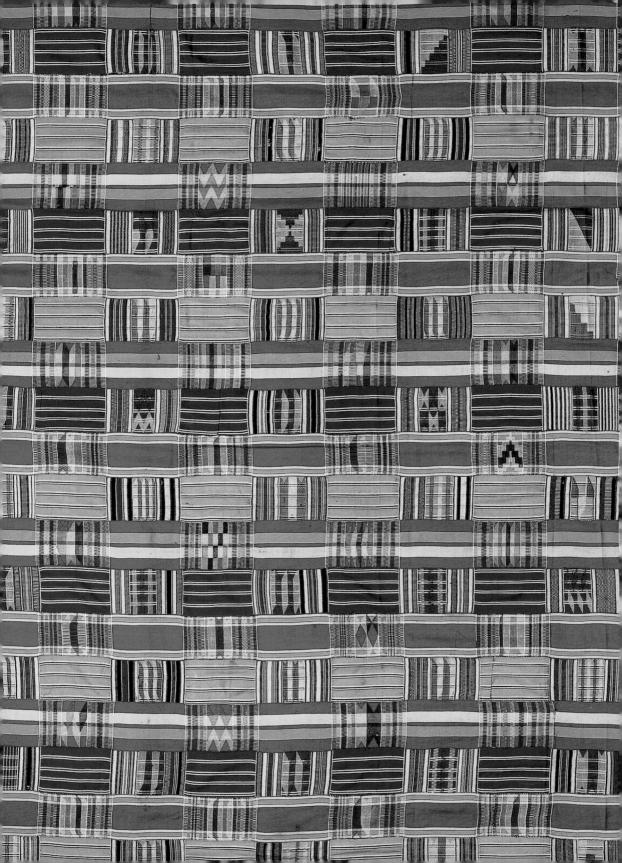

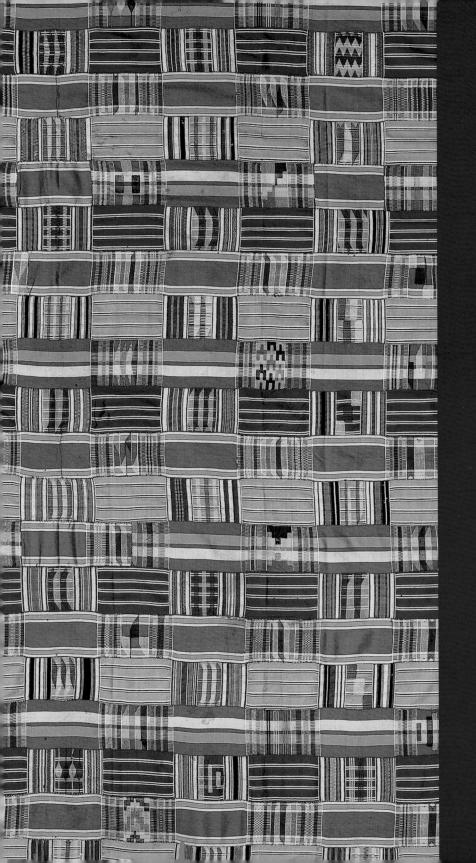

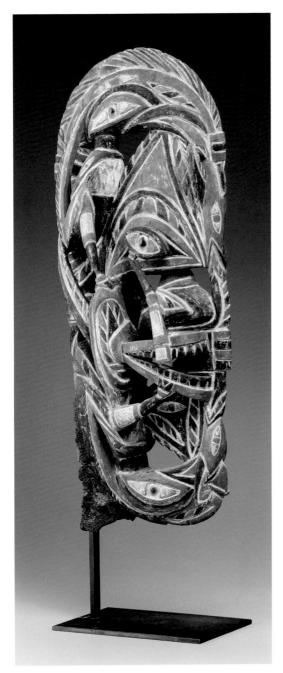

Canoe prow

Papua New Guinea (Northern New Ireland), late 19th-20th century

Melanesian art is represented here by objects from just two of its many thousands of islands-New Guinea and New Ireland. However, all the myriad cultures of Melanesia shared a belief that spirit forces permeated their environment. As a result, everything from ritual objects to weapons and musical instruments were shaped and decorated to capture spiritual essence and presence. The results are highly individual and dramatic.

The richly painted wooden sculptures of New Ireland are distinguished by openwork designs that weave together representations of humans, plants, and animals. The powerfully three-dimensional form of this sculpture—created to ornament either the prow or the stern of a canoe-includes a human face, birds, feathers, and flying fish that all relate to the ancestral myths of the canoe's owner. Some hidden figures are discovered by the glint of their eyes inlaid with shell.

Wood, pigment H. 21½ in. [54.6 cm] Gift of William E. and Bertha L. Teel 1991.1073

Female figure

Mundugumor (Biwat) or neighboring peoples Papua New Guinea (Yuat River), 20th century

Central to the religions of Melanesia was a deep reverence for ancestors, who were believed to be more intimately connected to their descendants than any deities. Carved human images both honored ancestor spirits and served as physical hosts that they might temporarily inhabit. The ancestor figures of the Mundugumor peoples are particularly forceful, even potentially dangerous, with their characteristic hunched postures and thrusting forms. Small ones, like this, were privately owned, but they were believed to benefit both the families that possessed them and the community at large. Unfortunately, the names of the figures and their stories seldom have survived.

Wood, traces of pigment
H. 19 in. (48.3 cm)
Gift of William E. and Bertha L. Teel 1991.1079

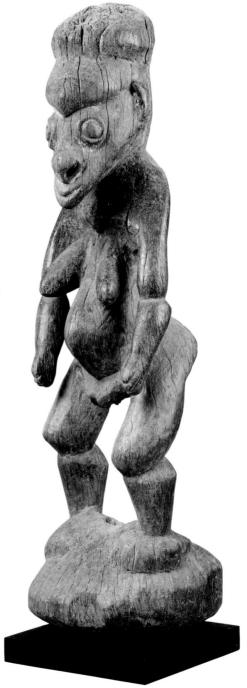

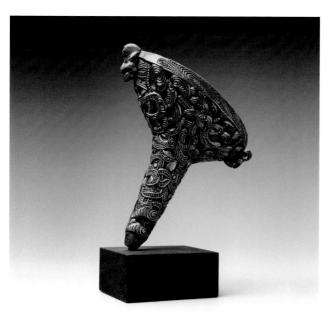

Feeding funnel (koropata)

Maori peoples

Aotearoa (New Zealand), 19th century

The tattoo was a mark of prestige and achievement among the Maori of Aotearoa, where both men and women practiced the art of tattooing and were tattooed themselves. The practice was regulated by *tapu*—traditional rules that governed many aspects of human behavior. When the face and lips of a chief were tattooed, tapu forbade cooked food to touch any part of his skin. The chief was fed during this long and painful process by liquid food proferred through a wooden funnel that was both a functional object and a work of art. This example is typical of Maori workmanship in that it is completely covered with fine relief carving and then finished to bring out the intricacy of the design and the natural beauty of the wood.

Wood H. 7 in. [17.8 cm] Gift of William E. and Bertha L. Teel 1991.1071

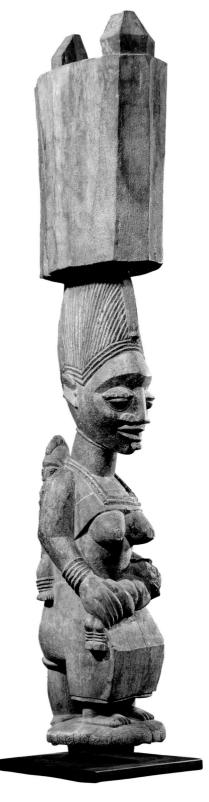

facing page, right

Agbonbiofe Adeshina

Nigerian, died 1945

Veranda house post

Yoruba peoples

Nigeria (Efon-Alaiye, Ekiti region), about 1912-15

Carved veranda posts, representing figures that uphold the power of rulers, support the roofs around the interior courtyards of Yoruba palaces. This seated woman clasps a child; another is strapped to her back. She embodies dignity and authority and epitomizes the forces of creation and sustenance of life. The sculpture was made by a member of the Adeshina family, eminent carvers and beadworkers who worked in Efon-Alaiye, a Yoruba town in southwestern Nigeria. In 1912 a fire swept through the palace of Efon-Alaiye, and Agbonbiofe Adeshina carved twenty or more new veranda posts for its courtyards. Typical of Adeshina's sculpture, the decorative details of hair and jewelry are subdued and contained so that nothing detracts from the strength of the essential form.

Wood, pigments
H. 58 in. (147.3 cm)
Gift of William E. and Bertha L. Teel 1994.425

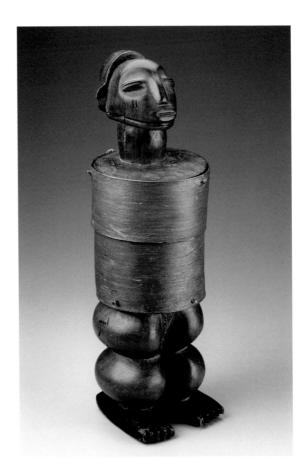

Container

Mangbetu peoples

Democratic Republic of the Congo, early 20th century

Artists of the Mangbetu peoples create containers like this one to hold such personal objects as jewelry, hairpins, and toiletries; the elegant craftsmanship indicates the wealth, high status, and refined taste of its original owner. The cylindrical central portion of the vessel is hollow and made of interlocking strips of bark sewn together with fibers. The fine-featured face and rounded legs of carved wood, typical of the Mangbetu style, lend this practical object a serene humanity.

Wood, bark, vegetable fiber
H. 15½ in. (39.4 cm)
Gift of William E. and Bertha L. Teel 1992.408

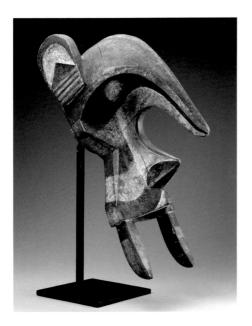

Headdress (ogbodo envi)

Igbo peoples Nigeria, 20th century

Among the Igbo peoples, mask makers are known as ndi n'atu isi mmuo (people who carve head spirits). As part of an intricate costume used in a ritual drama that often includes music and dance, masks represent powerful spirits. During the summer dry season, there are festivals, or masquerades, to thank ancestors and deities for the successes of the agricultural year and to ensure their support in the future. The masquerade called ogbodo enyi (spirit elephant) is intended to cleanse and purify the village. In it the performer wears this mask on top of his head; dressed in a knotted raffia costume, he moves energetically through the village—sometimes for up to six hours. The ogbodo envi headdress does not specifically represent an elephant but captures that creature's strength and endurance.

Wood, pigments H. 20½ in. (52.1 cm) Gift of William E. and Bertha L. Teel 1992.419

Standing bird figure (porpianong)

Senufo peoples

Côte d'Ivoire, early 20th century

This large bird probably represents a hornbill, believed by the Senufo peoples to be one of the five original creatures of the earth. Thus, the figure is sometimes called "the first ancestor," its long beak and projecting belly symbolizing conception, pregnancy, and the continuity of the community. Such sculptures were used during initiation ceremonies of the secret Poro society that guides the religious and social education of boys. The base of the

figure is hollow so that it could be carried on the head; cords were passed through the holes in the wings to help maintain its balance.

Wood, pigments H. 63 in. [160 cm] Gift of William E. and Bertha L. Teel 1994.415

Mask (deangle) Dan peoples

Liberia/Côte d'Ivoire, 20th century

Among the Dan and other peoples of the Côte d'Ivoire, the Poro and Sande societies initiate young boys and girls into adulthood and teach them to become productive members of the community. Like the Senufo bird sculpture on the facing page, this mask was used in a ceremony of the masculine Poro society. The deangle represents a beautiful and gentle female spirit; the masker who wears it collects food from onlookers at dance performances and distributes it to boys of the society. Many wooden Dan masks were enhanced with materials such as feathers and shells, and this example has survived with its cowrie shells and vegetable-fiber hair intact.

Wood, fiber, shells H. 16½ in. (41.9 cm) Gift of William E. and Bertha L. Teel 1994,420

Power figure (nkisi nkonde)

Kongo peoples

Democratic Republic of the Congo, late 19thearly 20th century

The spirits represented by these Kongo sculptures are believed to punish those who steal, swear false oaths, break treaties, cause illness, and otherwise threaten the social fabric of the community. Petitioners drove nails and blades into this figure to arouse the spirit to solve disputes and harm wrongdoers. Most nkonde are male, although female and animal figures exist. Every detail is significant: the pierced ears, for example, indicate attentiveness to all problems, and the placement of hands on hips signifies alertness and vigilance. The source of the nkonde's power is a packet of medicinal substances (special earths and stones, vegetable materials, parts of birds and animals) that enable the image to attract the spirit. On this figure, the packet is located in the belly, behind the mirror, a symbol of mystic vision.

Wood, pigments, metal, glass, sacred material H. 24 in. [61 cm] Gift of William E. and Bertha L. Teel 1991.1064

Mask (kifwebe)

Songve peoples

Democratic Republic of the Congo, early 20th century

The powerful and aggressive male masks of the Songye people, their surfaces deeply scored with grooves, are unparalleled in African sculpture. The size of the crest is an indication of the wearer's supernatural strength, and the red paint is associated with blood, flesh, and fire-a potent symbol of courage and achievement but also of the malignant forces of witchcraft and sorcery. Like most masks, this one can be only partly understood without the entire costume that accompanied it: head covering, shirt, leggings made of raffia fiber, and goat skins fastened around the hips. The

costume was worn at ceremonies designed to help leaders maintain economic and political power, to prepare for war, and to judge and punish wrongdoers.

Wood, pigments H. 20 in. [50.8 cm] Gift of William E, and Bertha L. Teel 1992,409

Woman's ceremonial skirt (ntchak)

Kuba peoples

Democratic Republic of the Congo, first half of the 20th century

The Kuba peoples value textiles not only for their aesthetic qualities but also as measures of rank and as prestigious political gifts; until the late nineteenth century, woven raffia cloth also functioned as currency. This skirt, unique in its contrasting squares of positive and negative embroidered patterning, was made for a woman of the royal Bushong group to wear on festival and ceremonial occasions. Almost five feet long, it was wrapped horizontally over an inner skirt that was coiled around the wearer in a voluminous, many-layered spiral. The skirt's wavy edging of twisted reeds undulated sensuously as the dancer moved. Kuba men cultivate and harvest the raffia palm and weave its fiber into squares of cloth: women hem the cloth, pound it until soft, embroider it with dyed raffia thread, and join the completed sections to make the skirt. The entire process may take several years.

Raffia and bundled reed; embroidery on plain weave 26³/₄ x 58⁷/₈ in. [68.7 x 151 cm] Benjamin and Lucy Rowland Fund 1995.91

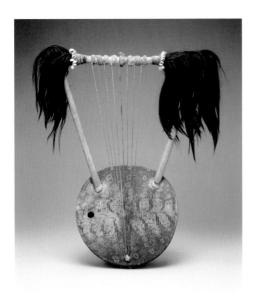

Bowl lyre (ndongo)

Ganda peoples Uganda, 19th century

Lyres—on which each string sounds only one note—are among the most ancient musical instruments. Until recently, they were the primary instruments used by East African singers and storytellers to accompany songs that entertained and educated at wedding parties and other social events. The *ndongo* has an unusual buzzing tone, produced as the strings vibrate against the rough lizard skin that covers the wooden body. The tufts of goat hair that crown the lyre are purely decorative.

Wood, monitor lizard skin, goat hair, cowrie shells, calfskin, twisted plant fiber H. 26 in. [66 cm] Leslie Lindsey Mason Collection 17.2179

Man's wrapper Asante peoples Ghana, early 20th century

Strip-woven mantles are traditional dress for men and women throughout West Africa. Strips about four inches wide are woven and then sewn together to make larger pieces of cloth. A style of strip weavings called <code>kente</code>—colorfully patterned cloth woven by hand—is a particular specialty of the Asante and Ewe peoples, who now live in Ghana and Togo. Far beyond its function as cloth, <code>kente</code> is the visual embodiment of history, political thought, religious beliefs, and social ethics. This example has the prestigious design of burgundy, gold, and green stripes that is reserved for the royal clan of the Asante. Purchased in Ghana, this wrapper adds to the Museum's increasing collection of African textiles in a range of materials and techniques.

Silk; plain weave with supplementary weft patterning 120×72 in. $(304.8 \times 182.9 \text{ cm})$ Museum purchase with funds donated by Jeremy and Hanne Grantham 2005.78

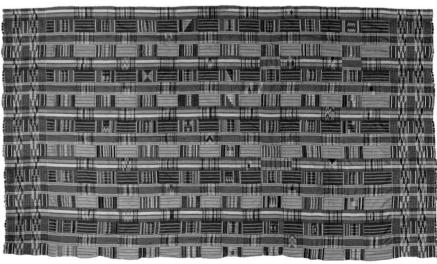

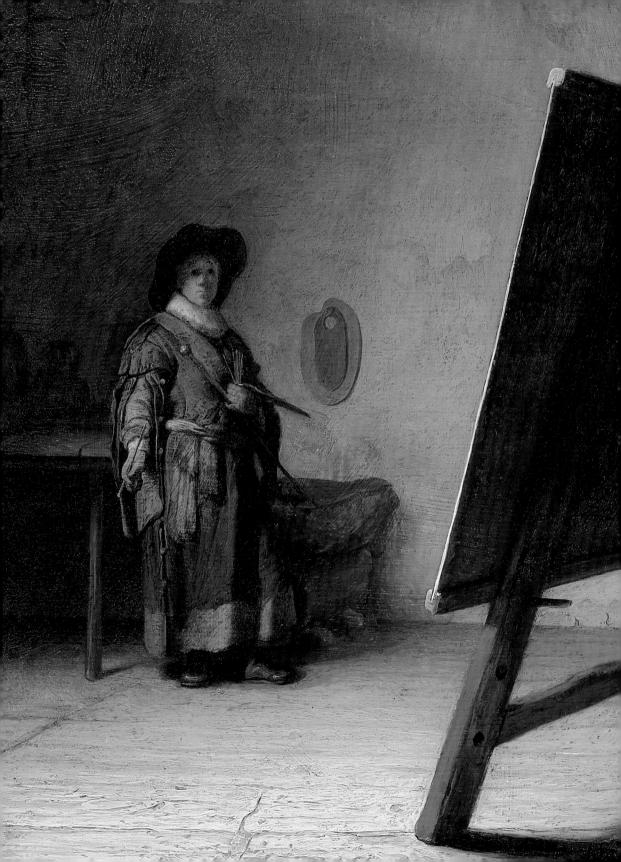

Reliquary shrine (Emly Shrine)

Ireland, late 7th or early 8th century

Made to hold the sacred relics of a saint (often parts of the saint's body), Irish house-shaped reliquaries have been discovered as far away as Norway and Italycarried there by Irish pilgrims or Viking raiders. This one, however, was found in Ireland and is named for its nineteenthcentury owner, Lord Emly of Limerick. It is quite tiny and was probably hung from the neck or shoulder of its owner as a source of

Champlevé enamel on bronze over yew wood; gilt bronze moldings, inlay of lead-tin alloy 35/4 x 15/4 x 41/4 in. [9.2 x 4.1 x 10.5 cm] Theodora Wilbour Fund in memory of Charlotte Beebe Wilbour 52,1396

protection and spiritual strength.

Fragment of a shroud

Southern Spain (probably Almería), early 12th century

Important individuals in the Middle Ages were often buried wrapped in precious fabrics, and this silk weaving brocaded with gold thread is believed to have been part of the shroud of a bishop of Burgo de Osma, a city in central Spain. Its design is Islamic and within the small circles is the Arabic inscription "This was made in Baghdad, may God protect it." Luxury goods from Baghdad were highly prized in Europe, but this cloth was probably made in the Muslim city of Almería in Spain; the false inscription was intended to increase the value of the cloth.

Silk; lampas with supplementary metallic patterning wefts 17 x 19¾ in. [43 x 50 cm] Ellen Page Hall Fund 33.371

Oliphant

Southern Italy (probably Amalfi), about 1100

Horns called oliphants (from the Old French word for elephant) were carved from elephant tusks acquired from the East Africa coastline. Amalfi, where this oliphant was probably made, was one of several southern Italian ports that traded with Africa in the twelfth century. Although horns were used for hunting, drinking, and in battle, large and intricately carved examples such as this were prized as luxury objects and symbolic statements of wealth and status. Sometimes they were exchanged ceremonially as part of the transfer of land, which included the right to hunt on that land—a carefully guarded marker of feudal privilege, as only the nobility was allowed to hunt. Some nobles gave their oliphants to the Church, and most surviving examples were preserved through the centuries in the treasuries of cathedrals or monasteries.

Ivory
L. 21 in. (53.4 cm)
Maria Antoinette Evans Fund 57.581

Madonna and Child

Central Italy, second quarter of the 12th century

Made of stone instead of the more typical wood, and with most of its original paint intact, this sculpture of the Madonna and Child is extremely unusual. It was probably made for placement on or over an altar. While many twelfth-century sculptures of the Madonna are frontal and austere, this one, with its tenderly entwined figures, invites viewing from oblique angles. The striking depiction of Mary holding a son who is more man than baby powerfully foreshadows Jesus's death and increases the emotional intensity of this extraordinary work.

Limestone with polychromy $29\,\%\,x\,15\,\%\,\,x\,8\,\%\,\,\text{in.}\,\,(74\,x\,40\,x\,22\,\,\text{cm}]$ Maria Antoinette Evans Fund $\,\,$ 57.583

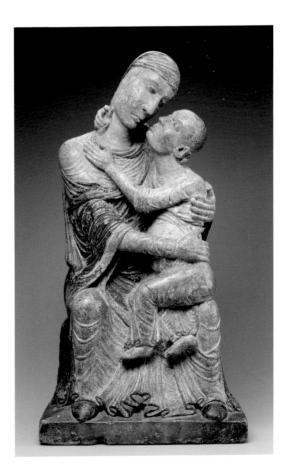

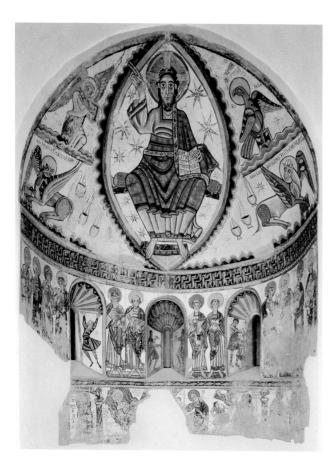

Christ in Majesty with Symbols of the Four Evangelists Spain (Catalonia), 1150-1200

This fresco once decorated the apse of Santa Maria del Mur, a small church in the foothills of the Spanish Pyrenées. Huge-eyed and solemn, the imposing figure of Christ in Majesty dominates the composition. He is surrounded by symbols of the four Evangelists, whose writings form the core of the Bible's New Testament, and he holds a book inscribed "I am the way, the truth, and the life; no man cometh unto the Father but by me." Below are images of Christ's original disciples, the twelve Apostles, and scenes from the Bible. More than twenty feet high, the fresco was sold from the church in 1919. The process of removing it from the wall was a delicate and difficult one. First, craftsmen glued to the front of the painting layers of cotton muslin

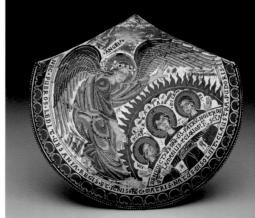

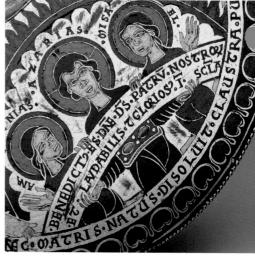

that, when dry and hard, kept the paint in place. Next, a thin layer of plaster was chiseled away behind the fresco to separate it, in sections, from the wall on which it was painted. The fresco was then backed with canvas, waterproofed with a mixture of lime and Parmesan cheese, and transported to Barcelona, eventually coming to Boston.

Fresco secco transferred to plaster and wood 254 x 150% in. [645 x 382 cm] Maria Antoinette Evans Fund 21.1285

facing page, right

Three Worthies in the Fierv Furnace

Southern Netherlands (Meuse region, Maastricht?), 1150-75

Composition, color, and technical precision place this large plaque among the finest examples of medieval enamelwork to survive. It tells the Old Testament story of the Three Worthies who refused to worship a golden image and were cast into a furnace where they "walked about in the midst of the flames, singing hymns to God and blessing the Lord. Then Azariah stood and offered this prayer: 'Blessed art thou, O Lord, God of our fathers, and worthy of praise; and thy name is glorified for ever." Hearing this, an angel "drove the fiery flame out of the furnace . . . so that the fire did not touch them at all or hurt or trouble them." In the Middle Ages, many Old Testament stories were viewed as precursors of New Testament ones; the Three Worthies prefigured the purity of the Virgin, as the encircling inscription here makes clear: "Neither the fury of the King nor the fire can harm the youths, nor can the birth of the Mother destroy the seal of her Virginity."

Champlevé enamel and gilding on copper $8\% \times 8\%$ in. (20.8 x 22.7 cm) William Francis Warden Fund 51.7

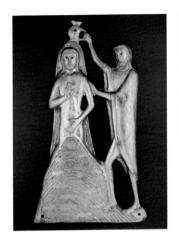

Baptism of Christ France (Limoges), mid-13th century

This relief was originally one of several scenes from the life of Christ that were mounted on a flat plague that decorated an altar. It is of exceptional quality, with the gilded-copper surface skillfully worked to capture the textures of hair, fur, and water. The relief is unusual in showing John the Baptist baptizing Jesus in two ways by pouring water from an ewer over his head and by immersing him in the river Jordan, Jesus, his hand raised in blessing, stands in water whose ripples are suggested by curved segments of white enamel interspersed with shapes of swimming fish.

Champlevé enamel and gilding on copper 14½ x 8½ x 1½ in. [36.8 x 21.1 x 2.8 cm] Francis Bartlett Donation of 1912 50.858

Samson and lion aquamanile Northern Germany, late 13thearly 14th century

In the Old Testament's book of Judges, the young Samson met a lion that "roared against him; and the Spirit of the Lord came mightily upon him, and he tore the lion asunder as one tears a kid." Here, Samson has just leapt onto the lion's back and confronts its fearsome jaws. The story often appears in medieval art and literature as a prefiguration of Christ's conquest of the devil. Here, it is presented in the form of an aquamanile, a vessel used for ritual hand-washing during the Mass that was later adapted for use in monasteries and princely residences. The aquamanile was filled through an opening on Samson's head; there is a spout below the lion's left ear and its tail makes a handle.

Leaded latten (a copper alloy)
13% x 14½ x 4½ in. [34 x 36.8 x 11.4 cm]
Benjamin Shelton Fund 40.233

Duccio di Buoninsegna and Workshop Italian (Siena), active in 1278, died by 1319 Triptych: The Crucifixion: The Redeemer with Angels; Saint Nicholas; Saint Gregory, 1311-18

Duccio's ability to weave groups of figures into moving and compelling pictorial narratives was unprecedented in Italian painting. His jewel-like color and elegant, linear style dominated Sienese painting for two hundred years. Here, beneath the poignant, subtly modeled body of Christ, mourners gathered around the Virgin Mary melt together in shared grief; on the other side of the cross, the poses and gesticulations of soldiers and onlookers suggest confusion and

disarray. This remarkably well-preserved triptych is one of Duccio's few surviving paintings. A sumptuous object for private devotion, it was undoubtedly commissioned by a wealthy individual whose patron saints were probably Nicholas and Gregory. Designed to be portable, the triptych is beautiful even when closed; the backs of the wings are painted in imitation of marble and semiprecious stones.

Tempera on panel

Center panel: 24 x 15½ in. (60 x 39.5 cm) Left wing: 173/4 x 75/8 in. [45 x 19.4 cm] Right wing: 17³/₄ x 7⁷/₈ in. [45 x 20.2 cm]

Grant Walker and Charles Potter Kling Funds 45.880

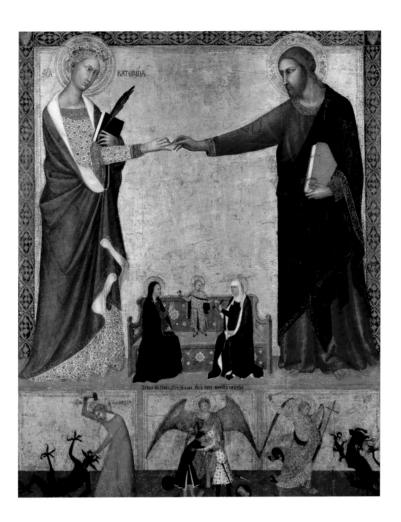

"Barna da Siena"

Italian (Siena), active about 1330–1350

The Mystic Marriage of Saint Catherine, about 1340

The legendary Saint Catherine of Alexandria had a vision in which Christ took her as his spiritual bride, placing a ring on her finger. In this painting, the union symbolized by this event is echoed in the central scenes below: the Christ Child grouped with his mother and his grandmother, Saint Anne, and two enemies reconciled by an archangel. The triumph of good over evil is represented in the lower scenes to right and left by saints Margaret and Michael subduing demons. These images suggest that the donor

named in the inscription, Arigo di Neri Arighetti, commissioned the painting to celebrate the end of a feud. Many aspects of the painting seem to be unique in fourteenth-century Italian art, including the representation of Saint Catherine of Alexandria with the adult rather than the infant Christ and the topical scene of enemies discarding their weapons and embracing. This is one of the largest and most unusual fourteenth-century Sienese paintings, but the identity of the artist known as "Barna da Siena" remains a mystery.

Tempera on panel 54% x 43% in. (138.9 x 111 cm) Sarah Wyman Whitman Fund 15.1145

Crucifixion

Italy (Florence), late 14th century

This embroidery probably was one of twelve scenes from the life of Christ that, grouped around a central panel, hung across the front of an altar. The design was first drawn on the linen cloth, possibly by a professional artist. The embroiderer then worked the design in silk and metallic yarns, achieving subtle variations of tone and texture through the use of more than twenty colors of silk and a range of different stitches. The background, with raised scrollwork across the sky, was originally covered with gilded-silver yarns, an effect that paralleled the use of gold leaf on the background of medieval paintings.

Cotton and linen; plain weave embroidered with silk and metallic thread 11½ x 16½ in. [28.6 x 41.9 cm] Helen and Alice Colburn Fund 43,131

Virgin and Child on the crescent moon

Lower Austria, about 1440-50

This refined and graceful sculpture was once part of an elaborate altar shrine (now lost) in the parish church of Krenstetten in

Lower Austria. It is carved from a single piece of wood, except for the piece from which the face at the bottom is carved, which may be a later addition or repair. It is hollowed out behind to prevent cracking. The quality of the carving is remarkable, as seen in the deep, looping folds of the Virgin's mantle. Crowned as the Queen of Heaven, the Virgin-with her gently swaying posture and delicate features-represents the epitome of idealized beauty.

Poplar with polychromy and gilding 69½ x 22 x 12 in. [176.5 x 55.9 x 30.5 cm] Centennial Purchase Fund 65.1354

Rogier van der Weyden Flemish, about 1400-1464 Saint Luke Drawing the Virgin, about 1435-40

Saint Luke is the patron saint of artists, and this altarpiece, a masterwork of fifteenth-century painting, may have been made for the chapel of the painters' guild in Brussels. Rogier van der Weyden made at least three full-size copies of this original version, evidence of the high regard in which the composition was held in its time. Tests using infrared reflectography, which can reveal the underdrawing or prepatory sketches hidden below a painting's surface, show that van der Weyden redrew the head of Saint Luke and other details many times before settling on the final composition. The other versions of the painting do

not have this evidence of developing ideas, indicating that they were derived from the Museum's example.

It was once popularly believed that Saint Luke was the first to record the Virgin's likeness, and here the saint reverently makes a preliminary drawing for his portrait of her. Among the meticulously rendered, realworld details, the enclosed garden beyond the room symbolizes the Virgin's purity, the couple gazing out at a river and a Flemish town may represent the Virgin's parents, and tiny carvings of Adam and Eve on Mary's throne allude to Christ and his mother as the new Adam and Eve come to redeem mankind from original sin.

Oil and tempera on panel $54\% \times 43\%$ in. $(137.5 \times 110.8 \text{ cm})$ Gift of Mr. and Mrs. Henry Lee Higginson 93.153

Wild Men and Moors

Southern Germany (possibly Strasbourg), about 1440

Hairy "wild men," neither entirely man nor beast, were popular subjects in medieval art and literature. On the left of this tapestry (top detail), wild men attack a castle defended by Moors, whose king and queen look out from a window. In the center are wild men with a unicorn, a dragon, and a lion, and on the right (bottom detail), men return from the hunt and

pay homage to a mother with her children. This spectacular tapestry probably hung along the back of a choir stall in a church or above a row of benches. Against the latticework background, fanciful plants and animals and the patterned, hairy coats of wild men create a magical world.

Linen and wool; tapestry weave 39½ x 193 in. [100 x 490 cm] Charles Potter Kling Fund 54.1431

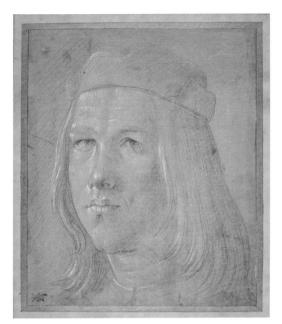

Lorenzo di Credi Italian, 1456/59-1537 *Head of a Youth*, about 1500

Like the one Saint Luke makes in Rogier van der Weyden's painting (see page 165), this is a silverpoint drawing. Such drawings, common from the late fourteenth to the early seventeenth centuries, were made with a sharp, silver instrument on paper specially coated so that the metal would leave a mark. The son of a goldsmith, Lorenzo di Credi was a fellow pupil of Leonardo da Vinci in the Florentine workshop of painter and sculptor Andrea del Verrocchio. Credi later inherited and became the master of that studio and, although a fine portraitist, is best known for his religious paintings.

Silverpoint, highlighted with white, on gray prepared paper $8\% \times 7\%$ in. (22.5 x 19.5 cm)

Denman Waldo Ross Collection 17.592

Spoon
Southern Netherlands, about 1430

On the bowl of this spoon, a fox dressed as a monk and carrying three dead geese in his cowl holds a document bearing the word pax (peace). He is preaching to a flock of geese while another fox seizes one of the congregation. The perceived hypocrisy of the clergy was frequently mocked in the late Middle Ages, and the inspiration for the decoration of this spoon may have been a well-known proverb: "When the fox preaches, beware your geese." Or the scene may be drawn from a Flemish version of the immensely popular Roman de Renart, a collection of stories (featuring Renart the fox) in which animals live in a society modeled on that of medieval France. The spoon is one of a group of luxury objects that are believed to have been made for Philip the Good, Duke of Burgundy, a great patron of the arts who amassed large collections of tapestries, paintings, metalwork, illustrated books, and jewels.

Painted enamel and gilding on silver $6\% \times 1\% \times 1$ in. $\{17.6 \times 4.9 \times 2.6 \text{ cm}\}$ Helen and Alice Colburn Fund 51.2472

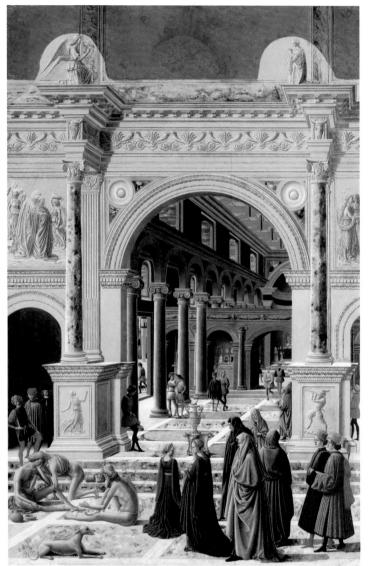

Fra Carnevale (Bartolomeo di Giovanni Corradini) Italian (School of the Marches). active by 1445, died in 1484

Presentation of the Virgin in the Temple, about 1467

Fra Carnevale most likely painted this work as part of a monumental altarpiece for the church of Santa Maria della Bella in Urbino, and the repainted area along the top edge reveals the shape and placement of the original frame. The figures stand before a vast basilica whose facade, with its triumphal arch based on those of Constantine and Septimus Severus in Rome, is an important early instance of Renaissance fascination with classical architecture. The painting's precise spatial organization allows the viewer to gaze deep into the temple, discovering painted altarpieces and a glimpse of the street. Although traditionally identified as a Presentation of the Virgin in the Temple (with the young Virgin, dressed in blue, standing in the center foreground), the painting's unusually secular aspects and lack of specific focus make it uncertain what event in the Virgin's life is actually depicted.

Oil and tempera on panel 57% x 38 in. [146.5 x 96.5 cm] Charles Potter Kling Fund 37.108

Donatello

Italian, 1386-1466

Madonna of the Clouds, about 1425-35

One of very few works in the United States by the preeminent sculptor of the early Italian Renaissance, this exquisite marble relief was probably commissioned as an object of private devotion and may have been framed in a wooden tabernacle with painted wings. The relief depicts the Madonna of Humility, surrounded by angels and seated on a bank of clouds. The extremely shallow carving, measurable in millimeters, relies on soft, raking light that creates shadows to delineate the edges of the forms. This subtle and exacting relief technique is called rilievo schiacciato (flattened relief). Possibly inspired by the classical art of cameo carving (see page 77), schiacciato relief was invented by Donatello, and few other sculptors attempted it.

Stone; marble

13 x 12% in. (33.1 x 32 cm)

Gift of Quincy Adams Shaw through Quincy Adams

Shaw, Jr. and Mrs. Marian Shaw Haughton 17.1470

Length of velvet

Italy (possibly Florence), about 1450-1500

During the Renaissance, Florence and Venice were centers for innovation in all the arts, including textiles. Weavers perfected the complex technique of making patterned silk velvets, often in two or three heights of cut and uncut pile that produced a sculptural, three-dimensional quality. Patterns were made even more complex when gold wefts were raised by a small hook to form loops, or bouclé, which were thought to enhance the color of the velvet and so were known poetically as allucciolature, a term meaning "to throw forth light." Such velvets are often seen in tapestries and paintings and were used to make altar cloths, religious vestments,

and luxury clothing worn by aristocrats.

The popular motif of the pomegranate seen here was a symbol of immortality and fertility in Middle Eastern and Asian religions and was introduced to Italy through trade with the Ottoman Empire.

Silk; velvet with supplementary metallic patterning wefts 77½ x 29 in.
[197 x 73.5 cm]
Julia Knight Fox Fund 31.140

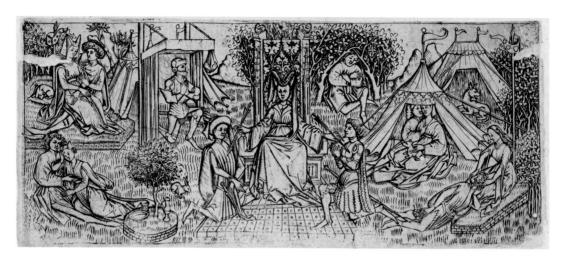

Master of the Gardens of Love Netherlandish, active 1440-1450 The Little Garden of Love, 1440-50

The first prints from engraved plates were made in the mid-fifteenth century by armorers and other metalworkers who decorated their wares with sharp tools. To record and preserve their patterns, these craftsmen filled the indented lines with ink and printed the design onto paper. The Master of the Gardens of Love, one of the first engravers for whom a body of work can be identified, was perhaps trained as a goldsmith. This image is an allegory of courtly love: enthroned in a pastoral and romantic setting, the Queen of Love casts her spell on a knight and a nobleman. Around her are a variety of courting couples as well as a knight who kneels reverently and a sad young man in a bower of trees, suffering pangs of love.

Engraving

Platemark: 31/4 x 73/4 in. [8.4 x 19.6 cm] Katherine E. Bullard Fund in memory of Francis Bullard 65.594

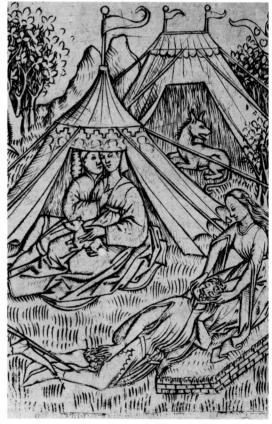

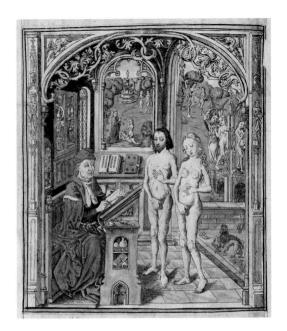

Master of the Boccaccio Illustrations Netherlandish, active about 1470–1490 Adam and Eve, 1476

Published in 1476 in the prosperous Flemish town of Bruges, this is the earliest known printed book illustrated with engravings, which were printed separately and pasted into the volume. In the Museum's copy (the finest and most complete surviving example), the engravings were also colored by hand. The text, written in the later fourteenth century by Giovanni Boccaccio, consists of a series of imaginary interviews with celebrated sufferers of misfortune. Translated from the original Latin into French in the fifteenth century, the book was admired throughout Europe. In the engraving illustrated here, Boccaccio sits in his study interviewing Adam and Eve. Beyond the windows, vignettes recall events from their lives, including, on the left, the two pleading for mercy from God, who is dressed as a bishop.

Engraving, hand-colored

From *De la ruine des nobles hommes et femmes* (Of the ruin of noble men and women) (Bruges: Colard Mansion, 1476)

Page: 14½ x 10½ in. (36.8 x 26.6 cm)
Image: 8¼ x 6¼ in. (21 x 15.9 cm)
Maria Antoinette Evans Fund 32.458

Saddle

Central Europe (Tyrol), about 1430-60

This saddle is covered with large plaques of bone that are carved with images of Saint George and figures in courtly dress among scrolls, vines, and animals. A German inscription painted below the pommel reads Gedench Und Halt (Look Before You Leap, or literally, Think and Stop). The saddle is clearly a ceremonial object, probably related to some knightly order, but the carving is worn and most of the original paint is gone, indicating that the saddle may have been used, perhaps in parades. Only about twenty of these saddles have survived, all apparently made in what is now Austria and the Italian Tyrol; this one belonged to a noble Hungarian family from the early sixteenth century.

Bone over wood core, lined underneath with hide covered with birch bark; polychromy $14\,\%\,x\,21\,\%\,x\,14\,\%\,in.\,(36.2\,x\,54.6\,x\,37.1\,cm)$ Centennial Purchase Fund 69.944

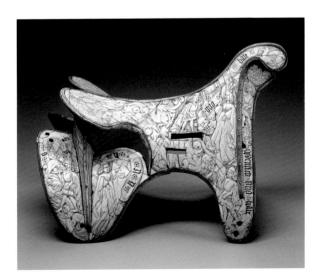

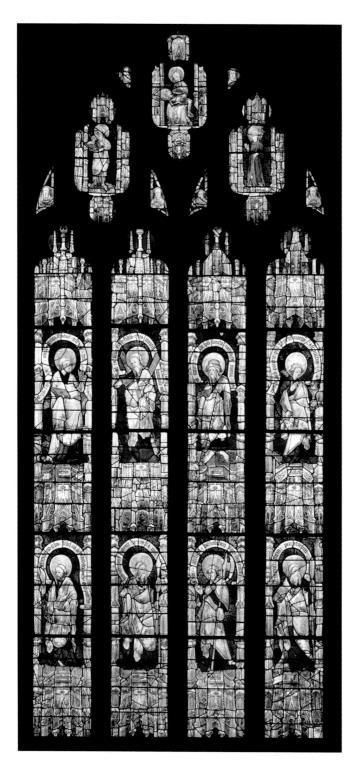

Window with eight Apostles and other saints

England, about 1420-35

This imposing stained glass window is one of the finest produced in England in the early fifteenth century. Possibly made for Hereford Cathedral, it was moved to the chapel at Hampton Court, in Herefordshire, and sold from there in 1924. Once part of a larger window, this portion depicts eight of the twelve Apostles, the original disciples of Jesus; all but one has his name inscribed on the dais below his feet. Above their heads are long scrolls with Latin inscriptions from the Apostles' Creed, a fundamental statement of Christian belief, A Pietà. John the Baptist, and Saint Francis are depicted in the three tracery lights (uppermost windows). The figures are softly modeled and delicately detailed, silhouetted against backgrounds of deep red and blue.

Pot-metal glass, flashed glass, and white glass with silver-oxide stain; modern limestone tracery 221½ x 103½ in. [563 x 263 cm] Maria Antoinette Evans Fund 25.213

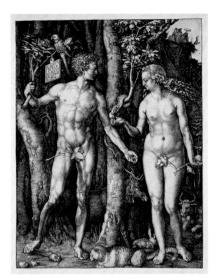

Albrecht Dürer German, 1471–1528 Adam and Eve, 1504

In the sixteenth century, prints increasingly were appreciated as works of art in their own right, and Dürer's engravings provided him with a considerable income. On one level, his Adam and Eve, produced shortly after his return from Italy, was intended to present the perfect human body as represented in the ideals of the Italian Renaissance. On another level, the image is dense with late-medieval symbolism. For example, the animals in the foreground represent characteristics of the four "humors"—melancholy (the elk), sensuality (the rabbit), cruelty (the cat), and sluggishness (the ox). It was believed that these "humors" had been in perfect equilibrium within the human body until Adam ate the forbidden fruit, Afterward, this balance was destroyed, and individual men and women were controlled by different "humors," resulting in defects of character and in sin, illness, and death.

Engraving
Platemark: 9% x 7% in. (25.1 x 19.4 cm)
Centennial Gift of Landon T. Clay 68.187

Narcissus

France or the Franco-Flemish territories, 1480-1520

In northern Europe, tapestries were prized and costly works of art. Used to decorate walls in both religious and secular spaces, large tapestries served much the same function as fresco paintings in Italy and Spain. This example shows Narcissus admiring himself in a fountain. According to myth, Narcissus angered the goddess Juno when he spurned the love of a nymph, Echo; as punishment, Juno made him fall helplessly in love with his own reflection, staring at it until he pined away. After his death, Narcissus was changed into the flower that bears his name. The story was particularly appropriate for tapestries like this one, called "millefleurs" because their backgrounds are densely strewn with flowers.

Wool and silk; tapestry weave 111 x 122½ in. [282 x 311 cm] Charles Potter Kling Fund 68.114

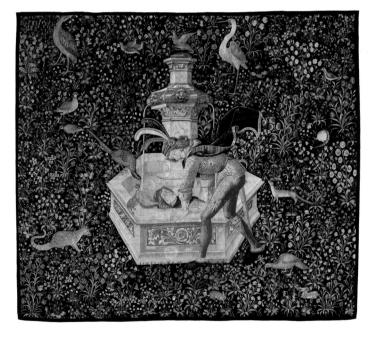

Unidentified artist

Flemish, 1475-1500

Martyrdom of Saint Hippolytus

In legend, Hippolytus was a Roman soldier who was present at the martyrdom of Saint Laurence and soon after converted to Christianity. Refusing to renounce his new faith, Hippolytus was condemned to be torn apart by horses. The explosive drama of this painting is heightened by two elements not usually found in representations of the subject: the men who whip the horses to pull still harder and the way the scene is

spread across all three panels, intensifying the viewer's experience of the saint's torment. The side panels of this large, exceptionally well-preserved altarpiece would have been opened or closed according to the liturgical cycle of the year; when the altarpiece is closed, these panels reveal figures of saints painted in grisaille (monochrome gray) to simulate sculpture.

Tempera and oil on panel 34½ x 99% in. [87.6 x 253.1 cm] Walter M. Cabot Fund 63.660

Appearance of the altarpiece with left and right panels closed

Rosso Fiorentino (Giovanni Battista di Jacopo)

Italian (Florence), 1494–1540

The Dead Christ with Angels,
about 1524–27

At once intensely spiritual and physical, this painting is one of few surviving works by Rosso Fiorentino, a major practitioner of the Mannerist style, characterized by the use of contrasting colors, ambiguous space, and sinuous, elongated figures. Most depictions of the dead Christ show him at the moment of being taken down from the cross or held by his grieving mother. Here, however, Christ's body—which seems strangely alive—is attended only by four adolescent angels.

A belligerent redhead from Florence, Rosso ("red" in Italian) painted this altarpiece for the bishop of the town of Borgo San Sepolcro. The picture's relatively small size and unusual depiction of a traditional subject suggest that it was intended for the bishop's private chapel. Rosso painted the altarpiece in Rome, and his profound admiration of Michelangelo's recently painted frescoes in the Sistine Chapel is evident in the colors of the angels' garments and in the idealized, muscular nude body of Christ.

Oil on panel 52½ x 41 in. [133.5 x 104.1 cm] Charles Potter Kling Fund 58.527

Carlo Crivelli Italian (Venice), born 1430-35, died about 1495 Lamentation over the Dead Christ, 1485

Crivelli spent his career along the Adriatic coast of Italy, away from his native Venice, and there developed a highly personal artistic style in which splendor of ornament is combined with intense emotion. In this painting, Christ's body is supported by the mourning figures of the Virgin, Mary Magdalene, and Saint John. Suffering is powerfully conveyed by the boldly foreshortened head of Saint John and the intertwined hands of Saint John and Christ, one tense with grief, the other rigid in death. At the same time, the illusionistic swag of fruits and vegetables and the profusion of tooled and embossed gold give this devo-

tional image the quality of a precious object. The shape of the painting and the implied point of view (well below the level of the figures) suggest that it once may have been the center of the upper tier of a large altarpiece.

Tempera on panel 34¾ x 20% in. [88.3 x 53 cm] Anonymous Gift and James Fund 02.4

Plate Italy (Urbino), about 1524 Nicola da Urbino, Italian, active by 1520, died in 1537-38

This plate is one of twenty-two surviving pieces of a splendid service made for Isabella d'Este, Marchioness of Mantua: it bears her coat

of arms in the center. In spite of being constantly short of money, Isabella was an ambitious patron of the arts with, as she admitted, an "insatiable desire" for ancient Greek and Roman art.

Tin-glazed earthenware, known as maiolica, was often decorated during this period with scenes from classical mythology. This plate features the exploits of the mythological Greek hero Perseus who beheaded the snake-haired gorgon Medusa (whose head he holds, at left) and rescued the princess Andromeda, chained to a rock by a monster. The composition is derived from a woodcut in a 1497 edition of Ovid's Metamorphoses.

Tin-glazed earthenware (maiolica) Diam. 10% in. (26.8 cm), h. 2 in. (5.1 cm) Otis Norcross Fund 41.105

Giuseppe Niccolò Rossigliani, called Vicentino
Italian, active about 1510-1550
Chronos (Allegory of Time)
After a drawing by Giovanni Antonio de Sachis,
called Il Pordenone, Italian, about 1484-1539

Chiaroscuro (light and dark) woodcuts are particularly effective for reproducing wash drawings as prints. In this technique, the artist cuts a separate block to print each different area of tone. The blocks are then printed in succession, one on top of the other, resulting in a print with far more tonal variations and sense of three-dimensional form than a traditional woodcut could achieve. First used in Germany, the technique was introduced to Italy by Ugo da Carpi (about 1479–1532); it was patented by the Senate of Venice in 1516 and copyrighted by the Vatican in Rome two years later.

Chiaroscuro woodcut printed from four blocks 12% x 17% in. [32.1 x 44.1 cm]

Bequest of W. G. Russell Allen 64.1111

Albrecht Dürer German, 1471–1528 Saint Jerome Seated near a Pollard Willow, 1512

In the fourth century A.D., Saint Jerome renounced his passion for ancient Greek and Latin literature in favor of the Bible and an ascetic, Christian life. He spent many years translating the Old and New Testaments into Latin, and Dürer shows him in a mood of intellectual and religious intensity, seated with his books in a harsh landscape. The lion sleeping at his feet became his lifelong companion after Saint Jerome pulled a thorn from the animal's paw.

Dürer excelled in the uncommon medium of drypoint, in which a sharp metal instrument is used to scratch lines directly into the copper plate from which the image will be printed. This process raises, along the incised line, a ragged edge of copper called burr that holds ink and thus gives softness and depth to the print's tonal range. Because the burr is very delicate and usually wears away after fewer than twenty printings of the plate, drypoint impressions of this superb quality are extremely rare.

Drypoint

Platemark: $8\% \times 7\%$ in. [20.8 x 18.5 cm] Anna Mitchell Richards Fund 37.1296

Lucas van Leyden Netherlandish, 1494-1533 Moses and the Israelites after the Miracle of Water from the Rock, 1527

Glue tempera on linen 71% x 93½ in. [181.9 x 237.5 cm] William K. Richardson Fund 54.1432 In the Old Testament, as Moses led the Israelites through the desert, they complained: "Why have you made us come up out of Egypt, to bring us to this evil place? It is no place for grain, or figs, or vines, or pomegranates; and there is no water to drink." Advised by God, Moses struck a rock with his staff, bringing forth a spring of water. This painting depicts the aftermath of the miracle, as the Israelites eagerly quench their thirst.

Like Albrecht Dürer, Lucas van Leyden is best known as a printmaker although he was also a painter of distinction. This dramatic composition is his only work painted in tempera on linen, instead of the more usual panel. Canvases of this large size may have been intended to decorate rooms as a less expensive alternative to woven tapestries.

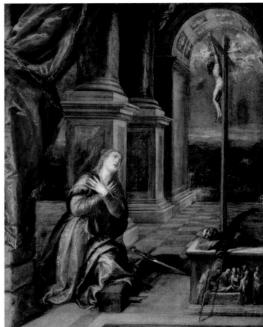

Lorenzo Lotto
Italian (Venice), about 1480–1556
Virgin and Child with Saints Jerome and Nicholas
of Tolentino, 1523–24

Vibrant colors and deep, atmospheric landscapes are hallmarks of the work of Lotto, a Venetian contemporary of Titian, who worked as both a portraitist and a religious painter. Here, in a characteristically clear and straightforward way, Lotto presents a visual statement of fundamental Christian beliefs. The table that supports both the Christ Child and his mother represents the altar. The small coffin beneath the Child foretells his death, as does the crucifix held by the weeping Saint Jerome. But the Child turns away from the cross and toward the lily that evokes both the Annunciation, when Mary learned she was to bear a child, and Christ's triumphant Resurrection after his death.

0il on canvas 37 ½ x 30 ½ in. (94.3 x 77.8 cm) Charles Potter Kling Fund 60.154

Titian (Tiziano Vecellio)
Italian (Venice), about 1488–1576
Saint Catherine of Alexandria at Prayer, about 1567

Titian, the greatest Venetian painter of the sixteenth century, brought new depth of emotion and an unrivaled sense of color to the Renaissance mastery of rationally depicted space. He painted this somber and meditative work—likely intended for private worship—when he was nearly eighty years old. Within a splendid architectural interior, Saint Catherine of Alexandria kneels reverently before a crucifix. More frequently portrayed in her symbolic marriage to Christ, the saint is shown here with the attributes of her martyrdom—a piece of the spiked wheel (broken by divine intervention) on which she was to be executed and the sword that eventually beheaded her. The painting's flickering light, muted color, and uneven brushwork are typical of Titian's late work.

Oil on canvas $46\% \times 39\% \text{ in. } (119.2 \times 100 \text{ cm})$ $1948 \text{ Fund and Otis Norcross Fund} \quad 48.499$

Born on the Greek island of Crete. Domenikos Theotokopoulos spent most of his career in Spain where he became known as El Greco, the Greek. Celebrated for religious subjects painted in a passionate, strikingly individual style, El Greco was also a portraitist who looked beyond likeness to probe his sitter's inner life. The brilliant young man depicted here—a close friend of the artist—was a monk of the Trinitarian Order, a poet much influenced by Luis de Góngora (see page 192, and a professor of rhetoric. Paravicino loved this portrait and wrote El Greco a sonnet praising it. The poem begins:

> O Greek divine! We wonder not that in thy works The imagery surpasses actual being But rather that, while thou art spared, the life that's due

Unto thy brush should e'er withdraw to Heaven The sun does not reflect his rays in his own sphere As brightly as thy canvases.

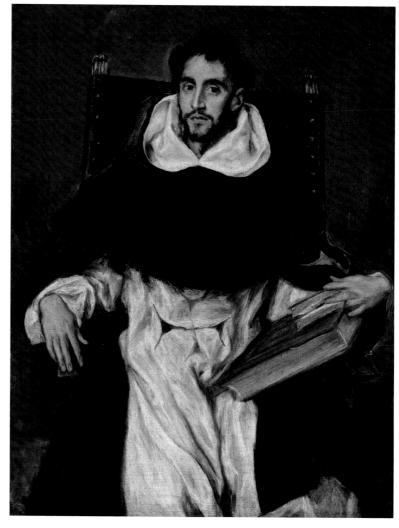

In later years, Paravicino became preacher to the king and the most celebrated orator of his time. The painting's restrained color range and its focus on Paravicino's dark eyes, sensitive mouth, and long fingers are compelling; the swift, broad brushstrokes give the portrait vitality and immediacy.

Oil on canvas 44 % x 33 % in. [112 x 86.1 cm] Isaac Sweetser Fund 04.234

Sofonisba Anguissola Italian, about 1532–1625 Self-Portrait, about 1556

Sofonisba Anguissola was one of six sisters, all painters, from a wealthy Italian family. Because women were not permitted to study anatomy or draw from live, nude models, the sisters were inadequately trained to attempt complex religious or historical compositions. Therefore, they primarily painted portraits, including many of each other and themselves.

The art historian Giorgio Vasari wrote that Anguissola "has shown greater application and better grace than any other woman of our age in her endeavors at drawing . . . [and] by herself has created rare and very beautiful paintings." In this miniature self-portrait, the artist holds a medallion inscribed in Latin around the rim: "The maiden Sofonisba Anguissola, depicted by her own hand, from a mirror, at Cremona." Inside the circle is a cryptogram whose entwined letters are included in the name of Anguissola's father, Amilcare, also a painter. The full meaning and original purpose of this enigmatic portrait remain a mystery.

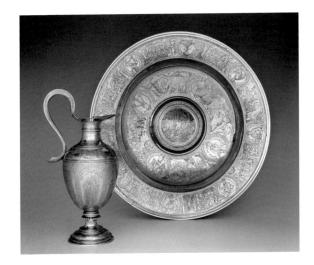

Ewer and basin
England (London), 1567-68
Maker's mark: a pick or scythe;
monograms of engraver: P over M

The lavish display of valuable objects on a sideboard near the dining table was central to social and ceremonial events in the courts of Europe. On occasion, this ewer and basin may also have been passed around the table with scented water for washing hands. The set stands out among silver of the Tudor period for the quality of its engraved decoration. Finely detailed scenes from the Old Testament are interspersed with portraits of every English sovereign from William the Conqueror to Elizabeth I, suggesting that the set may have been commissioned as a gift to or from Queen Elizabeth herself.

Silver, parcel gilt

Ewer: 13 ½ x 4 ½ in. (33.8 x 10.9 cm) Basin: 2 ½ x 19 ¾ in. (5.4 x 50 cm)

John H. and Ernestine A. Payne Fund, Theodora Wilbour Fund in memory of Charlotte Beebe Wilbour and funds by exchange from an Anonymous gift in memory of Charlotte Beebe Wilbour [1833–1914], Bequest of Frank Brewer Bemis, the M. and M. Karolik Collection of 18th-century American Arts, Gift of G. Churchill Francis, Gift of the Trustees of Reservation, Estate of Mrs. John Gardner Coolidge, Gift of Phillips Ketchum in memory of John R. Macomber, Gift of Mrs. Richard Cary Curtis, Gift in memory of Dr. William Hewson Baltzell by his wife, Alice Cheney Baltzell, Gift of Mrs. and Mrs. Richard Storey in memory of Mr. Richard Cutts Storey, Gift of Mrs. John B. Sullivan, Jr., Gift of Mrs. Heath-Jones, Bequest of Charles Hitchcock Tyler, Gift of Miss Caroline M. Dalton, Bequest of Clara Bennett, Maria Antoinette Evans Fund, Gift of Miss E. E. P. Holland 1979.261–262

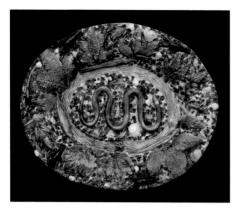

Oval dish France, 1570-85 Attributed to Bernard Palissy, French, about 1510-about 1590

Originally a stained-glass painter, Palissy turned to ceramics, experimenting to create naturalistic glazes that would not, as he wrote, "appear to involve any appearance or form of the art of sculpture, nor any labor of the hand of man." He made molds of actual animals and plants for such dishes as this one, preserving their intricate details through the use of translucent glazes in their natural colors. Here, casts of a snake, shells, fish, frogs, lizards, crayfish, and leaves are artfully assembled into a composition that is both richly decorative and almost disconcertingly realistic. Palissy was also a geologist and a philosopher. As a Protestant in Catholic France, he was arrested for heresy in 1588 and imprisoned in the Bastille, where he died.

Lead-glazed earthenware L. 22 in. (56 cm) Arthur Mason Knapp Fund and Anonymous gift 60.8

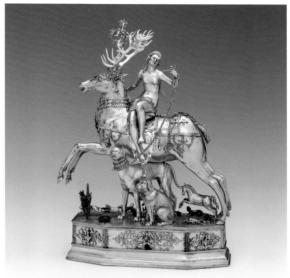

Diana and Stag automaton Germany (Augsburg), about 1610-20 Marked by Joachim Fries

Intricate silver automata were among the most marvelous works of art in Kunstkammers, German princely collections of artistic and natural wonders. Craftsmen in the city of Augsburg, a major European artistic center, specialized in objects for courtly Trinkspiele (drinking games). This superbly made figure represents Diana, classical goddess of the hunt, riding on a leaping stag. The base contains a mechanism that, when wound with a key, moved the piece across the banquet table on concealed wheels. The gentleman near whom it stopped removed the stag's head and drank the wine that filled the hollow body. If the closest diner was a lady, she drank from the body of the largest dog. This automaton unusual in that its movements have survived—may have been a tournament prize at the celebrations accompanying the coronation, in 1612, of Holy Roman Emperor Matthias.

Cast-and-chased silver, partially gilded H. 13 in. [33 cm]

Museum purchase with funds donated anonymously and the William Francis Warden Fund, Frank B. Bemis Fund, Mary S. and Edward J. Holmes Fund, John Lowell Gardner Fund, and by exchange from the Bequest of William A. Coolidge 2004.568

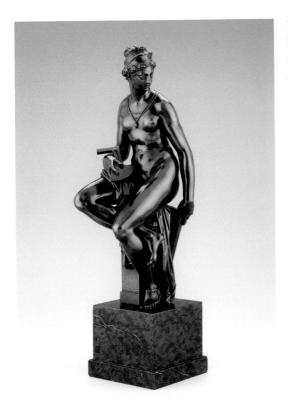

Giambologna (Jean Boulogne)
Flemish (worked in Italy), 1529-1608
Architecture, about 1600

Born in Flanders, Giambologna traveled to Italy to study sculpture and remained there for the rest of his life. By the early 1560s he was employed by the Medici grand dukes in Florence, and he soon became admired as the foremost sculptor in Europe. His bronze statuettes were sometimes offered as prestigious diplomatic gifts and became part of many important collections, including that of Emperor Rudolph II, who owned almost thirty nudes.

This beautifully finished figure, which still bears traces of its original translucent red lacquer, was inspired by ancient Greek and Roman bronzes. Compared to classical examples, however, this sculpture exhibits greater complexity and sense of movement in

the graceful bends and turns of body and limbs. The figure, who personifies Architecture, holds a framing square, protractor, and compass. This cast is distinguished by the artist's signature, which appears on the drawing board behind her.

Bronze; marble base 17% x 4% x 6 in. [45.1 x 12.1 x 15.2 cm] Maria Antoinette Evans Fund and 1931 Purchase Fund 40.23

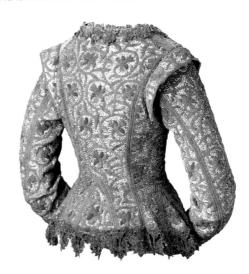

Woman's jacket England, about 1610-15 with later alterations

The stylized daffodils (or "daffadillies," as they were called) exquisitely embroidered on this jacket reflect Elizabethan England's love of botany and gardening. According to family tradition, the jacket was given by Queen Elizabeth I to a member of the Wodehouse family, following a royal visit to their estate in 1578. However, the style of the embroidery and the cut of the jacket indicate that it was made at least thirty years later.

Linen; plain weave embroidered with silk, metallic threads, and spangles

H. 17 in. (43 cm)

The Elizabeth Day McCormick Collection 43.243

Clock

Germany (Augsburg), about 1625-50

A specialty of Augsburg, elaborate clocks like this were prized as sophisticated mechanical devices and as metaphors of cosmological organization and discipline. The astronomer Johannes Kepler wrote: "My goal is to show that the celestial machine is not like a divine being but like a clock."

The body of this German clock revolves upon its base, so that either side can be brought to the front. The face shown here is astronomical, indicating the position of the sun, moon, and planets and the "Twelve Houses of Heaven" that astrologers used to cast horoscopes. On the other side of the clock, the disks and dials show—among other things—the time, the days and months, and the signs of the zodiac. Two overlapping disks, whose relationship changes with the seasons, record the relative hours of day and night.

Gilded bronze and brass, enameled silver 21% x 9% x 12% in. [54 x 23.7 x 31.4 cm] Lina Franck Hecht Fund 22.395

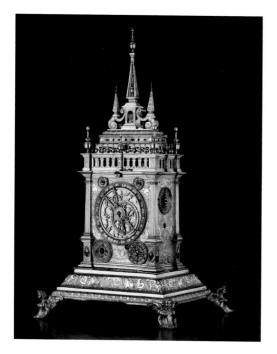

Hercules Segers

Dutch, 1589/90-about 1638

Rocky Landscape with Church Tower
in the Distance, 1610-20

Segers's etchings are remarkable for their experimental use of color and innovative combinations of techniques. Rocky Landscape, for example, was printed with blue ink on paper prepared with a pink ground; after printing, the image was washed over with olivegreen pigment. At a time when artists often made several hundred identical impressions from a single etched plate, each of Segers's prints is a unique work of art. Not even Rembrandt—who greatly admired Segers's work—employed so many techniques in such unprecedented ways. Etched with tangled, snaking lines, Segers's landscapes are haunting and otherworldly. The contemporary painter and theorist Samuel van Hoogstraten wrote that Segers was "pregnant with whole provinces, which he gave birth to in immeasurable spaces."

Etching and drypoint

Platemark: 5% x 7% in. (13.3 x 18.7 cm)

Kate D. Griswold Fund, Ernest Wadsworth Longfellow Fund, Gift of Jessie H. Wilkinson-Jessie H. Wilkinson Fund, Katherine E. Bullard Fund in memory of Francis Bullard, and M. and M. Karolik Funds 1973 208

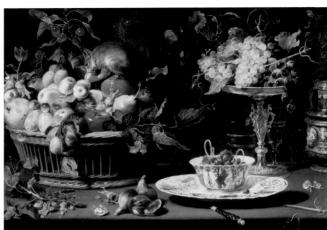

Jacques Bellange French (active in Lorraine), active 1595-1616 The Three Women at the Tomb, about 1613

The New Testament's Gospel of Saint Mark describes three female followers of Christ who came, the day after his Crucifixion, to the cave where his body had been placed. There, the women found only an empty tomb and an angel who told them that Christ had risen from the dead. Bellange's depiction of this event (including another appearance of the three women entering the cave at upper left) is wonderfully artificial and theatrical with its dramatic light effects and unsettling, tilted space. The attenuated figures, posed like modern-day fashion models with affected gestures and sweeping gowns, are characteristic of Bellange's style, which was much appreciated by the worldly dukes of Lorraine, for whom he also painted religious subjects and portraits. Working at a time when few French painters were making prints, Bellange's mastery of etching is particularly notable.

Etching and engraving
Platemark: 17½ x 11½ in. (44.1 x 28.8 cm)
Otis Norcross Fund 40.119

Frans Snyders Flemish, 1579–1657 Still Life with Fruit, Wan-Li Porcelain, and Squirrel, 1616

A successful artist in Antwerp, Snyders specialized in intricate compositions that display a wonderful sensitivity to color, texture, and light. Here, in one of his most elaborate still lifes, Snyders celebrated lovely creations of nature and man—a nibbling squirrel, the rounded shapes of many fruits, a precious Mingdynasty Chinese porcelain cup, a gold dish on a high foot, and a ceramic jug. The alternatingly soft and shiny fruit and the knife handle projecting convincingly into the viewer's space emphasize the illusionistic perfection of Snyders's technique. The artist painted this work on copper, an extremely costly support, and the painting's coloristic brilliance and meticulous, barely discernible brushwork are enhanced by its hard, smooth surface.

Oil on copper 22 x 38% in. (56 x 84 cm) M. and M. Karolik Fund and Frank Brewer Bemis Fund 1993.566

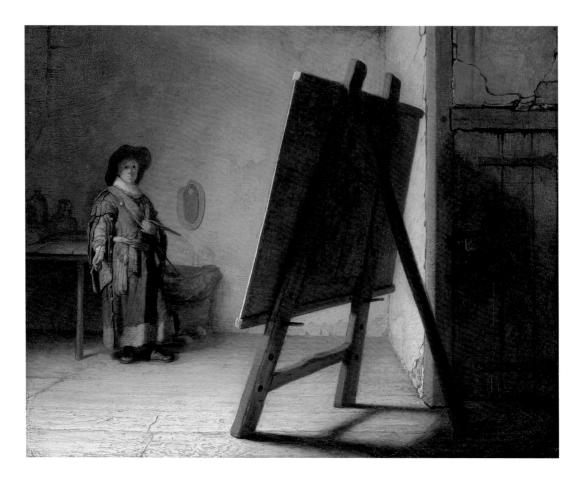

Rembrandt Harmensz. van Rijn Dutch, 1606-1669 Artist in His Studio, 1628

Within the cracked plaster walls of his modest studio, an artist holds his brushes and the mahlstick he will use to steady his hand as he paints. Beside him are his palette and a stone for grinding pigments. The easel's worn rung suggests that the artist sits when he paints, resting his foot, but here he stands back, readying himself. The drama is one of thought rather than action, and it is intensified by contrasts of light and shadow and by bold juxtapositions of near and far. The painter is dwarfed by his canvas—a darkened, looming object that appears to challenge, even threaten him. This moving image transcends visual reality to explore the daunting experience of artistic creation. It is not about painting itself but about when, where, and how to begin.

Oil on panel 9³/₄ x 12¹/₂ in. [24.8 x 31.7 cm] Zoe Oliver Sherman Collection given in memory of Lillie Oliver Poor 38.1838

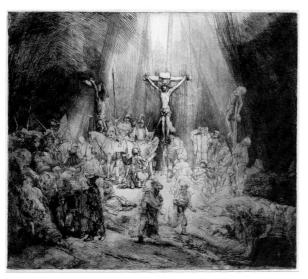

Rembrandt Harmensz. van Rijn Dutch, 1606-1669 Christ Crucified (The Three Crosses), 1653

Rembrandt was one of the greatest printmakers of all time, and his hundreds of prints reflect his endless struggle to find new forms of graphic expression. This scene of anguish and confusion, executed in the fragile medium of drypoint, shows his bold experimentation. It illustrates the moment when, according to the biblical account, "There was a darkness over all the earth. . . . And when Jesus had cried with a loud voice, he said, Father, into thy hands I commend my spirit." Before printing the image, Rembrandt shrouded much of the copper plate with a heavy veil of ink that would print as an almost impenetrable darkness. He then wiped the central area so that Christ appears to be illuminated by a great cone of supernatural light.

Drypoint

Platemark: 15% x 17% in. (38.5 x 45 cm)

Katherine E. Bullard Fund in memory of Francis Bullard and

Bequest of Mrs. Russell W. Baker 1977.747

Rembrandt Harmensz. van Rijn

Dutch, 1606-1669

Sleeping Watchdog, about 1638

In his paintings and prints, Rembrandt brilliantly delved into the depths and complexities of human experience. In this drawing (on which he later apparently based a small etching), the artist records a much more humble subject with the same sureness and sensitivity to the potential of a few swift lines and a wash of color.

Pen and brown ink with brush and brown wash on paper

5% x 6% in. [14.3 x 16.8 cm]

John H. and Ernestine A. Payne Fund 56.519

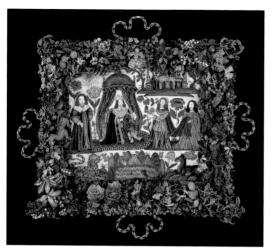

Whimsical baskets such as this, composed of beads threaded on wire and embroidered on silk, were the prized handiwork of amateur needleworkers. Most likely presented as gifts at weddings and christenings, they imitate silver baskets, such as the one illustrated at right, made to display a child's clothes before a christening. On this basket, the figures may depict England's king Charles II and his queen, Catherine of Braganza. However, biblical figures were often shown in contemporary dress on English needlework of this period, and the figures may represent King Solomon and the queen of Sheba.

Wire, silk, wood; embroidered with silk, glass beads, seed pearls, and feathers; raised work L. 25 in. [63 cm] The Elizabeth Day McCormick Collection 43.530

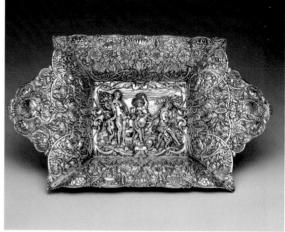

Layette basket The Netherlands (The Hague), 1666-67 Marked by Adrien van Hoecke, Dutch, 1635-1716

Layette baskets such as this one—uniquely Dutch in form—were intended for the ceremonial presentation of an infant's christening garments. This opulent silver example, one of only five known today, is enriched by exquisite and varied floral decoration on the sides and handles. The central scene depicts Venus, goddess of love, accepting gifts of wine and fruit from Bacchus, god of wine, and Ceres, goddess of agriculture. An outstanding example of seventeenth-century Dutch silver, the basket is worked in the embossed or repoussé technique. The decoration was first shaped by hammering from the back, and the ornament was then chased—defined and finished on the front with hammers and punchers—to achieve surface textures and decoration without removing any metal.

Silver 28% x 17 x 5 in. [72 x 42.1 x 12.8 cm] John H. and Ernestine A. Payne Fund 1982,617

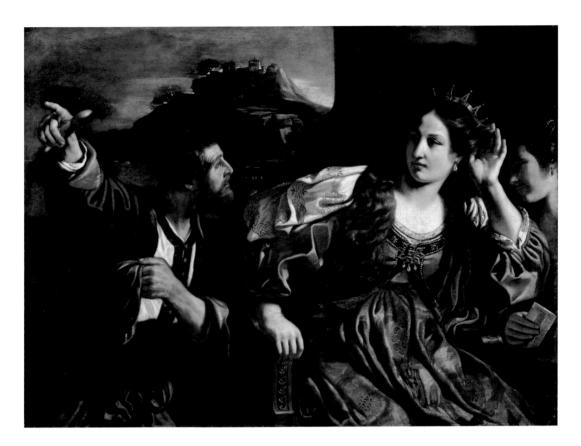

Guercino (Giovanni Francesco Barbieri) Italian (Bologna), 1591-1666

Semiramis Receiving Word of the Revolt of Babylon, 1624

Oil on canvas $44\,\%\,x\,60\,\%\,in,\,[112.5\,x\,154.4\,cm]$ Francis Welch Fund $\,48.1028$

Interrupted at her toilette by a messenger bringing news of a revolt, Semiramis, the legendary queen of Babylon, quelled the uprising with a single command and then coolly returned to combing her hair. In Guercino's theatrical rendering of the story, the figures appear like actors on a shallow stage, with the maid, holding a comb, boldly cropped at one side. Gestures are exaggerated and emphatic, particularly that of the messenger, who seems to reach out of the painting into the viewer's space. Giovanni Francesco Barbieri (nicknamed Guercino because of his squint) was greatly admired by his contemporaries. This painting, once owned by King Charles II, was a gift from the Dutch state in 1660 on the occasion of his restoration to the English throne after the Civil War and subsequent period of parliamentary rule.

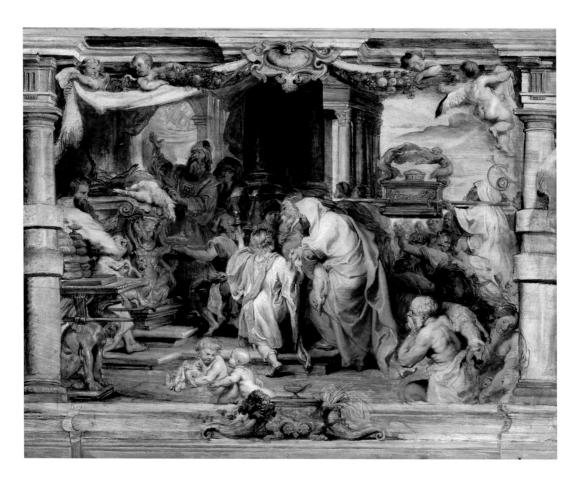

Peter Paul Rubens

Flemish, 1577-1640

The Sacrifice of the Old Covenant, about 1626

Oil on panel 27³/₄ x 34 ½ in. [70.8 x 87.6 cm] Gift of William A. Coolidge 1985.839 Courtier, diplomat, and among the foremost artists of his age, Rubens painted this fresh and vibrant oil sketch as a design for a tapestry in a cycle known as the Triumph of the Eucharist. Commissioned by a daughter of Spain's King Philip II for a convent in Madrid, the tapestries were woven in Brussels and remain in the convent today. On the left, an Old Testament priest sacrifices a lamb in a ceremony foreshadowing the sacrifice of Christ that is commemorated in the Christian sacrament of the Eucharist, or Holy Communion. The cornucopias of wheat and grapes in the foreground allude to the bread and wine of that sacrament. Delighting in pictorial illusionism, Rubens painted the scene as if it were a tapestry held up by cherubs, so that the final, woven version would suggest a tapestry within a tapestry.

Georg Petel

German, about 1601-1634

The Three Graces, about 1624

Most of Petel's brief career as a sculptor was centered in Augsburg, Germany, where he died of the plague in his early thirties. His work was strongly influenced by the paintings of Rubens, whom he first met on a trip to Flanders about 1620. Several of Petel's sculptures, including this one, translate paintings by Rubens into three dimensions. According to Calepinus, an Italian cleric writing in 1502, the Three Graces of classical antiquity represented freshness, gladness, and delight. Calepinus described them as always depicted young, cheerful, and nude "to show that kindness should be open and frank," and with their bodies intertwined in "a perpetual link of friendship." As in Rubens's painting (now in the Vienna Academy Museum), which Petel saw during a visit to Antwerp in 1624, this group originally supported a basket of flowers or fruit.

Gilded bronze $12 \times 7 \% \times 2 \text{ in. } (30.5 \times 19.1 \times 5.1 \text{ cm})$ Gift of John Goelet in honor of Hanns Swarzenski 1976.842

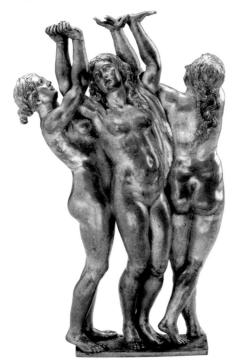

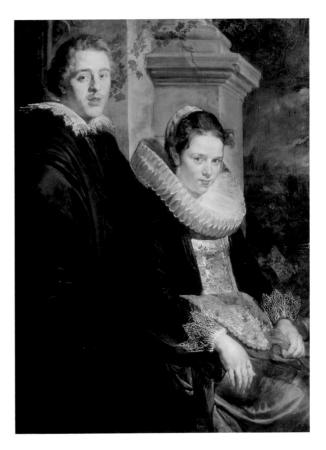

Jacob Jordaens

Flemish, 1593-1678

Portrait of a Young Married Couple, about 1621-22

Jordaens, a prolific painter and printmaker, worked for a time in the studio of Rubens, and after Rubens's death he became the leading painter of Antwerp.

Although the couple in this portrait remains unidentified, Jordaens's sitters were primarily members of Antwerp's prosperous middle class, and both husband and wife are handsomely and expensively dressed. Some details may have a symbolic significance, such as the ivy, an emblem of love and fidelity, that climbs over a broken column, a symbol of fortitude in adversity.

Oil on panel 49 x 36% in. (124.5 x 92.4 cm) Robert Dawson Evans Collection 17.3232

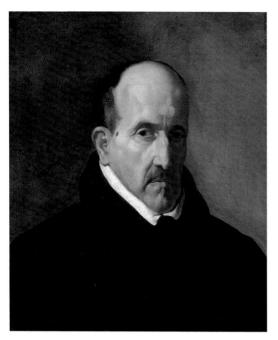

Diego Rodríguez de Silva y Velázquez Spanish, 1599-1660 Luis de Góngora y Argote, 1622

One of Velázquez's most incisive psychological studies, this portrait was painted during the artist's first trip to the court in Madrid. It was commissioned by Velázquez's teacher and father-in-law, who wanted it as a model for his own series of paintings of celebrated writers. Góngora is now considered among Spain's leading poets, but in his lifetime, although his light verse was much appreciated, his serious poetry was considered obscure and pedantic. When Velázquez painted him, the poet was sixty years old and in frail health, embittered by his long years and lack of recognition at court. This acclaimed portrait may well have led to Velázquez's appointment as a court painter at the age of twenty-four.

Oil on canvas 19% x 16 in. (50.3 x 40.5 cm) Maria Antoinette Evans Fund 32.79

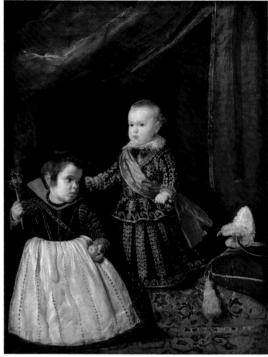

Diego Rodríguez de Silva y Velázquez Spanish, 1599-1660 Don Baltasar Carlos with a Dwarf, 1632

Born in 1629, Baltasar Carlos was the first son of King Philip IV. This portrait, at once majestic and tender, may commemorate the ceremony in which the nobility swore allegiance to the two-year-old prince as heir to the throne. The baby is dressed as he was at that ceremony, with the sash, sword, and baton of command. The lively pose of one of the dwarfs employed as companions to royal children provides a foil to the regal immobility of the very young prince. The dwarf holds an apple and a rattle, trifles that may allude playfully to the orb and scepter that Baltasar Carlos would wield as king of Spain (in fact, the prince died at the age of seventeen without succeeding to the throne).

Oil on canvas $50\% \times 40\% \text{ in. } [128.1 \times 102 \text{ cm}]$ Henry Lillie Pierce Fund 01.104

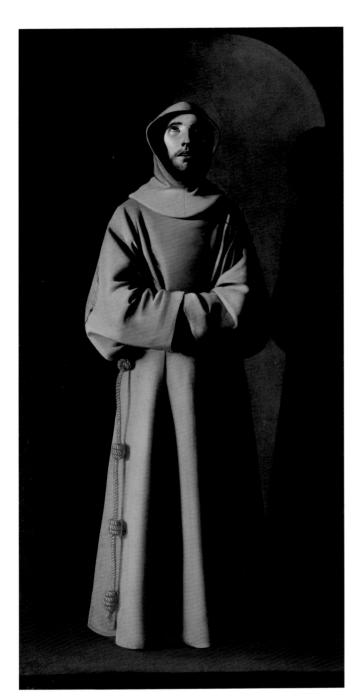

Francisco de Zurbarán Spanish, 1598-1664 Saint Francis, about 1640-45

Zurbarán was renowned as a painter of austere religious images for churches and monasteries throughout Spain. Muted colors, rigorously simple compositions, and theatrical lighting give the artist's sacred figures an almost mystical presence. This painting, which may have been painted as one of a set of four portraits of founders of religious orders, apparently illustrates a ghostly legend invented to promote a belief that the body of Saint Francis had never decomposed. According to the story, in 1449 Pope Nicholas V visited the church where Saint Francis had been buried for more than two hundred years. There, in the darkness of the crypt, the pope saint, standing in a shallow niche and showing no sign of decomposition. Zurbarán captures the moment when the pope first saw the body, illuminated by torchlight that throws an eerie shadow on the wall.

0il on canvas $81\% \ x \ 42 \ in. \ [207 \ x \ 106.7 \ cm]$ Herbert James Pratt Fund 38.1617

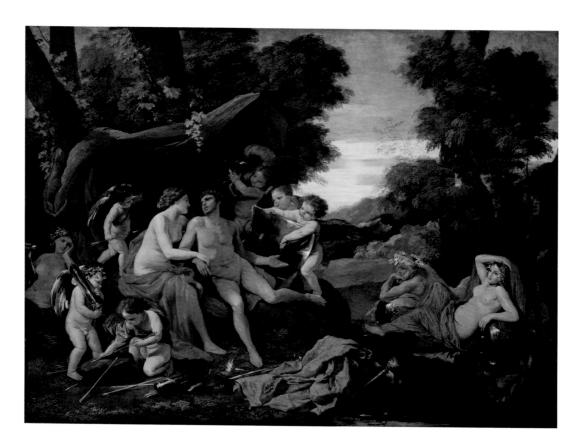

Nicolas Poussin

French (active in Rome), 1594-1665 Mars and Venus, about 1630

Oil on canvas 61 x 84 in. [155 x 213.5 cm] Augustus Hemenway Fund and Arthur William Wheelwright Fund 40.89

Although he spent most of his career in Rome, the French artist Poussin's intellectual, idealizing style influenced the course of painting in his native land for three hundred years. This allegory of the triumph of Love over War shows Mars, god of war, enraptured by Venus, goddess of love, while her attendant cherubs make playthings of his weapons and armor. Intended for a circle of erudite collectors and connoisseurs in Rome, Poussin's paintings were inspired by the art and literature of classical antiquity and the Renaissance. Mars and Venus was based on a passage from the ancient Roman poet Lucretius, and many elements of the composition derive from an antique sarcophagus relief. However, in its warm color, harmonious landscape, and sensuous mood, the painting also demonstrates Poussin's early admiration for Titian and other Venetian painters of the Renaissance.

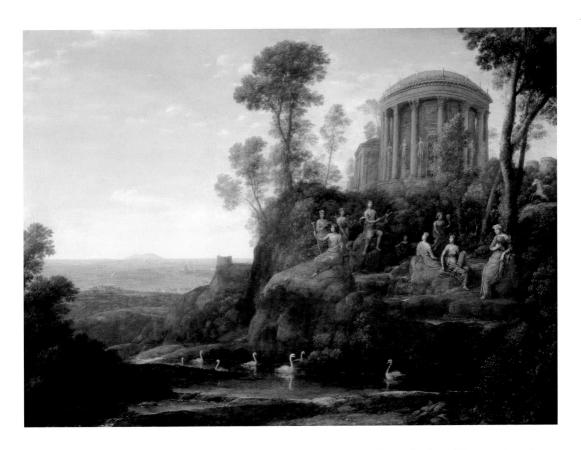

Claude Lorrain (Claude Gellée) French (active in Rome), about 1600-1682 Apollo and the Muses on Mount Helicon, 1680

0il on canvas 39½ x 53¾ in. (99.7 x 136.5 cm) Picture Fund 12.1050 Claude Lorrain, born Claude Gellée in the Lorraine region of France, lived (like Poussin) most of his life in Rome, painting the countryside—redolent with associations of classical antiquity—around the city and along the Bay of Naples. Painted when the artist was almost eighty, this work represents Apollo, god of poetry and music, surrounded by the nine Muses, embodiments of the arts. At the upper right, the winged horse Pegasus has dislodged a rock, thus releasing the waters of Hippocrene, the fountain of the Muses and the source of artistic inspiration.

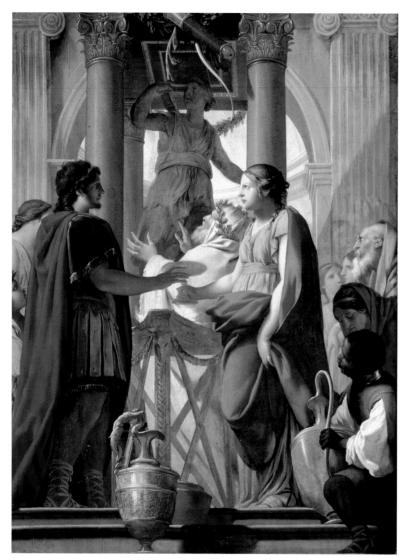

Eustache Le Sueur French, 1616-1655 Camma Offers the Poisoned Wedding Cup to Synorix in the Temple of Diana, about 1644

The ancient world also provided ideas and subjects for works of art in more modern styles. The painting of Camma and Synorix looks nothing like any surviving work of classical art, but the Greek writer Plutarch (about 46-120 A.D.) provided the artist with this story of love, murder, and revenge. The climax of the tragedy takes place in a temple of Diana, goddess of the hunt: in the interest of authenticity, Le Sueur included a depiction of an ancient sculpture of Diana then housed in the Louvre.

Oil on canvas 67% x 49½ in. [171.8 x 125.7 cm] M. Theresa B. Hopkins Fund 48.16

Pietro da Cortona
Italian (Rome), 1596-1669
Landscape with the Construction of a
Classical Temple, 1630s

Cortona—ranked with Gian Lorenzo Bernini and Francesco Borromini as one of the most important artists of the Roman Baroque—was a leading painter of frescoes. He also was an architect, an interest evident in the building that rises in this large and accomplished work. An early drawing, this is the first major Cortona landscape to enter an American public collection. Using tightly arranged pen lines and very loose strokes of wash applied with a brush, Cortona conjured an idealized vision of antiquity, balancing the skilled work of man against the voluminous, light-filled hillside and dramatic, cloudy sky. The drawing's exuberance and virtuosity make it a touchstone for understanding the art of seventeenth-century Italy.

Pen and brown ink with brush and brown wash, over black chalk on paper $8\% \ x \ 16\% \ in. \ [22.5 \ x \ 41.9 \ cm]$ Charles Potter Kling Fund 2000.996

Pier Jacopo Alari Bonacolsi, called Antico Italian (Mantua), about 1460–1528 Bust of Cleopatra, about 1519–22

The Roman Empire fell but never disappeared. The languages, literature, art, and architecture of the ancient world have provided Europe with models—to be imitated or rejected-for the last fifteen hundred years. Latin remained the language of religion and intellectual life through the Middle Ages, and in the fifteenth and sixteenth centuries, a wild enthusiasm for antiquities encouraged the close study and copying of Roman art. The bust of Cleopatra, commissioned by Isabella d'Este (see page 176), is by a sculptor who became so skilled at capturing the spirit of ancient art that his contemporaries gave him the nickname "Antico."

Bronze, with traces of gilding
H. 25% in. (64.5 cm)
William Francis Warden Fund 64.2174

Anthony van Dyck

Flemish, 1599-1641

Princess Mary, Daughter of Charles I, about 1637

This portrait of Mary, Princess Royal (the daughter, sister, and eventually mother of kings of England), was probably a gift to her bridegroom, the Dutch prince William of Orange, on the occasion of their marriage in 1641. Poised beyond her years, ten-yearold Mary is richly dressed, her gown densely ornamented with embroidery and lace, although still with her child's leading strings hanging down behind.

Described by Peter Paul Rubens as "the best of my pupils," van Dyck was in the service of James I of England by the age of twenty and later became court painter to James's son and Mary's father, King Charles I. He produced a series of portraits of the king, his family, and the court that are of almost unparalleled elegance and distinction.

Oil on canvas 52 x 41% in. [132.1 x 106.3 cm] Given in memory of Governor Alvan T. Fuller by the Fuller Foundation 61.391

Jan Havicksz. Steen
Dutch, 1626–1679
Twelfth-Night Feast, 1662

Twelfth Night, the sixth of January, was the day when the three kings, led by a star, are believed to have arrived in Bethlehem to honor the birth of Jesus. Although the celebration of this and other Catholic holidays was condemned in the Protestant Netherlands, many people continued to observe it at home with festive gatherings. Steen was a gifted and lively storyteller, and this painting, originally owned by a

Catholic family in Leiden, is crowded with convivial detail. A baby (wearing a paper crown) has been chosen by lottery to be king. Children play a jumping game over candles symbolizing the three kings, and in the background, a servant greets the "star singers" who traveled from house to house. The revelers are individualized and yet drawn together by the light (whose source we do not see) emerging from the table.

Oil on canvas 51% x 64% in. [131.1 x 164.5 cm] 1951 Purchase Fund 54.102

Glove England, early 17th century Leather, embroidered with silk, metallic threads, and spangles; metallic bobbin lace H. 15 in. [38 cm] Gift of Philip Lehman in memory of his wife Carrie L. Lehman 38.1356a-b Glove Italy, late 17th century Linen bobbin lace with silk ribbons H. 15 in. (38 cm) Gift of Philip Lehman in memory of his wife Carrie L. Lehman 38.1271

Dish England (Staffordshire), 1670-75

The provincial potteries of Staffordshire grew dramatically in the late seventeenth century and eventually became famous throughout Europe and beyond for the production of lead-glazed earthenware. The finest seventeenth-century Staffordshire wares were decorated with slip (clay diluted to a creamy consistency) and then covered with a lead-based glaze and fired. Although most slipware was utilitarian, such elaborately decorated examples as this one were made for special occasions births, betrothals, and weddings. The royal figure with the letters C and R flanking his crown represents England's King Charles II, whose restoration to the throne in 1660 was commemorated in many of the decorative arts.

Lead-glazed, slip-decorated earthenware Diam. 14 in. [35.6 cm] Gift of Dr. and Mrs. Lloyd E. Hawes 1986.974

An Italian visitor to London in 1618 observed: "The fashion of gloves is so universal that even the porters wear them very ostentatiously." Indeed, throughout Europe, delicate lace or splendidly decorated leather gloves (sometimes perfumed at extra expense) were a mark of wealth and style and frequently presented as prestigious gifts. Most gloves were made in one size, and the extremely long fingers reflect fashion more than the actual size of the wearer's hands. Although these gloves show signs of occasional use, the fact that they have survived is evidence of the esteem in which they were held.

Direk van Baburen Dutch, born 1590–1595, died 1624 *The Procuress*, 1622

The city of Utrecht was the center of Catholic life in the otherwise Protestant Dutch republic, and Baburen was one of a group of Utrecht painters who, unlike most of their Dutch contemporaries, had studied in Catholic Rome. Influenced by the Italian master Caravaggio, these artists specialized in painting large half-length figures, brought close to the picture surface and solidly modeled in strongly contrasting light and shadow. In this spirited image of mercenary love,

an amorous client bargains with a procuress (one who solicits clients for a prostitute) for the favors of a voluptuous young woman. The figures' colorful costumes, so different from the modest black-and-white dress favored by respectable burghers of Utrecht, suggest street entertainers or characters in a play. A lute, symbol of love, occupies the center of the composition and the gestures of the hands that surround it tell the painting's story.

Oil on canvas 40 x 42% in. (101.5 x 107.6 cm) M. Theresa B. Hopkins Fund 50.2721

Jacob Isaacksz. van Ruisdael Dutch, 1628 or 1629-1682 View of Alkmaar. about 1670-75

Early Northern landscape painting generally had as its subject either imaginary views or picturesque scenes of Italy and other foreign lands. But seventeenth-century Dutch artists invented a new form of landscape painting that captured without embellishment. the low horizons and expansive skies of their native country. Understood as proud emblems of

View of Alkmaar is dominated by a vast, cloud-filled sky that patterns the countryside below with sun and shadow. Although modest in size, the painting's effect is monumental.

Oil on canvas 17½ x 17½ in. [44.4 x 43.4 cm] Ernest Wadsworth Longfellow Fund 39.794

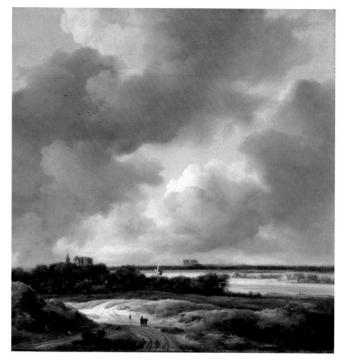

facing page, left

Jan van Huysum

Dutch, 1682-1749

Vase of Flowers in a Niche, about 1732-36

Although flowers had traditionally enlivened portraits and other paintings, Dutch artists of the seventeenth century developed the independent flowerpiece. This speciality later reached its peak in van Huysum's exuberant paintings, which are unsurpassed in their illusionism and dazzling color. Although apparently real, this composition is of an imaginary bouquet, combining flowers that bloom in different seasons. Yet, to the delight of the botanist and gardener alike, each blossom is a faithful record of a living specimen, some of which were much sought after, including the

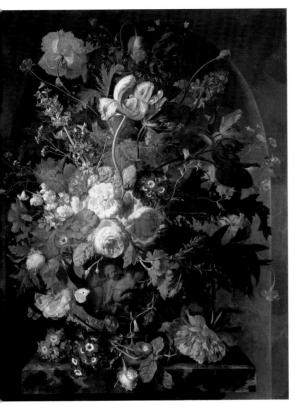

Cistern and fountain
England (London), about 1708-9
Marked by David Willaume I, British, 1658-about 1741

Almost six feet tall, this monumental cistern and fountain were made for the earls of Meath, an ancient noble family with extensive holdings in England and Ireland. They were subsequently acquired by George Augustus, Prince of Wales, who later became England's George II (reigned 1727-60). The objects were kept in Germany, at Hanover, the ancestral home of the English Hanoverian kings. The cistern and fountain are distinguished by their superb quality and condition, confident and sensitive modeling, royal provenance, and massive size. They were made by London silversmith David Willaume, who counted the most wealthy and powerful among his clients. These pieces would have been displayed on the buffet, a dramatic display of silver and an essential component of elaborate court dining rituals. The fountain, holding water, was placed on a table above the cistern. Footmen filled glasses of wine from bottles cooling in the cistern and rinsed drained glasses with water from the fountain so that they might be used again.

hybrid striped tulip, the hyacinth, the yellow rose, and the *Rosa huysumiana*, named for the artist and now known only from his paintings. The artist traveled every summer to Haarlem, a center of flower cultivation, to make studies of rare flowers. Van Huysum's determination to paint blossoms from life could delay a work's completion; in 1742 he wrote to an impatient client: "The flowerpiece is very far advanced; last year I couldn't get hold of a yellow rose, otherwise it would have been completed."

Oil on panel $35 \times 27 \% \text{ in. [88.9 \times 70 \text{ cm}]}$ Bequest of Stanton Blake 89.503

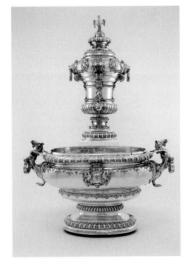

Silver
Cistern: 26 x 45 x 27 in.
[66 x 114.3 x 68.6 cm]
Fountain: H. 42½ in.
[108 cm]
Museum purchase with funds donated anonymously, Theodora
Wilbour Fund in memory of Charlotte
Beebe Wilbour,
Harriet J. Bradbury
Fund, and other funds, by exchange
1999.98.1-2a-b

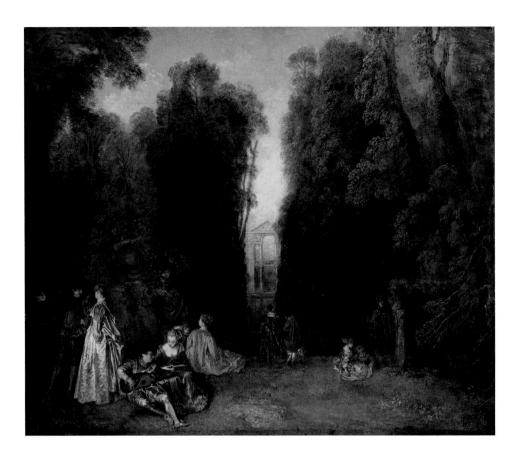

Antoine Watteau

French, 1684-1721

La Perspective (View through the Trees in the Park of Pierre Crozat), about 1715

Watteau was famous for a specific type of painting he developed, the fête galante, in which ladies and gentlemen converse, flirt, and make music in idyllic landscapes. Although he lived in Paris from the age of eighteen, Watteau's roots were Flemish. And it is from Flemish paintings, like Rubens's depiction of lovers in gardens, as well as the outdoor scenes of lovers and musicians painted by the Venetians Titian and Giorgione, which he saw in Parisian collections, that Watteau created his poetic vision of love and artifice.

This is Watteau's only fête galante with an identifiable setting: the Château de Montmorency near Paris,

home of Watteau's patron, the art collector and financier Pierre Crozat. The artist often visited Montmorency where he observed firsthand the aristocratic delight in artifice and ambiguity that his paintings capture with such perfection. Here, the marble facade of the house (originally built for Charles Le Brun, First Painter to King Louis XIV) appears in the distance beyond a reflecting pool. Seamlessly blending reality and fantasy, Watteau transformed Crozat's park into a dreamlike world where fashionably gowned women and men in costumes are arranged like actors on a stage framed by towering trees.

Oil on canvas 18% x 21% in. [46.7 x 55.3 cm] Maria Antoinette Evans Fund 23.573

Antoine Watteau

French, 1684-1721

Three Studies of a Woman and a Study of Her Hand Holding a Fan, about 1717

Drawing from life, Watteau made sheets of figure studies that he often incorporated into paintings, bringing a sense of naturalness and spontaneity to his romantic and idealized canvases. Such sheets, however, are also harmoniously composed works of art in their own right, as in this example with its three views of a young model and her hand holding a fan. Watteau used red chalk (his favorite drawing medium) to shape and model the figures, combining it with black to define and emphasize the forms and white for the planes of eyelids, cheeks, and chest.

Red, black, and white chalk on tan paper $13\frac{1}{2} \times 9\frac{1}{2}$ in. [34.1 x 24.1 cm] Bequest of Forsyth Wickes-The Forsyth Wickes Collection 65.2610

Guitar

France (Paris), 1680

Nicolas Alexandre Voboam II

French, after 1633-about 1693

King Louis XIV played the guitar, and the instrument was a feature of aristocratic French social gatherings. (Note the man in the foreground in Watteau's painting La Perspective.) One contemporary observed: "Everyone at court wanted to learn, and God alone can imagine the universal scraping and plucking that ensued." Enjoyed both as solo instruments and to accompany singers, many guitars were beautifully decorated. Here, the graceful outline of the instrument's body is accentuated with a border of inlaid ivory and ebony that contrasts handsomely with the spruce top. Guitars made by the Voboam family, active in Paris between 1650 and 1730, were much in demand, but only about thirty examples survive today.

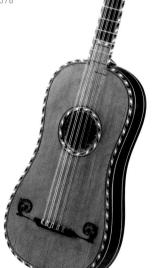

Luis Meléndez

Spanish, 1716-1780

Still Life with Melon and Pears, about 1770

Oil on canvas 25 % x 33 ½ in. [63.8 x 85 cm] Margaret Curry Wyman Fund 39.41 Like his French contemporary Chardin, Meléndez favored arrangements of everyday objects painted with sober yet sensuous realism. He savored shapes, surfaces, and colors—from the webbed rind of the melon to the glint of a wine bottle cooling in a cork bucket—and despite the profusion of objects, his paintings convey a satisfying sense of balance and measure. This still life may be from a series of fortyfive, said to represent "every species of food produced in Spain," that Meléndez created for the king's summer residence outside Madrid. Ironically, many were painted at a time when poor harvests had produced severe food shortages. The artist himself had no money to buy food, claiming that his brush was his only asset.

Sauceboat and stand

France (Paris), about 1756-59 Made by François-Thomas Germain French, 1726-1791

After the 1755 earthquake that devastated Lisbon, Portugal's King Jose I ordered four new table services to replace the extensive holdings of royal silver that had been lost. As did many European royalty, he turned to a Parisian silversmith, in this case François-Thomas Germain, who employed 120 workers to execute the commission. This is one of a pair of sauceboats with a rockwork base and handles formed of branches of celery. A vivid document of the artistic and technical mastery of the French silversmith, the sauceboat is one of about 300 pieces of silver that came to the Museum from the estate of Elizabeth Parke and Harvey S. Firestone, whose collection of exceedingly rare French domestic silver was one of the most magnificent in the world.

Silver $5\frac{1}{2} \times 15\frac{3}{2} \times 8\frac{7}{2}$ in. (13.8 x 39 x 22.6 cm) Elizabeth Parke Firestone and Harvey S. Firestone. Jr. Collection 1993.515.2

Jean Siméon Chardin

French, 1699-1779

Still Life with Teapot, Grapes, Chestnuts, and a Pear, 17[64?]

Chardin celebrated the commonplace. There is an air of informality and intimacy about his still lifes, as if he were working in his kitchen rather than his studio. In fact, inventories reveal that he owned most of the objects that he painted so meticulously, balancing form and texture. He also loved the pure, sensuous quality of paint, as the patch of brilliant orange brushed on the pear attests. The critic Denis Diderot enthused: "O Chardin! It's not white, red, or black pigment that you crush on your palette: it's the very substance of the objects, it's air and light that you take up with the tip of your brush and fix onto the canvas."

Oil on canvas 12% x 15% in. (32 x 40 cm) Gift of Martin Brimmer 83.177

The Emperor on a Journey France (Beauvais), late 17th or early 18th century

Designed by Guy Louis Vernansal, Jean-Baptiste Belin de Fontenay, and "Batiste" (probably Jean-Baptiste Monnoyer)

During the reign of Louis XIV, the French tapestry industry enjoyed a brilliant period. At this time, there was a passion for what has come to be called "chinoiserie"—depictions of Asian life and landscape that reflect a little knowledge and a great deal of imagination. For many years, the manufactory at Beauvais wove a series of chinoiserie tapestries called The Story of the Emperor of China, perhaps inspired by the accounts of a French Jesuit priest who returned from China in 1697. On this panel, the emperorenthroned beneath a fanciful canopy with his feet on a Near Eastern rug—is probably Kang Xi, who reigned from 1661 to 1721. The tapestry has survived in particularly fine condition, with its vibrant colors intact.

152 x 94 in. [386 x 239 cm] Wool and silk; tapestry weave Gift of Mr. and Mrs. Henry U. Harris in the name of Mrs. Edwin S. Webster and Mr. and Mrs. Henry U. Harris 65.1352

Giovanni Battista Tiepolo Italian (Venice), 1696-1770 Time Unveiling Truth, about 1745-50

One of the last great, international court artists, Tiepolo is best known for huge frescoes that decorate the walls and ceilings of palaces in Italy, Germany, and Spain. This complex allegory is among Tiepolo's largest paintings in oil on canvas. It depicts Truth as a proud young woman whose opulent beauty is set off by the dark, winged figure of Time. Time's scythe denotes death, and Cupid, whose quiver of arrows remains on the ground, symbolizes earthly love rendered powerless by Time. The parrot at right represents the enemies of Truth: vanity and deceit. Truth's emblem, the sun, shines above, while earthly things, represented by the globe, lie subject beneath her foot.

Oil on canvas 91 x 65% in. [231 x 167 cm] Charles Potter Kling Fund 61.1200

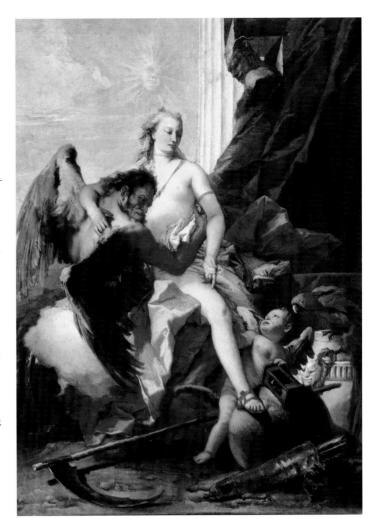

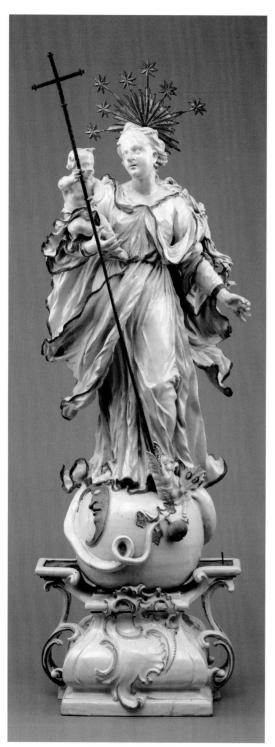

Modeled by Franz Martin Mutschele German, 1733-1804 Virgin and Child, 1771 Made at the Schrezheim Manufactory

Standing on a celestial globe and treading on a serpent (symbol of original sin), this image of the Madonna of Victory derives from the description in the Bible's Book of Revelation of a woman crowned with stars and "clothed with the sun." Statues of the Madonna were often placed outside houses to ensure heavenly protection from evil. This one stood above the door of the meeting house of the Teutonic Knights (originally militant crusaders championing Christianity in eastern Europe) in the town of Wolframs-Eschenbach in Germany.

Tin-glazed earthenware with brass halo and iron staff H. 44% in. (112.3 cm) William Francis Warden Fund 61.1185

facing page, left

Tureen with lid; stand

England (Chelsea), about 1755

Made at the Chelsea Manufactory

When porcelain was introduced to Europe from China, it inspired enormous enthusiasm among collectors and connoisseurs, but for many years, the recipe for making true, hard-paste porcelain remained a mystery. Many European manufactories developed imitations known as soft-paste porcelain, and in 1744 the silversmith Nicholas Sprimont established England's first soft-paste porcelain manufactory in the London suburb of Chelsea. That year, a local newspaper reported: "We hear that the China made at Chelsea is arriv'd to such Perfection, as to equal if not surpass the finest old Japan.... The Demand is so great, that a sufficient

Quantity can hardly be made to answer the Call for it." Many of Chelsea's most successful products were tureens such as this one, skillfully modeled as animals, fish, or birds and colored "according to nature."

Soft-paste porcelain with polychrome enamels
Tureen with lid: 10 x 15 in. (25.4 x 38.1 cm)
Stand: 15½ x 19 in. (38.7 x 48.3 cm)
Jessie and Sigmund Katz Collection 1972.1081a-b

Console table

Germany (Munich), about 1730 Possibly designed by **Josef Effner** German, 1687–1745

This console table, supported by only two legs, was made to be placed against a wall. The structure of this ornately carved and gilded example features two cherubs supporting the Austrian coat of arms and a portrait of Maria Amalia, daughter of the Austrian emperor and wife of the elector (prince) of Bavaria, in Germany. It is one of a set of four (two are in the Museum's collection) designed for the hall imperial at the Ettal Monastery in Bavaria by Josef Effner, whose family had served the electors of Bavaria as gardeners for generations. Deeply enamored of French style, the elector sent Effner to Paris to learn gardening skills. There, the artist turned to architecture, and in 1724 he was appointed chief architect and interior designer to the Bavarian court.

Gilded pine and limewood; marble top $33\% \times 59\% \times 25\% \text{ in. } [85.7 \times 150.5 \times 64.4 \text{ cm}]$ Helen and Alice Colburn Fund -57.658

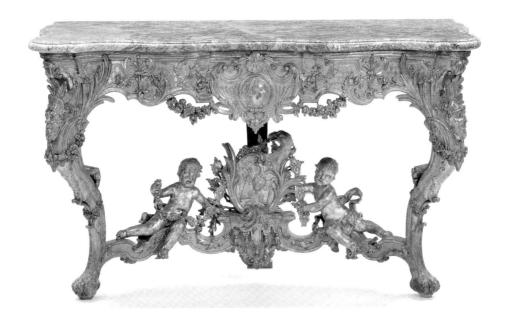

François Boucher French, 1703-1770 Halt at the Spring, 1765

Boucher, possibly the most influential French artist of the eighteenth century, was also one of the most versatile. He not only decorated palaces and private residences but also painted portraits, landscapes, and mythological scenes and designed opera sets, porcelains, and tapestries. He enlarged and reworked this painting (originally a depiction of the Rest on the Flight into Egypt, with Mary, Joseph, and Jesus at left) into a fantasy of peasant life enlivened by dashing brushwork, lighthearted sensuousness, and pastel colors punctuated by vibrant red. Attracted to

the fanciful and artificial, Boucher objected to the natural world as "too green and badly lit." When this painting was exhibited in Paris in its earlier form in 1761, the critic Denis Diderot wrote: "What colors! what variety! what richness of objects and of ideas! This man has everything except truth." Acquired in the mid-nineteenth century for a house in Boston's South End, Halt at the Spring and its companion, Return from Market, subsequently became the first European paintings to enter the Museum's collection.

Oil on canvas 82 % x 114 % in, [208.5 x 290 cm] Gift of the heirs of Peter Parker 71.2

Canaletto (Giovanni Antonio Canal) Italian (Venice), 1697-1768 Bacino di San Marco, Venice, about 1738

Giovanni Antonio Canal, known as Canaletto, was the foremost painter of *vedute*, or views, of Venice, and his works were much in demand among eighteenth-century travelers on the "Grand Tour" of Europe. This painting, purchased by the Earl of Carlisle for his home, Castle Howard in Yorkshire, England, is among Canaletto's masterpieces. The expanse of the lagoon, or *bacino*, is animated with gondolas, work boats, and ships flying the flags of England, France, and Denmark. Famous landmarks include the Doge's Palace at left and the church of

San Giorgio Maggiore at right. The clear light and the drifting clouds that dapple the water unite all this activity into a grand, unified whole. Canaletto composed his paintings from several viewpoints so as to encompass more buildings than actually could be seen from one place. A contemporary wrote: "He paints with such accuracy and cunning that the eye is deceived and truly believes that it is reality it sees, not a painting."

Oil on canvas 49 x 80½ in. (124.5 x 204.5 cm) Abbott Lawrence Fund, Seth K. Sweetser Fund, and Charles Edward French Fund 39.290

Giovanni Domenico Tiepolo Italian (Venice), 1729-1804 The Milliner's Shop, about 1791

Son and chief assistant of a famous and successful father (see page 209), Tiepolo was an accomplished artist in his own right: a masterful draftsman with a special talent for acutely observed images of Venice's upwardly mobile middle class going about their daily business. In this drawing, one in a series depicting scenes of contemporary life, employees of a fashionable shop mingle with customers and their children. Amid the bustle, the motionless woman in yellow (seen from behind) provides the composition's focal point; her sweeping gesture leads the eye to the allimportant bonnet displayed on the table at right.

Pen and brown ink, gray and brown washes, yellow watercolor on paper 11% x 16% in. [30.2 x 42.3 cm] William E. Nickerson Fund 47.2

Jean-Baptiste Greuze French, 1725-1805 The White Hat, about 1780

Best known for his moralizing scenes of middle-class domestic life, Greuze also painted accomplished portraits. "I don't like faces that are painted already," Greuze declared, and this image of an unidentified young woman captures the combination of sensuality and innocence much admired in prerevolutionary France. The sitter's artfully dishevelled dress reflects a "natural" fashion favored by Queen Marie Antoinette, and her glowing skin is enhanced by the painting's palette of soft blues and grays. The oval shape, which Greuze often employed for images of beautiful women, is echoed in the curves of the woman's shoulder and breast-and in the remarkable feathered hat that dominates the composition.

Oil on canvas 22% x 18¼ in. [56.8 x 46.5 cm] Gift of Jessie H. Wilkinson-Jessie H. Wilkinson Fund. Grant Walker Fund, Seth K. Sweetser Fund, and Abbott Lawrence Fund 1975.808

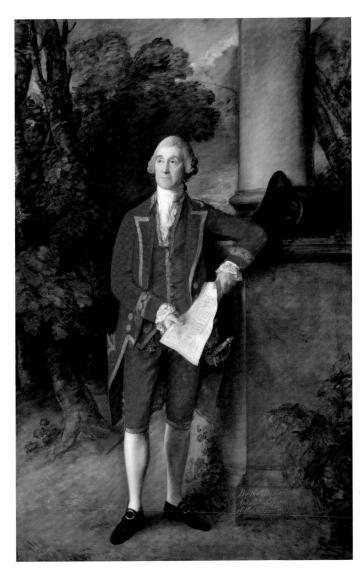

Thomas Gainsborough
English, 1727–1788

John Eld of Seighford Hall, Stafford,
about 1775
Inscribed on base of pedestal:
"By the Command/And at the
Expence/of the Subscribers"

John Eld (1704-1796) was a founder of the Staffordshire General Infirmary, and this portrait was commissioned by the infirmary's trustees. It hung in the board room there until it was sold to benefit the hospital in 1912. Employing a traditional formula for fashionable portraiture, Gainsborough depicted Eld, holding a sketch of the hospital's facade, formally dressed yet at ease, and placed so that the viewer looks up at him from below. Although Gainsborough made his living with such elegant portraits, his "infinite delight" was painting landscapes, for which, at that time, there was little market. Not surprisingly, he includes a glimpse of wooded landscape in his painting of Eld.

0il on canvas 94 x 60% in. [238.6 x 153 cm] Special Painting Fund 12.809

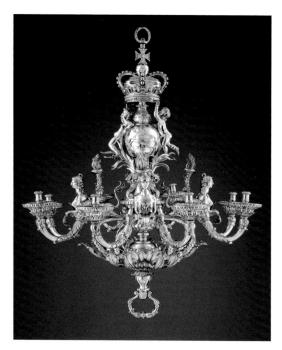

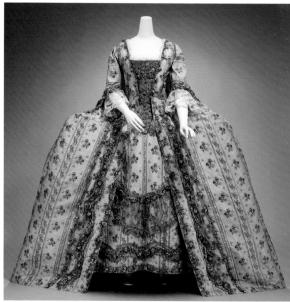

Chandelier

Germany (Hanover), 1736

Designed by William Kent, English, 1685-1748; marked by Balthasar Friedrich Behrens, German, 1701-1760

George II was the second Hanoverian king of England. This chandelier is one of five that he commissioned, probably for the Leineschloss, the royal palace in Hanover; the figure of a horse on the globe beneath the sovereign's crown is the emblem of the House of Hanover. The chandelier was designed in England by William Kent and executed in Germany by the goldsmith of the court of Hanover, who worked from a wooden model carved after Kent's original design.

Kent was the first and most influential of the great eighteenthcentury English architect-designers, and received many important commissions from the court and the aristocracy, designing not only buildings but also gardens, furniture, silver, paintings and their frames, book illustrations, and theatrical productions.

Silver

H. 46½ in. [118.1 cm]

William Francis Warden Fund, Anonymous gift in memory of Zoë Wilbour, Gift of Henry H. Fay, and Gift of W. K. Flint, by exchange 1985.854

Woman's formal dress

France, about 1770

Opulent dress epitomized status and taste in the eighteenth century, when textiles and decorative trims made from precious materials were extremely costly. This extravagant French gown literally reshaped the body of the woman who wore it. Tightly laced, boned stays (corset) supported the bust and imposed an elegant posture, while wide side hoops (paniers) under the skirt extended the hips by as much as four feet.

Silk and metallic thread; plain weave (tafetta) with warp float patterning, brocaded with silk; applied metallic bobbin lace and silk flowers Overdress center front height: 58 in. (147.3 cm); Petticoat center front height: 40% in. [102 cm] The Elizabeth Day McCormick Collection 43.643a-b

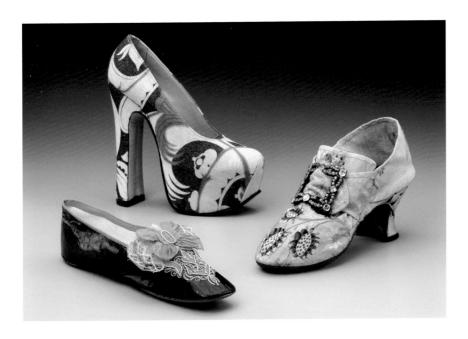

Woman's buckle shoe

England, about 1770

Silk; plain weave with supplementary patterning wefts; silk ribbon; leather; linen lining $5 \times 3 \% \times 9 \%$ in. (12.5 x 8 x 24.2 cm) Gift of Emily Welles Robbins [Mrs. Harry Pelham Robbins] and the Hon. Sumner Welles, in memory of Georgiana Welles Sargent 49.1007a-b

Woman's slipper

England (worn in America), about 1850

Leather, silk plain weave (taffeta) and lace, machine embroidery, silk satin, cotton plain weave, metal buckle (probably gold-plated brass)

 $2^{1}\!/_{\!2} \times 2^{3}\!/_{\!4} \times 9^{1}\!/_{\!4}$ in. [6.5 x 7 x 23.7 cm]

Gift of Emily Welles Robbins (Mrs. Harry Pelham Robbins) and the Hon. Sumner Welles, in memory of Georgiana Welles Sargent 49.1020a-b

Woman's shoe

England, 1991

Designed by Vivienne Westwood, English, born in 1941

Cotton; printed twill

7% x 3% x 3% in. [20 x 8 x 8.5 cm]

Textile Income Purchase Fund 2002.672.1-2

Shoes have long been among the most important of women's fashion accessories. These examples, dating from three different centuries, share a use of luxurious materials and elaborate decoration that makes it clear they were not made simply to protect feet from cold and wet. Made in about 1770 of ribbed yellow silk brocaded with polychrome silk yarns, the buckle shoe was worn in America by Mehetable Stoddard (Hylsop), 1719–1792. The flat slipper at lower left, made in England in the 1850s, was called a "Chameleon shoe," a style that became popular in the middle of the nineteenth century. Vivienne Westwood took the abstract pattern on her 1991 platform shoe at top left directly from an eighteenth-century brocaded silk damask fabric, known as a "bizarre silk," transforming the elegant and exotic silk into a modern printed cotton denim.

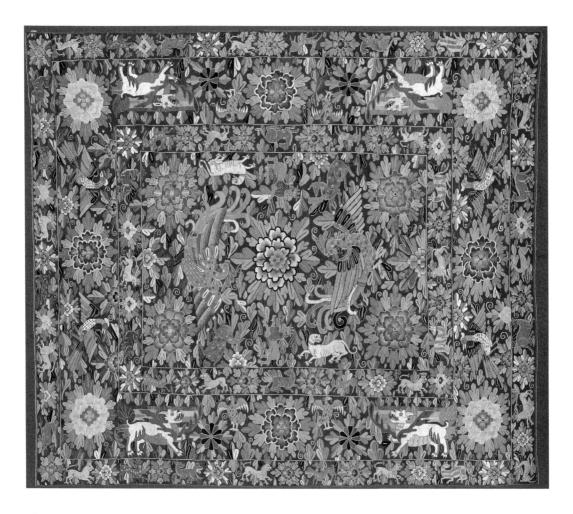

above

Cover with Chinese-influenced motifs

Peru, late 17th-early 18th centuries

Cotton, wool, silk and linen; tapestry weave 93³/₄ x 81¹/₂ in. [238.1 x 207 cm] Denman Waldo Ross Collection 11.1264

facing page, left

Cathedra (bishop's chair)

Mexico (possibly Puebla), 1750-1800

Spanish cedar 44 x 37 x 23 in. [111.8 x 94 x 58.4 cm] Gift of Landon T. Clay and Harriet Otis Cruft Fund 1980.171 facing page, right

Bureau-cabinet

India (Vizagapatam), 1725-40

Teak with ebony and ivory 96 x 26 ½ x 44 ½ in. (243.8 x 67.3 x 113 cm) Gift of James Deering Danielson 1981.499

As Europeans traveled, conquered, and settled around the world, they brought with them not just their religions, governments, and diseases, but also their tastes. Through conquest and the creation of new trade routes, European imperialism fostered the invention of new decorative styles, as objects moved across cultural boundaries in ways they never had

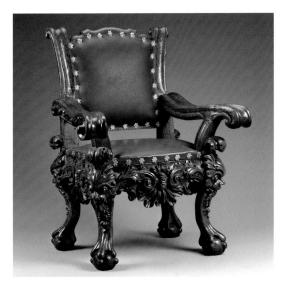

Spanish employed Andean weavers to create cloth for household use. This cover mixes a generally European pattern and Andean subjects (there are llamas in the narrow interior border) with images of peonies and mythical beasts derived from Chinese silks, which came to the Andes through yet another of Spain's colonies, the Philippines. The Museum's collections of colonial art frequently demonstrate the circuitous travel of people, goods, and artistic styles during the colonial period.

before. This chair, for example, was most likely made as the seat for a Roman Catholic bishop. In taste and form it is Spanish, down to the feet carved in the shape of a claw grasping a ball, stylish in the mid-eighteenth century. In this case, however, the chair was probably made in Puebla, Mexico, for a bishop whose flock was for the most part not Spanish but of indigenous heritage.

Although the overall shape and construction of this bureau-cabinet is characteristic of eighteenth-century English furniture, its decoration is not. Crafted in Vizagapatam, in British-ruled India, it may have been made for export to England as an exotic, but not too exotic, piece of furniture for the British market. Alternatively, it may have been made for a wealthy Indian patron who had absorbed some English habits, but had not adopted English decorative taste. Vizagapatam had been a center of ivory carving centuries before the arrival of the British; work like this represents the adaptation of a local tradition to new conditions and new markets.

Before the European conquest, Andean weavers in South America were among the most sophisticated in the world, creating complex textiles for clothing and burial shrouds. During the colonial period, the

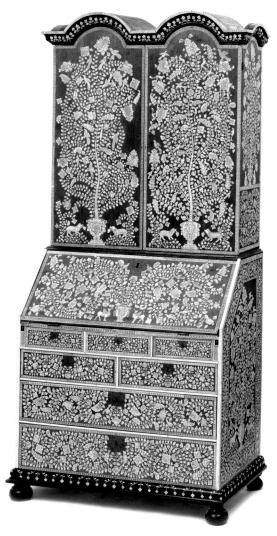

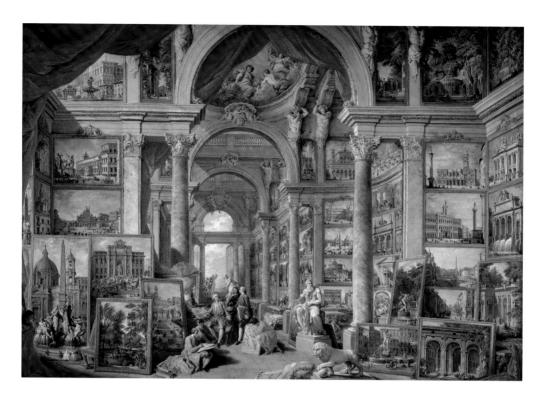

Giovanni Paolo Pannini

Italian (Rome), 1691-1765

Picture Gallery with Views of Modern Rome, 1757

Pannini, like his contemporary Canaletto in Venice, was trained as a stage designer and became extremely successful painting images of Rome for foreign visitors on the "Grand Tour." This enormous painting is one of four views of ancient and modern Rome commissioned by the Duc de Choiseul to commemorate his four years as French ambassador to the Vatican. Here, in a theatrical and totally imaginary gallery, the duke sits surrounded by plaster casts of sculptures by Michelangelo and Bernini and detailed views (all painted, of course, by Pannini) of Saint Peter's Square, the Trevi Fountain, the Spanish Steps, and other famous Roman buildings, fountains, and monuments.

Oil on canvas 67 x 96 1/4 in. [170 x 244.5 cm] Charles Potter Kling Fund 1975.805

facing page, bottom

The Richmond Race Cup

England (London), 1764

Designed by Robert Adam, Scottish, 1728-1792; marked by Daniel Smith and Robert Sharp, English, in partnership about 1763-1788

The form and ornament of this opulent trophy reflect the enthusiasm for classical antiquity sparked by mid-eighteenth century excavations at the Roman sites of Herculaneum and Pompeii, which provided a wealth of previously unknown information about ancient architecture and decoration. This winner's cup was designed by Robert Adam, whose style—inspired and shaped by two years in Rome—introduced Neoclassicism to England. Commissioned by the stewards of the prestigious Richmond Gold Cup race, this trophy was won by Silvio, a horse owned by John Hutton of Yorkshire.

Gilded silver
H. 19% in. [48.6 cm]

Theodora Wilbour Fund in memory of Charlotte Beebe Wilbour and Frank Brewer Bemis Fund 1987.488a-b

Joseph Wright of Derby

English, 1734-1797

Grotto by the Seaside in the Kingdom of Naples with Banditti, Sunset, 1778

The first major English artist to make a successful career outside London, Wright painted portraits, landscapes, and images of contemporary life for the affluent middle class in his native Derby, who derived their wealth from the Industrial Revolution. In 1773, Wright made an extended trip to Italy where he sketched, in meticulous detail, the grottoes off the coast of Salerno, near Naples. After his return to England in 1775, he used these drawings to create paintings, like this one, that combine powerful observation and spectacular light effects with a sense of the sublime. The mysterious, moody figures (which the artist identified as "bandits") enhance this painting's haunting blend of reality and imagination.

Oil on canvas 48 x 68 in. [121.9 x 172.7 cm] Charles H. Bayley Picture and Painting Fund and other Funds, by exchange 1990.95

Jean-Antoine Houdon French, 1741-1828 Thomas Jefferson, 1789

One of the greatest portrait sculptors, Houdon is most celebrated for his psychologically acute and technically superb images of famous contemporaries. Thomas Jefferson (1743-1826) had recommended the sculptor for a statue of George Washington in the Virginia state capitol years before. Jefferson

was serving as American minister to France when he sat for Houdon in Paris. Houdon first modeled the likeness in clay, and then made a plaster cast that he used as the model from which he created this marble version, the most recognizable and enduring image of Jefferson. It was the source of the presidential portrait on the 1801 Indian Peace Medal, for the Jefferson dollar (minted in 1903), and for the nickel, as it was issued in 1938.

Marble H. 22½ x 18½ x 10½ in. [56.5 x 48 x 26 cm] George Nixon Black Fund 34.12

After a model by Claude-André Deseine Honoré-Gabriel Riqueti, comte de Mirabeau, about 1791

Made by the Duc d'Orléans Factory, Paris

A gifted orator and a fiery personality, the comte de Mirabeau (1749–1791) played a major role in the politics of revolutionary France and advocated the establishment of a constitutional monarchy rather than the deposition of the king. After his death in 1791, the political group known as the Jacobins, who shared his opinions, sponsored a competition for a memorial portrait to be displayed in the Society of Friends of the Constitution. The plaster model for this bust won that competition, but the intended marble was never carved. A number of small porcelain versions were made, but life-size porcelain busts such as this one were seldom attempted because of the technical difficulties in controlling the firing process. This porcelain sculpture is remarkable for its dramatic pose and expression, and for the unflinching realism with which the artist rendered Mirabeau's face. scarred by smallpox.

Vase

France (Sèvres), 1779

Painted by Antoine Caton, French, active 1749-1797

This vase once stood on a marble mantelpiece in the council chamber of King Louis XVI at Versailles. The painted scene depicts an episode from the life of the sixth-century Roman general Belisarius. It is based on a popular French novel and an engraving of a painting by Anthony van Dyck. In its imposing size, lavish gilding, and vivid blue color, this vase is one of the supreme productions of the porce-

of the supreme productions of the porcelain factory at Sèvres, which made porcelains for royal and aristocratic patrons from throughout Europe. A drawing and a plaster model for this vase survive in the manufactory's archives. During the French Revolution, many furnishings from Versailles and other palaces were seized by the revolutionary government and sold. This vase was acquired in Paris in the 1790s by James Swan, a Boston merchant who exported basic supplies to warravaged France in exchange for luxury goods.

Soft-paste porcelain with polychrome enamels and gold

H. 28 in. [71.1 cm]

Gift of the heirs of Helen L. Jaques 38.65a-b

Grand piano

England (London), 1796

Manufactured by John Broadwood and Son, English, active 1795–1808

Case designed by **Thomas Sheraton**, English, 1751–1806 Satinwood, purpleheart, tulipwood, with cameos and medallions by **Josiah Wedgwood** and coin casts by **James Tassie**

Unequaled in its sumptuous Neoclassical ornamentation, this instrument was commissioned from England's leading piano maker by Manuel de Godoy, prime minister of Spain. It is the earliest extant piano with a range of six full octaves and the only piece known to have been specifically designed by the influential cabinetmaker Thomas Sheraton. The piano's decoration includes inlays of rare tropical woods, opaque glass-paste casts of ancient Greek coins, and cameos and medallions made of jasperware, a white porcelain invented by Josiah Wedgwood, the artist who raised English ceramics to an unprecedented level of artistic and commercial success.

 $97\% \times 43\% \times 3\%$ in. [248.7 x 111.5 x 91.2 cm] From the George Alfred Cluett Collection, given by Florence Cluett Chambers 1985.924

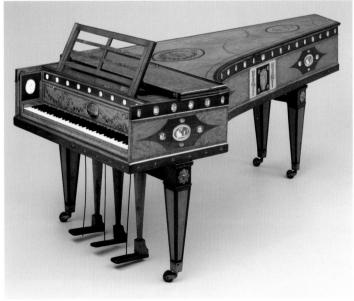

Bergère

France (Paris), 1787 Made by Jean-Baptiste-Claude Sené, French, 1747-1803

This bergère (an armchair with fully upholstered arms) is part of a suite of ten pieces of bedroom furniture purchased by Marc-Antoine Thierry de Ville d'Avray, administrator of the Garde-Meuble de la Coronne, the office responsible for furnishing royal residences. Intended for his bedroom, Thierry placed the order with craftsmen patronized by King Louis XVI and, for the upholstery, requisitioned yardages left over from the silk woven for the King's Gaming Room at Fontainbleau. Boston merchant James Swan, official agent for the French revolutionary government in the United States, acquired the set in exchange for grain, munitions, and other things the cash-poor French government desperately needed. This is the only complete suite of eighteenth-century French furniture in the United States. It was regilded and reupholstered in California and France beginning in 1998, among the most complicated conservation treatments ever undertaken by the Museum.

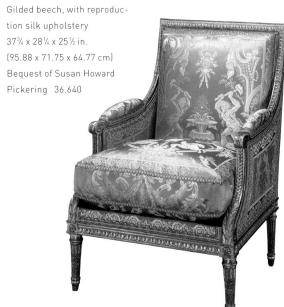

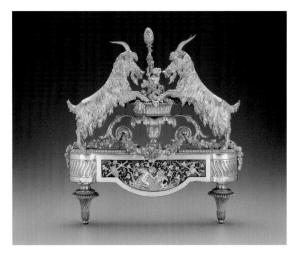

Andiron

France (Paris), about 1785 Attributed to Pierre-Philippe Thomire, French, 1751-1843

This andiron (one of a pair in the Museum's collection) evokes the splendors of prerevolutionary France. It is made of bronze and coated with a thin layer of gold, a process involving the application of mercury that burned off in the firing, unwittingly exposing workers to the deadly effects of this toxic element.

These refined andirons are the work of Thomire, a prominent French bronzeworker, and the collaborative effort of many individual specialists in modeling, casting, chiseling, and gilding. The design features goats eating grapes from a basket while below them, against a background originally covered with blue enamel, two cherubs shear a ram. The andirons may have been made for the dining room of the Queen's Billiards House, part of Marie Antoinette's "rustic" village near the Palace of Versailles.

Gilt bronze, silver-plated copper plaque decorated with oil-based paint containing Prussian blue pigment H. 19 in. [48.3 cm]

Bequest of Miss Elizabeth Howard Bartol 27.521-2

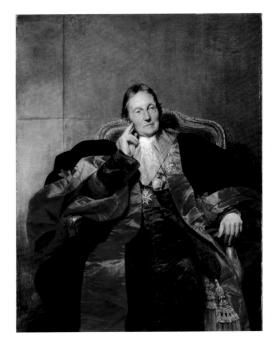

Hippolyte Delaroche French, 1797–1856 Marquis de Pastoret, 1829

When Delaroche painted Pastoret (1756–1840) the marquis had just become chancellor of France, the culmination of a long career in public life. Commissioned by Pastoret's son from an artist best known for his detailed paintings of highly charged historical events, this image recalls aristocratic portraits of the seventeenth century in its scale and emphasis on Pastoret's voluminous robes. The marquis wears the insignia of a Grand Officer of the Order of Saint-Esprit and two medals (the Saint Andrew Cross and the Legion of Honor) on his lapel. This opulence is strikingly contrasted with the sitter's thoughtful pose and austere, unidealized face.

About a year after his portrait was painted, Pastoret was stripped of his honors for refusing allegiance to the new constitutional monarch, Louis Philippe. The change in political climate may explain why Pastoret's coat of arms (still faintly visible in the upper left corner) was removed from the painting.

Oil on canvas $61\% \ x \ 48\% \ \ in. \ [155.3 \ x \ 122.6 \ cm]$ Susan Cornelia Warren Fund and the Picture Fund $\ \ 11.1449$

Claude Michel, called Clodion French, 1738–1814 The Flood, 1800

Clodion, who had benefitted from royal patronage, fell out of favor during the French Revolution. Determined to reestablish his career, the aging artist, who had previously specialized in small terra-cotta statues, exhibited at the Paris Salon of 1801 a life-sized plaster sculpture for which this superb terra-cotta was a preparatory model. Balanced on a rocky ledge surrounded by water, a man struggles to save his son; behind him (not visible here) is the half-submerged figure of a drowned woman and her child. In conceiving a human drama caused by a flood, Clodion was being deliberately "modern," for recent scientific discoveries suggested that earthquakes and floods had played a major role in the formation of the planet.

Terra-cotta
21½ x 11 x 9 in.
(54.5 x 27.9 x 22.9 cm)
John H. and
Ernestine A.
Payne Fund
1981.398

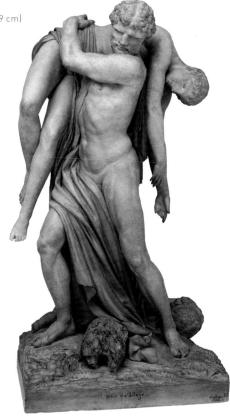

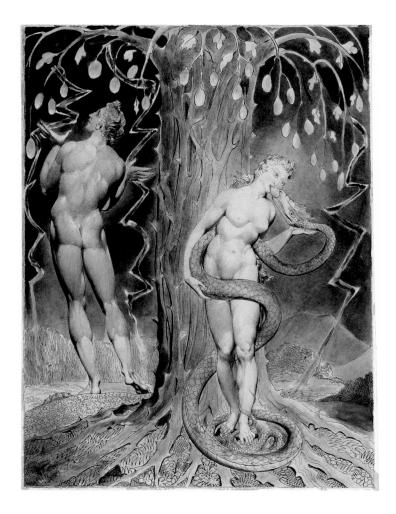

William Blake

English, 1757-1827

The Temptation and Fall of Eve (illustration to Milton's Paradise Lost), 1808

Living in a time he viewed as excessively confused and materialistic, Blake expressed his mystical, theological, and philosophical beliefs in visionary poetry, prints, and paintings. This watercolor illustrating a scene from John Milton's epic poem Paradise Lost is one of a set commissioned by Blake's loyal patron Thomas Butts. In the Bible, Adam and Eve were forbidden by God to eat fruit from the tree of the knowledge of good and evil. Like Milton, Blake specifically identifies the Fall of Man with the moment when Eve succumbs to temptation and takes the fruit from the mouth of the evil serpent. The sky is rent by lightning and the tree covered with thorns, as Blake expresses Milton's words: "Earth felt the wound, and Nature from her seat / Sighing through all her Works gave signs of woe / That all was lost."

Watercolor and pen and ink on paper 19½ x 15¼ in. [49.7 x 38.7 cm] Museum purchase with funds donated by contribution 90.90

Francisco Goya y Lucientes Spanish, 1746–1828 Reclining Nude, 1824–25

Goya's paintings, drawings, and prints, which range from official royal portraits to bitter satire on the foibles and atrocities of contemporary society, reflect the dramatically changing world in which he lived. Near the end of his life, Goya left Spain for France, arriving "deaf, old, clumsy, and weak . . . and so happy and wanting to experience life." It was during the winter of 1824 that he painted a group of tiny yet extraordinarily innovative paintings on thin sheets of ivory. According to a contemporary description, Goya "blackened the ivory plaque and let fall on it a drop of water which removed part of the black ground as it spread out, tracing random light areas. Goya took advantage of these traces and always turned them into something original and unexpected."

Carbon black and watercolor on ivory $\label{eq:carbon} Overall: 3\,\%\,x\,3\,\%\,in,\,[8.7\,x\,8.6\,cm]$ $\label{eq:carbon} Ernest\,Wadsworth\,Longfellow\,Fund \quad 63.1081$

Antonio Canova Italian, 1757-1822

Bust of Beatrice, about 1819-22

Canova was arguably the greatest Neoclassical sculptor and the most famous artist of his day. He invented the "ideal head" about 1811 to capture his conception of perfect, timeless beauty. This bust began as a portrait of his friend, the famous beauty Juliette Recamier; her celebrated portrait by Jacques-Louis David is in the Louvre. Canova's original plaster bust did not please Recamier, and he abandoned the idea of carving the final marble. Instead, he idealized Recamier's features, transforming the bust into an imagined portrait of Beatrice, mythical muse of the medieval Italian poet, Dante. This precise and delicate bust—technically brilliant in the carving of spiraling hair, translucent veil, and softly textured flesh-is a work of evolutionary mastery, as the portrait of a real woman became an imaginative personification of a literary figure and the expression of Canova's ideal of beauty.

Marble
23 x 11 x 10 in.
[58.4 x 27.9 x 25.4 cm]
William Francis Warden
Fund, Edward J. and Mary S.
Holmes Fund, John Lowell
Gardner Fund, Russell B. and
Andrée Beauchamp Stearns
Fund, Helen B. Sweeney
Fund, Frank B. Bemis Fund,
Seth K. Sweetser Fund,
H. E. Bolles Fund, Arthur
Mason Knapp Fund, and
Benjamin Pierce Cheney
Donation 2002.318

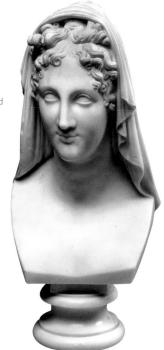

Mask fan

England, made for the Spanish market,

1740s

Paper leaf (double). patched with skin, etched. engraved, and

painted in watercolor; ivory sticks, pierced, partially painted, varnished and gilded; mother-of-pearl buttons on brass rivet Maximum open: 19 % in. (48.5 cm)

Oldham Collection 1976.179

The fan, more than all other fashion accessories to elegant dress, was an essential part of the rituals of the arts of conversation and flirtation. The English writer James Addison

commented in 1711:

"Women are armed with fans as men with swords and sometimes do more execution with them." First introduced into European court circles in the late sixteenth century, fans are wonderfully varied both in the materials of which they are made and their decoration, which ranges from biblical scenes to famous architectural landmarks and the words of popular songs. Some examples feature

masks with eye openings and can be held to provocatively conceal the user's identity. Brisé (broken, in French) fans, constructed without connecting leaves of paper or skin, were inspired by Japanese examples. The intricate, silver brisé fan shown here belonged to Marie Louise, second wife of Napoleon I. It survives with its original

leather case, stamped with a crown and its owner's initials.

Brisé fan depicting Gothic church ruins

England, about 1825

Horn blades, painted in watercolor and gilded; silk connecting ribbon; paste studs at rivet Maximum open: 13 in. (33 cm) Oldham Collection 1976.317

Brisé fan

Possibly Italy, 1810-30

Silver filigree blades with silk connecting ribbon; silver washer and filigree ring Maximum open: 14% in. [36.5 cm] Oldham Collection 1976.354

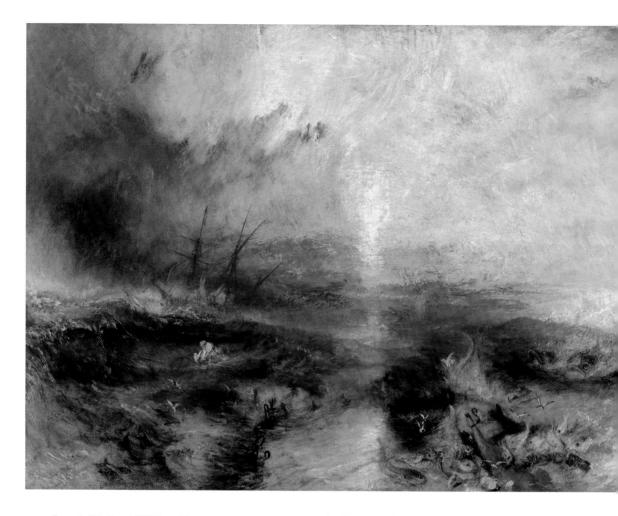

Joseph Mallord William Turner

English, 1775-1851

Slave Ship (Slavers Throwing Overboard the Dead and Dying, Typhoon Coming On), 1840

One of Turner's most celebrated paintings, Slave Ship was inspired by an eighteenth-century poem and by the true story of an English ship, traveling in 1781 from Africa to Jamaica. The captain of this ship threw overboard 132 sick slaves because he could collect insurance money for slaves "lost at sea," but not for those who died from disease. Although the limbs and chains of the victims are discernible in

the foreground, Turner focuses on the terrifying power of nature and the merging of churning sea and livid sky. The painting was owned for almost thirty years by art critic John Ruskin who stated: "If I were reduced to rest Turner's immortality upon any single work, I should choose this."

Oil on canvas 35¾ x 48¼ in. [90.8 x 122.6 cm] Henry Lillie Pierce Fund 99.22

Joseph Mallord William Turner English, 1775–1851 Stonehenge at Daybreak, about 1811

Turner had equal command of oil and of watercolor but favored the latter when working outdoors, rendering directly and spontaneously the changing qualities of atmosphere and light. This drawing is one of many studies he made specifically to be engraved for his *Liber studiorum*, a compilation of landscapes—long regarded as his most important achievement—which occupied the artist for over a decade. Here, dramatically silhouetted on the horizon, is Stone-

henge, a mysterious circle of massive, ancient stones on Salisbury Plain in southern England. Turner loved such picturesque and romantic subjects, and he captured the essence of Stonehenge's grandeur and monumentality in this small image.

Brush and brown wash over graphite pencil on paper $7\% \times 10\%$ in. (19.4 x 27 cm) Anonymous gift 59.795

John Constable English, 1776-1837 Stour Valley and Dedham Church, about 1815

Unlike his contemporary Turner, who traveled widely in search of dramatic subjects, Constable painted the ancient villages and rural landscape of his native Suffolk, in England. The resulting images are fresh, immediate, and closely observed. This painting was commissioned by Thomas Fitzhugh as a wedding present for his bride, Philadelphia Godfrey, so that she might have a memento of the countryside stretching out around her family home. In the foreground is a dunghill from which workers dig manure to fertilize the fields for next year's crops. As well as making

numerous preliminary drawings and oil sketches, Constable worked on the canvas itself outdoors-rendering enthusiastically the expansive landscape early in the morning of a perfect fall day.

Oil on canvas 21% x 30% in. [55.5 x 77.8 cm] Warren Collection—William Wilkins Warren Fund 48.266

Jean-Baptiste-Camille Corot French, 1796–1875 Forest of Fontainebleau, 1846

Beginning in the 1820s, Corot spent summers sketching in the vast Forest of Fontainebleau, south of Paris. He based this painting on such informal sketches, reworking them to create a more structured composition, with the horizontals of foreground and background balanced by the verticals of trees and the cows positioned to mark recession into space. Nevertheless, as a depiction of a familiar, local site without the "justification" of a biblical or mythological subject, this painting became a pivotal work in the development of French landscape painting when it was

accepted for the Salon of 1846. Corot believed that artists "must... never lose the first impression that quickened our emotion." His work formed a bridge between traditional, idealizing landscapes and those of the Impressionists, to whom Corot was a mentor and an inspiration.

0il on canvas 35%~x~50%~in.~[90.2~x~128.8~cm] Gift of Mrs. Samuel Dennis Warren ~90.199

facing page

Eugène Delacroix

French, 1798-1863

The Entombment of Christ, 1848

Against a deep and somber landscape, desolate mourners gather around the body of Christ. Delacroix's use of resonant color and expressive, sketchy brushwork had a profound influence on later painters, including the Impressionists. Although Delacroix constantly struggled with his personal spiritual beliefs, American writer and critic Henry James called this "the only modern religious picture I have seen that seemed to me to be painted in good faith." Delacroix himself wrote that "the whole arouses an emotion that astonishes even me."

0il on canvas 64×52 in. $(162.6 \times 132.1 \text{ cm})$ Gift by contribution in memory of Martin Brimmer 96.21

Gustave Courbet French, 1819-1877

The Quarry (La Curée), 1856

Courbet was the self-styled leader of the Realist movement in French art. Most of his paintings of modern life were condemned as offensively ordinary, but The Quarry was well received when it was exhibited at the Salon of 1857. Probably set in the Jura Mountains along the French-Swiss border, the painting features the artist himself, posed as a huntsman. He enlarged the original canvas as he worked, adding one piece across the top above the hunter's head and others to include the horn blower and the dogs. In 1866 when he learned that The Quarry had been purchased by a group of young Boston artists, Courbet exclaimed: "What care I for the Salon, what care I for honors, when the art students of a new and great country know and appreciate and buy my works?"

Oil on canvas 82¾ x 72¼ in. (210.2 x 183.5 cm) Henry Lillie Pierce Fund 18.620

Jean-François Millet

French, 1814-1875

Harvesters Resting (Ruth and Boaz),

1850-53

Oil on canvas 26½ x 47½ in. [67.3 x 119.7 cm] Beguest of Mrs. Martin Brimmer 06.2421 Millet conceived this painting as a depiction of the biblical story of Ruth, a poor widow who supported herself by gathering grain left behind by the harvesters. When the artist exhibited this work at the Salon of 1853, however, he changed the title to underscore its contemporary significance. Millet has painted peasants of his own time, and the setting is the fertile plain of Chailly, breadbasket for much of France. In the 1850s, rural France was increasingly owned by absentee landlords more interested in personal gain than in the welfare of the people who worked their fields. The gleaner's meager bundle contrasts poignantly with the stacks of grain behind her, and Millet's Boaz is not the landowner of the biblical story but a sharecropper hired to work a rich man's land. In this, as in so many of his works, Millet urges respect for the hardship and dignity of humble lives.

Jean-François Millet French, 1814–1875 The Sower, 1850

Striding across broken ground, a peasant sows winter wheat in the cold November twilight. Behind him, an ox-drawn harrow closes the soil over the grain. This painting's dark, heavily worked surface inspired one critic to write that the artist "seemed to paint with the very earth that is being planted." Millet said that he was "driven to make pictures that mattered," and his art was revolutionary in its assertion that the commonplace activities of ordinary people were worthy subjects for serious art. France's Revolution of 1848 had granted the vote to all male citizens, including the landless peasants who vastly outnumbered landowners. Although Millet insisted that his art was not politi-

cal, many Parisians found this powerful, shadowed figure threatening when the painting was exhibited at the Salon of 1850. One writer saw the peasant as sowing not wheat but "the seeds of discord and revolution." In the 1850s, long before Millet was widely appreciated in his homeland, Boston artists and collectors traveled to France to meet the artist and purchase his works. The Museum acquired its world-famous holdings of Millet's work through the generosity of these foresighted collectors, in particular Martin Brimmer, the Museum's first president; local artist William Morris Hunt; and collector Quincy Adams Shaw.

Oil on canvas $40 \times 32 \% \text{ in. (101.6} \times 82.6 \text{ cm)}$ Gift of Quincy Adams Shaw through Quincy Adams Shaw, Jr. and Mrs. Marian Shaw Haughton 17.1485

Jean-Francois Millet French, 1814-1875 **Dandelions**, 1867-68

Millet frequently worked in pastel, which allowed him to combine his love of drawing and painting. Indeed, after 1865 he made almost as many pastels as oil paintings, thanks to an admiring patron, Parisian architect and financier Emile Gavet, who was prepared to buy every pastel that Millet produced. Here, against a richly variegated green background, Millet presents the life of a common wildflower, from tight buds to airy bursts of white-plumed seeds. Not a conventional still life, Dandelions is a landscape—a close-up view of a small patch of meadow that might otherwise be overlooked.

Pastel on tan wove paper 16 x 19³/₄ in. [40.6 x 50.2 cm] Gift of Quincy Adams Shaw through Quincy Adams Shaw, Jr. and Mrs. Marian Shaw Haughton 17.1524

Cabinet England, about 1870 Designed by Bruce Talbert, Scottish, 1838-1881

Trained as a woodcarver, architect, and cabinetmaker, Talbert was among the foremost designers of nineteenth-century Britain to work in the Gothic-revival style. He created designs not only for furniture but also for cast iron, textiles, ceramics,

stained glass, carpets, and wallpapers. Talbert worked in the Modern or Reformed Gothic style that aimed to counteract the extravagances of other revival styles with designs that were more honest and historically accurate.

The form of this cabinet derives from the English court cupboard of the Tudor period; its carved, gilded, and inlaid decoration is gothic in inspiration. The design for the cabinet appeared in Gothic Forms Applied to Furniture, Metal Work and Decoration for Domestic Purposes (1868), the book that established Talbert's reputation in England, Europe, and America.

Cherry, oak; veneers of thuya, ebony, walnut, and rosewood 85% x 24% x 44% in. [218.1 x 61.9 x 112.4 cm] John Wheelock Elliot and John Morse Elliot Fund and Arthur Tracy Cabot Fund 1997.188

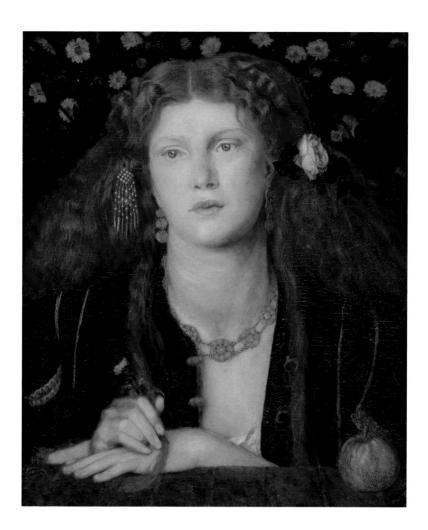

Dante Gabriel Rossetti

English, 1828-1882

Bocca Baciata (Lips That Have Been Kissed), 1859

Rossetti was a founding member, in 1848, of the Pre-Raphaelite Brotherhood, which sought to counteract the eclecticism and excess of the mid-nineteenth century by returning to the simplicity of medieval art. His works in the new style are detailed, story-telling images drawn from the Bible, the writings of Dante, or the legends of King Arthur. This painting, however, represents a turning point in Rossetti's career—the first example of the subject that was to occupy him

for the rest of his life. The painting depicts a sensual young woman with loosened hair and a distant, unfocused gaze. There is no story here, no clue to the painting's meaning. The poet Algernon Swinburne declared that *Bocca Baciata* was "more stunning than can be decently expressed," and many others recognized it as an assertion that a work of art might be only beautiful, without any obligation to moralize or instruct.

Oil on panel 12% x 10% in. [32.1 x 27 cm] Gift of James Lawrence 1980.261

Jean-Léon Gérôme French, 1824-1904 L'Eminence Grise, 1873

Gérôme's paintings—with their precise detail, imperceptible brushwork, and brilliant effects of color and light-epitomized the admired and officially sanctioned academic style that prevailed throughout Europe in the later nineteenth century. This wonderfully theatrical painting recreates the grand staircase of the palace of Cardinal Richelieu (the Red Cardinal) who ruled France during the childhood of Louis XIII in the early seventeenth century. Descending the staircase is Richelieu's secretary and confidant, François LeClerc du Trembly, a friar known as l'éminence grise (the Gray Cardinal), a term that has come to mean "the power behind the throne." Framed by a huge tapestry bearing Richelieu's coat of arms, the friar reads his prayerbook, ignoring the obsequious bows and resentful glances of

Oil on canvas 27 x 39³/₄ in. [68.5 x 101 cm] Bequest of Susan Cornelia Warren 03.605

the courtiers, whose opulent dress contrasts strikingly with his own sober garments.

Henri Regnault

French, 1843-1871

Automedon with the Horses of Achilles, 1868

Full of youthful fire and passion, this mammoth painting more than ten feet square—was painted while Regnault, the son of the director of the Sèvres porcelain manufactory, was a student in Rome. Several years later, the artist returned home to fight in the Franco-Prussian War and was killed during the siege of Paris at the age of twenty-seven. Derived from Homer's epic, the *Iliad*, the painting depicts Automedon, chariot driver for Achilles, struggling to control Xanthos and Balios, the horses that will carry the Greek hero into his final, fatal battle, Exhibited around the United States in the 1870s and 1880s, the painting was called both "the grandest painting in America" and "highly seasoned and unhealthful food which renders the palette insensitive to the milder flavors of what is wholesome." Following petitions by Boston artists and art students, this work was purchased by public subscription and presented to the Museum in 1890.

Oil on canvas 124 x 129½ in. [315 x 329 cm] Museum purchase with funds donated by contribution 90.152

Sir David Octavius Hill

Scottish, 1802-1870

Robert Adamson

Scottish, 1821-1848

 $Mrs.\ Elizabeth\ (Johnstone)\ Hall,$

Seated Newhaven Fishwife, 1843-47

The early photographic process of calotype, unstable and difficult to control, was nevertheless capable of effects of great beauty. Intrigued by its possibilities. Hill and Adamson formed a remarkable collaboration, and in less than four years they produced three thousand calotypes described by a contemporary as "the wonder of every gathering of scientific or artistic men." Their most innovative project—which effectively invented social documentary photographywas a series of photographs of the fishermen and women in the village of Newhaven, just north of Edinburgh. The fishwives, famous for their good looks and picturesque dress, cleaned the catch and carried it to market in huge baskets. In portraits like this one, where broad areas of light and dark are skillfully juxtaposed, the photographers created small works that are nevertheless monumental in feeling.

Calotype $8\% x \, 6\% \, in. \, [21.3 \, x \, 15.9 \, cm]$ Purchased with funds given by David Bakalar 1974.469

Sir Lawrence Alma-Tadema
Dutch (active in England), 1836–1912
Woman and Flowers (Opus LIX), 1868

On his honeymoon in Italy in 1863, Alma-Tadema spent hours sketching among the ancient Roman ruins at Pompeii, and throughout his career, he painted numerous works inspired by classical antiquity. The smooth, polished surfaces of his romantic re-creations of the past, like those of Jean-Léon Gérôme, are luminous in color and meticulous in the delineation of every material, surface, and detail. Alma-Tadema kept 168 volumes of photographs of Greekand Roman antiquities, and the objects in his paintings are scrupulously correct. Here, a young woman, probably modeled by the artist's wife Pauline, leans on a Pompeiian bronze table, the model for which is now in the archaeological museum of Naples.

Oil on panel 19% x 14% in. (49.8 x 37.2 cm) Gift of Edward Jackson Holmes 41.117

Master of the Housebook (Master of the Amsterdam Cabinet)

German, active about 1470-1500

Gypsy Woman with Two Children Holding a Blank Shield and Gypsy Man Holding a Blank Shield,

about 1475-80

Drypoint

Platemarks: 3\% x 2\% in. (9.2 x 7.2 cm); 3\% x 2\% in. (9.3 x 7.2 cm) Katherine E. Bullard Fund in memory of Francis Bullard 66.375, 66.376

Francisco Goya y Lucientes

Spanish, 1746-1828 The Giant, by 1818

Burnished aquatint

Platemark: 111/4 x 81/4 in, [28.5 x 21 cm]

Katherine E. Bullard Fund in memory of Francis Bullard

65.1296

Pablo Picasso

Spanish (worked in France), 1881-1973 The Bull, 1945

Lithograph (6 states) $12\frac{3}{4} - 13\frac{1}{4} \times 17\frac{1}{4} - 21\frac{1}{4}$ in. [32.4-33.6 x 44-53.9 cm] Lee M. Friedman Fund 1970.272-277 All encyclopedic collections of prints are measured both by the depth of their holdings and by individual works of superb artistic quality or rarity. These drypoints (below) are by the printmaker known as the Master of the Amsterdam Cabinet, one of the first to explore the medium for artistic purposes. These images, which demonstrate a remarkable ability to create natural poses and a convincing illusion of three-dimensional form, are among very few surviving examples. Similarly, the Museum's fine impression of Goya's *The Giant*, among the most enigmatic and compelling of the Spanish artist's graphic works, is a highlight of the collection.

On the other hand, one of the primary characteristics of printmaking is that many images—subtly or dramatically different—can be made by inking, printing, or otherwise altering the same woodblock, etching or engraving plate, lithographic stone, or silkscreen. Many printmakers value this ability to create variations on a theme, printing a composition and then modifying it by adding or removing lines, or by simply changing the colors of the ink, printing the image on papers of contrasting colors or textures, or wiping the ink in different ways to alter the balance of light and dark.

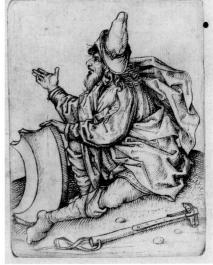

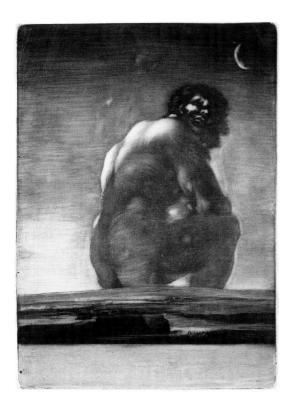

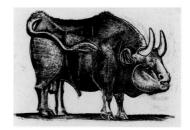

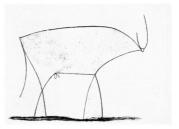

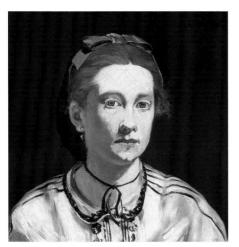

Edouard Manet French, 1832-1883 Victorine Meurent, about 1862

When Manet first saw Victorine Meurent, he was "struck by her unusual appearance and her decided air." She became his favorite model, posing for Street Singer and many other paintings of the 1860s. This small portrait clearly illustrates Manet's bold style, which was criticized for its "crude conflict of chalk whites with black tones" and for brushwork that seemed rough and unfinished. For Manet, however, this style was a means of rendering modern subject matter in an equally modern way.

Oil on canvas 16% x 17¼ in. (42.9 x 43.7 cm) Gift of Richard C. Paine in memory of his father, Robert Treat Paine 2nd 46.846

Edouard Manet French, 1832-1883 Street Singer, about 1862

Manet was one of the first great painters of modern urban life. One day, while walking through the streets of Paris, he saw a woman with a guitar emerging from a modest café. He asked her to pose for him, but she laughed and ran away. Although Street Singer was ultimately created in the studio using a professional model (eighteen-year-old Victorine Meurent), it retains the impact of Manet's initial experience-including the swiftly brushed glimpse of a petticoat as the woman lifts her skirt, her enigmatic expression, and the blurred impression of an aproned waiter beyond the swinging doors.

In this large painting, Manet gave a humble member of the working class great dignity, but most contemporary critics found the work vulgar and offensive.

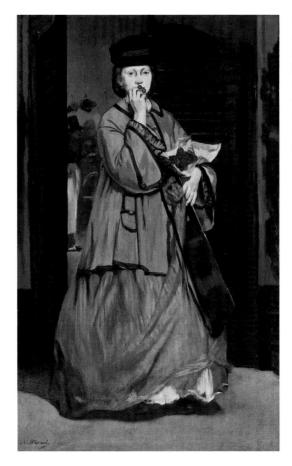

Oil on canvas 67% x 41% in. [171.1 x 105.8 cm] Beguest of Sarah Choate Sears in memory of her husband, Joshua Montgomery Sears 66.304

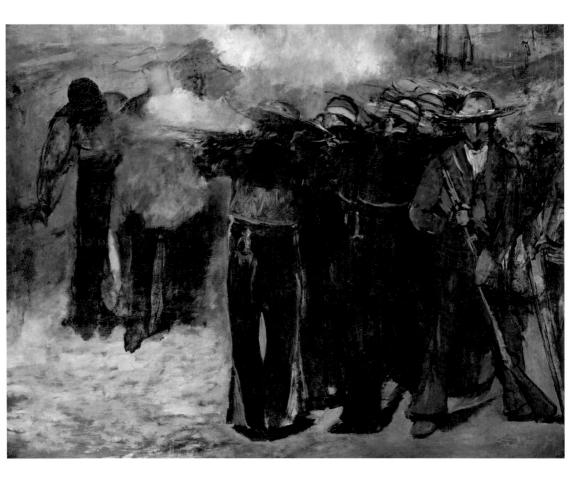

Edouard Manet

French, 1832-1883

Execution of the Emperor Maximilian, 1867

In 1864 Maximilian, brother of the emperor of Austria, was installed as emperor of Mexico under the protection of the French emperor Napoleon III and a French army of occupation. In 1867, however, Napoleon suddenly withdrew his support and his troops, and Maximilian was captured and executed by Mexican forces loyal to their former government. When the shocking news reached Paris, Manet—a republican and fervent critic of the French empire—decided to immortalize

this event on a scale traditionally reserved for scenes from history or the Bible. Basing his composition on photographs and eyewitness accounts, the artist worked for almost two years, producing four oil paintings and a lithograph of the subject. This immediate and impassioned painting is the first, unfinished version.

Oil on canvas

77% x 102% in. (195.9 x 259.7 cm)

Gift of Mr. and Mrs. Frank Gair Macomber 30.444

below

Pierre-Auguste Renoir

French, 1841-1919

The Seine at Chatou, 1881

This is one of Renoir's most radiant landscapes, in which the edges of forms dissolve in the brilliant sunlight, and even the figure merges into the meadow. It was painted near Chatou, a town ten miles from Paris on the banks of the Seine, easily reached by train, and popular among Parisians for weekend sailing and swimming. Not surprisingly, therefore, Renoir's painting evokes a mood of idyllic escapism. Working here in the spring of 1881, Renoir postponed a trip to London with a friend, explaining, "I'm struggling with trees in flower, with women and children, and I don't want to look at anything else."

Oil on canvas 28% x 36% in. (73.3 x 92.4 cm) Gift of Arthur Brewster Emmons 19.771

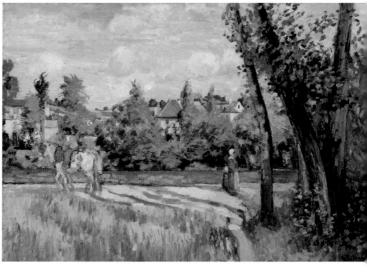

above

Camille Pissarro

French (born in the Danish West Indies), 1830-1903 Sunlight on the Road, Pontoise, 1874

Somewhat older than the other French Impressionists, Pissarro was an early leader of the group and later an important mentor to Cézanne and Gauguin. This serene view of a village near Paris,

with its fresh palette and broad brushwork, exemplifies Impressionist painting at the time of the group's first exhibition in 1874. Typical of Pissarro, the painting is not only direct and spontaneous but carefully structured around a series of horizontal bands punctuated by the verticals of the trees and animated by the woman and horseman making their way along the road.

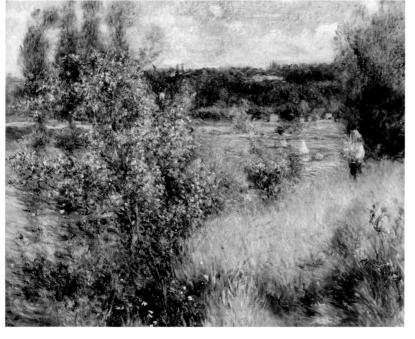

Oil on canvas 20% x 32% in. [52.4 x 81.5 cm] Juliana Cheney Edwards Collection 25.114

Furnishing panel

France (Lyon), about 1860-80

This is one of thirty-three woven silk furnishing panels in the Museum's collection that were made in the nineteenth century at the Mathevon et Bouvard factory. Founded in 1750, Mathevon et Bouvard was the most prestigious silk-weaving company of Lyon, France's center of textile production. The firm provided interior decoration for palaces throughout Europe; for royalty in Germany, Denmark, Spain, Russia, Britain, Egypt, and Morocco; and for private clients that included Sarah Bernhardt and members of the Rothschild family. The designs of these textiles reflect the period's fascination with historical styles, but the fabrics also reflect the burgeoning industrial era in which they were made. The remarkable colors are the result of chemical dyes, and these were among the first outstanding productions of

the innovative Jacquard loom, introduced about 1800, which allowed increasingly complex patterns and subtle shading.

Silk; velvet 25% x 61% in. (65.5 x 156.2 cm) John H. and Ernestine A, Payne Fund 1987.110

Odilon Redon

French, 1840-1916 **Tears (Les pleurs)**, 1878

During the late 1870s, Redon—a foremost Symbolist artist—began to work with charcoal to express and exorcize the visions and dreams that haunted him. He was drawn to charcoal's extensive tonal range and to its rich black, which he called "the most essential color." Redon referred to his large, elaborately worked charcoal drawings as his *noirs* (blacks). This powerful, mysterious work is a major example of the *noirs*, many of which depict floating heads or eyes, which seem to be images of the artist's inner, seeking self.

Charcoal with touches of white watercolor on paper

17½ x 14 in. (44.5 x 35.6 cm)
Sophie M. Friedman Fund and funds donated by Ruth V. S. Lauer in memory of Julia Wheaton Saines, and Susan Bennett, Claire and Richard Morse and Gift of Elizabeth Marshall Thomas and John K. Marshall 2005.199

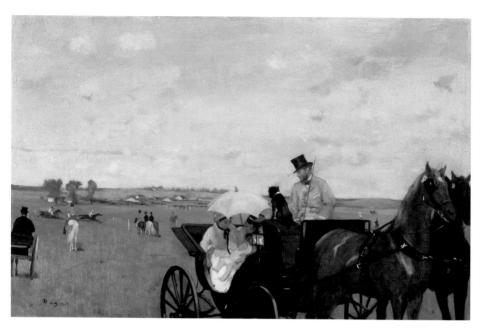

Edgar Degas French, 1834-1917 At the Races in the Countryside, 1869

Degas's paintings were often inspired by the amusements that he enjoyed as a well-to-do Parisian: the opera, the ballet, art exhibitions, and horseracing. Like many of his compositions, this painting of a race course in Normandy, shown at the first Impressionist exhibition in 1874, is artfully structured so as to appear as casual as a snapshot. Grouped informally in the foreground are Degas's friend Paul Valpinçon, his wife, and their infant son in the arms of his wet nurse. Their carriage and horses are cut off at the edges of the canvas in a radical crop of the scene. The abrupt juxtaposition of objects near and far away and the contrast of indistinct and sharply focused forms are other features that give this painting its revolutionary effect of spontaneity.

Oil on canvas 14% x 22 in. [36.5 x 55.9 cm] 1931 Purchase Fund 26,790

facing page, bottom

Edgar Degas

French, 1834–1917

The Violinist, about 1879

Degas's father was an accomplished organist, and the artist had a deep love and appreciation of music. During the 1870s he frequently attended rehearsals of the orchestra and ballet of the Paris Opéra, sketching the performers at work, often as preparatory studies for paintings. This study is for the violinist in The Rehearsal, a painting of a ballet practice now in the Frick Collection, New York. Although sketchy and spontaneous, the drawing is rich in tonal variations and bold line, the fall of light rendered with accents of white chalk. Degas captures with remarkable facility the progression of arms and instrument as they move from one position to the next.

Charcoal heightened with white chalk on blue-gray paper $18\% \times 12 \text{ in.} (47.9 \times 30.5 \text{ cm})$ William Francis Warden Fund 58.1263

Edgar Degas

French, 1834-1917

Edmondo and Thérèse Morbilli, about 1867

This intriguing double portrait shows Degas's sister Thérèse and her husband Edmondo Morbilli, their first cousin, whom she married in 1863. While never a professional portraitist, Degas created numerous images of family and friends in which he explored personality through pose, gesture, and the subtleties of facial expression. Here, Edmondo, self-assured and at ease, physically dominates the composition, while Thérèse, more introspective, one hand resting on her husband's shoulder, is partly in shadow, the details of her clothing a little blurred, as if out of focus. Although the composition suggests the formal, sixteenth-century portraits Degas had studied in Italy, the neutral background, shallow space, and overlapping poses are typical of contemporary daguerreotype photographs.

Oil on canvas 45% x 34% in. [116.5 x 88.3 cm] Gift of Robert Treat Paine, 2nd 31.33

Claude Monet French, 1840-1926 Rouen Cathedral Facade and Tour d'Albane (Morning Effect), 1894

Monet's series paintings of the 1890s-multiple variations of a single motif conceived, executed, and exhibited as a group—are among his most inventive and remarkable works. In the winter of 1892 the artist spent several months studying and painting the facade of Rouen Cathedral in his native Normandy. From rooms facing the cathedral across a square, Monet concentrated on the analysis of light and its effects on the forms of the facade, changing from one canvas to another as the day progressed. Later he extensively reworked the thirty paintings of the cathedral series in his studio at Giverny. Their encrusted surfaces of dry, thickly layered paint evoke the rough texture of weathered stone, absorbing and reflecting light like the walls of the cathedral itself.

Oil on canvas 41³/₄ x 29 ¹/₈ in. [106.1 x 73.9 cm] Tompkins Collection—Arthur Gordon Tompkins Fund 24.6

Claude Monet French, 1840-1926 Poppy Field in a Hollow near Giverny, 1885

Monet and his fellow Impressionists believed that art should express its own time and place and that it should do so in an appropriately modern style. In the 1860s and 1870s, working primarily outdoors, the Impressionists observed that objects seen in strong light lose definition and appear to blend into one another. No clear outlines exist in this sunny landscape. Its forms and textures are suggested by the size, shape, and direction of the brushstrokes, and the juxtaposition of complementary reds and greens gives the painting a vibrant intensity. By the mid-1880s, most members of the original group had turned away from Impressionism, but Monet declared: "I am still an Impressionist and will always remain one."

Oil on canvas 25% x 32 in. [65.2 x 81.2 cm] Juliana Cheney Edwards Collection 25.106

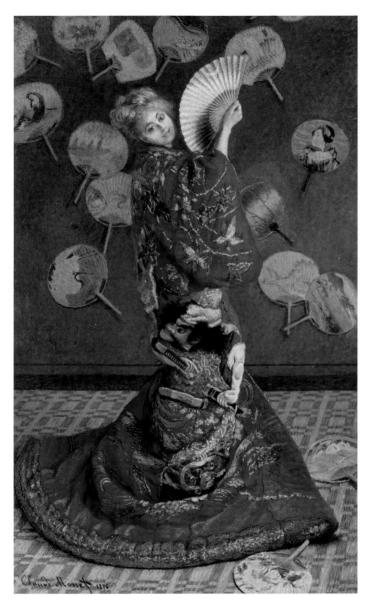

Claude Monet
French, 1840-1926

La Japonaise (Camille Monet
in Japanese Costume), 1876

The quintessential Impressionist landscape painter, Monet executed only a handful of major figure paintings. This life-size portrait, a great success at the second Impressionist exhibition in 1876, is a virtuoso display of color and texture as well as a witty comment on the current enthusiasm-which Monet shared-for all things Japanese. The seemingly coy model is Monet's wife, Camille, who wears a blond wig to emphasize her Western identity and holds a fan with the colors of the French flag. On one of the Japanese fans decorating the background wall, a woman in traditional costume casts the impostor a startled look, while the clever arrangement of the splendid robe animates the fierce warrior embroidered on it.

Oil on canvas 91½ x 56 in. [231.8 x 142.3 cm] 1951 Purchase Fund 56.147

Gustave Caillebotte

French, 1848-1894

Fruit Displayed on a Stand, about 1881-82

Although less well known than other French Impressionists, Caillebotte was one of the style's most original practitioners and a major promoter and collector of Impressionist art. Often attracted by unusual vantage points and innovative manipulation of space, his close-up view of a fruit vendor's wares enticingly arranged on rumpled paper was described by a contemporary critic as "still life freed from its routine." It is a memorable composition of complementary shapes and colors that gives an immediate sense of a display glimpsed along a Parisian street.

Oil on canvas 30 % x 39 % in. [76.5 x 100.6 cm] Fanny P. Mason Fund in memory of Alice Thevin 1979.196

Auguste Rodin

French, 1840-1917

Eternal Springtime

Modeled about 1881; cast about 1916-17

Rodin modeled Eternal Springtime while planning his monumental project The Gates of Hell, the bronze doors inspired by Dante's Inferno that were commissioned in 1880 for a planned museum of decorative arts. The Gates of Hell were never finished; the original plaster version is now in the Musée d'Orsay, Paris. Although Rodin ultimately did not include Eternal Springtime in his composition for the doors, it is among his most celebrated works, daring in the precarious pose of the figures, their lean bodies extended into space, and in the complexity of convex and concave curves as the bodies intertwine.

Bronze H. 24³/₄ in. [62.9 cm] Bequest of William A. Coolidge 1993.50

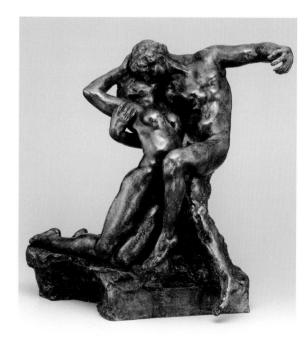

Cray

England, about 1884

Designed by William Morris, 1834–1896, for Morris & Company

Selvedge printed: Morris & Company 449 Oxford Street London W

The name of William Morris is synonymous with the Arts and Crafts movement, which reacted against the Industrial Revolution by advocating a return to hand-craftsmanship, honesty in materials and construction, and traditional crafts and techniques. Morris designed this furnishing fabric in 1884, and his London firm, Morris & Company, produced it for several decades. The firm employed centuries-old methods of dyeing and printing and rejected the bright, synthetic aniline dyes that had appeared in the 1850s. *Cray* was Morris's most complex and expensive textile, requiring thirty-four carved wooden blocks to print the lush design of peony blossoms, meandering vines, and delicate leaves. It

exemplifies the artist's belief that patterns were meant to "fill the eye and satisfy the mind."

Block-printed cotton plain weave 150 x 170 in. (381 x 177.8 cm) Samuel Putnam Avery Fund and Ernest Kahn Fund 2005.4

Théophile-Alexandre Steinlen
French (born in Switzerland), 1859-1923
Collection of the Chat Noir, 1898

In the 1890s Le Chat Noir (The Black Cat) was an innovative Montmartre cabaret, famous for its shadow plays, poetry readings, and concerts that attracted both Parisian artists and members of high society. Rodolphe Salis was the owner of Le Chat Noir, and Steinlen-who lived in Montmartre and made many posters for its artists, entertainers, and cabaret owners-first designed this bold and arresting poster to advertise the shows that brought Montmartre to Europe and North Africa every summer. Like many such ventures. Le Chat Noir could not survive the death of its founder, and it folded in 1897 after sixteen years. This poster is Steinlen's reworking of the original to announce the sale of Salis's art collection. The integration of text and image is particularly striking. Steinlen had a strong (but not sentimental) affection for cats, as is clear in this iconic image. In the cat's halo are the words "Mon Joye Montmartre."

Poster, color lithograph $54\% \times 39\%$ in. [139.4 x 99.1 cm] Ernest Wadsworth Longfellow Fund and partial gift of James A. Lapides 2002.62

Pierre-Auguste Renoir French, 1841-1919 Dance at Bougival, 1883

One of Renoir's most ambitious and beloved works, this painting was executed in the studio but captures with delightful immediacy a sunny afternoon at Bougival. Close to Paris and frequented by city dwellers, Bougival's open-air cafés were described as "quite select and expensive, and girls go there without particular expectations." Renoir's young woman was modeled by Suzanne Valadon, a trapeze artist turned professional model who became well known as a painter and was the mother of artist Maurice Utrillo. Renoir's friend Paul Auguste Llhote, a notorious ladies' man, posed as Valadon's intent partner. The motion of the dancing couple is conveyed by the swirl of the woman's skirt and by the blurred focus of the revelers in the background. The painting is timeless in the pleasure it conveys but modern in its setting and details-Valadon's dress, bonnet, and haircut, for example, were the latest summer fashions in 1883.

Oil on canvas 71% x 38% in. [181.9 x 98.1 cm] Picture Fund 37.375

James Jacques Joseph Tissot French, 1836–1902 Women of Paris: The Circus Lover, 1885

Tissot, like the Impressionists, chose his subjects from modern urban life, but his detailed and polished style is that of traditional academic painting. This is one of a series called *Women of Paris (La femme à Paris)* that depicts women of different social classes encountered as if by chance at their occupations and amusements.

Circuses were popular entertainments in Paris and were painted by Degas and, later, by Picasso, among others. The event seen here is a "Cirque du High Life" in which the amateur performers were aristocrats. An early exhibition catalogue explained: "The man on the trapeze facing you . . . is no less than the Duc de la R—, and his companion is of the same blue blood."

Oil on canvas 58 x 40 in. [147.2 x 101.6 cm] Juliana Cheney Edwards Collection 58.45

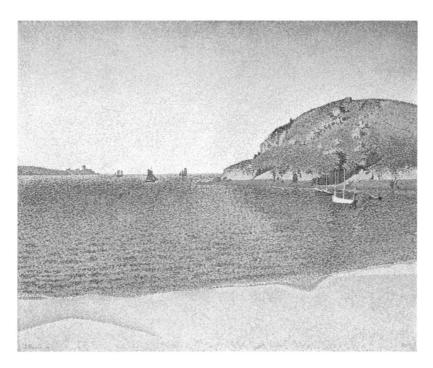

Paul Signac French, 1863-1935 Port of Saint-Cast, 1890

Signac was profoundly inspired by Georges Seurat (1859–1891), who developed the style of painting called pointillism (or divisionism), in which color and form are rendered in tiny touches of paint. Signac became the chief theorist of the new style and also devoted himself to the scientific study of optics, publishing his findings on the relationship of light and color in 1898. This austere, luminous seascape is one of a series of four paintings depicting different views of the coast of Brittany, France, that Signac exhibited in 1891 as The Sea. The large, simplified forms of the spare design may reflect Signac's admiration for the Japanese woodblock prints that influenced many French painters in the later nineteenth century.

Oil on canvas 26 x 32½ in. [66 x 82.5 cm] Gift of William A. Coolidge 1991.584 facing page, bottom

Paul Cézanne

French, 1839-1906

Turn in the Road, about 1881

During the 1870s, Cézanne worked closely with Camille Pissarro, who taught him to paint outdoors using the bright colors and broken brushstrokes of Impressionism. Cézanne, however, was always less interested in the changing face of nature than in its permanent aspects. Here, the artist shows his preference for clearly outlined shapes and for threedimensional forms modeled with squarish brushstrokes of changing colors. While the road draws us back into space, it exists at the same time as a flat, yellowish shape: Cézanne is asserting that, although his painting gives the illusion of recession and of depth, it is first and foremost a work of art that actually exists only on the surface of the canvas. Turn in the Road was owned for many years by Claude Monet.

Oil on canvas 23% x 28% in. [60.6 x 73.3 cm] Bequest of John T. Spaulding 48.525

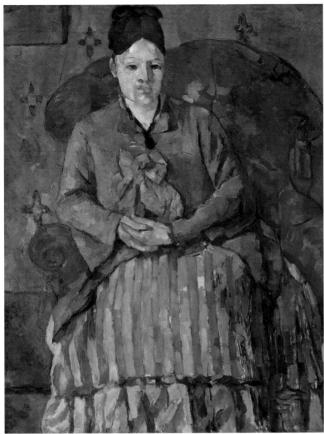

Paul Cézanne French, 1839–1906 Madame Cézanne in a Red Armchair, about 1877

Cézanne said: "I want to make Impressionism into an art as solid and lasting as the art of the museums." Whether painting landscapes, still lifes, or people, the artist spent many painstaking hours studying and analyzing his subjects, and some of his portraits required up to one hundred sittings. More than two dozen portraits exist of Hortense Figuet. who lived with Cézanne for almost twenty years before they married in 1886. Painted in the couple's Paris apartment, this early portrait has a serene and timeless monumentality; its many small blocks of subtly varied color, describing shadows and volume, are locked into a harmonious whole. After seeing this painting in a 1907 exhibition, the German poet Rainer Maria Rilke wrote: "In this red armchair, which is a personality, a woman is seated....It seems that each part [of the paintingl knows of all the other parts."

Oil on canvas 28½ x 22 in. (72.5 x 56 cm) Bequest of Robert Treat Paine, 2nd 44 776

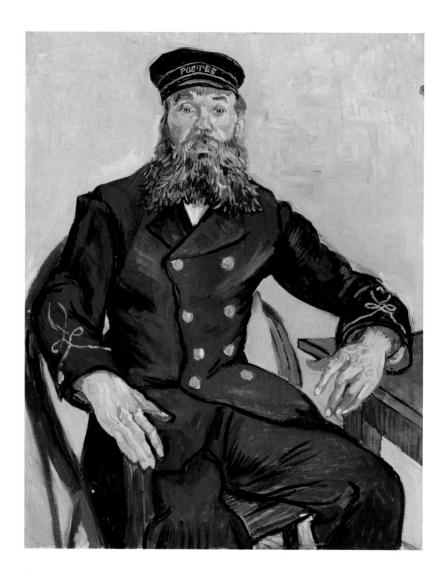

Vincent van Gogh Dutch (worked in France), 1853-1890 Postman Joseph Roulin, 1888

In 1886 van Gogh left his native Holland for Paris, where he learned from the Impressionists to look closely at nature and to lighten his dark palette. Unlike the Impressionists, however, he became less interested in capturing visual reality than in exploring color and line as a means of personal expression. In 1888 he went south to Arles, where he made six portraits of the local postman, Joseph Roulin. Wanting to "paint the postman as I feel him," he rendered the figure in intense, brilliant color, the forms notably the hands—distorted for expressive effect. The artist described his subject as "a man who is neither embittered, nor sad, nor perfect, nor happy, nor always irreproachably right. But such a good soul and so wise and so full of feeling and so trustful."

Oil on canvas 32 x 25³/₄ in. [81.3 x 65.4 cm] Gift of Robert Treat Paine, 2nd 35.1982

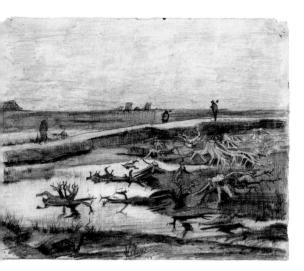

Vincent van Gogh

Dutch (worked in France), 1853-1890

Landscape with Bog Trunks (Work in the Fields),
1883

Van Gogh studied for the ministry and worked as a lay preacher among coal miners before deciding to become an artist. The work of his early, Dutch period, inspired by the art of French painter Jean-François Millet, is imbued with his intense sympathy for the harsh life of the working poor. This early drawing of workers digging peat in a bleak landscape anticipates the emotional power of van Gogh's mature style. The artist wrote to his brother about it: "Yesterday I drew some decayed oak roots, so-called bog trunks (that is, oak trees that have perhaps been buried for a century under the bog...). Some black ones were lying in the water in which they were reflected, some bleached ones were lying on the black earth. A little white path ran past it, behind that more peat, pitch-black....it was absolutely melancholy and dramatic."

Graphite pencil with pen and brown ink on paper $13\frac{1}{2} \times 16\frac{1}{2}$ in. $[34.3 \times 42.4 \text{ cm}]$ Gift of John Goelet 1975,375

Vincent van Gogh Dutch (worked in France), 1853-1890 Houses at Auvers, 1890

Van Gogh moved in 1890 to the village of Auvers, near Paris, placing himself in the care of Dr. Paul Gachet, who had long been interested in both psychiatry and the arts. Here, van Gogh depicted the street not far from Dr. Gachet's house, creating a flattened tapestry of shapes in which the tiled and thatched roofs form a patchwork of texture and color. Although based on observation, *Houses at Auvers*—with its swirling, stabbing brushstrokes and sinuous contours—is a landscape of emotions, charged with energy and passionate feeling. Not long after this painting was finished, van Gogh committed suicide at the age of thirty-seven.

Oil on canvas $29\% \times 24\% \text{ in. } [75.6 \times 61.9 \text{ cm}]$ Bequest of John T. Spaulding 48.549

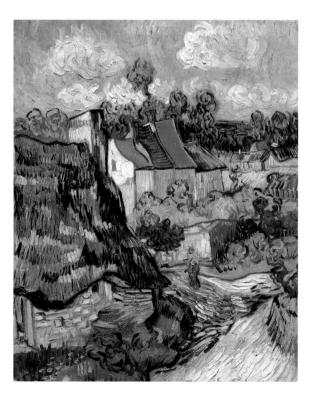

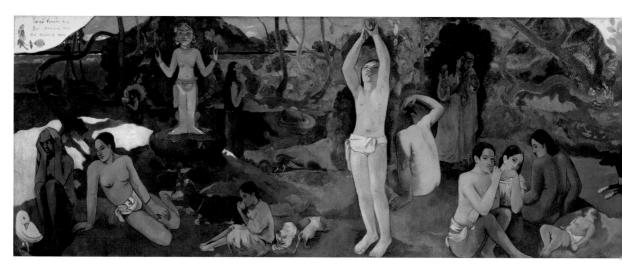

Paul Gauguin

French, 1848-1903

Where Do We Come From? What Are We? Where Are We Going?, 1897-98

Gauguin wrote, "The Impressionists look for what is near the eye, and not at the mysterious centers of thought." He, in contrast, sought to capture an inner world of fantasy and dream and considered this enormous canvas, created in Tahiti, his masterpiece. He indicated that the painting should be read from right to left, with the three major figure groups illustrating the questions posed in the title. The three women with a child represent the beginning of life; the central group symbolizes the daily existence of young adulthood; and in the final group, according to the artist, "an old woman approaching death appears reconciled and resigned to her thoughts"; at her feet "a strange white bird . . . represents the futility of words." Yet, as so often in Gauguin's work, the whole remains mysterious: "Explanations and obvious symbols would give the canvas a sad reality," Gauguin wrote, "And the questions asked [by the title] would no longer be a poem."

Oil on canvas 54¾ x 147½ in. [139.1 x 374.6 cm] Tompkins Collection—Arthur Gordon Tompkins Fund 36.270

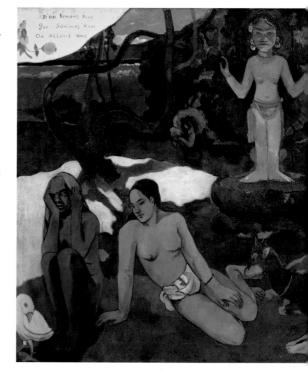

Paul Gauguin

French, 1848-1903

Soyez amoreuses vous serez heureuses

(Be In Love and You Will Be Happy), 1889

A stockbroker by profession, Gauguin began painting as a hobby in the early 1870s and soon became part of the Impressionist circle. In 1883 he lost his job and decided to become a full-time artist. Three years later he made his first trip to Brittany, in France—the beginning of his lifelong search for places untainted by the materialism of modern urban society, which Gauguin saw as "morally and physically corrupt."

Carved in Brittany, this extraordinary relief addresses the theme of love with bitterness and

sarcasm. Gauguin wrote: "I have carved something... remarkable. Gauguin (as a monster) seizing the hand of a protesting woman and telling her: 'Be in love and you will be happy.'" The fox at lower right is an Indian symbol of perversity and reappears in the work Gauguin executed in Tahiti.

Carved and painted lindenwood $37\% \times 28\% \times 2\%$ in. $(95 \times 72 \times 6.4$ cm) Arthur Tracy Cabot Fund 57.582

Vase Hungarian (Pécs), about 1900 Produced by the Zsolnay Manufactory after a model by Lajos Mack

This vase molded with a winged dragon was made at the factory founded by Vilmos Zsolnay in 1855 in Pécs, a Hungarian town near the Austrian border. Beginning with earthenware vessels in traditional styles, the Zsolnay factory expanded production in the 1870s to include more refined and decorative wares, some inspired by Turkish, Chinese, or ancient American ceramics. Luster glazes imitating contemporary iridescent glass were developed at the factory in the 1890s. A range of subtly colored luster glazes creates the rich surface effect of this fanciful vase whose asymmetrical, curving forms and stylized naturalism typify the influential Art Nouveau style.

Earthenware with luster glazes 13³/₄ x 7⁵/₈ in. [34.9 x 19.4 cm] European Decorative Arts Curator's Fund 1990.173

Edvard Munch Norwegian, 1863-1944 Evening (Melancholy), 1896

Munch's first attempts at printmaking, of which this is an example, were made in Paris, a center of experimentation in printmaking methods. At first working in color lithography (which required extensive collaboration with a professional printer), Munch soon turned to woodcut, a technique that enabled him to prepare the block himself up to the moment of printing. In his woodcuts, the artist innovatively included the grain of the wood into his designs. He also developed a unique jigsaw-puzzle technique of sawing the wooden blocks into pieces, inking them individually, then reassembling and printing them as a single block. Composed of simplified shapes and curving, expressive line, this image, derived from his Frieze of Life paintings, universalizes human experience while depicting a specific subject—a friend, infatuated with an older woman, who mourns alone on a beach while his lover and her husband embark on a boat trip on a midsummer night.

Color woodcut, printed from two blocks on thin Asian paper Block: 14³/₄ x 17⁷/₈ in. [37.6 x 45.5 cm] William Francis Warden Fund 57.356

Edvard Munch Norwegian, 1863–1944 Summer Night's Dream (The Voice), 1893

Many of Munch's most memorable paintings are from the series called *The Frieze of Life*, which deals symbolically with themes of love and death. *Summer Night's Dream* presents a gently melancholy evocation of adolescent sexual awakening, in which the still figure of the girl both offers herself to and holds back from the viewer, whom the artist has placed in the position of her anticipated lover. The setting is

probably the Borre woods on the Oslo Fjord, a site of ancient Viking graves and a traditional place for courtship during Norway's softly illuminated summer nights. Munch's notes reveal that this painting recalls his first, ultimately painful love affair: "What a deep mark she left on my mind, so deep that no other image can ever totally drive it away."

Oil on canvas 34% x 42% in. [87.8 x 108 cm] Ernest Wadsworth Longfellow Fund 59.301

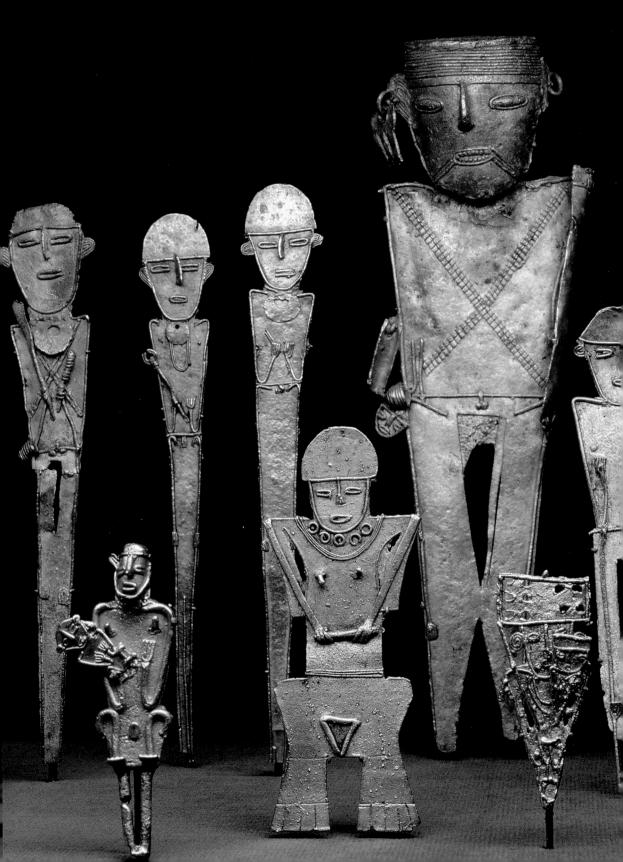

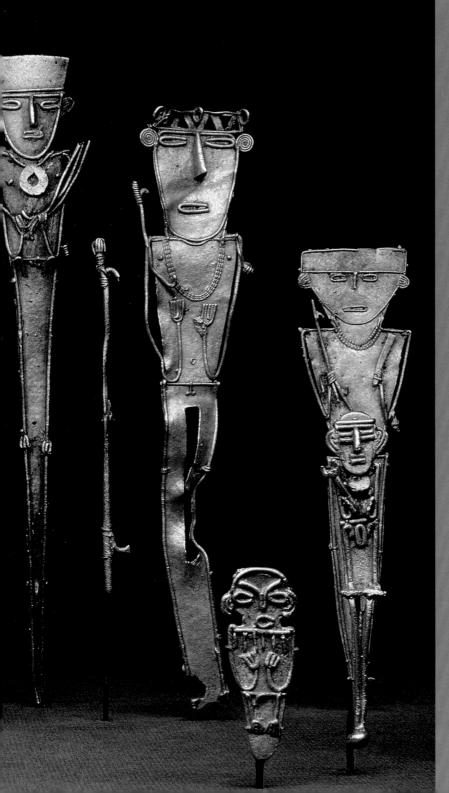

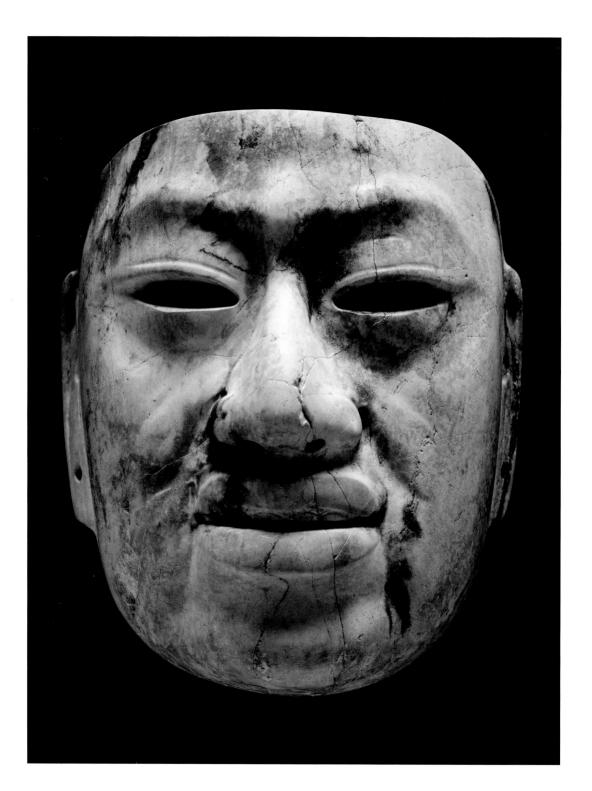

Mask

Olmec culture Mexico, 900-550 B.C.

Beginning three thousand years ago in what are today Mexico, Central America, and South America, great civilizations arose, prospered, declined, and were absorbed into succeeding cultures that built upon their achievements. The art, architecture, city planning, science, religion, social structure, and political organizations that existed before the Spanish invasions of the midsixteenth century represent the accomplishments of societies that—

along with Mesopotamia, Egypt and Nubia, India, and China—are among the cradles of civilization.

The Olmec, who lived along what is now the Gulf Coast of Mexico, were the first inhabitants of the Americas to develop a writing system, to create complex visual symbolism, and to use art as a means of embodying their beliefs. Olmec civilization influenced all subsequent societies in ancient Mesoamerica (present-day Mexico, Guatemala, Belize, Honduras, and El Salvador). Olmec artists excelled in working precious, green jadeite that they presumably acquired through trade with distant places. Jadeite is an extremely hard stone, and the Olmec, who had no metal tools, worked it with other stones and abrasives such as crushed garnet. This powerful Olmec mask may have been displayed as a symbol of authority, worn during ceremonies, or attached to the mummified body of a deceased lord.

Jadeite with black inclusions H. 8½ in. [21.6 cm] Gift of Landon T. Clay 1991.968

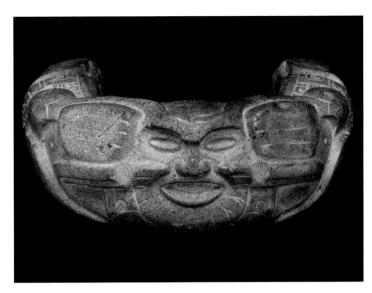

Ballgame yoke
Veracruz culture
Mexico, A.D. 450-700

Throughout Mesoamerica, players of the ritual ballgame wore U-shaped yokes around their waists. The remains of the sole surviving example are wood. Players used the yoke to hit a solid rubber ball, batting it between two teams or two players and never allowing it to touch the ground. This stone yoke was too heavy to be worn, and its carved image of a bearded person—perhaps the hero Quetzalcóatl—suggests a ritual function. The yoke may have been a prized possession or a trophy that eventually was placed in a tomb as a funerary offering.

Carved stone L. $16\,\%$ in, [42 cm] Gift of Lavinia and Landon T. Clay 2003.855

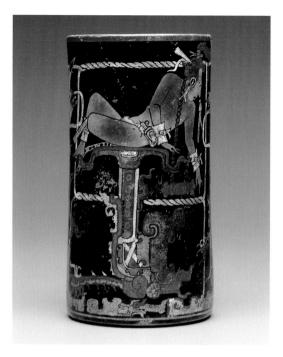

Drinking vessel (cylinder vase) Maya culture Guatemala, A.D. 740-80

The sophisticated civilization of the Maya reached its height in the Classic period (A.D. 250-900). During this time, artists-who were highly educated members of elite society-produced extraordinary painted ceramics that served ritual functions in life and were also buried in tombs of the honored dead. This vessel is one of the masterpieces of Maya art. The artist has exploited the watercolor-like potential of slip paint (clay diluted to a watery consistency and colored with mineral pigments) to create the subtle washes on the figures' bodies. The painting depicts the birth of a supernatural being whose supple body is framed by a stylized white umbilical cord.

Earthenware with red, white, gray, and black slip paint on cream slip ground H. 8¾ in. [22.5 cm] Gift of Landon T. Clay 1988.1168

Burial urn Maya culture Guatemala, A.D. 650-850

The Kichai Maya people of highland Guatemala buried royal and noble individuals in large, ceramic urns such as this. The body of the deceased was tightly flexed and wrapped in cloth, placed in the urn with offerings of pottery and jadeite, and then buried inside pyramids or sacred caves. The lid of this urn is sculpted as the head of a supernatural being whose open mouth may have been used to make offerings to the deceased in the afterlife. The figure on top of the lid, holding two cobs of corn (maize), is probably the Maize God.

Earthenware with white, black, yellow, and red slip paint H. 52 in. (132.1 cm) Gift of Landon T. Clay 1988.1290b

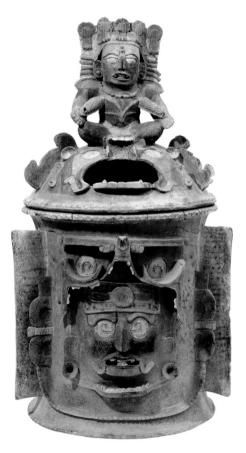

Drinking vessel (cylinder vase)

Maya culture

Mexico, A.D. 600-750

The painstaking decipherment of the hieroglyphic texts and images painted on Maya ceramics is enabling scholars, for the first time, to grasp the intricacy of Maya politics, history, and religion. The figures on this vessel are identified by the large

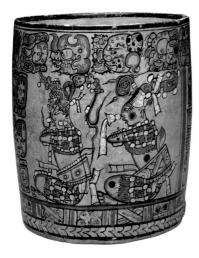

hieroglyphs above their heads as Hun Ajaw and Yax Balam, the Hero Twins. The bold escapades of these supernaturals are recounted in the *Popol Vuh*, the creation myth of the Kichai Maya people. The father of the Hero Twins had descended to the Underworld and been tricked and then killed by the lords who resided there. Later, the Hero Twins traveled in their father's footsteps and succeeded in outfoxing the Lords of the Underworld. The hieroglyphic text around the rim states that the vessel was used for a special chocolate drink made from the sweet pulp of the cacao fruit that was consumed by the elite on ceremonial occasions.

Earthenware with red, white, and black slip paint on yellow-cream slip ground H. 8 in. [20.3 cm]
Gift of Landon T. Clay 1988.1169

Codex-style plate

Maya culture

Guatemala, A.D. 680-750

The Maya believed that the first humans were formed from ground corn (maize), and they saw the reappearance of maize in the fields each spring as a metaphor for the resurrection of the human soul. This plate depicts the Maize God "growing" from the crack in a turtle shell, symbol of the earth. The figure also represents First Father flanked by his sons, the Hero Twins, who defeated the Lords of the Underworld, rescued their father's bones, and thus created the path of resurrection from death. The style of painting on this plate, which was used to hold corn tamales, is similar to that found in a Maya codex, or book made of folded leaves of fig-bark paper. Thousands of these books were burned by the Spanish, who believed they contained "lies of the devil," and only four fragments are known to exist today. The scenes painted on codexstyle vessels are therefore important evidence of classic Maya religion and cosmology.

Earthenware with brown-black and red slip paint on cream slip ground
Diam. 12% in. (32 cm)
Gift of Landon T. Clay 1993.565

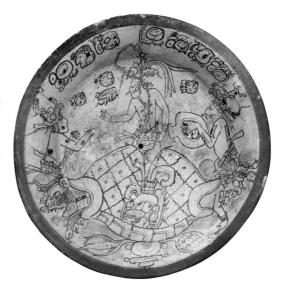

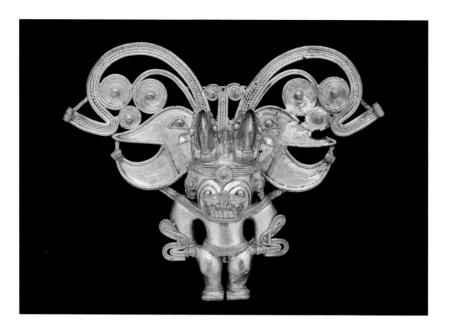

Effigy pendant

Tairona culture Colombia, A.D. 1000-1530

Called "sweat of the sun" by the Inca of Peru, gold was believed by many ancient American civilizations to embody the essence of the sun. Gold ornaments were used in religious ceremonies, buried with the dead, and worn as emblems of political power and social status. Skilled artisans showed a fine sensitivity to the inherent beauty of the metal and produced an amazing variety of forms that, like all ancient American art, embodied symbolic meanings and functions. Gold, mostly mined from riverbeds, was plentiful. Although goldsmiths worked only with stone and bronze tools, they developed most techniques known

today, including cold-hammering, embossing, soldering, welding, casting, gilding, and fabricating alloys.

The Spanish who invaded Central and South America in the mid-sixteenth century were interested only in the monetary value of gold and melted down thousands of objects, sending an estimated 18,000 pounds of American gold to Spain. The vast majority of gold objects known today survive because they were hidden in burials. The Spanish invaders believed that male figures of this sort, wearing masks and fantastic headdresses and grasping ritual objects, represented caciques, or chiefs.

Gold alloy H. 6% in. [16 cm] Gift of Landon T. Clay 2000.813

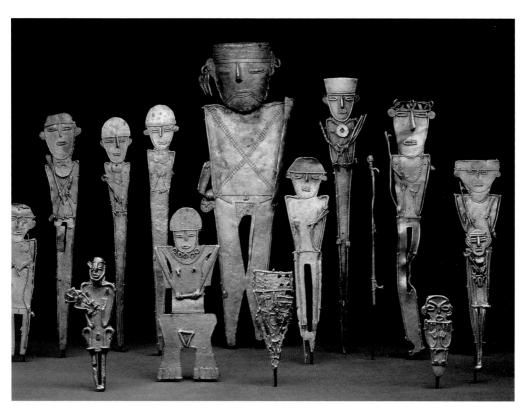

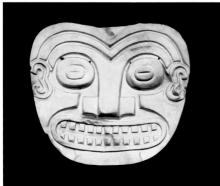

Pectoral

Coclé style Panama, A.D. 700–1520

Gold W. 10¾ in. [26.3 cm] Gift of Landon T. Clay 1971.1127

Offering figures (tunjos)

Muisca culture Colombia, 1300–1550

In an isolated highland valley near modern-day Bogotà, Colombia, the Muisca people developed unique works of art in metal, including these distinctive offering figures, or *tunjos*. Many represent men with implements and headdresses indicating political, religious, or social affiliation. *Tunjos* were cast in a single mold using only one flow of metal. In their search for gold, the Spanish invaded Muisca lands three times. Enslaved and with no resistance to European diseases, the Muisca were extinct by the seventeenth century.

Gold, copper, and tin alloy Height of tallest figure: 8½ in. [21 cm] Gifts of Landon T. Clay

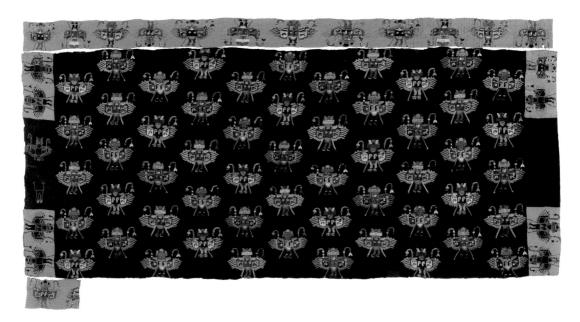

Mantle

Paracas culture Peru, A.D. 50-100

In the ancient Andean world, textiles played a profound symbolic role in sacred and secular life. Andean textiles are among the most complex ever made (some of their techniques have never been replicated), and the prestige of cloth was directly related to the extraordinary energy that spinners, dyers, weavers, and embroiderers expended to produce it.

When burials of the Paracas civilization were uncovered in the early twentieth century, the bodies were found wrapped in textiles that had been perfectly preserved in the desert sands of Peru's coastal plain for almost 2,000 years. It has been estimated that all the textiles in one large mummy bundle may have taken between 11,000 and 29,000 hours to complete. The ritual figures embroidered on this mantle wear elaborate headdresses, masks, embroidered tunics, and feathered capes. They hold serpentheaded staffs and decapitated heads that denote their power.

Camelid fiber; plain weave with stem-stitch embroidery 39³/₄ x 96¹/₈ in. [101 x 244.3 cm] Denman Waldo Ross Collection 16.34a-c

Wari-related culture Peru, probably A.D. 500-800

The ancient Andean cultures of western South America (present-day Peru and parts of Bolivia, Chile, and Ecuador) flourished in a harsh environment in which the world's second highest mountains—the Andes—are bounded on the west by coastal desert and on the east by Amazonian jungle. In these cultures, featherwork textiles were highly prized, and people of the highlands and coast were prepared to cross the Andes

to trade with inhabitants of the jungle for the brilliant feathers of curassows, egrets, and various types of macaws. This textile, sewn with rows of cut feathers, shows standing figures wearing tapestry-woven tunics. The large faces below may represent the decapitated heads of defeated warriors.

Cotton and tropical bird feathers; plain weave with applied strings of knotted cut feathers $39\,\%\,x\,38\,\%\,in.\,(99.5\,x\,98.5\,cm)$ John H. and Ernestine A. Payne Fund $\,$ 60.253

Storage jar

New Mexico (Cochiti or Santo Domingo Pueblo), about 1860-75

This unusually large jar was created for use in the home, not for the collectors' market. In this period, women made the ceramic vessels necessary for ceremonial use and for the cooking, serving, and storage of food and water. Jars of this size, intended to hold grain, were highly valued and passed down from mother to daughter. The bold decorations evoke rain and water; they were painted with slip, a thin mixture of clay and water colored with mineral pigments.

Earthenware with slip paint H. 18 in. (45 cm) Gift of Independence Investment Associates, Inc. 1997.175

Silver Horn (Huangooah)

Kiowa Apache, 1861-1940

The Once-famous Black Eagle (Ka-et-te-kone-ke) of the Kiowa in Deadly Conflict with Ute Chief. Ute Killed.

Oklahoma (Fort Sill), 1877-78

Over many centuries, Plains Indians painted records of their battles, ceremonies, and tribal history on rock walls, hide robes, and tipi coverings. In the reservation period, some native artists continued this tradition using new materials—paper, pencils, crayons, and inks. Such works as this one are called "ledger drawings" because many were executed in ledger, or account, books. This lively image of a battle between Kiowa and Ute warriors is the work of Silver Horn, a member of a family known for several generations of artists. The drawing is one of thirty-three in a sketchbook annotated by Horace Pope Jones, a civilian interpreter at Fort Sill, Oklahoma.

Graphite pencil and colored crayons on paper 10 % x 14 in. (25.7 x 35.6 cm) Gift of the Grandchildren of Lucretia McIlvain Shoemaker and the M. and M. Karolik Fund 1994,429,24

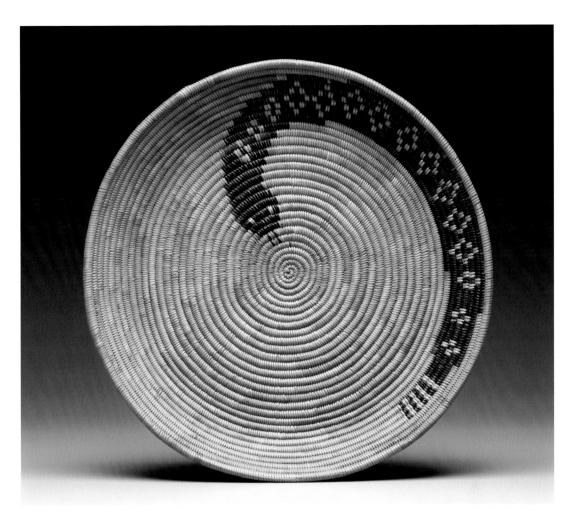

Tray

Mission culture

Southern California, probably Cahuilla, about 1900 Attributed to **Guadalupe Arenas**, active about 1900–1920

Basketry was the major art form of the Mission Indians (so named because they lived near the Spanish missions along the California coast). Coiled baskets and other objects were woven primarily of native sumac that was often dyed and juncus grass, whose stem changes naturally from deep brown to tan as it grows. Fine Mission baskets such as this were made

for collectors from the 1890s into the 1930s, providing much-needed income for the weavers and their families. This tray may be the work of Guadalupe Arenas, who worked as a laundry woman in a Palm Springs tuberculosis sanatorium. The rattlesnake, a favorite motif on Mission baskets, was viewed as a symbol of power, an avenging spirit, and a protective deity that would bring good fortune to the weaver.

Coiled grass stems, juncus grass, sumac

Diam. 11½ in. [29.2 cm]

John Wheelock Elliot and John Morse Elliot Fund 1992.197

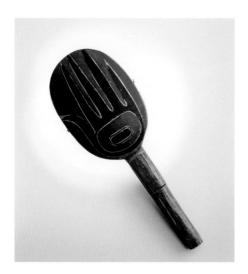

Rattle Probably Tsimshian culture Canada (coastal British Columbia), about 1900

Among Northwest Coast cultures, rattles played important roles in rituals of power and healing. They were made in an immense variety of shapes and patterns. Because artistic motifs and actual works of art were shared among the groups of native people along the coast of British Columbia, it is often difficult to identify the origin of a particular object.

Probably alder and birch, paint, gut, pebbles H. 10½ in. (26.7 cm) Gift of Elizabeth Wetherill McMeel and The Seminarians 1996.28

Bent-corner chief's chest Probably Tsimshian culture Canada (coastal British Columbia), about 1860

In traditional Tsimshian society, chests like this were used to store ritual objects such as masks and rattles, as well as the blankets and copper plaques that were indicators of wealth and status. The work of a highly skilled carpenter, the chest's four sides are made of a single piece of wood, which was steamed and bent into the shape of a box. Native people of the Northwest Coast believed in close and constant contact between the physical and spirit worlds, with humans and animals passing back and forth between the two realms, changing from one shape to another as they did so. Ravens, fish, and a mythical creature intermingle across the surface of this chest and defy any single interpretation.

Yellow cedar and red cedar with black, red, and blue pigment 26³/₄ x 41³/₈ x 24¹/₄ in. [67.7 x 105.1 x 61.8 cm] Gift of a Friend of the Department of American Decorative Arts and Sculpture 1997.9

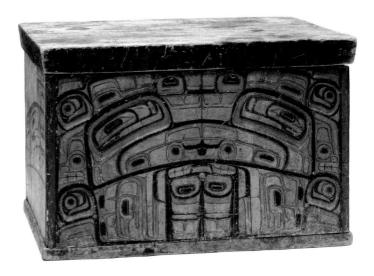

Potlatch figure

Canada (Northern Vancouver Island), about 1840

A center of social and ritual life among the peoples of the Northwest Coast, the potlatch was a feast in which the host showered his guests with food, drink, and gifts of blankets, masks, and valuable plaques of decorated copper. In this way the potlatch host demonstrated his wealth and ensured both the respect of his neighbors and his own future gain, since at a later time his guests would present him with even more lavish gifts at their ceremonies. This monumental figure would have been set up on the shore to welcome guests to the potlatch. The trapezoidal shape over his chest represents a copper plaque, symbol of the real goods that guests would receive during the festivities.

Red cedar, paint
H. 67% in. (168 cm)
Gift of a Friend of the Department of American
Decorative Arts and Sculpture 1998.3

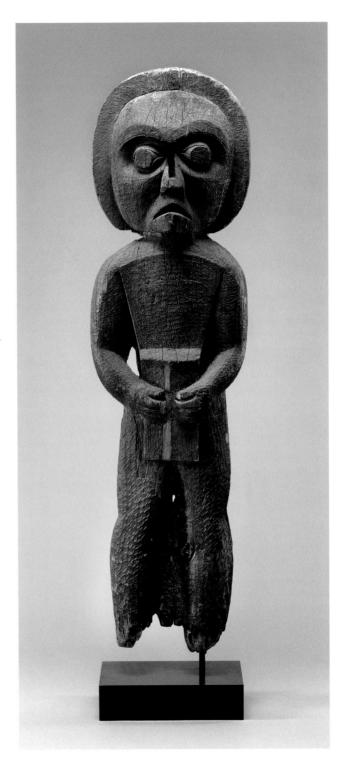

american art TO 1900

Freake-Gibbs painter

Margaret Gibbs, 1670

Robert Gibbs, the fourth son of a knight, left England to seek his fortune in the New World and became a prosperous Boston merchant. As a statement of his own social and economic success, Gibbs commissioned portraits of his children—Margaret, Robert (also in the Museum's collection), and Henry (Sunrise Museum, Charleston, West Virginia). Even the elaborate lace and needlework on Margaret's dress testify to her father's status, because Massachusetts law forbade the wearing of such finery unless the man of the house "possessed either a liberal education or an annual income of £200." This charming image of seven-year-old Margaret is one of very few surviving portraits from seventeenth-century New England; its emphasis on detail of costume and on line reflect a style—fashionable at the court of Queen Elizabeth which was still current in parts of England in the 1660s.

Oil on canvas

40½ x 33½ in. (102.9 x 84.1 cm) Beguest of Elsie Q. Giltinan 1995.800

Leather great chair

Massachusetts (Boston), 1665-80

With its leather coverings, marsh grass stuffing, and rows of brass nails, this is the only known upholstered great chair (armchair) to survive from seventeenth-century New England. Many families in this period did not even own a chair, and the great chair was a luxury item reserved for heads of families and honored guests. It became a possession of even more value and status when upholstered. This one belonged to Zerrubabel Endicott (1635–1683) of Salem, Massachusetts, a prominent surgeon and son of John Endicott, governor of the Massachusetts Bay Colony. The frame is virtually identical to those of London upholstered great chairs made at the same time, an indication of the determination and ability of colonial Americans to keep up with English fashions. The velvet cushion is a reproduction based on those depicted

> in prints and paintings of seventeenth-century interiors.

Oak and maple with original upholstery foundation, leather cover, and brass nails $38 \times 23\% \times 16\%$ in. [96.5 × 60 × 41.6 cm] Seth K. Sweetser Fund 1977.711

Joined chest

Massachusetts (Ipswich), 1670-1700 Attributed to the shop of Thomas Dennis, American (born in England), 1638-1706

This oak chest is a highlight of the Museum's extensive collection of seventeenth-century New England furniture. The chest is believed to be from the shop of Thomas Dennis, a furniture maker (or joiner) trained in England. Chests of this kind, which could be used for seating as well as storage, were the most common furniture form in the small houses of the period. The vigorous carving with its abundance of stylized leaves and flowers contained within geometric fields—and the indication of an original, brightly painted surface testify to the love of pattern and color in the Puritan society of early New England.

Oak, white pine 30½ x 44¾ x 19 in. [77.5 x 112.7 x 48.3 cm] Gift of John Templeman Coolidge 29.1015 Sugar box Massachusetts (Boston), about 1680-85 John Coney, American, 1655/56-1722

John Coney was the most versatile and productive American silversmith of his generation. Like many silversmiths, he was an active citizen, engraving paper money for the colony of Massachusetts and serving as constable and tithingman. This sugar box, which weighs almost two pounds, testifies to the preciousness of sugar and demonstrates Coney's

remarkable skill in embossing, engraving, and casting. Such boxes were often given as wedding presents, and the cast handle of this one takes the form of a coiled snake—a traditional emblem warning against interfering in quarrels between husband and wife. The box was made for Marv Mason Norton, wife of the Reverend John Norton of Hingham, Massachusetts.

Silver H. 4% in. [12.2 cm] Gift of Mrs. Joseph Richmond Churchill 13.421

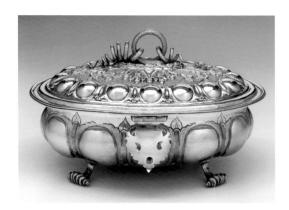

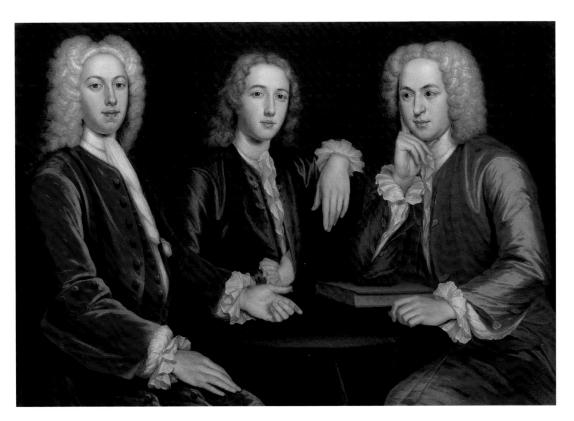

John Smibert
American (born in Scotland), 1688–1751
Daniel, Peter, and Andrew Oliver, 1732

In the eighteenth century, portraits were incontrovertible evidence of wealth and status. Arriving in Boston in 1729, London-trained Smibert was commissioned to paint almost 250 portraits during the seventeen years he lived there. His up-to-date style, ability to capture appearance and character, and deft modeling of three-dimensional form were much admired. This is one of eleven portraits Smibert painted for the affluent and accomplished Oliver family, among his most devoted patrons. Depicting the three sons

of Daniel and Elizabeth Belcher Oliver (instead of the more usual single individual), the portrait tested Smibert's skills. He placed the three young men around a table—a common device for group portraits—and wove the figures together through the gestures of their hands. The challenge was increased by the fact that Daniel, on the left, had died in London five years before. Smibert based his likeness on a miniature that Daniel had had painted in London to send to his parents.

Oil on canvas $39\% \times 56\% \text{ in. } [99.7 \times 144.5 \text{ cm}]$ Emily L. Ainsley Fund 53.952

Chest-on-chest

Massachusetts (Boston), 1715-25

Until the discovery of this chest-on-chest in the mid-1980s, little early-eighteenth-century Boston furniture was known that was close to contemporary, high-style English furniture. Based on its stylistic features and construction, this chest was originally believed to be English, but it is made of American woods and was owned by the Warland family of Cambridge, Massachusetts. In addition, microanalysis of

dirt particles undisturbed by restoration or refinishing revealed not the expected English pollen but pollen from plants that grow in Massachusetts and Rhode Island—a strong indication of the chest's American origins. As such, this chest-on-chest has provided exciting evidence that English furniture designs reached Boston very early, apparently brought by London-trained craftsmen attracted by Boston's

> thriving economy. A visitor, writing in 1725, commented: "A Gentleman from London would almost think himself at home at Boston when he observes the numbers of people, their Houses, their Furniture, their Tables, their Dress and Conversation, which perhaps is as splendid and showy as that of the most considerable Tradesman in London."

Black walnut, burl walnut veneer, eastern white pine 70³/₄ x 42¹/₄ x 21¹/₂ in. [179.7 x 107.3 x 53.8 cm] Gift of a Friend of the Department of American Decorative Arts and Sculpture and Otis Norcross Fund 1986.240

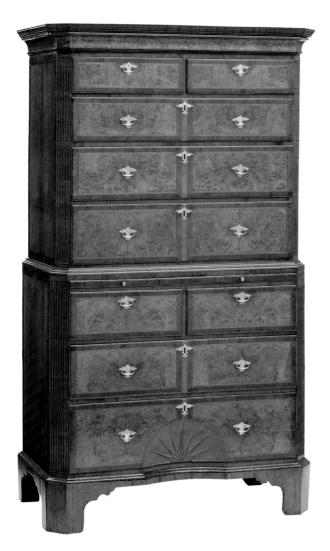

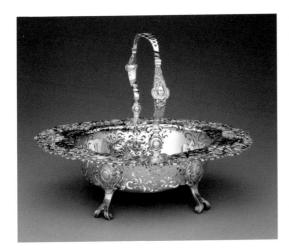

Bread basket

New York (New York), about 1765

Daniel Christian Fueter, American (born in Switzerland), 1720–1785

Elaborate pierced silver was a New York specialty, and this bread basket is the most sophisticated American example of its kind. The lacy openwork—lavish but perfectly controlled—is contained within a rim of cast scrolls, fruit, and flowers; unusual female masks decorate the handle. Daniel Christian Fueter, born and trained in Switzerland, fled into exile following his involvement in a plot to overthrow the local government; he worked in London before coming to New York.

Silver
H. 10% in. [27.1 cm]
Decorative Arts Special Fund 54.857

Covered cup Massachusetts (Boston), 1740-45

Jacob Hurd, American, 1702/3-1758

For the few colonial Americans who owned them. objects made of silver testified to wealth, social position, and discerning taste. They could also be (and often were) melted down and converted back to money in times of need. A Virginia gentleman wrote in 1688: "I esteem it as well politic as reputable, to furnish my self with an handsom Cupboard of plate which gives my self the present use & Credit, is a sure friend at a dead lift, without much loss, or is a certain portion for a Child after my decease." Jacob Hurd was among the most prolific of early American silversmiths, and this finely proportioned cup is evidence of his mastery of strong, sculptural form and elegant engraving. Such "grace cups" (traditionally passed around the table for a final toast after grace was said at the end of a meal) were favored in Boston as presentation pieces for ceremonial occasions. The cup bears the coat of arms of its first owner, John Rowe, a prosperous Boston merchant and shipowner.

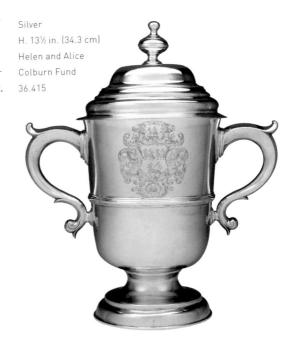

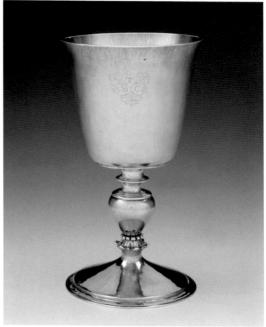

Beaker or tunn

Massachusetts (Boston), 1659 John Hull, American (born in England), 1624-1683, and Robert Sanderson, Sr., American (born in England), about 1608-1693

Silver H. 3% in. [9.9 cm] Anonymous gift 1999.90

Wine cup

Massachusetts (Boston), about 1660-80 John Hull, American (born in England), 1624-1683, and Robert Sanderson, Sr., American (born in England), about 1608-1693

Silver H. 8 in. (20.3 cm) Anonymous gift 1999.91 As was often the case in early Puritan churches, these simple, elegant pieces are domestic forms that were used as liturgical silver in communion services. They were given to the First Church of Boston (now the First and Second Church) and were owned continuously by that church until acquired by the Museum. Both were made by the partnership of John Hull and Robert Sanderson, North America's first silversmiths. Masterpieces of American silver, the tunn and wine cup are also major landmarks in the evolution of the silversmith's craft and are significant documents of American history and culture. Their importance is increased by their impeccable provenance and outstanding condition.

View of Boston Common Massachusetts (Boston), about 1750 Hannah Otis, American, 1732–1801

Like many well-to-do girls of her time, Hannah Otis learned genteel skills at school, including drawing, letter writing, conversation, and fine needlework. Large embroidered pictures, like this "chimneypiece" for display above the fireplace, were often framed or mounted and kept as a reminder of a woman's girlhood. Most schoolgirl embroidery reproduced standard compositions derived from European prints, but Otis's needlework picture is unique. She depicted a scene she knew-Boston Common, with the beacon on Beacon Hill and the fashionable stone mansion built. in 1737 by wealthy merchant Thomas Hancock. The couple by the wall are believed to be Thomas and Lydia Henchman Hancock; the dashing figure on horseback may be their nephew and heir, John Hancock, later to be a governor of Massachusetts and signer of the Declaration of Independence.

Otis's brother James led radical colonial opposition to Britain, and her sister Mercy Otis Warren became the first historian of the American Revolution. (John Singleton Copley's portrait of Mercy Otis Warren is on page 294). Otis herself never married but lived with her widowed father in Barnstable, Massachusetts, and later kept a shop and ran a boarding house in Boston.

Silk, wool, metallic threads, and beads on linen canvas; predominantly tent stitch $24\% \times 52\%$ in. [61.6 x 134 cm]

Gift of a Friend of the Department of American Decorative
Arts and Sculpture, a Supporter of the Department of
American Decorative Arts and Sculpture, Barbara L. and
Theodore B. Alfond, and Samuel A. Otis; and William Francis
Warden Fund, Harriet Otis Cruft Fund, Otis Norcross Fund,
Susan Cornelia Warren Fund, Arthur Tracy Cabot Fund,
Seth K. Sweetser Fund, Edwin E. Jack Fund, Helen B.
Sweeney Fund, William E. Nickerson Fund, Arthur Mason
Knapp Fund, Samuel Putnam Avery Fund, Benjamin Pierce
Cheney Fund, and Mary L. Smith Fund 1996.26

Sampler

Massachusetts (probably Boston), 1771 Sally Jackson, American, born 1760

The Museum's collection of needlework executed by girls and women of colonial New England is among the finest in the world. Samplers were a schoolgirl's first needlework project, and Sally Jackson made this finely executed example-striking for its fresh and brilliant state of preservation—when she was only eleven. Her sampler, embroidered with silk in cross, split, French knot, satin, and stem stitches, includes an alphabet, a moral verse, and a pastoral scene, all within an elaborate floral border. The scene, with its running stag and parrot on a branch, relates closely to other embroidered textiles from eighteenth-century Boston.

Linen plain weave, embroidered with silk 30 x 20 in. [76.2 x 50.8 cm] Museum purchase with funds donated anonymously and Frank B. Bemis Fund 2001.739

Card table

Massachusetts (Boston), 1730-50

Despite laws dating to the Puritan era that regulated such social vices as alcohol, tobacco, and card playing, the existence of this card table and a small group of related examples made between 1730 and 1750 proves that wealthy Bostonians of the time participated in these forbidden activities. This table and its mate were originally owned by Peter Fanueil, one of the city's most prominent merchants and the builder of Boston's Fanueil Hall. This piece's finely wrought needlework playing surface—no doubt the handiwork of a young woman—belies the small transgression that the table represents. The embroidered scene, derived from contemporary print sources, depicts a shepherdess resting on her elbow amid an abundance of flora and fauna. Thus, secular rebellion and the innocence of young womanhood collide in this single piece of furniture.

Mahogany, chestnut, eastern white pine; original needlework top 27 x 35 % x 35 % in. (68.6 x 90.5 x 89.2 cm) Anonymous contribution and Income of William E. Nickerson Fund 49.330

Joseph Blackburn

American (born in England), active in America 1753–1763

Isaac Winslow and His Family, 1755

Trained in England, Joseph Blackburn came to New England from Bermuda in 1753. For the next ten years, he was a highly successful painter of portraits that reflected the decorative grace and silvery colors of current London style. He particularly delighted his female sitters by painting them with dainty heads on long, slender necks and by rendering their elegant dress and the textures of luxurious fabrics with skill

and precision. In this ambitious group portrait, Blackburn posed the Winslows informally before an imaginary garden setting far grander than any existing in Boston. Isaac Winslow, who made his fortune in the shipping business, stands beside his wife Lucy; in her lap, baby Hannah holds a coral-and-bells teething toy. Daughter Lucy holds fruit, possibly alluding to the family's prosperity.

Oil on canvas 54½ x 79½ in. [138.4 x 201.3 cm] A. Shuman Collection 42,684

High chest of drawers Pennsylvania (Philadelphia),

about 1760-70

Handsome, monumental high chests proclaimed their owners' wealth and taste while providing ample storage at a time when closets were still uncommon. In the last quarter of the eighteenth century, long after the high chest had lost favor in England, the form reached its artistic peak in Philadelphia—the fastest growing city in America. Fine Philadelphia high chests, like this one, are wellproportioned and richly ornamented. The wood is highly prized mahogany imported from the Spanish colonies of Cuba, Honduras, or Santo Domingo. On the drawer fronts, the warm color and lively patterns of mahogany crotch-grain veneer are enhanced by pierced brasses, placed to curve slightly inward, lightening the basic rectilinearity of the chest. The carved decoration, accentuated by the use of different-colored mahogany, reflects the fluid, graceful Rococo style that dominated European art in the mid-eighteenth century. More than seven feet above the ground, the flourish of an asymmetrical cartouche provides the crowning touch.

Mahogany, yellow-poplar, yellow pine 85³/₄ x 43 x 23 in. [217.9 x 109.2 x 58.4 cm] The M. and M. Karolik Collection of Eighteenth-Century American Arts 39.545

Coffeepot

Pennsylvania (Philadelphia), about 1770–80 **Richard Humphreys**, American (born in the British West Indies), 1749–1832

Philadelphia was the American center of the Rococo style, with its animated ornament of entwined scrolls, shells, leaves, and other natural forms. The shape of this coffeepot, with its stepped foot and domed cover, expresses the Rococo love of curving movement, as do the applied decoration and the delicate foliate engraving. The Rococo style—also exemplified by the high chest on the preceding page—was introduced to America from England through imported objects, immigrant craftsmen, and such books of design as Thomas Chippendale's *The Gentleman and Cabinet-Maker's Director* (1754). Made by one of Philadelphia's foremost silversmiths, this coffeepot is unusual in that it retains its original stand.

Silver with wooden handle H. 13% in. (34.4 cm)

Gift in memory of Dr. George Clymer by his wife, Mrs. Clymer 56,589

Fruit basket Pennsylvania (Philadelphia), 1770–72 American China Manufactory

The first porcelain factory in the colonies was established in Philadelphia in 1770 by Gousse Bonnin and George Anthony Morris, who imported English workers to produce domestic wares comparable to the soft-paste porcelain (a bone china) made in English factories. The Non-Importation Agreements of the late 1760s, which urged the boycott of imported British goods and encouraged colonial industry, made this seem a perfect moment for such a venture. However, expenses were much higher than expected, and many local merchants, ignoring the Non-Importation Agreements, continued to trade with England. Quantities of inexpensive English and Chinese wares were available in America and, after only two years, Bonnin's and Morris's factory closed. This open fretwork fruit basket is a very rare survivor of what was known in its day as "American China."

Soft-paste porcelain with underglaze blue decoration Diam. 6% in. (17.5 cm) Frederick Brown Fund 1977.621

High chest of drawers

Massachusetts (Boston), about 1730-40

Japanned butternut, maple, white pine 71% x 42% x 24% in. [182.2 x 108.9 x 62.9 cm] Bequest of Charles Hitchcock Tyler 32.227

Cupboard

Massachusetts (probably Ipswich or Newbury), 1685-90

Oak, maple, white pine 583/4 x 481/2 x 193/8 in. [149.2 x 123.2 x 49.2 cm] Gift of Maurice Geeraerts in memory of Mr. and Mrs. William R. Robeson 51.53

Desk and bookcase

Rhode Island (Newport), about 1760-75

Mahogany, chestnut, pine, cherry 95 ½ x 39 ½ x 23 ½ in. [241.9 x 101.3 x 60 cm] The M. and M. Karolik Collection of Eighteenth-Century American Arts 39.155

Chest-on-chest

Massachusetts (Salem), 1806-9 Design and carving attributed to Samuel McIntire, American, 1757-1811

Mahogany, pine, ebony, satinwood 102½ x 46¾ x 23 in. [260.4 x 118.7 x 58.4 cm] The M. and M. Karolik Collection of Eighteenth-Century American Arts 41.580

The Museum has one of the world's finest collections of colonial New England furniture. In the seventeenth and eighteenth centuries, such monumental chests as those illustrated here were the supreme expression of their makers' skill and their owners' affluence and status. Exploring the elegant proportions, handsome carving, rich surface ornamentation, and intricately worked brass handles of these solid and imposing pieces of furniture can offer the viewer visual delight.

A good example is this chest-on-chest (opposite page, far right)—among the greatest

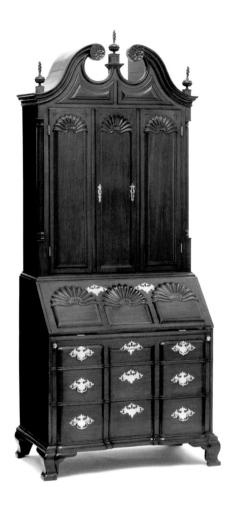

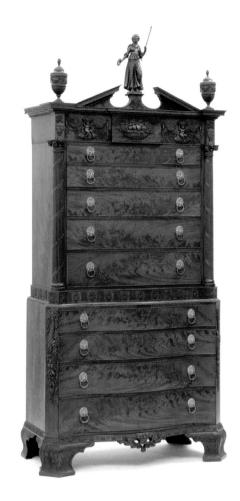

masterpieces of Salem furniture. The chest's form is of the eighteenth century, but its ornament reflects both the international taste for neoclassicism and the new American nation's search for cultural unity in symbols that would be meaningful to all. The artistic vocabulary of ancient Greece and Rome seemed tailor-made for Americans who compared their infant democracy to the revered societies of the ancient world. Thus, on this chest, urns, garlands, and cornucopias overflowing with fruit speak optimistically of America's prosperity, and the crowning female figure bears attributes symbolic of the new nation's ideals—truth, virtue, and power. The chest was made for Elizabeth Derby West (see page 303) the daughter of Salem merchant Elias Hasket Derby whose success

embodied the American dream. The chest was undoubtedly among its owner's proudest possessions, but when the collector Maxim Karolik rediscovered it in 1941, its drawers were being used for ripening pears.

John Singleton Copley

American, 1738-1815

Mrs. James Warren (Mercy Otis), about 1763

Virtually self-taught, Boston artist John Singleton Copley eclipsed all his rivals with his brilliant technique and his ability to portray wealthy and ambitious Americans as they wished to be seen. Copley looked to London for the latest styles, flattering his sitters with elegant costumes, grand settings, and confident poses often derived from mezzotint engravings that reproduced oil portraits of English aristocracy. Mercy Otis Warren (1728-1814), the wife of prosperous merchant and farmer James Warren, wears a sumptuous and expensive blue satin dress trimmed with silk, lace, and silver braid. She tends nasturtium vines, a metaphor for her nurturing role as mother and wife. Mercy Warren was also a formidable intellectual and a highly influential writer and activist for the patriot cause; her three-volume Rise, Progress, and Termination of the American Revolution was published in 1805.

Oil on canvas 49% x 39% in. [126.1 x 100.3 cm] Beguest of Winslow Warren 31.212

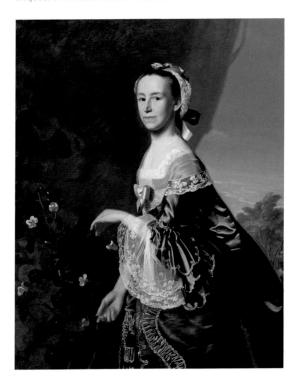

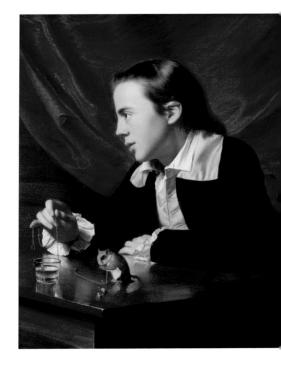

John Singleton Copley American, 1738–1815 Henry Pelham (Boy with a Squirrel), 1765

By 1765 Copley was eager to compare his work to that of the English portraitists he so much admired. This intimate image was not a commissioned portrait; rather, he made it to be exhibited at the Society of Artists in London. In Boston, Copley was especially renowned for his ability to depict luxurious material objectsexpensive textiles, furniture, and silver. He portrayed his half-brother Henry Pelham (1749–1806) to showcase his illusionistic skill in rendering animal fur, pink satin, metallic gold, polished wood, glass, and water. English portraitist Sir Joshua Reynolds praised the painting as "a very wonderful Performance" and urged Copley to come to England before his "Manner and Taste were corrupted or fixed by working in [his] little way at Boston."

Oil on canvas $30\%\,x\,25\%\,in.\,[77.2\,x\,63.8\,cm]$ Gift of the artist's great granddaughter $\,$ 1978.297

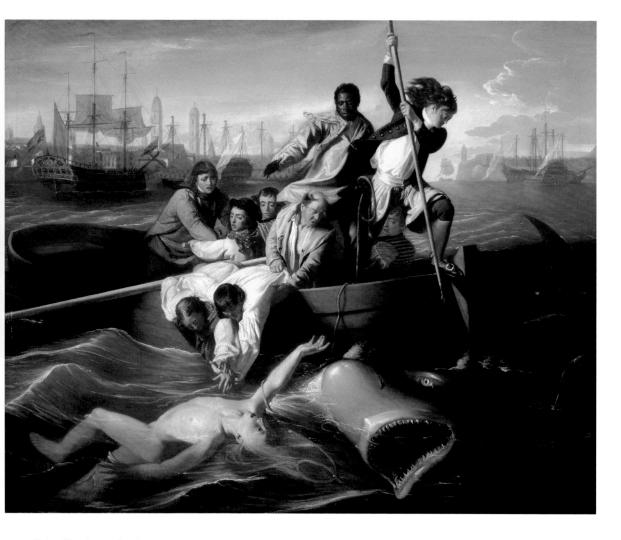

John Singleton Copley

American, 1738-1815

Watson and the Shark, 1778

Oil on canvas $72\,\%\,x\,90\,\%\,\text{in.}\,\,\text{[183.5}\,x\,229.6\,\text{cm]}$ Gift of Mrs. George von Lengerke Meyer 89.481

"Was it not for preserving the resemblance of particular persons," Copley complained about colonial America, "painting would not be known in the place." He dreamed of working in England's more cosmopolitan artistic environment and of making "history paintings," those images of religious, mythological, or historical events that were traditionally considered the apex of artistic achievement. In 1774 Copley left America and began a forty-year career in London. Watson and the Shark, his first large-scale history painting, depicts the heroic rescue of English merchant Brook Watson (1735–1807) who, as a young cabin boy, lost a leg to a shark while swimming in the harbor of Havana, Cuba. Watson and the Shark is an astonishing achievement for an artist who before this had mainly painted portraits.

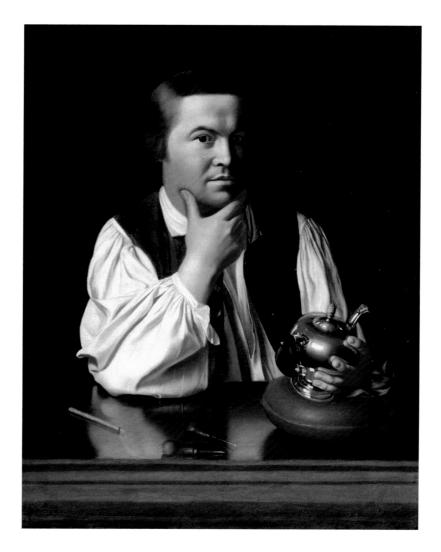

John Singleton Copley American, 1738-1815 Paul Revere, 1768

This image of a craftsman at work, one of the most familiar and beloved icons of American art, is unusual in colonial portraiture. Paul Revere (1735–1818) was a distinguished Bostonian, active in public affairs, an impassioned patriot, and a prominent silversmith. The circumstances surrounding the commissioning of this portrait are unknown, but it was as a silversmith that Copley painted Revere—wigless and informally dressed in a white linen shirt and unbuttoned waistcoat. With his engraving tools spread before

him, Revere seems to be contemplating the design he will engrave on a silver teapot. Teapots were among the most expensive items made by Revere; the inclusion of a teapot in his portrait may simply signify his craft, but the portrait was painted at the time of the much-resented Townshend Acts, which imposed heavy duties on imported tea. The teapot might thus be read as a provocative political statement.

Oil on canvas 35 % x 28 ½ in. [89.2 x 72.4 cm] Gift of Joseph W. Revere, William B. Revere and Edward H. R. Revere 30.781

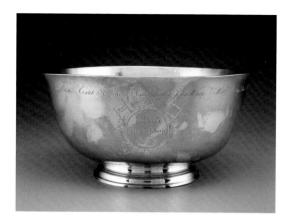

Sons of Liberty Bowl
Massachusetts (Boston), 1768
Paul Revere, American, 1735–1818

The Liberty Bowl is a powerful and eloquent symbol of America's struggle for independence. It was commissioned by fifteen members of the Sons of Liberty, a secret, revolutionary organization to which Paul Revere belonged. The bowl was intended to honor ninety-two members of the Massachusetts House of Representatives who had refused to rescind the circular letter sent throughout the colonies to protest against the Townshend Acts (1767), which taxed tea, paper, glass, and other commodities imported from England. The legislators' defiant act of conscience directly embodied growing colonial resentment of high-handed British policies, and "the glorious Ninety-two" soon became a catchphrase expressing revolutionary sentiment. The Liberty Bowl, the Declaration of Independence, and the Constitution have been called the nation's three most cherished historical treasures. The bowl was purchased in 1949, with funds that included 700 donations by Boston public school children and the general public.

Silver
Diam. 11 in. [27.9 cm]
Gift by Subscription and Francis Bartlett Fund 49.45

Sugar bowl and creampot
Massachusetts (Boston), 1761
Paul Revere, American, 1735–1818

This sugar bowl and creampot are highlights of the Museum's collection of almost 200 pieces of Paul Revere silver. The sheer variety of Revere's work is evident when we compare the intricate, curvilinear shapes and opulent decoration of these pieces with the simple elegance and rich, reflecting surface of the Sons of Liberty Bowl. The shape of the Liberty Bowl is influenced by imported Chinese porcelain bowls, while these objects are superb examples of the Rococo style that dominated American and European decorative arts at the time.

Silver
H. of sugar bowl: 6½ in. [16.5 cm]
H. of creampot: 4¾ in. [11.1 cm]
Pauline Revere Thayer Collection 35.1781, 35.1782

Desk and bookcase Massachusetts (Boston), 1770-85 George Bright, American, 1726-1805

Admired as "the neatest workman in town," George Bright was among Boston's most successful cabinetmakers in the years just before and after the Revolution. The superb craftsmanship that made Bright famous is evident in this massive, handsomely proportioned desk and bookcase. The front and sides are bombé in form, from the French bomber, "to bulge." In America, the bombé form was a specialty of Boston

cabinetmakers, used on the most expensive and fashionable furniture. This desk and bookcase was made for wealthy merchant Samuel Barrett and is fitted with drawers, shelves, pigeonholes, and several secret compartments to hold the papers of a busy man. On the front of the doors are mirrors within curving gilded frames.

Mahogany, white pine, glass 99½ x 43 x 24 in. (252.7 x 109.2 x 61 cm) Beguest of Miss Charlotte Hazen 56.1194

Missal stand (atril)

Bolivia (Moxos mission), 1725-30

This early Baroque-style silver atril, or missal stand, was created out of local silver for a Jesuit church in Bolivia in the early eighteenth century. Composed of a wooden frame and five sheets of elaborately shaped silver, the stand held the clergy's liturgical books during Mass. The iconography of the stand incorporates both Latin American and Spanish imagery, including local flora and fauna such as the vizcacha, a small rodent with large ears, and passionflowers, a native symbol of resurrection appropriated by the Catholic Church to symbolize the Passion of Christ. Each figure flanking the central monogram combines the ancient pagan hombre verde, or green man—a symbol of life, nature, and fertility—with the square-necked costume of archangels. The monogram, "IHS" with a cross and three nails, is the seal of the Jesuit order.

Silver, replaced wooden frame 11% x 13% x 10% in. [29.5 x 34.8 x 27 cm] Gift of Landon T. Clay 2001.843

Covered goblet (pokal)

Maryland (New Bremen), about 1785-95 Probably made at the **New Bremen Glass Manufactory**

Although many glass factories were set up in the colonies, eighteenth-century American glass is very rare because few factories survived the competition from inexpensive, high-quality imported glass. In 1784 John Frederick Amelung (1741–1798) emigrated from Germany with sixty-eight skilled workers and established a factory at New Bremen, Maryland, that employed at its peak 500 people. This goblet bears no maker's mark, but its chemical composition matches that of objects known to be from Amelung's factory. Probably made for an Evangelical Lutheran church, the goblet's form seems appropriate for use in a church dedicated to "those who preach the Word [of God] in its simplicity and purity."

Glass

H. 12% in. [31.4 cm]

Gift of The Seminarians and Mr. and Mrs. Daniel F. Morley 1994.82a-b

Gilbert Stuart American, 1755-1828 Martha Washington, 1796 George Washington, 1796

Oil on canvas Each 47³/₄ x 37 in. [121.3 x 94 cm]

William Francis Warden Fund, John H. and Ernestine A. Payne Fund, Commonwealth Cultural Preservation Trust. Jointly owned by the Museum of Fine Arts, Boston, and the National Portrait Gallery, Washington D.C. 1980.1, 1980.2

This unfinished portrait of George Washington may well be the most famous of all American paintings. As Washington (1732-1799) neared the end of his second term as president, his wife, Martha (1731-1802), commissioned paintings of them both from the celebrated portraitist Gilbert Stuart. The works were never delivered; instead, Stuart kept them in his studio and used them as models for the many images of Washington he created in later years. Stuart painted numerous portraits of Washington, testifying to the new nation's hunger for visual symbols of its strength and pride. Aside from Stuart's own replicas, the painting was copied many times by other artists; a printed version appears in reverse on the dollar bill. "Every American considers it his sacred duty," a French visitor observed, "to have a likeness of Washington in his home, just as we have images of God's saints."

John Neagle
American, 1796-1865

Pat Lyon at the Forge, 1826-27

At the end of his career, the Philadelphia entrepreneur Patrick Lyon (1779-1829) commissioned John Neagle to portray him as the lowly blacksmith he once was rather than as the successful businessman he had become. The portrait also includes, in the upper left, a view of Philadelphia's Walnut Street jail, where the young Lyon, falsely accused of theft, had been briefly imprisoned. In celebrating Lyon's humble origins and the dignity of skilled physical labor, the painting captures the optimistic spirit of America at a time when conviction was widespread that individuals could rise to greatness from poverty and adversity. Lyon is depicted on a heroic scale, his powerful forearms bared, his virile figure dramatically set off by the flames and smoke of his forge. Neagle's reputation rests almost entirely on this monumental work, which was acclaimed at exhibitions in Philadelphia, New York, and Boston.

Oil on canvas $93\% \times 68 \text{ in. } [238.1 \times 172.7 \text{ cm}]$ Henry H. and Zoe Oliver Sherman Fund 1975.806

Lady's writing table with tambour shutters Massachusetts (Boston), about 1793-96 John Seymour, American (born in England), 1738-1818, and Thomas Seymour, American (born in England), 1771-1848

Born in England, John Seymour and his son Thomas created this elegant writing desk soon after their arrival in Boston, perhaps as an advertisement of their extraordinary skills. Typical of the Seymours' work is the upper section, painted blue inside and enclosed by sliding tambour doors made of alternat-

ing strips of satinwood and ebony glued onto canvas. The piece is very rare in American furniture in that virtually the entire visible surface is veneered with satinwood, animating the clean, spare lines of the desk itself. Even more remarkable is the complete and legible paper label—reading JOHN SEYMOUR & SON/ CABINET MAKERS/CREEK SQUARE/BOSTON—pasted on the backboard of the upper case. The Seymours produced many pieces, but very few are labeled. The importance of this survival cannot be overstated; it gives scholars firm information to help them identify and date other furniture by this prestigious firm.

Satinwood and curly satinwood veneer, eastern white pine, black ash, black walnut, cedar, cherry, light- and dark-wood inlays, brass 50½ x 40 x 21 in. [128.3 x 101.6 x 53.3 cm] Museum purchase with funds donated anonymously, Henry H. and Zoe Oliver Sherman Fund, and by exchange from Bequest of George Nixon Black, Bequest of Mrs. Charles R. Codman, and Gift of Mrs. Ruth K. Richardson 2000.636

Commode

Massachusetts (Boston), 1809
Made by **Thomas Seymour**, American (born in England), 1771–1848, probably assisted by **James Cogswell**, American, 1780–1862
Painted by **John Ritto Penniman**, American, 1782–1841
Probably carved by **Thomas**

Whitman, American, active 1802-1820

When the decorative arts wing opened in 1928, its most notable feature was three rooms reconstructed with woodwork from Oak Hill, a house built in 1800–1801 in South Danvers, Massachusetts. Now meticulously restored and filled with furnishings that belonged to the Derby-West families, the Oak Hill rooms provide a vivid picture of the taste and lifestyle of prosperous New Englanders at the turn of the nineteenth century.

The house, probably designed by Samuel McIntire (see page 292), was built for Captain Nathaniel West and his wife, Elizabeth, daughter of Salem millionaire-

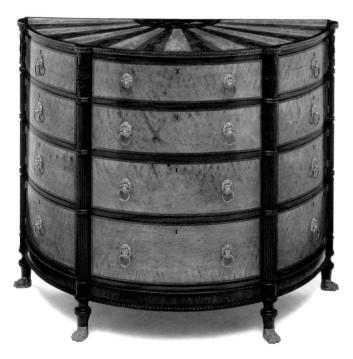

merchant Elias Hasket Derby. Elizabeth Derby West spared no expense in decorating her house with fashionable objects of the highest quality. The design and ornament of this magnificent commode express the love of geometry and contrasting color fundamental to the Neoclassical style. The commode survives with rare documentation: the bill from Thomas Seymour, which reads: "Large Mahogany Commode, \$80.00. Paid Mr. Penniman's bill for painting Shels on Top of Do [ditto] \$10.00."

In the parlor are carved mahogany side chairs and superb upholstered armchairs and sofas that testify unequivocally to Mrs. West's insistence on the best. Since the original fabrics did not survive,

the Museum, following a description in the Oak Hill inventory, re-covered the furniture in an "orange" silk damask. Both the block-printed wallpaper and the woven Brussels carpet re-create costly items that Mrs. West probably imported from abroad. A selection of engravings and a gilded looking glass with a broadly reflecting convex surface complete the decoration of a room where visitors enjoyed conversation, tea parties, and games of cards.

Mahogany; mahogany, birch, rosewood, and bird's-eye maple veneers; satinwood and rosewood banding; eastern white pine, maple, white ash $41\% \times 50 \times 24\%$ in. (105.4 x 127 x 62.4 cm) The M. and M. Karolik Collection of Eighteenth-Century American Arts 23.19

Desk and bookcase

Philadelphia (Pennsylvania), about 1830 Anthony G. Quervelle, American (born in France), 1789-1856

Born in France, Anthony Quervelle trained as a cabinetmaker there, probably in the imperial workshops of Napoleon. By 1817 he was in America, where he quickly became one of Philadelphia's leading craftsmen working in the late Neoclassical style. Quervelle's work combined French motifs with the British forms that were popular in his adopted city. In this majestic desk and bookcase he combines the massive form and richly grained woods derived from British designs with tapered columns, paw feet, and fan doors that add a French flair. Reflecting popular taste, Quervelle also incorporated Gothic arches on the glass doors and pigeonholes and pressed glass knobs on the interior drawers.

Mahogany, bird's-eye maple, burl ash, yellow-poplar, white pine, cedar, maple, glass, pressed glass 102 ½ x 49 ½ x 24 in. [259.7 x 125.1 x 61 cm]

Henry H. and Zoe Oliver Sherman Fund 2004.562

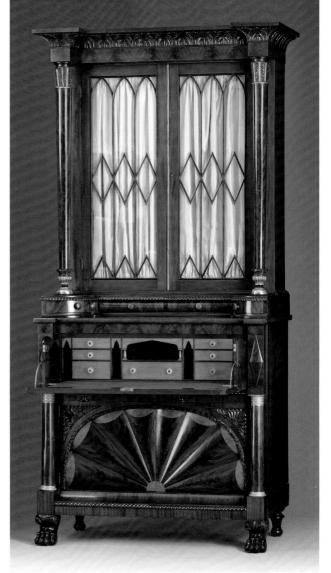

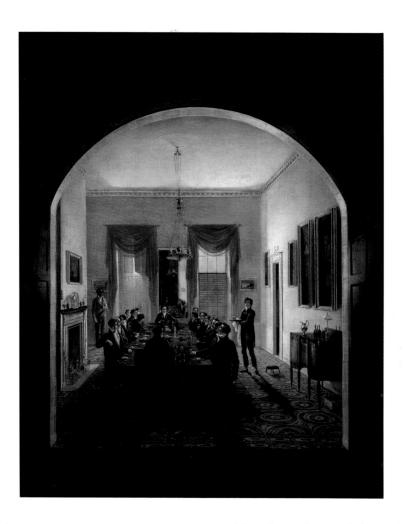

Henry Sargent American, 1770–1845 The Dinner Party, about 1821

The meticulous detail of Henry Sargent's painting provides an invaluable document of upper-class life in early-nineteenth-century Boston. It may depict a meeting of the Wednesday Evening Club, which gathered at the homes of its members to discuss the issues of the day. Mid-afternoon was the fashionable time for dining, and the gentlemen in Sargent's painting enjoy the final course of fruit, nuts, and wine, with a single candle to light their tobacco. The room is decorated in the latest Neoclassical style, with swagged draperies above the shuttered windows and

graceful carving on the mantelpiece and cornice. The sideboard was a new form in this period, as was the lead-lined cellarette, or wine cooler, at the end of the table. Beneath the table, a green baize "crumb cloth" protects the expensive carpet. Sargent, who studied with Benjamin West and John Singleton Copley in London, also served as a captain in the Boston Light Infantry and as a member of the Massachusetts State Legislature.

Oil on canvas
61% x 49% in. [156.5 x 126.4 cm]
Gift of Mrs. Horatio Appleton Lamb in memory of Mr. and Mrs.
Winthrop Sargent 19.13

Washington Allston

American, 1779-1843 Elijah in the Desert, 1818

Oil on canvas 49½ x 72¾ in. [125.1 x 184.8 cm] Gift of Mrs. Samuel and Miss Alice Hooper 70.1 According to the Bible's first book of Kings, the Lord sent the prophet Elijah into the desert where "the ravens brought him bread and flesh in the morning and bread and flesh in the evening; and he drank of the brook." Allston conveyed the mood and meaning of this subject by the stark landscape, the turbulent clouds, and the dry texture of the paint. Elijah kneels in prayer, his figure echoed by the gnarled roots of a barren tree. Allston spent many years in Europe and viewed himself as a painter in the tradition of the old masters. His fellow Americans admired his learned biblical and literary subjects and romantic, imaginary landscapes. Elijah in the Desert, painted shortly before Allston returned to Boston from London, was the first work of art acquired by the Museum.

Thomas Cole American (born in England), 1801–1848 Expulsion from the Garden of Eden, 1828

Oil on canvas 39% x 54% in. $\{101$ x 138.4 cm $\}$ Gift of Martha C. Karolik for the M. and M. Karolik Collection of American Paintings, 1815-1865-47.1188

The pioneer of American landscape painting, Thomas Cole made his reputation with images of the wilderness of New York's Hudson River Valley. In this painting, which Cole called an attempt "at a higher type of landscape than I have hitherto tried," he combined landscape with the kind of religious theme accepted for centuries as the proper subject matter for "serious" artists. The story is that of Adam and Eve who, having angered God by eating the forbidden fruit that gave them knowledge of good and evil, were expelled from the Garden of Eden. Cole conveys their anguish, not through pose and expression (as was traditional) but through landscape, contrasting serene, light-filled Paradise with the harsh world outside. Dwarfed by the power of nature, the helpless figures seem propelled from the garden by a shaft of supernatural light.

Grecian couch

Maryland (Baltimore), about 1820 Attributed to Hugh Finlay, American, 1781-1831

The new American nation, proudly associating itself with the ancient republics of Greece and Rome, turned to the classical world for everything from household furnishings and architecture to the names of its new towns. The "Grecian" couch—with one high, bolstered end-was among the most stylish furnishings of early-nineteenth-century parlors. Prosperous Baltimore favored painted furniture in the classical style. For more than forty years, Irish-trained brothers John and Hugh Finlay, working singly and together, provided Baltimore with the richest and most attractive examples. This couch, boldly sculptural in form, is enriched with superb painted ornament—classical anthemia, rosettes, and acanthus

leaves. The freehand painting was not intended to imitate expensive materials but to be a vibrant art form in its own right. Fabrics rarely survive time and use, and the Museum reupholstered the couch in a crimson silk damask based on threads of the original material that survived under the nail heads.

Yellow-poplar, cherry, white pine, rosewood graining, and

gilded painting; partial original foundation and new foundation materials, cover, and trim 35¾ x 92½ x 24¼ in. [90.8 x 232.4 x 61.6 cm] Gift of Mr. and Mrs. Amos B. Hostetter, Jr., Anne and Joseph P. Pellegrino, Mr. and Mrs. Peter S. Lynch, Mr. William N. Banks, Jr., Eddy G. Nicholson, Mr. and Mrs. John Lastavica, Mr. and Mrs. Daniel F. Morley, and Mary S. and Edward J. Holmes Fund 1988.530

Girandole wall clock

Massachusetts (Concord), about 1816-21 Lemuel Curtis, American, 1790-1857

Made when clocks were still costly and prized possessions, the girandole is a design unique to America. It was patented by Lemuel Curtis in 1816 and took its name from the circular, convex looking glasses popular in the period. Such clocks, which were the work of many skilled craftsmen, are characterized by the convex glass of their dial faces and pendulum chambers, their gilded cases with eagle finials, and their reverse-painted glass panels—here, depicting a medieval wedding ceremony. Soon after this particular piece was made, Curtis's business declined, undercut by the mass production of thirty-hour shelf clocks. In 1832 he became a merchant and grocer, but was declared bankrupt ten years later and died in poverty.

Carved, painted, and gilded wood; brass; reverse-glass painting
H. 46 in. [116.8 cm]
Gift of Mrs. Charles C. Cabot in memory of
Dr. and Mrs. Charles J. White 1991.241

Thomas Sully American (born in England), 1783-1872 The Torn Hat. 1820

In portraits of the seventeenth and eighteenth centuries, children were usually posed and dressed as miniature adults (see the portrait of Margaret Gibbs, page 280). But Philadelphia painter Thomas Sully discarded this convention in favor of more informal, naturalistic images, such as this one of his son Thomas. The curved brim of the boy's straw hat is torn, and this gives Sully the opportunity to display his skill at rendering the play of light and shadow on skin and fabric. The enthusiasm that greeted this unaffected image reflects the early nineteenth century's new appreciation of the appealing and distinctive nature of childhood.

Oil on panel 19 % x 14 % in. [48.6 x 37.2 cm] Gift of Miss Belle Greene and Henry Copley Greene in memory of their mother, Mary Abby Greene (Mrs. J. S. Copley Greene) 16.104

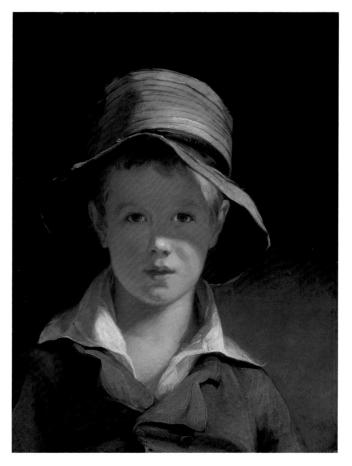

facing page

William Sidney Mount American, 1807-1868 The Bone Player, 1856

The musician depicted here plays the bones, thin bars of ivory or bone that were clicked together to create complex and energetic rhythms. The Bone Player has the sensitivity and specificity of a portrait, but Mount created it to be reproduced as a color lithograph in Paris, where images of "exotic" figure types enjoyed widespread popularity.

Mount, who lived on rural Long Island, New York, was the first major American artist to devote his career to depictions of the work and play of ordinary people. He wrote in his diary: "Paint pictures that will take with the public. In other words, never paint for the few, but for the many. Some artists remain in the corner by not observing the above."

Oil on canvas 36 % x 29 % in. [91.8 x 74 cm] Beguest of Martha C. Karolik for the M. and M. Karolik Collection of American Paintings, 1815-1865 48.461

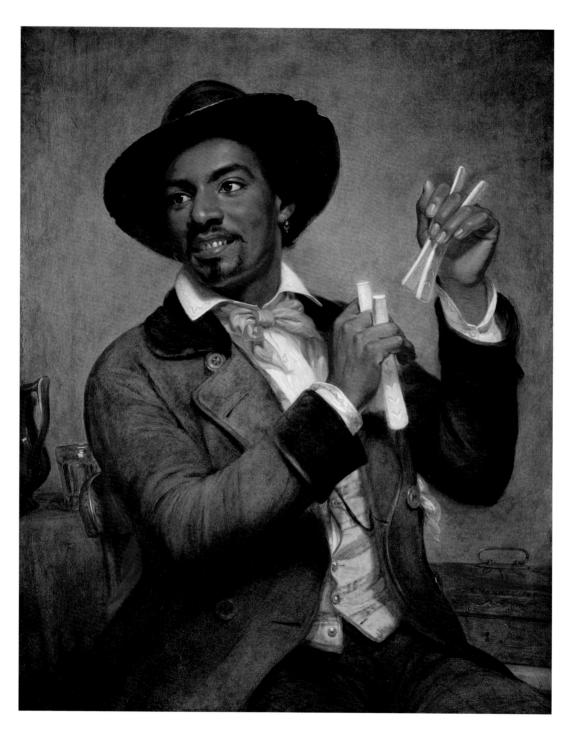

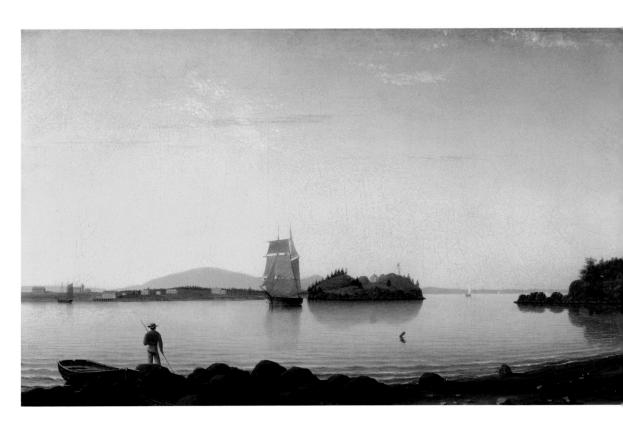

Fitz Henry Lane

American, 1804-1865

Owl's Head, Penobscot Bay, Maine, 1862

The son of a sailmaker in Gloucester, Massachusetts, Lane spent his life painting the coast of New England. Crippled as a result of a childhood illness, he moved about on land only with the aid of crutches. But he roamed widely by water. "The sea is his home," wrote a contemporary critic. "There he truly lives, and it is there, in that inexhaustible field, that his victories will be won." This is among the most spare and poetic of Lane's coastal views—small pictures whose horizontal shape emphasizes the line that separates land

and sea from an expanse of clear, delicately tinted sky. Although Lane depicts a specific spot in Maine and a specific moment in time, this painting's true subject is light, and its evocative stillness renders it timeless. Like Martin Johnson Heade (see pages 314 and 321), Lane was forgotten until his rediscovery by Maxim Karolik in the 1940s.

Oil on canvas

15% x 26% in [40 x 66.4 cm]

Bequest of Martha C. Karolik for the M. and M. Karolik Collection of American Paintings, 1815–1865 48.448

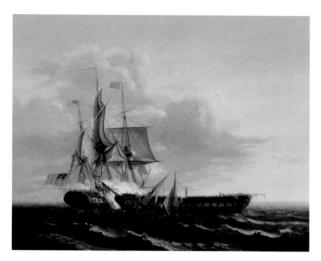

During the War of 1812, the infant American navy—to everyone's surprise—regularly defeated the supposedly invincible British fleet. Birch, who emigrated from England to Philadelphia in 1794, made his reputation with depictions of these naval battles, which were both as accurate as he could make them (details were often derived from interviews with members of the ships' crews) and romantically thrilling. In this picture, Birch documented, with fine patriotic passion, the defeat of the British warship Guerrière (on the right) by the USS Constitution. As the damaged Guerrière is driven up against the Constitution, the British standard sinks into the sea, and American flags wave triumphantly against a sky pink with clouds and smoke. The Constitution, nicknamed "Old Ironsides" for the virtually impenetrable oak planking of its hull, now is docked at the Charlestown Navy Yard in Boston.

Oil on canvas $28\times36\% \text{ in. } [71.1\times92.1\text{ cm}]$ Ernest Wadsworth Longfellow Fund and Emily L. Ainsley Fund 1978.159

Mary S. Chapin
American, 19th century
Solitude, 1815–20

Embroidery and watercolor painting, introduced to America from England in the seventeenth and eighteenth centuries, were considered requisite accomplishments of cultivated young ladies. Chapin's delightful watercolor shows a fashionably dressed young woman daydreaming in a bucolic setting. Although embroideries of such subjects were going out of fashion, Chapin rendered much of her picture with brushstrokes that imitate stitches. For example, the dots of white paint on the blue dress resemble French knots, and the foliage of the small trees in the background suggests featherstitch. But for the leaves of the large tree, the grass, and the roofs of the houses, the artist turned to the more fluid, "brushy" qualities of watercolor, Mary Chapin, most likely a student in her late teens, signed her name and wrote the picture's title on the back of the paper.

Watercolor over graphite pencil on paper $15\% \times 13\%$ in. $(38.7 \times 34.6$ cm)

Gift of Maxim Karolik for the M. and M. Karolik Collection of American Watercolors and Drawings, 1800-1875 60.469

Martin Johnson Heade

American, 1819-1904

Approaching Storm: Beach near Newport,

about 1861-62

Oil on canvas

28 x 58% in. [71.1 x 148.3 cm]

Gift of Maxim Karolik for the M. and M. Karolik Collection of American Paintings, 1815-1865 45.889

Unidentified artist

American, 19th century

Pennsylvania Farmstead with Many Fences, early 19th century

Pen and watercolor on paper 18 x 23 % in. [45.7 x 60.6 cm]

Gift of Maxim Karolik for the M. and M. Karolik Collection of American Watercolors and Drawings, 1800-1875 56.740

Side chair

Pennsylvania (Philadelphia), about 1740

Walnut, white pine H. 42³/₄ in. [108.6 cm]

The M. and. M. Karolik Collection of Eighteenth-Century American Arts 39,119

"Who ever accused me of being a gentleman? I am a tenor!" Trained as an opera singer in his native St. Petersburg, Russia, Maxim Karolik (1893-1963) came to the United States in the early 1920s and became a champion of American art and a great benefactor of the Museum. In 1927 he married Martha Codman (1858-1948), who was descended from several prominent New Englanders and was herself a distinguished collector of eighteenth-century American art. Together they assembled three major collections for the Museum of Fine Arts that transformed the institution's holdings and rewrote the history of American art.

Martha Karolik was a more reserved figure than her husband—it would have been difficult not to be but it was she who introduced him to the Museum and her money that allowed them to gather what Maxim called "the trilogy." The first collection was dedicated to eighteenth-century furniture and painting; the second to paintings of the half century between 1815 and 1865; and the last to drawings, watercolors, and folk art of the same period. It is for

their taste in paintings that the Karoliks are best remembered, for before them it had been generally assumed that there was almost no art worthy of the name in mid-nineteenth-century America. The Karoliks were among the first to champion Fitz Henry Lane and, above all, Martin Johnson Heade, whom Maxim called "the genius of our collection." Presented to the Museum in the late 1940s, the Karoliks' paintings spurred a nationwide reassessment of nineteenth-century American art, and a number of the Karoliks' unknowns are today among the most sought-after American artists.

The Karoliks themselves were almost extravagantly modest, and Maxim refused to attend the opening of the Museum's exhibition of the painting collection for fear his presence would distract from the art. Most movingly, he saw the trilogy as a celebration of his adopted country and the embodiment of its democratic spirit. In an open letter to the Museum's director, he concluded: "We are not 'Patrons of Art' or 'Public Benefactors.' We refuse to accept these banal labels. We accept with pleasure only one label: 'Useful Citizens.'"

Horatio Greenough

American, 1805-1852 Castor and Pollux, about 1847

Bostonian Horatio Greenough was the first of many American sculptors to train in Italy, drawn there by its famed marble quarries; the inspiring examples of ancient Greek, Roman, and Renaissance sculpture; and a thriving, international community of artists eager to recapture the glories of classical art. This sculpture, carved in subtly modulated low relief and influenced by Roman architectural friezes and sarcophagi, depicts the famous warriors Castor and Pollux. According to one legend, Zeus rewarded the love of these brothers, separated by death, by joining them eternally in the sky as the constellation of the twins, Gemini.

Marble 34 % x 45 % x 1 % in. [88 x 114.8 x 4.5 cm] Bequest of Mrs. Horatio Greenough 92.2642

Sideboard

Pennsylvania (Philadelphia), 1850-60 Ignatius Lutz, American, (born in France), 1817-1860

Concrete symbols of taste and social status change with changing times. In the mid-nineteenth century, massive sideboards—carved with fruit, vegetables, and animals and often laden with silver-adorned the dining rooms of the wealthy and style-conscious. In a period when much furniture was at least partly made by machine, handcrafted objects began to assume new status. The rich and complex carving that gives this massive piece its exciting silhouette could not have been achieved by machine. The sideboard bears the label of French-trained cabinetmaker Ignatius Lutz, who came to Philadelphia in 1844. One of many French and German furniture makers in American cities at this time, Lutz employed thirty craftsmen who mainly worked without power machinery in his successful shop.

Susan Catherine Moore Waters American, 1823-1900 The Lincoln Children, 1845

Laura Eugenie, Sarah Isabella, and Augusta were the youngest of twelve children born to Otis and Sarah Lincoln of Newark Valley (near Binghamton), New York. Their father, who owned a hotel, commissioned this painting from Waters, a self-trained itinerant artist. For a period in the mid-1840s when her husband was ailing, Waters traveled from town to town painting portraits, presumably to supplement the family income. This is the most ambitious of about thirty

known portraits by Waters, and the rendering of pattern—in the children's dresses, the carpet or floorcloth, the leafy plants—is characteristic of the best folk art of the period. Note the intent little dog whose neat, white feet echo the girls' pristine pantalettes. In the 1860s Waters turned from portraits to paintings of animals, which gained considerable acclaim. Her *Mallard Ducks and Pets of the Studio* was exhibited at the prestigious Philadelphia Centennial Exposition of 1876.

Oil on canvas $45\% \ x \ 50\% \ in. \ (114.9 \ x \ 127.6 \ cm)$ Juliana Cheney Edwards Collection, by exchange ~1981.438

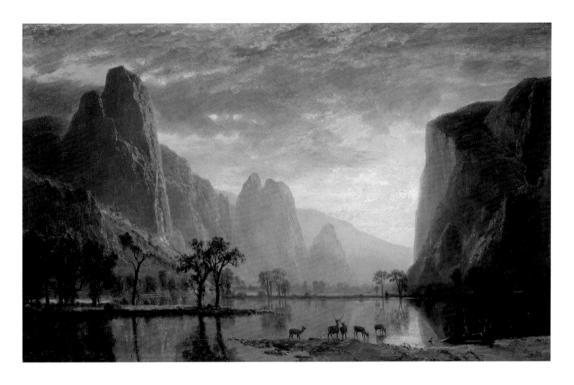

Albert Bierstadt American (born in Germany), 1830-1902 Valley of the Yosemite, 1864

Oil on paperboard

11% x 19¼ in. (30.2 x 48.9 cm) Gift of Martha C. Karolik for the M. and M. Karolik Collection of American Paintings, 1815-1865 47.1236

The unspoiled grandeur of the West was an endless source of fascination for armchair travelers in the eastern United States. Bierstadt, a canny businessman as well as a gifted painter, made several trips to the West. Back in his New York studio, he used the oil sketches and photographs from these journeys to create hundreds of paintings that range from the tiny to the gargantuan. These images celebrate the West's natural splendors, many of which would soon be altered forever by railroads, settlers, and tourists. The emotional charge that Americans found in the Western landscape—a charge similarly captured in Carleton Watkins's photographic vista from the same period (see opposite)—was conveyed by Bierstadt's companion on a trip to the recently discovered Yosemite Valley in 1864: "Far to the westward, widening more and more, it opens into the bosom of great mountain ranges,—into a field of perfect light, misty by its own excess,—into an unspeakable suffusion of glory created from the phoenix-pile of the dying sun."

Carleton E. Watkins

American, 1829-1916

Mount Starr King, Yosemite, No. 69, 1865-66

Photograph, mammoth albumen print from wet collodion negative $20 \times 16\%$ in. $(50.8 \times 41 \text{ cm})$

Ernest Wadsworth Longfellow Fund 2006.847

Frederick Hawkins Piercy

English, 1830-1891

Council Bluffs Ferry and Group of Cottonwood Trees, 1853

Watercolor on paper

101/ 5: (0/1 150

10½ x 7 in. [26.1 x 17.8 cm]

Gift of Maxim Karolik for the M. and M. Karolik Collection of American Watercolors and Drawings, 1800–1875 50,3870 During the 1850s, adherents of the Church of Jesus Christ of Latter-day Saints (the Mormons) migrated in great numbers from Europe and the eastern United States to the Utah territory. Mormons in Liverpool, England, hired English painter Piercy to document the trek in words and pictures and to produce a guidebook for future emigrants. In the course of a year-long journey, Piercy made a series of drawings and watercolors of the American plains that were reproduced as engravings in the book. This example, with its towering cottonwood trees, is typical of many nineteenth-century images of the West that contrast the diminutive fragility of human beings with the grand scale of the natural world.

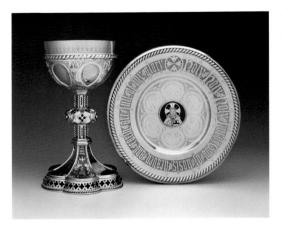

Chalice and paten

New York (New York), about 1860 Francis W. Cooper, American, and Richard Fisher, American, active 1858-1862

The chalice and the paten (a shallow dish) are used in the Christian church service of Communion, in which wine and bread are offered to the congregation as the body and blood of Christ. These are very rare examples of American silver in the Gothic Revival style, which emulated the perfection, grace, and exquisite workmanship of medieval liturgical vessels. Enriched with enamel and gilding, they reflect the "ecclesiological" movement in the mid-nineteenth-century Church of England and American Episcopal church, which called for a revival of the splendors of

Silver, gilded silver, enamel H. of chalice: 9% in. (25.1 cm) Gift of The Seminarians, Curator's Fund, and Ron Bourgeault 1996.27.1, 1996.27.2

medieval Catholicism.

Cabinet

New York (New York), about 1880 Made by Herter Brothers, American, active 1865-1905

Spare and linear in form, this cabinet is enlivened by a rich variety of carved and inlaid asymmetrical ornament after the Japanese taste. Although probably derived from Japanese screens and woodblock prints, this ornament is free of any historical or symbolic context. It features extraordinarily detailed insects and plants, including tiny beetles chewing holes in leaves. The pale wood and gilding reflect a movement away from the prevalent taste for heavy, dark furniture. The cabinet is in superb original condition; notable is the embossed and stenciled gilt paper lining the niches and splashboard—a rare survival. The cabinet is the work of Herter Brothers, the fashionable firm that produced some of New York's finest furniture in the eclectic styles typical of the time. It may have been made for railroad magnate Edward Henry Harriman, one of the New York robber barons who were Herter Brothers' frequent clients.

Maple, bird's eye maple, oak or chestnut, stamped and gilt paper; gilding, inlay, and carved decoration; original brass pulls and key 52½ x 72¾ x 15½ in. [133.4 x 148.8 x 38.4 cm] Museum purchase with funds donated anonymously and the

Frank B. Bemis Fund 2000.3

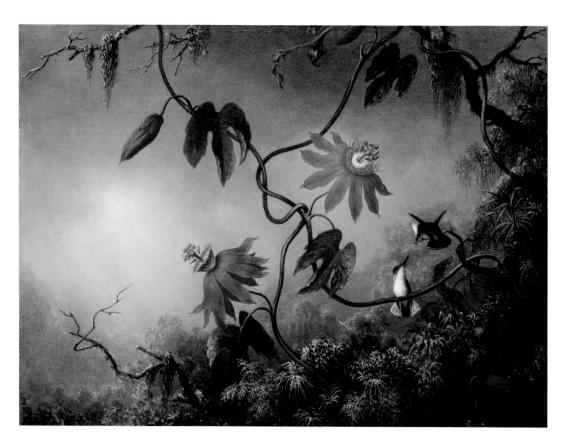

Martin Johnson Heade

American, 1819-1904

Passion Flowers and Hummingbirds, about 1870-83

Oil on canvas

15½ x 21% in. (39.4 x 54.9 cm)

Gift of Maxim Karolik for the M. and M. Karolik Collection of American Paintings, 1815–1865 47.1138

Heade traveled to Brazil in 1863 to paint illustrations for a book about hummingbirds. Although the book never materialized, Heade continued to paint images of tiny hummingbirds and exotic flowers—usually orchids—for more than forty years. Reflecting midnineteenth-century beliefs in the unity of art and science, Heade rendered his birds and blossoms with meticulous precision, but he was also clearly captivated by their sensuous beauty. Here, the brilliant flowers are silhouetted against gray mist shot with light, and we look through sinuous, snaking vines into a vast jungle landscape. Heade was the favorite painter of eminent collector Maxim Karolik (see page 314).

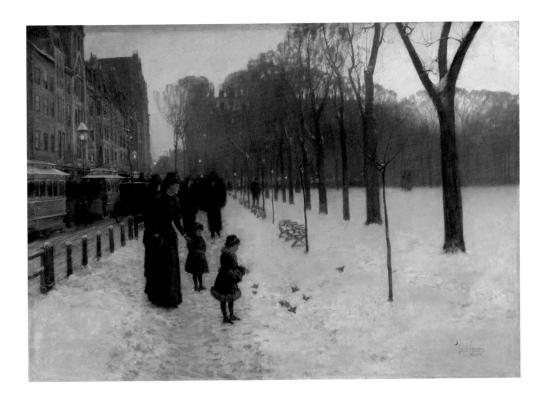

Childe Hassam

American, 1859-1935

Boston Common at Twilight, 1885-86

Along a snowy sidewalk, a fashionably dressed woman and her daughters, all wearing muffs against the cold, pause to feed some birds. Before them is the serene expanse of Boston Common; behind them, the gaslights are coming on and horse-drawn streetcars and cabs inch along crowded, and newly developed, Tremont Street. This painting, one of the most evocative of images of life in nineteenth-century Boston, is also an early example of Hassam's lifelong interest in the varied effects of light and in subjects drawn from the modern city; he later became one of the first American Impressionists.

Oil on canvas 42 x 60 in. [106.7 x 152.4 cm] Gift of Miss Maud E. Appleton 31.952 facing page, top

Edwin Austin Abbey

American, 1852-1911

A Pavane, 1897

Renowned for his decorative compositions and fascinated by the Middle Ages, Abbey was an illustrator and draftsman who turned to painting when he was forty. He settled in England in 1882. He is best known for his mural depicting scenes from the legend of King Arthur, which was installed in the Book Delivery Room of the Boston Public Library in 1895. This brilliant, opulent canvas shows two handsomely dressed couples gliding in a sixteenth-century court dance. The setting is stagelike, with the dancers carefully posed across the horizontal space of the large canvas, framed by potted trees and backed by a stunning golden screen. The painting was commissioned for the dining room of the Villard House at 50th Street and Madison Avenue, home of the prominent New

Yorker Whitelaw Reid. When the picture was exhibited at the Society of American Artists soon after its completion, the writer for the *New York Times* declared: "In loftiness of sentiment, nobility of conception . . . and ease of drawing, this superb work is altogether delightful."

Oil on canvas 40 x 103 in. [101.6 x 261.6 cm] Bequest of Susan A.D. McKelvey and Bequest of Kathleen Rothe, by exchange 2004.238

right

Southworth and Hawes American, 19th century

Portrait of a Woman in Nine Oval Views, 1845-61

The daguerreotype, introduced in 1839, was one of the earliest photographic processes. The Boston firm established by Albert Sands Southworth (1811–1894) and Josiah Johnson Hawes (1808–1901) was renowned for its ability to capture personality and expression in daguerreotype portraits—no mean feat in a medium that required the sitter to remain absolutely motionless for up to thirty seconds. In 1855 Southworth patented a device for making multiple exposures on the same plate, explaining that they might be used to

select "the best for a locket; or they may be different views of the same face taken upon the same plate for the purposes of preserving them together." This is the finest of only two known examples of this adventurous technique.

Photograph, daguerreotype $8\% \times 6\%$ in. (21.6 x 16.5 cm) Gift of Edward Southworth Hawes in memory of his father Josiah Johnson Hawes 43.1405

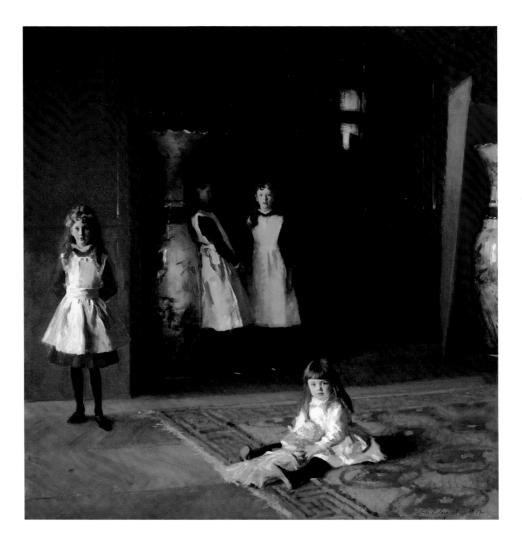

John Singer Sargent

American, 1856-1925

The Daughters of Edward Darley Boit, 1882

Sargent was a young painter of fashionable portraits when he created this unconventional image of his friend Edward Boit's daughters posing in the family's Paris apartment. The Boits, like Sargent, were often on the move, and the enormous Japanese vases in this picture survived multiple trips across the Atlantic (they were given to the Museum in 1997). The painting's square format is unusual, as is the isolated placement

of the children within a shadowy, cavernous space described by one critic as "four corners and a void." Each girl is individualized, expressing her age and personality by subtleties of pose and gaze. And "when," mused American writer Henry James, "was the pinafore ever painted with that power and made so poetic?"

Oil on canvas

87% x 87% in. [221.9 x 222.6 cm]

Gift of Mary Louisa Boit, Julia Overing Boit, Jane Hubbard Boit, and Florence D. Boit in memory of their father, Edward Darley Boit 19.124

Mary Stevenson Cassatt

American, 1844-1926

In the Loge, 1878

Oil on canvas
32 x 26 in. [81.3 x 66 cm]
The Hayden Collection—Charles Henry
Hayden Fund 10.35

Mary Stevenson Cassatt American, 1844–1926 Study for the painting In the Loge, about 1878

Graphite pencil on paper 4 x 6 in. (10.2 x 15.2 cm) Gift of Dr. Hans Schaeffer 55.28

Born and raised in Pennsylvania, Cassatt settled in Paris in 1875 and became the only American to exhibit with the Impressionist group. Like her friend Edgar Degas, she was a figure painter, attracted to detached and spontaneous views of modern life. Here, a woman in sober dress and hat uses her uptilted opera glasses to scan the occupants of other boxes. Self-contained and intent, she seems unaware of the man who leans out of another box, focusing his glasses on her. About the time this picture was painted, Cassatt began to carry a small sketchbook in which she swiftly recorded people and scenes that might later become subjects of paintings, as in the preparatory sketch for In the Loge.

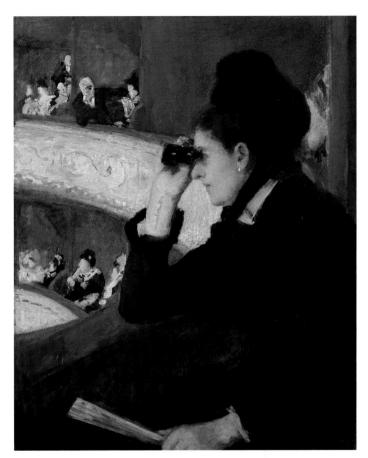

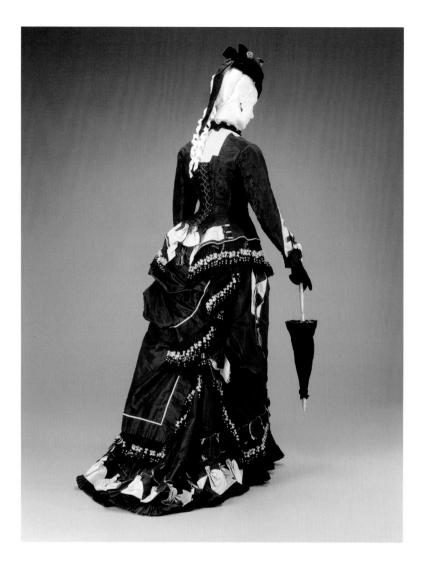

Walking dress

Massachusetts (Boston), 1874-75 Labeled: "John J. Stevens/282 Washington Street, Boston"

Sarah Howe of Lowell, Massachusetts, purchased this dress at the popular Boston shop of John J. Stevens (1824–1902), a dressmaker who also advertised his firm as "importers and dealers of Paris modes." It is possible that Mrs. Howe's stylish dress, with its bustle and complex arrangement of sweeping folds, was

made in Paris. Although designed as a "walking dress" for daytime strolls, it required the wearing of a corset and the cumbersome skirts would have been difficult to manage on the street. The dress reform movement, which had developed by the 1860s along with the women's suffrage movement, denounced such garments as restricting and unhealthy and scorned fashionable women as "upholstered bodies."

Silk; plain weave, trimmed with knotted net and tassels Gift of Miss Ruth Burke 56.818a-b

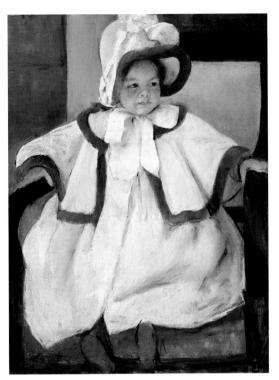

Mary Stevenson Cassatt

American, 1844-1926

Ellen Mary in a White Coat, about 1896

Cassatt was one of the first artists to explore the artistic possibilities of the sheltered domestic and social lives of upper-class women. This portrait of her niece Ellen Mary Cassatt (1894–1966) is unusual among the artist's many images of children for its directness and lack of sentimentality. Overdressed—indeed, almost overwhelmed—in a fashionable caped coat and bonnet, the baby sits waiting until the grownups are ready to go out. Her diminutive size is accentuated by the tiny hands and boots, but she fills the space of the picture entirely, touching every edge, and her firm personality dominates the portrait.

Oil on canvas $32 \times 23\%$ in. $(81.3 \times 60.3 \text{ cm})$ Anonymous Fractional Gift in honor of Ellen Mary Cassatt 1982.630

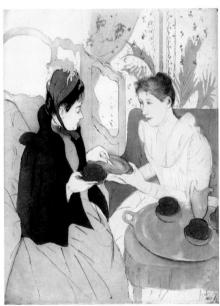

Mary Stevenson Cassatt
American, 1844–1926
Afternoon Tea Party, about 1891

After attending an 1890 Paris exhibition of more than 700 Japanese woodblock prints, Cassatt wrote: "You couldn't think of anything more beautiful. I dream of it." Like many of her contemporaries, Cassatt collected and admired Japanese prints for their modernlife subjects, emphasis on elegant line, unusual compositions, and barely modulated areas of color. This is one of a set of ten color prints in which Cassatt focuses on daily domestic life—women bathing and dressing, tending their children, out for a dressfitting or a social call. The several plates required to produce the variety of colors were each inked by hand, and every one of Cassatt's sophisticated etchings with aquatint is a unique work of art.

Drypoint and color aquatint
Platemark: 13³/₄ x 10¹/₂ in. (34.8 x 26.8 cm)
Gift of William Emerson and The Hayden Collection—
Charles Henry Hayden Fund 41.811

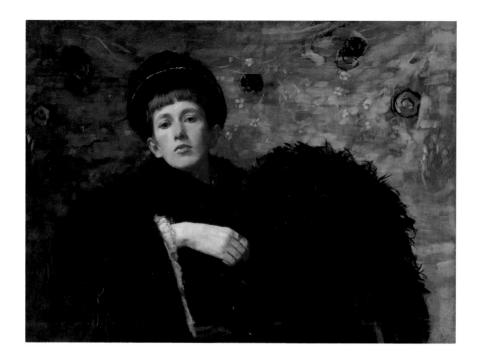

Ellen Day Hale American, 1855-1940 Self-Portrait, 1885

Hale studied in Boston, Philadelphia, and Paris and supported herself by teaching art in Boston, by selling her portraits and etchings, and by painting decorations in church interiors. This unconventional self-portrait is unusually forthright for a woman painter. Against a rather mysterious blue background decorated with swirling shapes and spots of bright color, her purposeful, unsmiling face and capable hand stand out from the surrounding soft blackness of dress, hat, and ostrich-feather fan. A critic writing in 1887 acknowledged the artist's originality and skill: "Miss Ellen Hale . . . displays a man's strength in the treatment and handling of her subjects—a massiveness and breadth of effect attained through sound training and native wit and courage."

Oil on canvas 28½ x 39 in. [72.4 x 99.1 cm] Gift of Nancy Hale Bowers 1986.645 facing page, bottom

Henry Ossawa Tanner American, 1859-1937 Interior of a Mosque, Cairo, 1897

Tanner, the foremost African-American painter of the late nineteenth century, was first trained in his native Philadelphia but settled permanently in Paris, in 1891. There, he specialized in religious compositions, exhibiting many at the prestigious Salon exhibitions from 1894 to 1914. Sponsored by Philadelphia businessman Rodman Wanamaker. Tanner traveled to the Near East in 1897, following a stream of artists who had made this trip since the 1830s. Like many individuals of his time. Wanamaker believed that "one should go [to the Near East] every two or three years, at least, to keep in touch with the Orientalist spirit." Tanner visited several mosques in Cairo; this loosely painted interior depicts the gibla wall at al-Ashrafiya.

Oil on canvas 20 ½ x 26 in. [52.1 x 66 cm]

Museum purchase with funds by exchange from The Hayden Collection—Charles Henry Hayden Fund, Bequest of Kathleen Rothe, Bequest of Barbara Brooks Walker, and Gift of Mrs. Richard Storey in memory of Mrs. Bayard Thayer 2005.92

William Rimmer

American (born in England), 1816-1879

Flight and Pursuit, 1872

What is the meaning of this nightmare vision of a man fleeing from a mysterious, shadowy figure? Suggested interpretations include man seeking to escape his conscience; the pursuit of John Surratt, suspected of scheming with John Wilkes Booth to assassinate Abraham Lincoln; and the biblical story of conspirators who raced to sanctuary after King David discovered their plot to usurp the throne. Whatever the intended subject of the painting may have been, Rimmer manipulated shadow and substance into a highly personal and disturbing vision.

The artist's own life was a troubled one, his childhood dominated by a father who believed he was the lost son of Louis XVI and Marie Antoinette. As an adult, Rimmer worked in Boston as a physician, sculptor, and an influential teacher of drawing and anatomy.

Oil on canvas 18% x 26% in. [46 x 66.7 cm] Bequest of Miss Edith Nichols 56.119

John White Alexander American, 1856-1915 Isabella and the Pot of Basil, 1897

And she forgot the stars, the moon, and sun, And she forgot the blue above the trees, And she forgot the dells where waters run. And she forgot the chilly autumn breeze: She had no knowledge when the day was done, And the new morn she saw not: but in peace Hung over her sweet Basil evermore. And moisten'd it with tears unto the core.

In John Keats's 1820 poem "Isabella; or, The Pot of Basil," the ambitious brothers of wealthy Isabella, determined that she marry a nobleman, murder her humble suitor Lorenzo. Isabella discovers Lorenzo's body buried in the woods, cuts off the head, and hides it in a pot planted with sweet basil, a symbol of undying love. Painted in Paris at the very end of the nineteenth century, this picture's theatricality and macabre theme reflect the decadent tastes of the period known as the fin de siècle.

Oil on canvas 75% x 36% in. [192.1 x 91.8 cm] Gift of Ernest Wadsworth Longfellow 98.181

William Michael Harnett

American (born in Ireland), 1848-1892

Old Models, 1892

"As a rule," Harnett said, "new things do not paint well." Here, fastidiously arranged against a scuffed and cracked wooden door, are a dented bugle that has lost its shine, an old violin, volumes of Shakespeare and Homer frayed and stained from many readings, tattered scores of romantic songs, and a ceramic jar from Europe. These are the models that Harnett painted often—objects treasured both for their textures and shapes and for their evocation of past times. The American master of the time-honored trompe l'oeil ("deceive the eye") style, Harnett rendered his subjects with such minute precision that viewers are led to wonder: "Is this really only paint?" Scorned by the art establishment as virtuoso trickery, Harnett's pictures enchanted patrons in the hotels and saloons where they most often hung. Old Models was Harnett's last work, painted shortly before his death at the age of forty-four.

Oil on canvas $54\% \times 28\% \text{ in. } \{138.1 \times 71.8 \text{ cm}\}$ The Havden Collection—Charles Henry Hayden Fund 39.761

Snake pitcher Rhode Island (Providence), 1885 Gorham Manufacturing Company

American mines were producing prodigious amounts of silver in the late nineteenth century, and a flourishing market for silver objects encouraged innovation in both form and technique. To keep pace with the demand, major silvermaking firms developed new production methods and hired skilled craftsmen and designers from Europe. This startling and seductive pitcher is a consummate expression of the period's love of novelty, surprise, and virtuoso craftsmanship. The work of the silversmith alone took fifty-five hours. The bodies of the two entwined snakes were embossed: pushed out or indented from the back. Another craftsman, the chaser, then articulated these basic snake forms from the front, defining the scales of backs and bellies in a process similar to engraving—which took another eighty-six hours to complete.

Silver H. 10 in. [25.4 cm] Edwin E. Jack Fund 1983.331

Keyed bugle in E-flat Massachusetts (Boston), about 1854 Elbridge G. Wright, American, 1811-1871

By the time of the Civil War, virtually every American town had a brass band that performed at dances, election-day parades, and outdoor summer concerts. The keyed bugle pitched in E-flat was usually the solo instrument in such bands, and skilled bugle players could become celebrities. Most bugles were copper; this costly silver instrument, as indicated on the engraved bell, was a presentation piece given in 1854 to Joseph J. Brenan, leader of the Marietta,

Ohio, town band. By the 1860s, keyed bugles had passed out of favor and become-like the one in William Harnett's painting Old Models-sentimental reminders of days gone by.

Silver H. 17½ in. [44.5 cm] Gift of The Seminarians and Friends in memory of Warren C. Moffett 1990.85

John Frederick Peto American, 1854–1907 The Poor Man's Store, 1885

Peto had more success as a cornet player than as a painter and sold his pictures for a few dollars—or gave them away. Until about 1950, Peto's paintings were often attributed to his friend and fellow Philadelphian William Harnett. This colorful image of a tiny street-front shop is Peto's masterpiece. He used a canvas for the central window area of the composition and set it into a wooden "frame" illusionistically

painted to represent the wall, shelf, and door. Multiple meanings and visual jokes are characteristic of trompe l'oeil painting. Here, the sign "Good Board" below the window may refer to the availability of lodging, to the shelf from which the sign hangs, or to the actual wood of the painting's "frame."

Oil on canvas and panel 35% x 25% in. (90.2 x 65.1 cm) Gift of Maxim Karolik for the M. and M. Karolik Collection of American Paintings, 1815-1865-62.278

Erastus Salisbury Field

American, 1805-1900

Joseph Moore and His Family,

about 1839

Oil on canvas 82% x 93% in. [209.2 x 237.2 cm] Gift of Maxim Karolik for the M. and M. Karolik Collection of American Paintings, 1815-1865 58.25

Mary Ann Willson

American, active 1800-1825

Young Woman Wearing a Turban,

between 1800-1825

Watercolor and graphite pencil on paper 7% x 6½ in. [20 x 16.5 cm] Gift of Maxim Karolik for the M. and M. Karolik Collection of American Watercolors and Drawings, 1800-1875 56.456

Peacock weathervane

Eastern United States, about 1860-75

Copper, painted gold; iron rod H. 19% in. (50 cm), including ball Gift of Mr. Maxim Karolik 54.1089

Storage jar

South Carolina (Edgefield County), 1857 Dave Drake (or Dave the Potter), American, about 1800-about 1870, for the Lewis J. Miles Factory

Stoneware with alkaline glaze H. 19 in. [48.3 cm] Harriet Otis Cruft Fund and Otis Norcross Fund 1997.10

Although its extraordinary diversity resists generalization, much American folk art was made in rural areas and small towns by artists who lacked formal training in the fine arts. Some were professionals, some amateurs; many of their names are lost. Most of the objects they produced—like pottery and weathervanes—were primarily functional. Others were created for the pleasure of the artists and their friends, family, and community.

At its best, American folk art is far more than the unskilled imitation of work produced by trained practitioners in urban centers. Among its hallmarks is an originality of conception

unhampered by the desire to be part of a recognized school or style. Although many folk artists were somewhat limited by their lack of training, they compensated for this with a directness of expression emphasizing pattern, contour, color, and simplified form in a way that is very pleasing to the modern eye.

Maxim Karolik (see page 314), who established the Museum's ever-increasing collection of American folk art, once observed that folk artists "sometimes lacked the ability to describe, but it certainly did not hinder their ability to express." Few objects bear this out as eloquently as the storage jar crafted by a slave known as Dave the Potter. Dave, who fashioned the work in the pottery of his owner, was literate, and was perhaps the only slave craftsman permitted to sign his work. This jar is signed, dated August 22, 1857, and inscribed: "I made this

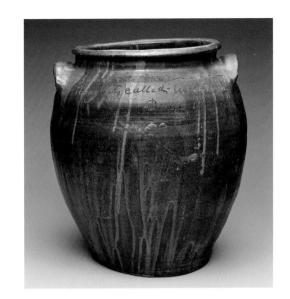

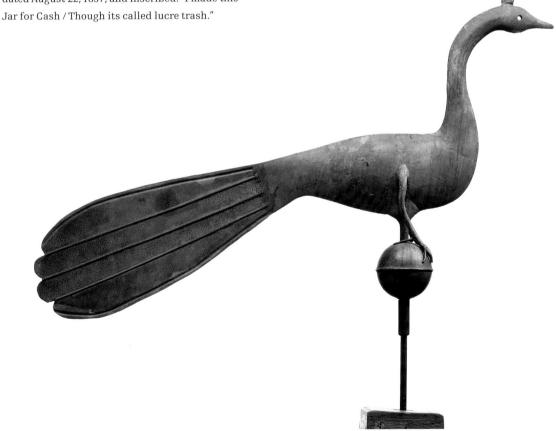

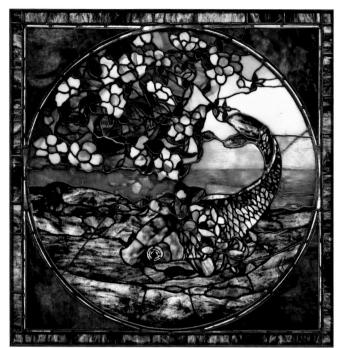

John La Farge American, 1835-1910 The Fish New York (New York), about 1890

La Farge began his experiments with stained glass in the 1870s and soon gained an international reputation. Some three hundred La Farge windows survive, many made for churches, public buildings, and private houses designed by major architects of the day. In 1880 La Farge patented the use of opalescent glass, and here he combined it with translucent and clear, colored glass to produce an exuberant pictorial illusionism. This window was made for the home of an ardent fisherman, Gordon Abbott of Manchester, Massachusetts.

Leaded stained glass 26½ x 26½ in. [67.3 x 67.3 cm] Edwin E. Jack Fund and Anonymous gift 69.1224

John La Farge American, 1835-1910 Vase of Flowers, 1864

Best known for his murals decorating Boston's Trinity Church and for his stainedglass windows, La Farge was also a gifted painter in watercolor and oil. His images of flowers are evocative rather than botanically accurate. Here the spare composition and background (which may represent a Japanese screen), as well as the vessel, a Japanese brush pot, reflect La Farge's fascination with Asian art. The painting is given a distinctive, personal quality by the inclusion of a bent calling card (inscribed "J. La Farge/1864") lying beneath a wilting bachelor's button.

Oil on gilded panel 18½ x 14 in. [47 x 35.6 cm] Gift of the Misses Louisa W. and Marian R. Case 20.1873

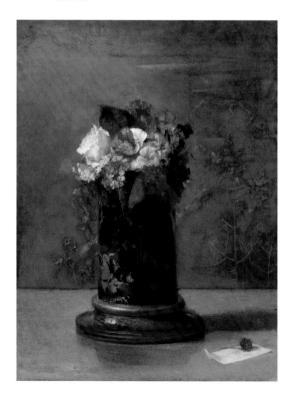

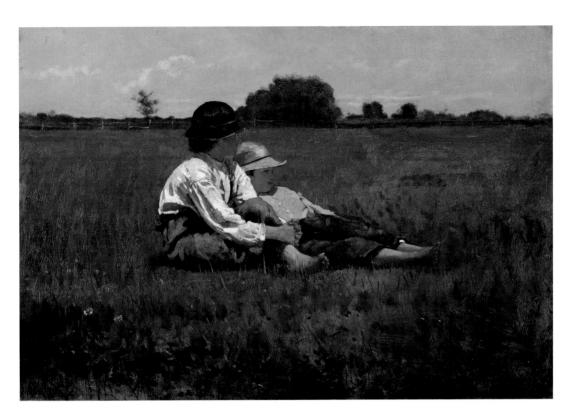

Winslow Homer
American, 1836–1910
Boys in a Pasture, 1874

Oil on canvas $15\% \times 22\% \text{ in. } \text{(40.3} \times 58.1 \text{ cm)}$ The Hayden Collection—Charles Henry Hayden Fund } 53.2552

Born in Boston, Homer was trained as a commercial printmaker, and during the Civil War, he worked at the front for the illustrated journal *Harper's Weekly*. In the 1870s, as America began to recover from the war, Homer turned to painting sunny, optimistic pictures of young women and children enjoying themselves outdoors. The boys in this painting—companionable, idle, at peace—may be seen as emblems of America's nostalgia for a simpler, more innocent time as well as of its hope for the future. Their faces are shadowed and averted, a device Homer often used to make his figures less individual and, therefore, more universal.

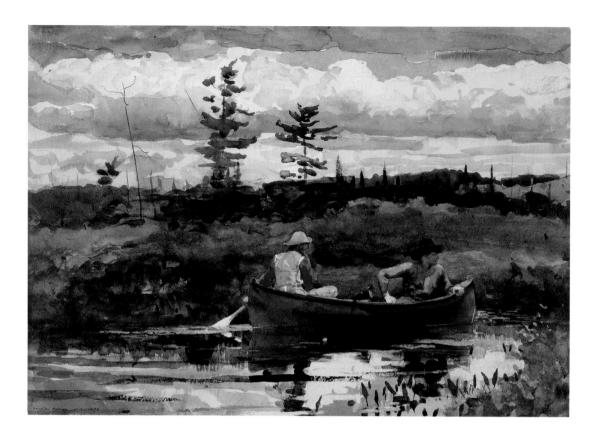

Winslow Homer American, 1836-1910 The Blue Boat, 1892

Watercolor over graphite pencil on paper 151/4 x 211/2 in. [38.6 x 54.6 cm] William Sturgis Bigelow Collection 26.764 In 1879 a critic stated that Winslow Homer had gone "as far as anyone has ever done in demonstrating the value of watercolors as a serious means of expressing dignified artistic impressions." Spontaneous in effect, Homer's watercolors demonstrate an unequaled mastery of technique. He laid out his compositions with broad, overlapping washes of color and then created a range of luminous coloristic and textural effects by both adding pigment and subtracting it by blotting and scraping. "You will see," Homer said, "in the future I will live by my watercolors." Although most watercolors fade over time, The Blue Boat, painted on one of Homer's frequent trips to the Adirondacks in New York State, is in pristine condition. Homer acknowledged his satisfaction with this masterwork by noting on the sheet: "This will do the business."

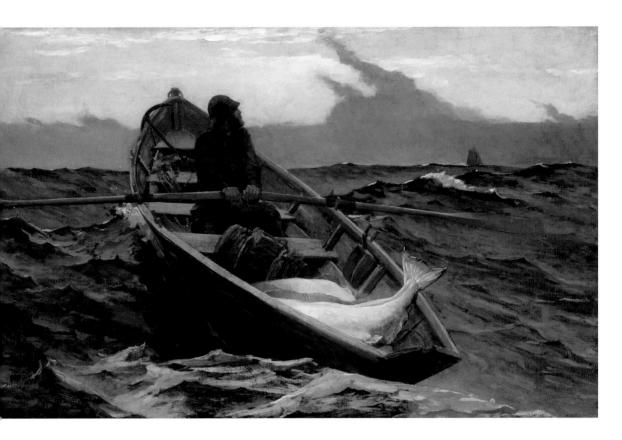

Winslow Homer
American, 1836-1910
The Fog Warning, 1885

Oil on canvas $30\% \times 48\% \text{ in. } [76.8 \times 123.2 \text{ cm}]$ Otis Norcross Fund -94.72

Homer moved to Prout's Neck, near Portland, on the rocky coast of Maine by 1883. There, for the rest of his life, he painted the sea and those who made their living from it. *The Fog Warning* was inspired by Homer's trip with a fishing fleet to the Grand Banks off Nova Scotia. Here, the lone fisherman, his dory weighed down by enormous halibut, tries to reach the mother ship before it becomes enveloped in the dark fog bank on the horizon. The painting explores man's constant struggle with the sea—the source of livelihood but also of danger. This was the first painting by Homer to enter a public collection.

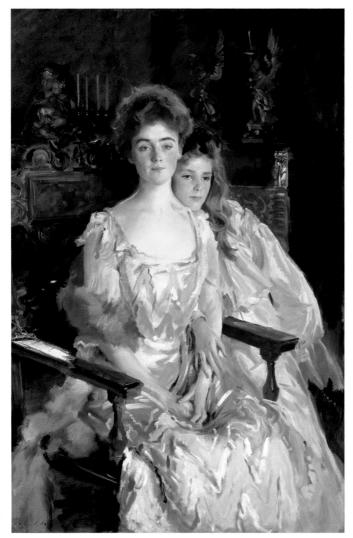

John Singer Sargent American, 1856-1925 Mrs. Fiske Warren (Gretchen Osgood) and Her Daughter Rachel, 1903

Born in Italy to American parents, Sargent became a highly successful portrait painter on both sides of the Atlantic. This portrait was painted in Boston at Fenway Court, which had just opened as the Isabella Stewart Gardner Museum and where the artist had a temporary studio. The portrait's imposing size, the Renaissance furniture, and Mrs. Warren's formal pose evoke aristocratic portraits of the past. At the same time, Sargent's style is very modern. He paints with freedom and confidence-notice the thick slash of white pigment that highlights the chair arm. Mrs. Warren, who wore at Sargent's insistence a borrowed pink dress, did not like the portrait, feeling that it focused on her social position and ignored her serious interest in poetry and the performing arts.

Oil on canvas 60 x 40% in. [152.4 x 102.6 cm] Gift of Mrs. Rachel Warren Barton and Emily L. Ainsley Fund 64.693

John Singer Sargent American, 1856-1925 An Artist in His Studio, 1904

On a summer trip to the Italian Alps, Sargent depicted his friend, the artist Ambrogio Raffele, painting a bucolic landscape. The setting is a cramped hotel bedroom. Surrounded by sketches presumably made outdoors, Raffele holds a palette that bears actual gobs of thick, bright paint. Half the composition is given over to rumpled sheets and a discarded smock—an extraordinary display of brilliant brushwork that gave Sargent the opportunity (which he loved) of painting white on white.

Oil on canvas 22½ x 28¾ in. (56.2 x 72.1 cm) The Hayden Collection—Charles Henry Hayden Fund 05.56

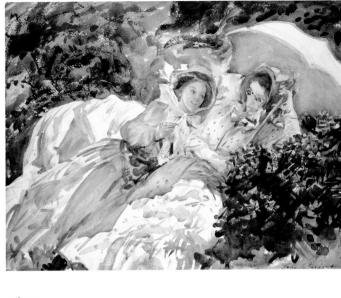

above

John Singer Sargent

American, 1856-1925

Simplon Pass: The Tease, 1911

Sargent often produced more than twenty society portraits in a year; in the summer, he escaped to the freer, more personal, and more experimental medium of watercolor. He called his informal, anecdotal watercolors of friends and family "snapshots." Fluent and

apparently spontaneous, they show a great mastery of complex techniques and are among Sargent's most admired works. Painted outdoors, they capture the colored shadows and the dappled effects of light; for this, watercolor—with its transparent washes of color over white paper—was the perfect medium. *The Tease* shows the artist's niece and a friend lounging on an outing at the Simplon Pass near the Italian—Swiss border.

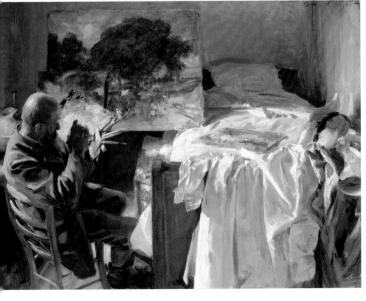

Watercolor over graphite pencil on paper $15\% \times 20\%$ in. $(40 \times 52.4$ cm) The Hayden Collection—Charles Henry Hayden Fund 12.216

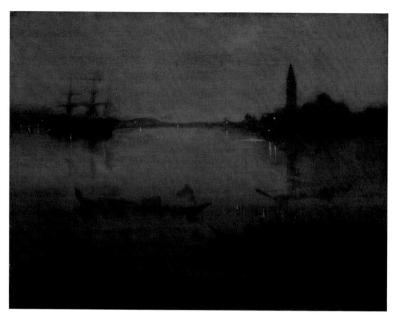

James Abbott McNeill Whistler American (active in England), 1834-1903 Nocturne in Blue and Silver: The Lagoon, Venice, 1879-80

Whistler liked people to believe that he was born in Russia: in fact, although he made his career abroad, he was born in the mill town of Lowell, Massachusetts. Extraordinarily gifted and innovative, Whistler was determined to free his art from representation and narrative. "Art should be independent of all clap-trap," he asserted. "[It] should ... appeal to the artistic sense of eye or ear, without confounding this with . . . devotion, pity, love, patriotism, and the like." In this night view of Venice, looking across still water to the church of San Giorgio Maggiore, Whistler painted the muted tones he loved. A friend who was with the artist when he created this image called it "possibly the most peace-bringing of Jimmy's pictures; certainly his finest night scene."

Oil on canvas 1934 x 2534 in. [50.2 x 65.4 cm] Emily L. Ainsley Fund 42.302

James Abbott McNeill Whistler American (active in England), 1834-1903 Weary, 1863

Whistler was a prolific and influential printmaker, particularly interested in etching and drypoint, techniques very similar to drawing with pen on paper. Weary was printed on silky, tissuelike Japanese paper to enhance the delicacy of fine and swiftly rendered drypoint lines. The model was Whistler's mistress, a red-haired Irish beauty named Joanna Hiffernan who also appears in a number of the artist's most celebrated paintings. Her pose in Weary was inspired by "Jenny," a poem by Whistler's friend Dante Gabriel Rossetti about a prostitute "fond of a kiss and fond of a guinea."

Drypoint Platemark: 7\% x 5\% in. [19.7 x 13 cm] Lee M. Friedman Fund 69 1178

Thomas Eakins
American, 1844–1916
Starting Out after Rail, 1874

"A boat is the hardest thing I know to put in perspective," wrote Eakins. "It is so much like the human figure, there is something alive about it." This image of a boat skimming across water enlivened by the play of wind and light seems wonderfully immediate, but most of Eakins's paintings were the result of careful measurements, precise calculations, and

many preparatory studies. Although he studied in Paris, he lived all his life in Philadelphia, and his family, friends, and the masculine world of sport were the subjects of his art. Here, he depicts two friends setting off to hunt for rail (a kind of bird) in the marshlands along the Delaware River, near Philadelphia.

Oil on canvas mounted on Masonite $24\% \times 19\%$ in. (61.6 $\times 50.5$ cm) The Hayden Collection—Charles Henry Hayden Fund 35.1953

Edmund Charles Tarbell

American, 1862-1938

Mother and Child in a Boat, 1892

Boston artists played a major role in the recognition and practice of Impressionism in America. Tarbell, who trained at the School of the Museum of Fine Arts and later became one of its most influential teachers, adopted a brilliantly colored Impressionist technique after returning to Boston from studies in Paris. He was a founding member of The Ten, a group of painters working in Impressionist styles whose exhibitions in New York, beginning in 1898, helped make Impressionism the most popular "modern" style in America.

Oil on canvas 30% x 35 in. [76.5 x 88.9 cm] Bequest of David P. Kimball in memory of his wife Clara Bertram Kimball 23.532

Pictorial quilt

Georgia (Athens), about 1895-98

Harriet Powers, American, 1837-1910

Described as "expressive in its every stitch of a most fiery imagination," this quilt was created at the end of the nineteenth century by an African-American woman, born a slave, who lived on a farm near Athens, Georgia. The fifteen squares depict familiar biblical events-stories of Adam and Eve, Noah, Job, Jonah, Moses, and Christ-and record local legends and such fearful and marvelous natural phenomena as the Leonid meteor shower of 1833. Although Powers probably could neither read nor write, she dictated a commentary on her work. The center panel, for instance, she explained as: "The falling of the stars on Nov. 13, 1833. The people were frightened and thought that the end had come. God's hand staid the stars. The varmints rushed out of their beds." Accounts of the eight-hour meteor shower of 1833, passed down through the generations, were part of the oral tradition from which Powers drew her imagery.

Narrative quilts are characteristically American, but Powers's textile is strikingly similar in design and technique to the appliquéd cotton cloths made by the Fon people of Abomey, the ancient capital of Dahomey (now the Republic of Benin) in West Africa.

Cotton; plain weave, printed, pieced, and appliquéd; hand- and machine-embroidered with cotton and metallic yarns

69 x 105 in. (175 x 267 cm)

Bequest of Maxim Karolik 64.619

Maurice Brazil Prendergast American (born in Newfoundland), 1858-1924 Umbrellas in the Rain, 1899

Prendergast was among the greatest American masters of watercolor. On a trip to Europe in 1898-99, he fell in love with Venice, painting watercolors that are among his finest works. Here, with the passing of a summer storm, a crowd of typically anonymous figures moves among famous Venetian monuments the somber facade of the prison at right; the delicate arcades of the Doge's Palace; and the marble bridge, Ponte della Paglia. The bright shapes of umbrellas lead the eye through a composition that has the abstract, patterned quality of a mosaic. Although Prendergast shared the Impressionists' enthusiasm for outdoor subjects from modern life, his exploratory style and his use of watercolor rather than oil as his primary medium place him among American modernist artists of the early twentieth century.

Watercolor over graphite pencil on paper 13% x 20% in. [35.4 x 53 cm] The Hayden Collection—Charles Henry Hayden Fund 59.57

Punch bowl Pasadena, California, about 1912 Clemens Friedell, American, 1872-1963

Early in his career, Clemens Friedell belonged to an elite group of artisans, working as a skilled decorator called a "chaser" at the Gorham Company in Providence, Rhode Island. In 1911 he opened a shop in Pasadena and quickly gained a reputation as one of California's top silversmiths. Friedell's designs merged hallmarks of the Arts and Crafts movement, such as visible hammer marks that emphasize handcraftsmanship, with the flowing curves and visual

depth of the Art Nouveau style. His decorative objects often incorporated native California flora, such as the large golden poppies that embellish this enormous punch bowl, made as a trophy for the Hogan Challenge Polo tournament about 1912. The bowl may be the "huge punch bowl" that Friedell later exhibited at the 1915 Panama-California Exhibition in San Diego. for which he received a gold medal.

Silver

14 ½ x 17 ¾ in. (36.2 x 45.1 cm)

Museum purchase with funds donated anonymously, and from Shirley and Walter Amory, John and Catherine Coolidge Lastavica, the H.E. Bolles Fund, the Michaelson Family Trust, James G. Hinkle, Jr., and Roy Hammer, Robert Rosenberg, Sue Schenck, the Grace and Floyd Lee Bell Fund, and Miklos Toth 2003.730

William McGregor Paxton American, 1869-1941 The New Necklace, 1910

At the turn of the twentieth century, a time of profound social, economic, and industrial change, Boston artists asserted a renewed ideal of beauty, extolling traditional values of fine drawing, rich color, and idealized compositions. Paxton believed that harmony and beauty were intrinsic to good art, and his paintings are carefully arranged and highly finished. Here two elegantly dressed women appear to be discussing

the implications of a recent gift from a suitor. Like the gold beads they hold, the women are exquisite ornaments in an opulent setting that includes a Japanese screen, a Chinese tunic and porcelain figurine, a Renaissance tapestry, and a copy of a painting by Titian. Paxton, a teacher at the School of the Museum of Fine Arts, was particularly inspired by the work of the seventeenth-century Dutch painter Jan Vermeer.

Oil on canvas 36% x 28% in. (91.8 x 73 cm) Zoe Oliver Sherman Collection 22.644

Wassily Kandinsky

Russian (worked in Germany), 1866-1944 Poster for the First Phalanx Exhibition, 1901

Kandinsky, widely regarded as the originator of purely abstract art, abandoned a legal career in his native Russia at the age of thirty to study art in Munich, the center of modern German art, music, literature, and theater. This poster, in the Art Nouveau style, is imbued with graphic energy and charged with symbolic meaning. It was one of Kandinsky's first public graphic works and advertised the initial exhibition of the Phalanx society, an organization of avant-garde artists that he helped to found. The armor-clad warriors who form an interlocked battle line, or phalanx, allude to the members of this tightly knit and militant group.

Color lithograph

Image: 17\% x 23\% in. [45.5 x 58.9 cm]

Gift of Susan W. and Stephen D. Paine 1984.959

facing page, right

Furnishing fabric

France (Paris), about 1927

Designed by Maurice Dufrène, 1876-1955

In the 1920s France was the undisputed leader of the luxury-goods market. Major Paris department stores were influential arbiters of taste, often establishing their own art studios to design and manufacture household goods in the most modern styles. Dufrène-who designed furniture, glassware, ceramics, wallpaper, and silverware as well as textiles—was artistic director of La Maîtrise, the art studio of the Paris department store Galeries Lafayette. This stunning and dramatic furnishing fabric is a superb example of the beauty and dynamism of Art Deco textiles and is influenced as well by both Cubist and Futurist art. The textile was woven on the mechanized Jacquard loom that made possible intricate designs and subtle variations in texture, giving this fabric a complex, reflective surface that is a tribute to the sophistication of French fabrics in the early twentieth century.

Rayon and cotton jacquard 51½ x 114½ in. [130.8 x 290.8 cm]

Museum purchase with funds donated by The Textile and Costume Society, Museum of Fine Arts, Boston 2000.673

Flower basket

Austria (Vienna), 1906-13

Designed by **Josef Hoffmann**, 1870-1956

Manufactured by the **Wiener Werkstätte**

In 1903 the Austrian architect Josef Hoffmann cofounded the Wiener Werkstätte (Viennese Workshops) to "produce good and simple articles of everyday use." The Workshops made metalwork, jewelry, leatherwork, and furniture according to principles that emphasized function, proportion, and the appropriate use of materials. Wishing to eliminate all historical references from his work, Hoffmann created a new vocabulary of modular, geometric design to replace the lush, curvilinear Art Nouveau style then current in Europe. Made from prefabricated, perforated metal sheets, this imposing flower basket employs pure geometry with cylinders and rectangles formed by repeated squares. Only thirteen of these baskets were manufactured by the Wiener Werkstätte between 1906 and 1913.

Painted metal 27½ x 12 in. [69.8 x 30.4 cm] Bequest of the Estate of Mrs. Gertrude T. Taft, Gift of Edward Perry Warren, Gift of Alex Cochrane, Anonymous gift, Gift of Charles Loring, and Estate of Mrs. William Dorr Boardman through Gift of Mrs. Bernard C. Weld, by exchange 1994.238

Ernst Ludwig Kirchner German, 1880-1938 Reclining Nude, 1909

Determined to "revitalize German art," Kirchner joined with three other architectural students to found, in 1905, the idealistic artistic brotherhood called Die Brücke (The Bridge). The group was active in Dresden and Berlin until 1913 and strove to form a bridge between art and life. Inspired by the psychological intensity and expressive form and color of van Gogh, Gauguin, Munch, and Matisse (although Kirchner vehemently denied the impact of these artists), Die Brücke developed the widely influential style known as German Expressionism. Here, Kirchner rendered a traditional studio nude in a forceful Expressionist style with rough brushwork, bold outlines, and strong acid colors that evoke feelings of tension and isolation.

Oil on canvas 29 % x 59 % in. [74 x 151.5 cm] Tompkins Collection—Arthur Gordon Tompkins Fund 57.2 facing page, left Henri Matisse French, 1869-1954

Carmelina, 1903

"What interests me most," Matisse wrote, "is neither still life nor landscape but the human figure. It is through it that I best succeed in expressing the nearly religious feeling that I have towards life." Here, in this rigorously balanced composition, the curves of the model's body are accentuated by the interlocking rectangles of the background, where the artist himself and the model's back are reflected in a mirror. Matisse declared that "the whole arrangement of my pictures is expressive. The place occupied by figures or objects, the empty spaces around them, the proportions, everything plays a part." In this early work, Matisse is already a master of color, playing off vibrating reds and blues against the blocks of warm earth tones representing furniture, walls, picture frames, and blank canvases.

Oil on canvas 32 x 23 1/4 in. [81.3 x 59 cm] Tompkins Collection—Arthur Gordon Tompkins Fund Res.32.14

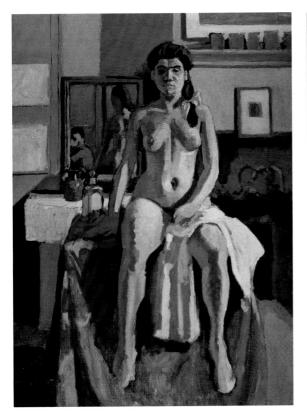

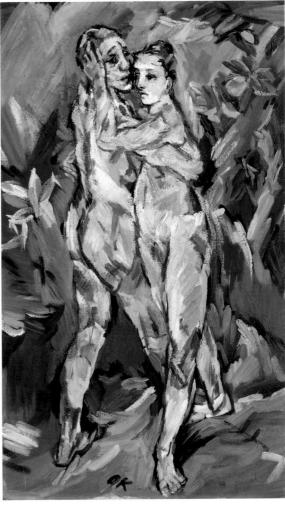

right

Oskar Kokoschka

Austrian, 1886-1980

Two Nudes (Lovers), 1913

Painted in Vienna on the eve of World War I, Kokoschka's self-portrait with Alma Mahler—widow of the composer Gustav Mahler—is a monument to their intense and stormy love affair. Powerfully evoking the artist's tumultuous feelings, the painting is filled with restless, dynamic movement. Its brushwork is agitated and expressionistic, with light carefully manipulated

to enliven the surface and create a sense of depth. There is, in addition, a tenderness to the image, evoked by the interlocked pose of the lovers, which suggests the formal intimacy of a dance.

Oil on canvas $64\,\%\,x\,38\,\%\,\text{in.}\,(163\,x\,97.5\,\text{cm})$ Beguest of Sarah Reed Platt $\,$ 1973.196

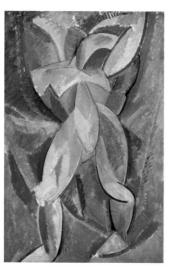

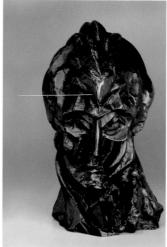

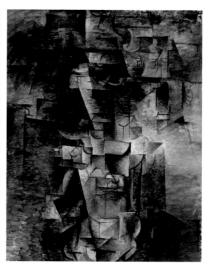

Pablo Picasso

Spanish (worked in France), 1881-1973 Standing Figure, 1908

Oil on canvas 59% x 39% in. [150.2 x 100.3 cm] Juliana Cheney Edwards Collection 58.976

Pablo Picasso

Spanish (worked in France), 1881-1973 Head of a Woman, 1909

Bronze 16¼ x 9³¼ x 10½ in. (41.3 x 24.8 x 26.7 cm) Gift of D. Gilbert Lehrman 1976.821

Pablo Picasso

Spanish (worked in France), 1881-1973 Portrait of a Woman, 1910

Oil on canvas 39% x 32 in. [100.6 x 81.3 cm] Charles H. Bayley Picture and Painting Fund, and Partial gift of Mrs. Gilbert W. Chapman 1977.15

These three works mark milestones in the early development of Cubism, possibly the most influential movement in twentieth-century art. The result of a unique collaboration between Pablo Picasso and Georges Braque, Cubism was an attempt to render three-dimensional forms on a two-dimensional surface in a radically new way—by breaking up the volumes into flat, angular facets or planes that imply multiple, simultaneous views of an object or figure.

In Standing Figure, Picasso took a time-honored subject—the female nude—and divided the body into simplified components that interact so that the figure seems to turn on the surface of the canvas. Painted two years later, Portrait of a Woman is much more systematically fragmented, its forms open out into flat planes that dissolve into each other. Only a few details such as the hair at top left are readily identifiable; the background suggests a studio setting with canvases stacked against a wall. Picasso used a nearly monochromatic palette to distance this image from real-world associations and to focus more clearly on the painting's compositional structure.

In Head of a Woman, Picasso translated the ideas he was exploring on canvas back into three dimensions, with the fragmented planes of the painting style reconfigured as convex and concave shapes. Cast in 1909 by Picasso's dealer Ambroise Vollard (only six examples are known), this is the most celebrated of all early Cubist sculptures.

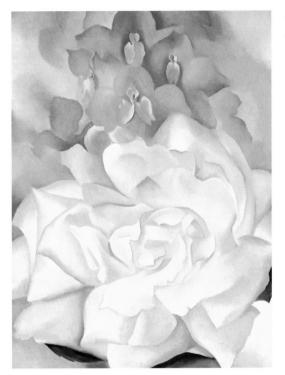

Georgia O'Keeffe American, 1887-1986 White Rose with Larkspur No. 2, 1927

O'Keeffe often painted objects from nature whose formal qualities attracted her. She once wrote: "Nobody sees a flower—really—it is so small—we haven't time—and to see it takes time, like to have a friend takes time.... So I said to myself—I'll paint what I see—what the flower is to me—but I'll paint it big.... I will make even busy New Yorkers take time to see what I see of flowers." One of O'Keeffe's favorite paintings, White Rose hung in the bedroom of her Abiquiu, New Mexico, home until 1979, when she selected it for the Museum.

Oil on canvas $40 \times 30 \text{ in.} \{101.6 \times 76.2 \text{ cm}\}$ Henry H. and Zoe Oliver Sherman Fund 1980.207

Alfred Stieglitz
American, 1864–1946
Georgia O'Keeffe, A Portrait (6), 1918

This photograph represents the long, dynamic interaction of two great American artists. Stieglitz-a key figure in the promotion of modern art and in the acceptance of photography as art-began photographing artist Georgia O'Keeffe in 1917, when she first came to New York. Fascinated with multiplicity, time, and change, Stieglitz believed that a single image was not sufficient to capture the complexity of a human personality. Over twenty years he made hundreds of photographs of the woman who became his lover and later his wife, a cumulative "portrait in time." This is one of the earliest photographs in a series of arrested moments that includes studies of her torso, feet, hands, and face. O'Keeffe remembered that Stieglitz photographed her with "a kind of heat and excitement." One scholar has called this "perhaps the most extraordinary series in the history of photography."

Photograph, palladium print $9 \% \times 7 \%$ in. $(23.5 \times 18.7 \text{ cm})$ The Alfred Stieglitz Collection—Gift of the Georgia O'Keeffe Foundation and M. and M. Karolik Fund 1995.692

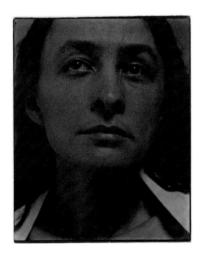

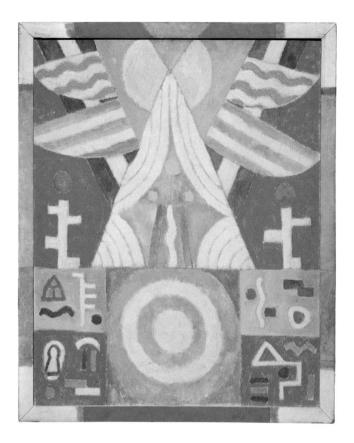

Marsden Hartley American, 1877-1943 Painting No. 2, 1914

In 1912 Hartley went abroad for the first time, but unlike many American modernists who traveled to France, he spent most of his time in Germany. There he came under the influence of the Blaue Reiter and other groups of young artists who were experimenting with new, basically abstract, forms of expression. He adopted their use of bright, flat color, emphasis on geometric patterns, and interest in folk culture. Painting No. 2 is one of several that make up Hartley's Amerika series, and it uses forms facing page, top

Léon Nikolaievitch Bakst Russian, 1866-1924

The Butterfly (Costume design for Anna Pavlova), 1913

Bakst dazzled early-twentieth-century Europe with his opulent designs for the ballet and theater. His feeling for exotic styles, voluptuous color, and sensuous line profoundly influenced contemporary fashion, interior design, and jewelry. Bakst created many costumes for performances by the great Russian ballerina Anna Pavlova (1881-1931) at the Imperial Ballet and the Ballets Russes. After she started her own troupe, the dramatic solo The Butterfly was one of Pavlova's most popular works.

Watercolor and graphite pencil on paper 17³/₄ x 11 in. [45 x 28 cm] Gift of Mrs. John Munro Longyear and Mrs. Walter Scott Fitz 14.701

derived from Native American cultures, such as the triangular tipi and the geometric shapes evoking sand paintings. Hartley placed great emphasis on the presentation of his works, and he constructed and painted the frame of this picture to complement its design.

Oil on canvas

With frame: $42\frac{1}{2} \times 34\frac{3}{4}$ in. [108 x 90.8 cm] Gift of the William H. Lane Foundation 1990.412

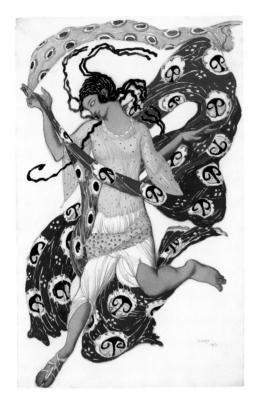

below

Arshile Gorky

American (born in Armenia-in-Turkey), 1904–1948 Study for Nighttime, Enigma, and Nostalgia, about 1931–32

Gorky had little formal training; he learned by imitation and observation, taking the work of other artists as his point of departure. In this drawing, for example, the black trapezoid at right was derived from Giorgio De Chirico's 1913 painting *The Fatal Temple*, and scholars have noted the work's connection to Picasso's synthetic Cubist still lifes. Gorky, who stated that "drawing is the basis of art," was a skilled and prodigious draftsman. This drawing is from a series of more than fifty drawings and at least two paintings that was executed in the early 1930s, a time when Gorky's work was becoming increasingly abstract. What is the meaning of this series and its rather mysterious title? Gorky chose not to say. When curators at New York's Museum of Modern Art queried the subject matter of a similar drawing, the artist replied: "Wounded birds, poverty, and a whole week of rain."

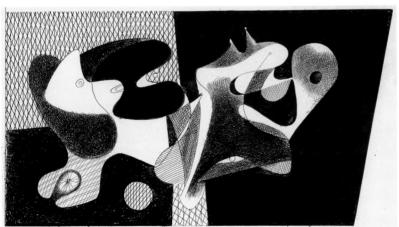

India ink with underdrawing in graphite pencil, on paper 13 x 21½ in. [33 x 54 cm]
Gift of Susan W. Paine in honor of Malcolm Rogers on the occasion of his tenth anniversary as Director 2004,2256

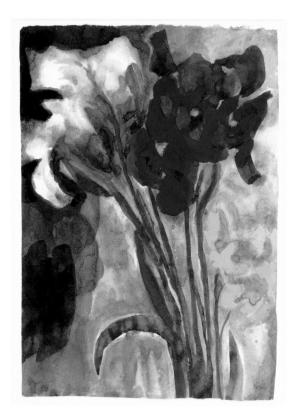

Nolde was among the most original painters and printmakers of his time, and his inventive and rapidly executed watercolors are among his greatest works. He favored simple subjects and bold forms that fill the entire sheet, and he used damp, highly absorbent Japanese paper that gave extraordinary depth and luminosity to his colors.

Watercolor on white Asian paper 18½ x 13½ in. [47.2 x 34.2 cm] Seth K. Sweetser Fund 57.667

Egon Schiele Austrian, 1890-1918 Schiele's Wife with Her Little Nephew, 1915

Schiele's distinctive style is characterized by an almost neurotic intensity of feeling, a love of pattern, and a magnificent energy of line. Here, he combines two media—broadly drawn charcoal and opaque watercolor. The woman's tight embrace and the yellowand-black striping of her dress evoke a tigress fiercely protecting her cub. Since his early death in the influenza epidemic of 1918, Schiele has come to be regarded as one of the greatest Expressionist artists.

Charcoal and watercolor on paper 19 x 12½ in. [48.3 x 31.8 cm] Edwin E. Jack Fund 65.1322

Margaret Bourke-White American, 1904–1971 The George Washington Bridge, 1933

One of the original staff photographers at Fortune, Life, and Time magazines, Bourke-White is celebrated for her coverage of European battlefields and concentration camps during World War II as well as for her powerful images of the American South during the Depression, guerrilla warfare in Korea, and twentieth-century industry. This photograph—an icon of early, idealizing, machine-age art—was made when the monumental George Washington Bridge was still under construction, for a Fortune essay on the Port of New York.

Photograph, gelatin silver print 13½ x 8¾ in. (34.3 x 22.5 cm) Charles Amos Cummings Fund 1988.2

Joseph Stella American (born in Italy), 1877-1946 Old Brooklyn Bridge, about 1941

New York's Brooklyn Bridge, completed in 1883 and hailed as an engineering marvel, spans the East River between Brooklyn and Manhattan. When Stella emigrated from Italy to Brooklyn in 1916, the borough's most famous landmark became a recurrent image in his work—a symbol of the dynamism and promise of the modern American city. Here, Stella shows the bridge at night: cables soar overhead, traffic signals and headlights flash through the darkness, and the bridge's Gothic arches rise in the background like those of a skyscraper or a church. The bridge, to Stella, was a "shrine containing all the efforts of the new civilization of AMERICA."

0il on canvas $76\,\%\,x\,68\,\%\,in.\,[193.7\,x\,173.4\,cm]$ Gift of Susan Morse Hilles in memory of Paul Hellmuth $\,$ 1980.197

Charles Sheeler

American, 1883-1965

Doylestown House-The Stove, 1916-17

Photograph, gelatin silver print 9% x 6% in. [23.8 x 17.1 cm] Gift of Saundra B. Lane in memory of William H. Lane 2002.886

Robert Rauschenberg

American, 1925-2008

Breakthrough II, 1965

Lithograph, printed from four stones Printed and published by Universal Limited Art Editions., Inc. Stone: 43 1/2 x 29 1/2 in. [110.5 x 74.9 cm] Gift of Lewis P. Cabot 1970.515

Nan Goldin

American, born 1953

Jojo at Home, New York City, 1990

Photograph, silver-dye bleach print (Ilfochrome) 20 x 24 in. [51 x 61 cm] Curator's Grant Program of the Peter Norton Family Foundation 1991,1097

By the end of the nineteenth century, photographers had recourse to faster, more easily managed processes such as gelatin silver prints, which use silver salts to produce a crisp image, favored by artists in the 1920s who renounced the painterly qualities of the earlier processes. This stunning Sheeler print is a pioneering image in the history of American photography—a highly modern, abstract, and Cubist-inspired photograph of a vernacular American subject. It is one of a series of twelve pictures that he took in his eighteenthcentury farmhouse in Doylestown, Bucks County, Pennsylvania. Before beginning to photograph it, the artist arranged, whitewashed, and pared down the house's interior to reflect his spare, modern vision. Photographed at night so that Sheeler could control the lighting, the dark silhouette of the iron stove is set

off against the rectangles of window and door, the starkness modulated by the small, irregular details of stove handle and door hinges. Sheeler was also a painter (see page 362) but from this point on, photographs became central to his art.

In the second half of the twentieth century, photographic processes became less expensive and more accessible to artists and the general public. As photographic imagery became ubiquitous in popular and domestic culture, the uses to which artists put it changed as well. By the 1980s, a broader crossover existed between photography, painting, and printmaking. Some people no longer thought of themselves strictly as photographers but rather as artists in a larger sense who happened to work with images made with a camera. Such artists as Robert Rauschenberg and Andy Warhol used a variety of means to transfer photographic images from daily life and the mass media to the printing surface. Works in the Museum's collections reflect the many methods and processes in which photographic images are produced and reproduced, from the portraits of the 1840s to modern works on paper, glass, plastic, and other media. Nan Goldin documented issues of gender and drug use in the relationships of her closely knit circle of bohemian friends, offering wry commentary on the American tradition of the "snapshot" ushered in by the advent of inexpensive color prints (introduced in the 1940s) such as the Cibachrome, popular for its bright, shiny surface and vivid, "bigger-than-life" colors.

Edward Hopper

American, 1882-1967 *Drug Store*, 1927

Among the first of Hopper's paintings to illustrate what became a favorite theme. Drug Store depicts nocturnal solitude in the city. Eerily illuminated by electric light, the drugstore window (probably located near his studio in New York's Greenwich Village) is a bright spot in a picture otherwise made up of shadowy doorways and blank facades. The painting is full of subtle contradictions; for example, the patriotism expressed by the red, white, and blue bunting in the window display is undermined by the indelicacy of the product advertised above, and the acid colors and depopulated street discredit the window's ostensible welcome. Like much of Hopper's work, this painting is edgy and unsettling, creating a sense of melancholy and alienation.

Oil on canvas 29 x 40 % in. [73.7 x 101.9 cm] Beguest of John T. Spaulding 48.564

Charles Sheeler

American, 1883-1965

View of New York, 1931

Sheeler's ironically titled picture shows the interior of his own photography studio on an upper floor of a midtown New York apartment building and was painted at a pivotal time in his career. Through the 1920s he had enjoyed critical and financial success as a photographer while struggling to gain recognition as a painter. His difficult decision, made about 1931, to set aside photography and concentrate on painting is expressed through the studio's stillness and austerity—the camera is covered, the lamp turned off, and the chair vacant. Through the open window, we do not see the skyscrapers and bustling crowds normally associated with New York but a cloudy sky. Sheeler thus gave universal meaning to his image of personal transition by contrasting the precisely defined, if barren, interior with an undefined external world full of uncertainties. He called *View of New York* "the most severe picture I ever painted."

Oil on canvas 48 x 36% in. [121.9 x 92.4 cm]

The Hayden Collection—Charles Henry Hayden Fund 35.69

Stuart Davis

American, 1892-1964

Hot Still-Scape for Six Colors-7th Avenue Style, 1940

From the time Davis moved to the city in his late teens, New York was the principal subject of his art. With a title evoking jazz (a great love of Davis's), his "Still-Scape" combines still life and landscape, alluding both to the objects in his studio and to the world outside, on Seventh Avenue. Davis wrote: "The subject matter of this picture is well within the everyday experience of any modern city dweller. Fruit and flowers and kitchen utensils; fall skies; horizons; taxi cabs; radio; art exhibitions and reproductions; fast travel; Americana; movies; electric signs; dynamics of city sights and sounds." The artist's impressions of the city are captured with energy and flair by his jaunty line, vibrant palette (the "six colors" of the title), and the gritty texture of his paint.

Oil on canvas $36 \times 44\%$ in. (91.4 x 114 cm) Gift of the William H. Lane Foundation and the M. and M. Karolik Collection, by exchange 1983.120

Punch bowl from the Jazz Bowl series

United States (Rocky River, Ohio), 1931 Designed and decorated by Viktor Schreckengost, American, 1906–2008 Molded at Cowan Pottery Studio

Between the world wars American ceramics underwent a transformation. with a new emphasis on modern, functional designs and streamlined, sometimes playful decoration. Viktor Schreckengost, who worked for the Cowan Pottery Studio near Cleveland. designed a series of twenty punch bowls commissioned by Eleanor Roosevelt for a party at the governor's mansion in Albany, New York. The bowls were decorated with motifs evoking contemporary New York-skyscrapers, ships, champagne glasses, moons, stars, and such words as follies, jazz, stop, and go. Later, Schreckengost refined the design, and Cowan produced a limited edition of fifty bowls, including this one.

Glazed porcelain with sgrafitto decoration H. 9 in. [22.9 cm] Gift of John P. Axelrod 1990.507

Jackson Pollock American, 1912-1956 Troubled Queen, 1945

At once the most controversial and the most influential artist of his generation, Pollock was the leading figure of the Abstract Expressionist movement that made New York, in the late 1940s, the center of the international avant-garde. Troubled Queen, painted soon after Pollock moved from New York to rural Long Island, is a fascinating transitional work in which the suggestions of heads and faces drawn from the artist's subconscious but echoing his earlier, figurative work—seem to struggle to assert themselves against the thick, slashing strokes and skeins of paint that became the hallmark of Pollock's revolutionary mature style. With its harsh, highly personal brushwork and startling, acidic colors, this turbulent painting, as one critic noted, "exudes raw power and psychic distress." Within a few years, all traces of the figure were gone from Pollock's work, and the act of painting itself became his subject.

Oil and enamel on canvas 74 % x 43 ½ in. [188.3 x 110.5 cm] Charles H. Bayley Picture and Painting Fund and Gift of Mrs. Albert J. Beveridge and Juliana Cheney Edwards Collection, by exchange 1984.749

Max Beckmann

German, 1884-1950 Still Life with Three Skulls, 1945

In this painting, Beckmann combined a modernist fondness for flattened space, schematic forms, and intense colors with traditional still-life subjects—skulls, an extinguished candle, playing cards—that signify the frailty and transience of human life. Considered a "degenerate" artist by the Nazis, Beckmann had fled Germany in 1937 and sought refuge in Amsterdam, where this painting was made during the final stages of World War II. The artist described those years to a friend: "I have had a truly grotesque time, full to the brim with work, Nazi persecutions, bombs, hunger . . ." In the choice of objects, the predominance of black, and the thick, rough paint, this still life captures the grim feelings underlying these words.

Oil on canvas 21½ x 35½ in. (55.2 x 89.5 cm) Gift of Mrs. Culver Orswell 67.984

Henri Matisse French, 1869–1954 Reclining Nude, 1946

Among the most powerful and innovative artists of the twentieth century, Matisse influenced generations of artists through the vast and varied output of a career that spanned more than sixty years. Throughout his exploration of drawing, painting, sculpture, printmaking, book illustration, and paper cutouts, his stated goal was to unearth "the essential character of things" and to produce an art "of balance, purity, and serenity." For Matisse, drawing was like "making an expressive gesture with the advantage of permanence." In this masterful late work, the artist's efforts to capture his subject remain clearly visible in the smudged, half-obliterated strokes of charcoal that underlie firm, sure outlines that define—in the most economical way—the voluptuous body and complex pose of his model.

Charcoal on cream laid paper 16 ½ x 24 in. [41.3 x 61 cm] Charles H. Bayley Picture and Painting Fund 2004.70

Arthur G. Dove American, 1880-1946 That Red One, 1944

About 1910 Dove became the first American artist to experiment with pure abstraction. He painted in this style throughout his career, but always with reference to the natural world. These adventurous paintings were admired by his fellow artists but rarely sold, and Dove's whole life was marked by financial struggle; That Red One was produced while the artist was living in an abandoned post office in Centerport, Long Island, New York. Despite Dove's personal difficulties, this painting is triumphant in mood, with the sunlike form in the center (a favorite Dove motif) dominating a design of broad shapes painted in clear, flat colors. Although the inspiration for the scene was characteristically commonplace-probably a view through trees across a pond at daybreak-the vision is monumental and heroic.

Oil and wax on canvas 27 x 36 in. [68.6 x 91.4 cm] Gift of the William H. Lane Foundation 1990.408

facing page, bottom

Hans Hofmann

American (born in Germany), 1880–1966

Twilight, 1957

After studying art in Paris, Hofmann opened an art school in New York City in the 1930s, bringing to his students not only knowledge of traditional European painting but also firsthand experience of the work of such modernist artists as Picasso, Braque, and Kandinsky. As a teacher, Hofmann played a major role in the development of American Abstract Expressionism. His own art, however, did not attain the vigor and exuberance of *Twilight* until the 1950s, when he was in his seventies. Here, the paint is applied with brush and palette knife—layered, blended, and scraped to produce a surface both physically rich and full of personal emotion. The painting's title suggests that it may have been inspired by the striking changes in color and light that occur at dusk.

Oil on plywood 48 x 36 in. (122 x 91.4 cm) Gift in the name of Lois Ann Foster 1973.171

Morris Louis

American, 1912–1962 *Delta Gamma*, 1959

A key figure in the movement called Color Field painting, Louis poured streams of thinned, acrylic paint onto canvas left raw and unsized so that the paint soaked into it. In this huge piece, the simplicity of the format, with its empty and airy center, gives maximum impact to the visual power of the rippling, brilliantly colored stripes. The painting takes its title from the Greek alphabet, reflecting Louis's lifelong preoccupation with series and progressions. Delta Gamma is one of the major works in a series Louis called the Unfurleds, in reference to flags or banners blowing in the wind.

Acrylic solution (Magna) on canvas 103½ x 150% in. (262.3 x 382.6 cm) Gift of Marcella Louis Brenner 1972.1074

Franz Kline American, 1910-1962 **Probst I**, 1960

Kline was a major figure in the Abstract Expressionist movement; his most characteristic and individual works are monumental, black-and-white paintings executed with very large brushes on a white ground. Although entirely nonrepresentational, this large painting might suggest the massive girders and I-beams of buildings on the rise. Freely and expressively brushed, the broad lines also invoke a more lyrical tradition, the ancient Asian art of calligraphy. Named for an artistfriend in New York's Greenwich Village, Probst I is at once powerfully monochromatic and subtly colorful, enlivened with delicate touches of yellow, orange, and brown.

Oil on canvas 1071/4 x 793/4 in. [272.4 x 202.6 cm] Gift of Susan Morse Hilles 1973.636

Robert Rauschenberg

American, 1925-2008

Plain Salt (Cardboards), 1971

Painter, sculptor, printmaker, and photographer, Rauschenberg was one of the most innovative and individual of all twentieth-century American artists. Beginning in the mid-1950s, he incorporated such "found" materials as advertisements and street trash into loose, abstract compositions. This assemblage belongs to a group of constructions, first exhibited in 1971, that consist simply of opening out the sides of cardboard boxes and laying them flat against the wall without the addition of painted marks of any kind. The artist's contribution was to visualize, compose, and construct. By focusing on cardboard, Rauschenberg invited comparison with the Cubist collages made by Braque and Picasso in the early twentieth century. At the same time, the exuberant way in which the boxes promote a product is in keeping with the "all-American" focus of much of Rauschenberg's work.

Cardboard and plywood 80 ½ x 10 ½ in. [204.5 x 26.7 cm] Gift of Martin Peretz 1992.396

right

Jasper Johns American, born 1930 Black Numbers, 1960

Johns heralded the Pop Art movement in New York in the 1950s with his transformation of everyday objects into art. This drawing is one of a number of works in several media in which Johns took simple numbers and then pursued a game of art and illusion, exploring spatial and formal relationships through the layering of transparent and opaque imagery. The drawing is made even more subtle by the artist's use of a wash created from powdered graphite,

Graphite wash on pale cream paper mounted on white paper 21 x 18 in. (53.3 x 45.7 cm)

Gift of Susan W. and Stephen D. Paine 1996.362

which produces an ambiguously shimmering surface.

Philip Guston American, 1913-1980 The Deluge, 1969

During the 1950s and early 1960s, Guston worked in a sensuous and luminous Abstract Expressionist style. In 1968, however, he began to introduce caricatural images into his freely painted abstract works, a movement from abstraction to representation that had a profound influence on many younger contemporaries. The Deluge is an early example of Guston's new direction. Both the image and the title suggest the aftermath of some cataclysmic event, with the objects on the horizon seeming about to be engulfed by the formless darkness below.

Oil on canvas 77 x 128 in. [195.6 x 325.1 cm] Bequest of Musa Guston 1992.509

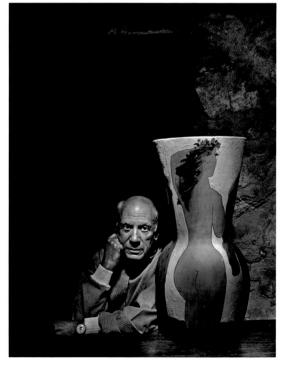

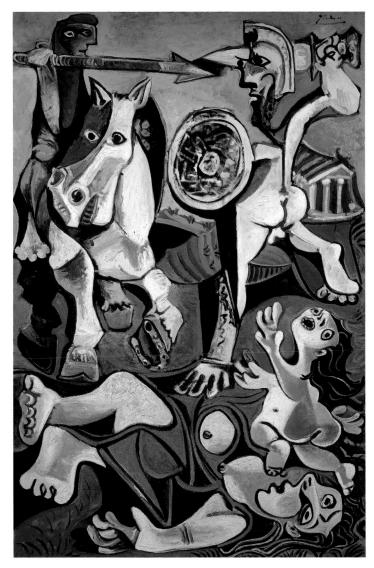

Pablo Picasso

Spanish (worked in France), 1881–1973

Rape of the Sabine Women, 1963

Painted when Picasso was eightytwo, this is his last major statement about the horrors of war, and is said to have been inspired by the Cuban missile crisis. In it, Picasso transforms a familiar subject from the art of the past-the story of early Romans who, suffering a shortage of marriageable women, invited the neighboring Sabines to Rome and then carried off all their young women. Against a sunny background of blue sky and green fields, the grotesquely distorted figures are compressed into the foreground space, the horses and soldiers trampling a woman and her child. Purchased by the Museum the year after it was painted, this powerful image of outrage and despair bears testimony to Picasso's productivity and energy in the last decade of his life.

Oil on canvas
76 x 51 in. [195.3 x 131.1 cm]
Juliana Cheney Edwards Collection,
Tompkins Collection—Arthur Gordon
Tompkins Fund, and Fanny P. Mason
Fund in memory of Alice Thevin 64.709

 $facing\ page,\ bottom$

Yousuf Karsh

Canadian (born in Armenia-in-Turkey),

1908-2002

Pablo Picasso, 1954

Photograph, gelatin silver print 40% x 29% in. (101.9 x 74.9 cm) Gift of Estrellita and Yousuf Karsh 2002.59

Souper Dress

United States, about 1967 Label: "The Souper Dress. No Cleaning-No Washing-It's Carefree"

A quirky but key aspect of the turbulent 1960s was the brief fad for disposable "paper" dresses. In 1966 paper dresses were introduced by Scott Paper Company, which sold more than half a million examples. Soon major stores had boutiques dedicated to this trendy and inexpensive clothing. The sleeveless, A-line dress illustrated here-patterned with

Campbell soup cans—was the most famous paper dress, capturing both Pop Art's mix of high art and popular culture and honoring the celebrated soup-can paintings of Andy Warhol, the king of Pop. The Campbell Soup Company offered the dress for one dollar and two labels from their soup cans; this example-never worn-came to the Museum with its original mailing envelope, order form, and care instructions, which discouraged cleaning. The dresses were to be worn once or twice and then thrown away.

Printed cellulose and cotton non-woven fabric H. 35 in. (88.9 cm) Lucy A. Morse Fund in memory of Kate Morse 2003 135

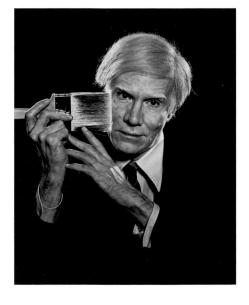

Yousuf Karsh Canadian (born in Armenia-in-Turkey), 1908-2002

Andy Warhol, 1979

Photograph, gelatin silver print Image: 23¾ x 18½ in. (60.3 x 47.3 cm) Gift of Estrellita and Yousuf Karsh 1996.182

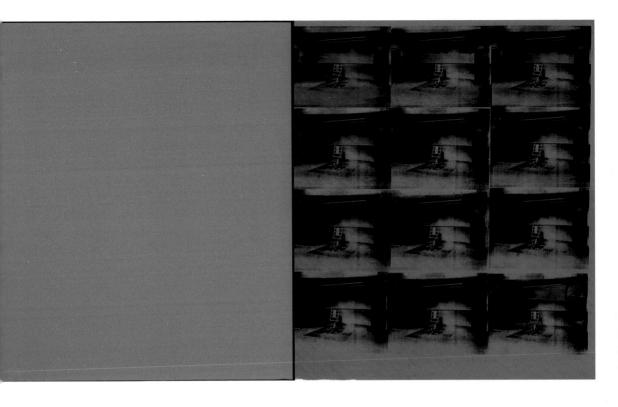

Andy Warhol

American, 1928-1987

Red Disaster, 1963, 1985

Silkscreen ink on synthetic polymer paint on canvas Each panel: $93 \times 80 \%$ in. [236.2×203.8 cm] Charles H. Bayley Picture and Painting Fund 1986.161a-b

Beginning his career as a successful commercial artist, Warhol became, in the early 1960s, an underground filmmaker and a painter who sought to mechanize painting by including photographic images reproduced by the silkscreen process. In 1962 his main subjects were soup cans, soda bottles, Elvis Presley, and Marilyn Monroe. The following year—a time of enormous social and political change—he began to explore death in modern American society. The electric chair was the first subject in his series of "disasters" that also included car crashes and images of police brutality. *Red Disaster*, derived from a photograph of the death chamber at Sing Sing Prison, may be viewed as a grave and haunting plea against capital punishment; some, however, see its grim repetitiveness as an embodiment of callousness and inhumanity.

left. David Smith American, 1906-1965 Cubi XVIII, 1964

Although never formally trained as a sculptor, Smith became intrigued by Picasso's welded-steel sculptures while studying painting at the Art Students League in New York. Realizing that the skills he had acquired during summer jobs in a car factory could be used to make art, in 1933 Smith created the first constructed, welded-steel sculptures in American art. Made the year before Smith's death, Cubi XVIII is one of a series of structures in which cubes and cylinders of burnished and abraded steel are counterbalanced in relationships that dynamically expand into space while reflecting their surroundings.

Polished stainless steel 115% x 60 x 21% in. [294 x 152.4 x 55.2 cm] Gift of Susan W. and Stephen D. Paine 68.280

facing page, bottom

Josef Sudek Czechoslovakian, 1896–1976 Labyrinths, 1969

One of the most quietly original photographers of the twentieth century, Sudek lived a withdrawn and frugal existence in Prague, a city marked for most of his lifetime by political upheaval and repression. His photographs document a world of private feeling and experience, drawn from the most commonplace materials and subjects. "I believe that photography loves banal objects," he said, "And I love the life of objects." Many of his photographs are focused explorations of themes. Labyrinths, one of his last series, captures the chaos of his small, cramped studio, but the photographs are much more. This image is a carefully arranged composition of straight edges and rounded shapes, each articulated by the magical and evocative natural light that Sudek revered.

Photograph, gelatin silver print 11½ x 15¼ in. (22.9 x 29.2 cm) The Sonja Bullaty and Angelo Lomeo Collection of Josef Sudek Photographs, The Saundra B. Lane Photography Purchase Fund 2003.196

Antonio López García Spanish, born 1936 Sink and Mirror (Lavabo y espejo), 1967

Spain's leading realist, López García—a great admirer of Diego Velázquez—creates austere images of modest, mundane subjects, which are both visually precise and magically dreamlike and lonely. Here, as in the artist's frequent paintings of Madrid street scenes, human beings are expected but absent. The painting's vantage point strongly suggests someone standing before the sink—we feel his or her presence—but there is no reflection in the mirror. Oddly, the perspective shifts midway at the line of lighter tiles, as if the person were both looking down into the sink and straight ahead at the glass shelf. The artist works slowly and methodically, but his handling of paint is free and almost sculptural in spite of its painstaking descriptiveness.

Oil on wood $44 \% \times 39 \times 2 \% in. \ [97.8 \times 83.8 \times 5.7 \ cm]$ Melvin Blake and Frank Purnell Collection 2003.41

Jean Dubuffet French, 1901-1985 L'Enqueteur, 1973

Throughout his career, Dubuffet's art deliberately challenged prevailing styles and traditional ideals of beauty. In 1962, reportedly inspired by doodling with a pen on scraps of paper, he began a series of sculptures and paintings in what he called his "Hourloupe" style. As here, the sculptures in this style are characterized by irregular, interlocking shapes that are colored blue, red, and white and heavily outlined in black. According to the artist, "Hourloupe" is a name "whose invention was based upon its sound. In French these sounds call to mind some wonderland or grotesque object or creature, while at the same time they evoke something rumbling and threatening with tragic overtones."

Epoxy, polyurethane, paint 34 x 23 x 13 in. [86.4 x 58.4 x 33 cm] Gift of Charlotte and Irving Rabb 1989.818

Sigmar Polke German, born 1941 *Lager*, 1982

Polke, who grew up in communist East Germany, escaped to West Germany in 1953. Working in collaboration with such artists as Gerhard Richter, Polke founded a German variation of Pop Art and often includes found objects in his work. His huge, multimedia Lager, which means "camp" in German, is one of a series of paintings in which the artist addressed the Holocaust. At the center is an image from a photograph of the electrified fence inside the concentration camp at Auschwitz, while the canvas is divided by an actual blanket that tangibly evokes the experience of the camp's prisoners. While Lager powerfully recalls the horrors of the Holocaust, the orange light of the sun in the background may symbolize the artist's hopes for an end to human atrocities.

Acrylic and spattered pigment on pieced fabric support 158 x 98% in. (401.3 x 250.8 cm) Gift of Charlene Engelhard 1993.961

Gerhard Richter German, born 1932 Vase, 1984

A key figure in the resurgence of German painting in the 1980s, Richter absorbed the disparate styles of Abstract Expressionism and Pop Art, refusing to paint in only one way. Some of his works are representational and figurative; others, such as Vase, explore color and form abstractly with wide, fluid brushwork that appears to be absolutely free and spontaneous but is, in fact, precisely calculated to achieve brilliant spatial effects.

Oil on canvas 88½ x 78¾ in. (224.8 x 200 cm) Juliana Cheney Edwards Collection 1985.229

Joseph Beuys

German, 1921-1986

Untitled (Blackboard), 1973

Sculptor, printmaker, performance artist, and impassioned teacher, Beuys created the images on this blackboard during his presentation of "12 Hour Lecture—An Homage to Anachrsis (Anacharasis) Cloots" at the Edinburgh Arts Summer School. This was one of a series of public lectures in which Beuys used blackboards to illustrate what he termed his "expanded concept of art," which incorporated science and economics and related social order to a living organism evolving toward freedom. He was inspired by Anacharsis Cloots (whose name is written across the bottom), an eighteenth-century radical born near Beuys's hometown of Kleves, who became an important figure in the French Revolution and whose idealistic belief in liberty, equality, and fraternity meant a great deal to the artist. With its complex visual layering of images, text, and diagrams, this blackboard is especially rare; most other early examples were considered merely teaching tools and wiped clean after use.

White and colored chalks on blackboard with wooden frame Framed: $41\% \times 53\%$ in. (105.4 x 135.9 cm) Catherine and Paul Buttenwieser Fund 2000.979

Onion teapot

United States (Rochester, New York),

Made by **John Prip**, American, born 1922

A pivotal figure in the history of modern metalsmithing, Prip was influential in bringing Scandinavian workmanship and style to the United States. In 1954, thoroughly trained during a decade in Danish workshops, Prip became a designer for Reed and Barton of Taunton, Massachusetts. Like most large silver manufacturers of the time, Reed and Barton primarily produced objects that evoked historical styles. In the 1950s, however, concerned about the loss of traditional craft techniques and the age-old connection between designer and maker, the company began to experiment with contemporary forms. Prip handcrafted this teapot to demonstrate for Reed and Barton his considerable technical skill. It later served as the prototype for a production-line beverage service called Dimension.

Silver, ebony, rattan $6 \% \times 10 \% \times 7 \%$ in. (15.8 x 25.5 x 19.1 cm) Gift of Stephen and Betty Jane Andrus 1995.137

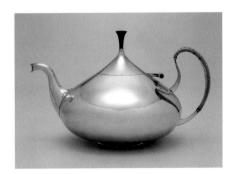

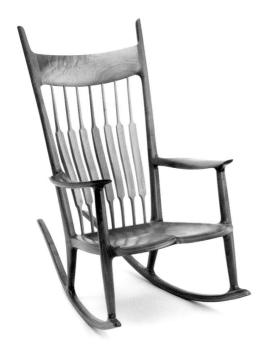

Rocking chair United States (Alta Loma, California), 1975 Sam Maloof, American, born 1916

Maloof is preeminent among the first generation of studio furniture makers who reacted against massproduced furniture, asserting the values of highquality workmanship, fine natural materials, and a more direct relationship between craftsman and client. Elegantly proportioned and comfortable, this rocking chair (an example of which is in the collection of the White House) reflects appreciation for the quality of the wood and for contrasts of soft, rounded edges and sharp, hard lines. Several works by Maloof were among the first examples of American furniture in the Museum's "Please Be Seated" program that provides works of art for seating in the galleries.

Walnut, ebony H. 45 in. [114.3 cm] Purchased through funds provided by the National Endowment

for the Arts and the Gillette Corporation 1976.122

Miss Blanche

Japan (Tokyo), manufactured 1989 Designed in 1988 by Shiro Kuramata, 1934-1991 Manufactured by Kokuyo Company, Japan

Kuramata's work is a unique blend of Japanese austerity, Western modernism, and his own sense of humor. Challenging traditional notions of look and materials, this chair is named for Blanche DuBois, the central figure in A Streetcar Named Desire by American playwright Tennessee Williams. Perhaps alluding to Blanche's romantic world of illusion, the suspended plastic roses are dramatically contrasted with the sharply angled slabs of clear acrylic resin. Kuramata is well known for the boutiques he created for fashion designer Issey Miyake in Tokyo, Paris, and New York.

Acrylic resin, silk, plastic, aluminum H. 35½ in. [90.2 cm] Maria Antoinette Evans Fund and Gift of Dr. John W. Elliot, by exchange and EDA Curator's Fund 1996.32

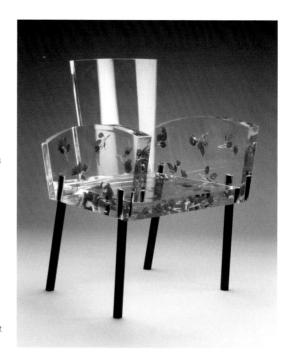

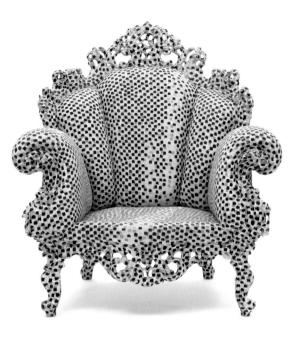

Poltrona di Proust

Italy (Milan), manufactured 1991 Designed in 1978 by **Alessandro Mendini**, Italian, born 1931

Manufactured by Studio Alchimia, Italy

Studio Alchimia was established in 1976 as part of the "anti-design" movement that rejected mainstream modernist works and created furnishings in banal and outmoded styles to mock the pretensions of "tasteful design." Here, Mendini caricatures a Victorian armchair (poltrona) that the French novelist Marcel Proust might have sat in. The frame and upholstery are hand-painted with a pointillist pattern of brushstrokes, a reference to the Neo-Impressionist painting that Proust admired.

Carved and painted wood, painted cotton upholstery H. 42% in. (108 cm) Gift of Mrs. S. M. B. Roby and Samuel Putnam Avery Fund, by exchange 1995.10

Flying Saucer dress

Japan, spring-summer 1994 Designed by **Issey Miyake**, Japanese, born 1938 Label: Issey Miyake

Born in Hiroshima, Japan, Miyake studied graphic design and fashion in Tokyo and Paris and established Miyake Design Studios in 1970. Considered by many the most visionary designer of the late twentieth century, Miyake's fashions rely on a graceful collaboration of art and technology. This dress, which suggests traditional Japanese paper lanterns, is composed of permanently pleated and ingeniously seamed cylinders that hold the shape of the dress when it is worn and collapse flat when stored.

Polyester with heat-set pleats

H. 44 in. (111.8 cm) Gift of Issey Miyake 1998.239

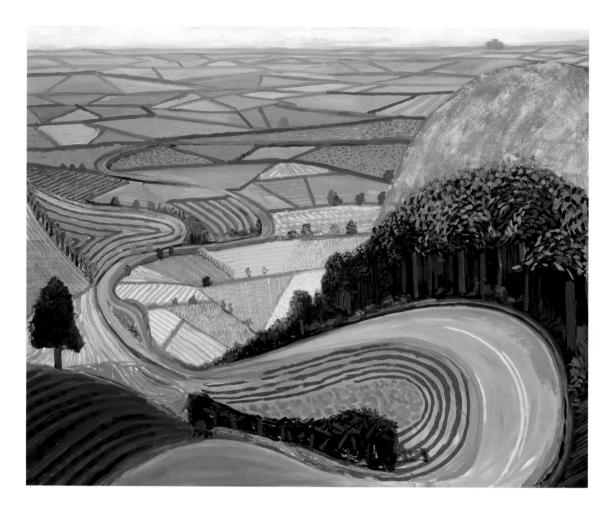

David Hockney

English, born 1937

Garrowby Hill, 1998

Coming to prominence as part of the British Pop Art movement in the early 1960s, Hockney is a painter and printmaker who has also worked innovatively as a photographer and stage designer. With the brilliant palette characteristic of many of his works, Garrowby Hill is one of a series of soaring, panoramic landscapes of his native Yorkshire, in northern England, begun in 1997. Hockney has long

worked with painting and photography together, and this painting's multiple perspectives are the result of photographs that the artist made while traveling in an open car and later synthesized in his Los Angeles studio.

Oil on canvas

60 x 76 in. [152.4 x 193 cm]

Juliana Cheney Edwards Collection, Seth K. Sweetser Fund, and Tompkins Collection—Arthur Gordon Tompkins Fund 1998.56

Ellsworth Kelly American, born 1923 Black Panel II, 1985

Kelly began his training at the School of the Museum of Fine Arts in 1946, as a student on the G.I. Bill. He has worked with abstraction through most of his career, saying that "structure" is the content of his art. Black Panel II belongs to a group of shaped, monochrome canvases that was the culmination of three decades of work. Although he is inspired by observation of things ranging from the curve of a hill to the shape of a shadow, his rigorously spare forms are seemingly far removed from their real-world associations. They are created to hang on expansive white walls where the work itself functions as the depicted object and the wall behind as the background. Shape, size, and blackness at first seem aggressive, but with prolonged looking, the viewer finds both subtlety and ambiguity.

Oil on canvas 100½ x 125 in. [255.3 x 317.5 cm] Ernest Wadsworth Longfellow Fund 1987.419

Kiki Smith

American, born 1954

Lilith, 1994

Edition 2 of 3

Smith's art is devoted to the exploration of the human body, inside and out. This deliberately unsettling sculpture was created from life casts of a female model, and in accordance with the artist's instructions, it is hung so that Lilith clings to the wall upside down, staring up at the viewer with glass eyes. The title refers to an ancient Sumerian demon, a creature of the air who, in postbiblical Hebrew legend, is identified as Adam's intended first wife, who flew away when he refused to accept her as his equal. Long relegated to the realms of superstition and viewed as an evil spirit dangerous to men and children, Lilith has been reinterpreted in recent decades as an ideal of female strength and independence.

Silicon bronze and glass

33 x 27½ x 19 in. [83.8 x 69.9 x 48.3 cm]

Contemporary Art Support Group Fund, the Bruce A.

Beal, Enid L. Beal and Robert L. Beal Acquisition Fund,

Barbara Fish Lee, and the Lorna and

Robert M. Rosenberg Fund

Cindy Sherman American, born 1954 Untitled #282, 1993

Sherman usually works in series, photographing herself in a range of guises that explore contemporary culture—from actresses in old black-and-white films to a new perception of Renaissance portraits to clowns. In 1993 Harper's Bazaar invited Sherman to select and photograph high-fashion clothes from the Spring collections, publishing the results in the magazine. Here Sherman wears clothing designed by Jean-Paul Gaultier, the enfant terrible of French fashion, known—among other things-for his use of older and overweight models. Like much of Sherman's work, the image is both humorous and disturbing, with the slightly bulging belly and the awkwardly protruding knee balanced by an elegantly posed hand. "I try to get something going with the characters so that they give more information than what you see," Sherman has said. "I'd like people to fantasize about this person's life."

Photograph, chromogenic color print Edition 3 of 6 91¼ x 61% in. [231.6 x 155.3 cm] Ernest Wadsworth Longfellow Fund 1993.687

Susan Rothenberg American, born 1945 The Chase, 1999

Since the 1970s—when abstraction was the norm and many declared painting dead—Rothenberg has been a singular voice in contemporary art with her charged application of paint, the emotional resonance of her work, and her determined reliance on imagery. "Without subject matter there is not me; there is no painting," she has said. "I don't want to do something if I don't have something to say." In 1990 Rothenberg moved from New York to a ranch in New Mexico, and

the hot light and forceful physicality of this new environment has inspired her work. *The Chase*—reflecting a new interest in near-abstraction—depicts animals whirling around an empty, white center in frantic pursuit or desperate escape from each other. This work, acquired by the Museum soon after its completion, is infused with a powerful, restless energy and excitement.

Oil on canvas 91 x 93 in. (231.1 x 236.2 cm) Catherine and Paul Buttenwieser Fund 1999.501

Takashi Murakami

Japanese, born 1962

If the Double Helix Wakes Up . . . , 2002

Known for his colorful paintings, sculpture, and commercial merchandise—T-shirts, watches, key chains, mouse pads-Murakami combines his deep knowledge of traditional Japanese art with contemporary cartoons (manga) and animation (anime). His work is produced in factory-style studios in Japan and New York, with numerous assistants creating objects from the artist's sketches. Murakami skillfully blends high and low culture, recognizing this as a factor of modern life. Although he says that he is "always looking to what lies beyond Pop," Murakami is particularly attracted to the anti-narrative, anti-emotional work of Andy Warhol, whose signature camouflage background appears in this painting. The title refers to a structural arrangement of DNA, and the painting contains Murakami's famous, mouselike, cartoon figure Mr. Dob-morphed almost beyond recognition. As Murakami firmly states: "I am surrounded by cute images and figures from cartoons and comic books, and so that is what I paint."

Acrylic on canvas mounted on wood Overall: 98½ x 157¼ in. [250.2 x 399.4 cm] 3 panels, each 98 1/2 x 52 1/4 in. Catherine and Paul Buttenwieser Fund 2002.108

Kara Walker American, born 1969 The Rich Soil Down There, 2002

Across an expanse of more than thirty feet, a dozen black-and-white silhouettes are paired in mysterious ways, all of which evoke struggle. Often violent and erotic. Walker's work addresses issues of racial and sexual stereotypes, of power and its abuse. "Silhouettes are reductions," the artist says, "and racial stereotypes are also reductions of actual human beings." Exploring black history is central to Walker's art, and she acknowledges the inspiration of earlier black artists whose work dealt with racial and cultural issues. In The Rich Soil Down There, many figures are exaggerated African stereotypes, and costumes seem to be of the nineteenth century, perhaps the antebellum South. Following the artist's instructions, assistants created the piece on a Museum wall, using templates to paint the precise borders of each image and then adhering the paper cutouts within the borders.

Cut paper and adhesive on painted wall Overall: 180 x 396% in. [457.4 x 1006.2 cm]

Museum purchase with funds donated by members of the 2004-2005 Contemporary Art Visiting Committee: Audrey and Jim Foster, Barbara Lee Endowment for Contemporary Art, Robert and Jane Burke, Henry and Lois Foster Contemporary Purchase Fund, Ann and Graham Gund, Elizabeth and Woody Ives, Joyce and Edward Linde, JoAnn McGrath, Davis and Carol Noble, John and Amy Berylson, Lorraine and Alan Bressler, Catherine and Paul Buttenwieser, Robert and Esta Epstein, The Fine Family Foundation, Sandra and Gerald Fineberg, Eloise and Arthur Hodges, Ellen and Robert Jaffe, Richard and Nancy Lubin, Susan W. Paine, Elizabeth and Samuel Thorne, Gail and Ernst von Metzsch, Stephen and Dorothy Weber, Rhonda and Michael Zinner, Karin and David Chamberlain, Marlene and David Persky, Ann Beha and Robert Radloff, Jan Colombi and Jay Reeg, Marcia Kamentsky, Alexandra and Max Metral, Joan Margot Smith, Marvin and Ann Collier, Jerry Scally, Martin and Deborah Hale, Katherine R. Kirk, Allison D. Salke, Gwendolyn DuBois Shaw, Robert and Bettye Freeman, Joan and Michael Salke, and Lois B. Torf 2005.339

Figure Illustrations

p. 6, fig. 1

Enrico Meneghelli

American (born in Italy), 1853–after 1912 The Picture Gallery in the Old Museum,

Oil on paperboard

16 x 12 in. (40.6 x 30.5 cm)

Gift of Hollis French RES.12.2

p.8, fig. 2

K. Calhoun

American, active in early 20th century Copley Square with Trinity Church and the Old Museum, 1911

Pastel and graphite on paperboard

 $5\frac{1}{2}$ x $11\frac{1}{8}$ in. (14 x 28.3 cm)

Gift of George H. Edgell 39.803

p. 10, fig. 3

Photograph of Morse, Okakura, Fenollosa, and Bigelow, 1882, Japan.

p. 10, fig. 4

Visitors to the MFA, 1910. The object on

view is:

Seated statue of Ramesses II Egypt (temple of Wadjet, Tell Nabasha)

New Kingdom, Dynasty 19, reign of Ramesses II. 1279–1213 B.C.

Granodiorite

H. 8011/16 in. (205 cm)

Egypt Exploration Fund by

subscription 87.111

p. 11, fig. 5

John Singer Sargent

American, 1856–1925

Portrait of Guy Lowell, 1917

Charcoal on paper

Sheet: 24% x 181/4 in. (62.5 x 46.4 cm)

Gift of Mrs. Guy Lowell 27.217

p. 11, fig. 6

Poster illustrating Guy Lowell's 1907 building plan for the MFA buildings on

Huntington Avenue.

p. 12, fig. 7

Paul Cézanne

French, 1839–1906

Fruit and a Jug on a Table, about

1890-94

Oil on canvas

123/4 x 16 in. (32.4 x 40.6 cm)

Bequest of John T. Spaulding 48.524

p. 12, fig. 8

Vincent van Gogh

Dutch (worked in France), 1853-1890

Lullaby: Madame Augustine Roulin

Rocking a Cradle (La Berceuse), 1889

Oil on canvas

36½ x 285% in. (92.7 x 72.7 cm)

Bequest of John T. Spaulding 48.548

p. 14, fig. 9

State Street Corporation Fenway
Entrance, Museum of Fine Arts, Boston,

2007.

p. 14, fig. 10

Huntington Avenue Entrance, Museum

of Fine Arts, Boston, 2007.

pp. 24-25:

fig. 11

George Reisner with George Edgell at Giza (Egypt), 1938. Harvard University—

Boston Museum of Fine Arts Expedition.

fig. 12

1

Sudanese workmen organizing the shawabtys of King Taharqa at Nuri

(Sudan), 1917. Harvard University—

Boston Museum of Fine Arts Expedition.

fig. 13

Removing the Anlamani sarcophagus at Nuri (Sudan), 1917. Harvard

University—Boston Museum of Fine

Arts Expedition.

Index of artists and works

A Pavane, 322–23
Abbey, Edwin Austin, 322–23
Adam and Eve, 171, 173
Adam, Robert, 221
Adamson, Robert, 241
Afternoon Tea Party, 327
Agbonbiofe Adeshina, 151
Alexander Fights the Monster of

Ali, Muzaffar, 144 Allston, Washington, 306 Alma-Tadema, Sir Lawrence, 241

Alexander, John White, 330

Altarpiece, 112

Habash, 142

American China Manufactory, 291 Amulet of Harsaphes, 32

An Artist in His Studio, 341
Andiron, 224

Andy Warhol, 372

Anguissola, Sofonisba, 181 Antico, 197

Apollo, 59

Apollo and the Muses on Mount

Helicon, 195

Approaching Storm: Beach near Newport, 314

Arenas, Guadelupe, 275

Artist in His Studio, 186

Architecture, 183

At the Races in the Countryside, 248

Athena Parthenos, 80

Automedon with the Horses of Achilles, 240

Avalokiteshvara, 106

Baburen, Dirck van, 201

Bacino di San Marco, Venice, 213

Bactrian camel, 111

Bakst, Lèon Nikolaievitch, 356–57

Ballgame yoke, 267

Baptism of Christ, 161

"Barna da Siena," 163

Batō Kannon, the Horse-Headed Bodhisattva of Compassion, 132

Beaker or tunn, 286

Beakers, 37

Beckmann, Max, 365

Behrens, Balthasar Friedrich, 216

Bellange, Jacques, 185

Bent-corner chief's chest, 276

Bergère, 224

Beuys, Joseph, 379

Bhairava or Mahakala, 102

Bierstadt, Albert, 318 Birch, Thomas, 313 Birth of a Prince, 96

Bishamonten, the Guardian of the North, with His Retinue, 133

Bishandas, 96

Black Numbers, 369

Black Panel II, 383

Blackburn, Joseph, 289

Rlake William, 226

Blake, William, 226
Blue Boat, The, 338

Bocca Baciata (Lips That Have Been

Kissed), 239 Bodhisattva, 92

Bonacolsi, Pier Jacopo Alari, 197

Bone Player, The, 310-16

Boston Common at Twilight, 322

Bottle, 112

Boucher, François, 212

Bourke-White, Margaret, 359

Bowl, 143

Bowl for mixing wine and water

(krater), 63, 64
Bowl lyre (ndongo), 155

Boys in a Pasture, 337

Bracelets, 73
Bread basket, 285
Breakthrough II, 360

Bright, George, 298

Brisé fan, 228

Brisé fan depicting Gothic church ruins, 228

Broadwood, John, and Son, 223

Buddha of Eternal Life and eight bodhisattyas, 107

Buddha of Medicine, 127

Bull, The, 242-43

Bureau-cabinet, 218-19

Burial urn, 268

 $Bust\ of\ Beatrice, 227$

 $Bust\ of\ Cleopatra, 197$

Bust of Prince Ankhhaf, 20

Butterfly, The, 356–57

Cabinet, 238, 320

Caillebotte, Gustave, 252

Cameo, 77, 77

Camma Offers the Poisoned Wedding

Cup to Synorix in the Temple of

Diana, 196

Canaletto (Giovanni Antonio Canal), 213

Canoe prow, 148

Canova, Antonio, 227

Card table, 288

Carmelina, 352-53

Cassatt, Mary Stevenson, 325, 327

Castor and Pollux, 316

Cathedra (bishop's chair), 218-29

Caton, Antoine, 223

Ceremonial hanging (palepai), 102-3

Ceremonial hanging (patola), 97

Cézanne, Paul, 256, 257

Chalice, 89

Chalice and paten, 320

Chandelier, 216

Chapin, Mary S., 313

Chardin, Jean Siméon, 207

Chase, The, 385

Chelsea Manufactory, 210

Chen Rong, 120

Chest-on-chest, 284, 292-93 Dance at Bougival, 254 Eakins, Thomas, 343 Christ Crucified (The Three Crosses), 187 Dancer, 70 Earring, 53, 68 Christ in Majesty with Symbols of the Dancing celestial figure (apsaras), 101 Edmondo and Thérèse Morbilli, 249 Four Evangelists, 160 Dandelions, 238 Effigy pendant, 270 Chronos (Allegory of Time), 177 Daniel, Peter, and Andrew Oliver, 283 Effner, Josef, 211 Cistern and fountain, 203 Daughters of Edward Darley Boit, El Greco (Domenikos Clock, 184 The. 324 Theotokopoulos), 180 Clodion, 225 Dave the Potter, 334-35 Elijah in the Desert, 306 Cloth painting (pechhavai), 99 Davis, Stuart, 363 Ellen Mary in a White Coat, 327 Codex-style plate, 269 Dead Christ with Angels, The, 175 Emperor Augustus, The, 76 Coffeepot, 291 Decorated spheroid jar, 45 Emperor Huizong, 116, 117 Cogswell, James, 303 Deer nursing her fawn, 58 Emperor on a Journey, The, 208 Cole, Thomas, 307 Degas, Edgar, 248, 249 Engagement between the "Constitution" Collection of The Chat Noir, 253 Delacroix, Eugène, 234-35 and the "Guerrière." 313 Commode, 303 Delaroche, Hippolyte, 225 Entombment of Christ, The, 234-35 Coney, John, 282 Delta Gamma, 367 Eternal Springtime, 252 Console table, 211 Deluge, The, 370 Evening (Melancholy), 262 Constable, John, 232 Denarius commemorating the Ewer, 101 Container, 151 assassination of Julius Caesar, 79 Ewer and basin, 128, 181 Cooper, Francis W., 320 Dennis, Thomas, 282 Execution of the Emperor Copley, John Singleton, 294, 295, 296 Deseine, Claude-André, 222 Maximilian, 245 Corot, Jean-Baptiste-Camille, 233 Design for a water clock, 143 Expulsion from the Garden of Cortona, Pietro da, 197 Desk and bookcase, 292-93, 298, 304 Eden. 307 Council Bluffs Ferry and Group of Diana and Stag Automaton, 182 Cottonwood Trees, 319 Feeding funnel (koropata), 150 Dinner Party, The, 305 Courbet, Gustave, 235 Dish. 200 Female figure, 149 Cover with Chinese-influenced Female figurine, 56 Don Baltasar Carlos with a Dwarf, 192 motifs 218 Donatello, 169 Field, Erastus Salisbury, 334 Covered cup, 285 Fifth King of Shambhala, The, 106 Dong Qichang, 122, 123 Covered drinking cup (kylix), 65 Figurine, 58 Dove, Arthur G., 366 Covered goblet (pokal), 299 Finlay, Hugh, 308 Doylestown House—The Stove, 360 Cray, 253 Fiorentino, Rosso, 175 Drake, Dave, 334-35 Credi, Lorenzo di, 167 Fish, The, 336 Drinking vessel, 49 Crivelli, Carlo, 176 Fisher, Richard, 320 Drinking vessel (cylinder vase), 268, 269 Crown, 103 Five-Colored Parakeet, The, 116 Drug Store, 362 Crucifixion, 164 Dubuffet, Jean, 376 Flight and Pursuit, 329 Crystal pendant with head of Hathor, 39 Flood, The, 225 Duccio di Buoninsegna and Cubi XVIII, 374 Flower basket, 351 Workshop, 162 Cupboard, 292 Dufrène, Maurice, 350-51 Flying Saucer dress, 381 Curtis, Lemuel, 309 Dürer, Albrecht, 173, 177 Fog Warning, The, 339 Dwarf holding a jar, 26 Fontenay, Jean-Baptiste Belin de, 208 Dainichi, the Buddha of Infinite Dyck, Anthony van, 198 Forest of Fontainebleau, 233 Illumination, 104-5 Fountain basin, 76

Four Sages of Mount Shang, The, 140 Fowl in Spring and Summer Landscape, 136

Fra Carnevale (Bartolomeo di Giovanni Corradini), 168

Fragment, 142

Fragment of a curtain, 88-89

Fragment of a shroud, 158

Fragment of a victory stele, 48

Fray Hortensio Félix Paravicino, 180

Freake-Gibbs painter, 281

Friedell, Clemens, 346

Fries, Joachim, 182

Fruit basket, 291

Fruit Displayed on a Stand, 252

Fueter, Daniel Christian, 285

Funerary relief, 82

Funerary stele, 44

Furnishing fabric, 350-51

Furnishing panel, 247

Gainsborough, Thomas, 215

Ganesha with his consorts, 94

Garaku Risuke, 141

García, Antonio López, 375

Garrowby Hill, 382

Gauguin, Paul, 260, 261

George Washington, 300

George Washington Bridge, The, 359

Georgia O'Keeffe, A Portrait (6), 355

Germain, François-Thomas, 207

Gérôme, Jean-Léon, 240

Giambologna (Jean Boulogne), 183

Giant, The, 242-43

Gift basket, 188

Girandole wall clock, 309

Glove, 200

Gogh, Vincent van, 258, 259

Goldin, Nan, 360-61

Gong Xian, 124

Gorham Manufacturing Company, 332

Gorky, Arshile, 357

Gourds, Hibiscus, Chrysanthemums, and Pine Tree. 126–27 Goya y Lucientes, Francisco, 227, 242

Granary jar, 108

Grand piano, 223

Grecian couch, 308

Greenough, Horatio, 316

Greuze, Jean-Baptiste, 214

Grotto by the Seaside in the Kingdom of Naples with Banditti, Sunset, 221

Guanvin, 110

Guercino (Giovanni Francesco

Barbieri), 189

Guitar, 205

Guston, Philip, 370

Gypsy Man Holding a Blank Shield, 242

Gypsy Woman with Two Children Holding a Blank Shield, 242

Hale, Ellen Day, 328

Halt at the Spring, 212

Harnett, William Michael, 331

Hartley, Marsden, 356

Harvesters Resting (Ruth and Boaz),

236

Hassam, Childe, 322

Hawes, Josiah Johnson, 323

Head of a nobleman (The Josephson

Head), 28

Head of a priest (The Boston Green

Head), 33

Head of a Woman, 354

Head of a Youth, 167

Head of Aphrodite, 67

Head of Gudea, 49

Headdress (ogbodo enyi), 152

Heade, Martin Johnson, 314, 321

Henry Pelham (Boy with a Squirrel), 294

Hermes Kriophoros, 61

Heroine Rushing to Her Lover

(Abhisarika nayika), 100

Herter Brothers, 320

High chest of drawers, 290, 292

Hill Sir David Octavius, 241

Hishikawa Moronobu, 137

Hockney, David, 382

Hoffmann, Josef, 351

Hofmann, Hans, 366-67

Homer, 81

Homer, Winslow, 337, 338, 339

Honoré-Gabriel Riqueti, comte de

Mirabeau, 222

Hopper, Edward, 362

 $Hot \, Still\text{-}Scape \, for \, Six \, Colors\text{---}7th$

Avenue Style, 363

Houdon, Jean-Antoine, 222

Houses at Auvers, 259

Hull, John, 286

Humphreys, Richard, 291

Hurd, Jacob, 285

Huysum, Jan van, 202-3

If the Double Helix Wakes Up..., 386

In the Loge, 325

Incense burner, 111

Interior face of the outer coffin of

Djehutynakht, 23

Interior of a Mosque, Cairo, 328-29

Irises, 358

Isaac Winslow and His Family, 289

Isabella and the Pot of Basil, 330

Itō Jakuchū, 140

Jackson, Sally, 288

Jacopo, Giovanni Battista di, 175

Jakuchū, 140

Jar. 121

Jar (pelike), 68

John Eld of Seighford Hall, 215

Johns, Jasper, 369

Joined chest, 282

Jojo at Home, New York City, 360-61

Jordaens, Jacob, 191

Joseph Moore and His Family, 334

Kaikei, 133

Kandinsky, Wassily, 350

Kano Shōei, 136

Karsh, Yousuf, 370-71, 372

Kelly, Ellsworth, 383

Kent, William, 216 Little Garden of Love, The, 170 Matisse, Henri, 352-53, 365 Kesi tapestry, 122 Lohan Manifestina Himself as an McIntire, Samuel, 292 Keyed bugle in E-flat, 332 Eleven-Headed Guanvin, 118 Meléndez, Luis, 206 King Aspelta, 42 López García, Antonio, 375 Mendini, Alessandro, 381 Lorrain, Claude (Claude Gellée), 195 King Menkaure (Mycerinus) and Michel, Claude, 225 queen, 18 Lotto, Lorenzo, 179 Millet, Jean-François, 236, 237, 238 King Tutankhamen, 31 Louis, Morris, 367 Milliner's Shop, The, 214 Kirchner, Ernst Ludwig, 352 Lovers, 138 Miniature dagger, 39 Kitagawa Utamaro, 138 Lovers (mithuna), 94 Minister Kibi's Trip to China, 132 Kline, Franz, 368 Luis de Góngora y Argote, 192 Miroku, the Bodhisattva of the Future, Kokoschka, Oskar, 353 Lute (pipa), 119 Kuramata, Shiro, 380 Lute (tambura), 100 Mirror, 130 Lutz, Ignatius, 316 Miss Blanche 380 L'Eminence Grise, 340 Missal stand (atril), 299 L'Enqueteur, 376 Mack, Lajos, 262 Miyake, Issev, 381 La Farge, John, 336 Madame Cézanne in a Red Armchair. Monet, Claude, 250, 251 La Japonaise (Camille Monet in 257 Monnoyer, Jean-Baptiste, 208 Japanese Costume), 251 Madonna and Child, 159 Moronobu, 137 La Perspective (View through the Trees Madonna of the Clouds, 169 Morris, William, 253 in the Park of Pierre Crozat), 204 Maharao Kishor Singh of Kota Mosaic, 84-85 Labyrinths, 374-75 Worshipping Brijrajji, 98 Mosaic bowl. 73 Lacquer tray, 121 Male and female figurines, 46 Moses and Israelites after the Miracle Ladies Preparing Newly Woven Silk, 117 Male spear thrower or dancer, 93 of Water from the Rock, 178 Lady's writing table with tambour Maloof, Sam. 380 Mother and Child in a Boat, 344 shutters, 302 Man's robe (chuba) of Chinese Mount Starr King, Yosemite, No. 69, 319 Lager, 377 fabric, 125 Mount, William Sidney, 310-11 Lamentation over the Dead Christ, 176 Man's wrapper, 155 Mountain goat, 47 Landscape with Bog Trunks (Work in Manaku, 98 Mrs. Elizabeth (Johnstone) Hall, Seated the Fields), 259 Manet, Edouard, 244, 245 Newhaven Fishwife, 241 Landscape with the Construction of a Mantle, 272 Mrs. Fiske Warren (Gretchen Osgood) Classical Temple, 197 Margaret Gibbs, 280-81 and Her Daughter Rachel, 340 Lane, Fitz Henry, 312 Marquis de Pastoret, 225 Mrs. James Warren (Mercy Otis), 294 Layette basket, 188 Mars and Venus, 194 Mummy mask, 31 Le Sueur, Eustache, 196 Martha Washington, 300 Munch, Edvard, 262, 263 Leaf of a landscape album, 124 Martyrdom of Saint Hippolytus, 174 Murakami, Takashi, 386 Leather great chair, 281 Mask, 266-67 Mutschele, Franz Martin, 210 Leg from a funerary bed, 40 Mask (deangle), 153 Mystic Marriage of Saint Catherine. Length of velvet, 169 Mask (kifwebe), 154 The, 163 Lewis J. Miles Factory, 334 Mask fan. 228 Leyden, Lucas van, 178 Master of the Boccaccio Illustrations. Narcissus, 173 Libation bowl, 60 171 Neagle, John, 301 Lilith. 383 Master of the Gardens of Love, 170 Neck ornament, 87 Lincoln Children, The, 317 Master of the Housebook (Master of New Bremen Glass Manufactory, 299

the Amsterdam Cabinet), 242

Lion, 50-51

New Necklace, The, 347	Picture Gallery with Views of Modern	Qi Baishi, 126–27
Night Attack on the Sanjō Palace, 135	Rome, 220	Quarry (La Curée), The, 235
Nine Dragons, 120	Piercy, Frederick Hawkins, 319	Quervelle, Anthony, 304
Nocturne in Blue and Silver: The	Pissarro, Camille, 246	Raising the Alms Bowl: Conversion of
Lagoon, Venice, 342	Pitcher, 50	$Hariti\ to\ Buddhism$, 130
Nolde, Emil, 358	Plain Salt (Cardboards), 369	Rama and His Armies Encamped;
	Plate, 53, 176	One Spy Returns to Ravana, 98
O'Keeffe, Georgia, 355	Playwright Menander, The, 74	Rape of the Sabine Women, 371
Offering figures (tunjos), 271	Polke, Sigmar, 377	Rattle, 276
Oil bottle (lekythos), 70	Pollock, Jackson, 364	Rauschenberg, Robert, 360, 369
Oil flask (aryballos), 59, 60	Poltrona di Proust, 381	Reclining Nude, 227, 352, 365
Old Brooklyn Bridge, 359	Poor Man's Store, The, 333	Red Disaster, 373
Old Models, 331	Poppy Field in a Hollow near	Redon, Odilon, 247
Oliphant, 159	Giverny, 250	Regnault, Henri, 240
Once-famous Black Eagle (Ka-et-te-	Port of Saint-Cast, 254	Relief of Akhenaten as a sphinx, 30
kone-ke) of the Kiowa in Deadly	Portrait of a man, 71, 78	Relief of Nofer, 22
Conflict with Ute Chief. Ute Killed.,	Portrait of a woman, 82	Reliquary shrine ("Emly Shrine"), 158
The, 374	Portrait of a Woman, 354	Rembrandt Harmensz. van Rijn,
Onion teapot, 379	Portrait of a Young Married Couple, 191	186, 187
Otis, Hannah, 287	Portrait of Woman in Nine Oval	Renoir, Pierre-Auguste, 246, 254
Oval dish, 182	Views, 323	"Reserve head" of a woman, 20
Owl's Head, Penobscot Bay, Maine, 312	Poster for the First Phalanx	"Reserve head" of Nofer, 22
	Exhibition, 350	Revere, Paul, 297
Pablo Picasso, 370–71	Postman Joseph Roulin, 258	Rich Soil Down There, The, 387
Painting No. 2, 356	Potlatch figure, 277	Richmond Race Cup, The, 220–21
Palissy, Bernard, 182	Poussin, Nicolas, 194	Richter, Gerhard, 378
Pannini, Giovanni Paulo, 220	Power figure (nkisi nkonde), 153	Rijn, Rembrandt Harmensz. van,
Passion Flowers and Hummingbirds, 321	Powers, Harriet, 345	186, 187
Pat Lyon at the Forge, 301	Prendergast, Maurice Brazil, 346	Rimmer, William, 329
Paul Revere, 296	Presentation of the Virgin in the	Risuke, 141
Paxton, William McGregor, 347	Temple, 168	Ritual vessel with cover (you) , 109
Peacock weathervane, 334–35	Princess Mary, Daughter of	Robe for the Nō theater ($karaori$), 141
Pectoral, 28–29, 271	Charles I, 198	Rocking chair, 380
Pendant on a chain, 32	Prip, John, 379	Rocky Landscape with Church Tower
Penniman, John Ritto, 303	Probst I, 368	in the Distance, 184
Pennsylvania Farmstead with Many	Procession of offering bearers, 22–23	Rodin, Auguste, 252
Fences, 314–15	Procuress, The, 201	Rossetti, Dante Gabriel, 239
Persian guard, A, 52	Protective Spirit, 50–51	Rossigliani, Giuseppe Niccolò, 177
Petel, Georg, 191	Ptahkhenuwy and his wife, 19	Rothenberg, Susan, 385
Peto, John Frederick, 333	Punch bowl, 346	Rouen Cathedral Façade and Tour
Picasso, Pablo, 242, 354, 371	Punch bowl from the $\it Jazz Bowl$	d'Albane (Morning Effect), 250
Pictorial carpet, 96	series, 363	Rubens, Peter Paul, 190
Pictorial quilt, 345		Ruisdael, Jacob Isaacksz. van, 202

Sacrifice of the Old Covenant, The, 190 Shawabty figures of King Taharqa, 41 Statue of Lady Sennuwy, 27 Saddle, 171 Sheeler, Charles, 360, 362 Steen, Jan Havicksz., 199 Saichi, 134 Sheraton, Thomas, 223 Steinlen, Théophile-Alexandre, 253 Saint Catherine of Alexandria at Sherman, Cindy, 384 Stele of the Nubian soldier Nenu, 36 Prayer, 179 Shitao, 130 Stella, Joseph, 359 Saint Francis, 193 Shiva, 95 Stevens, John J., 326 Saint Jerome Seated near a Pollard $Sh\bar{o}\ Kannon, the\ Bodhisattva\ of$ Stieglitz, Alfred, 355 Willow, 177 Compassion, 134 Still Life with Fruit, Wan-Li Porcelain. Saint Luke Drawing the Virgin, 165 Shōei, 136 and Squirrel, 185 Sampler, 288 Shōhaku, 140 Still Life with Melon and Pears, 206 Samson and Lion Aquamanile, 161 Shrine, 45 Still Life with Teapot, Grapes, Sanderson, Sr., Robert, 286 Side chair, 314-15 Chestnuts, and a Pear, 207 Sarcophagus, 83 Sideboard, 316 Still Life with Three Skulls, 365 Sarcophagus lid, 72 Signac, Paul, 256 Stonehenge at Daybreak, 231 Sarcophagus of Queen Hatshepsut, Silver Horn (Huangooah), 274 Storage jar, 202, 334-35 recut for her father, Thutmosis I, 29 Simplon Pass: The Tease, 341 Stour Valley and Dedham Church, 232 Sarcophagus or cinerary urn, 71 Sink and Mirror (Lavabo y espejo), 375 Street Singer, 244 Sargent, Henry, 305 Slave Ship (Slavers Throwing Over-Stuart, Gilbert, 300 Sargent, John Singer, 324, 340, 341 board the Dead and Dying, Typhoon $Study for {\it Nighttime}, Enigma, and$ Sauceboat and Stand, 207 Coming On), 230 Nostalgia, 357 Scenes from the Nakamura Kabuki Sleeping Watchdog, 187 Study for the painting In the Loge, 325 Theater and the Yoshiwara Pleasure Smibert, John, 283 Sudek, Josef, 374-75 Quarter, 137 Smith, Daniel, 221 Sugar bowl and creampot, 297 Schiele, Egon, 358 Smith, David, 374 Sugar box, 282 Schiele's Wife with Her Little Smith, Kiki, 383 Sully, Thomas, 310 Nephew, 358 Snake pitcher, 332 Summer Mist along the Lakeshore, Schreckengost, Viktor, 363 Snyders, Frans, 185 Seated dancer, 86-87 Soga Shōhaku, 140 Summer Night's Dream (The Voice), 263 Seated Sekhmet, 26 Solitude, 313 Summer robe (katabira), 139 Segers, Hercules, 184 Sons of Liberty Bowl, 297 Sunlight on the Road, Pontoise, 246 Seine at Chatou, The, 246 Souper Dress, 372 Sutra of Perfect Enlightenment, 129 Self-Portrait, 181, 328 Southworth, Albert Sands, 323 Semiramis Receiving Word of the Sower, The, 237 Takeshiba Toshiteru and others, 134 Revolt of Babylon, 189 Talbert, Bruce, 238 Soyez amoreuses vous serez heureuses Sené, Jean-Baptiste-Claude, 224 (Be In Love and You Will Be Happy), Tanner, Henry Ossawa, 328-29 Set of matched mountings for a long 261 Tarbell, Edmund Charles, 344 and a short sword (daisho) with Spoon, 167 Tassie, James, 223 design of autumn plants and insects, Spouted jar, 57 Tea bowl, 119 134-35 Standing bird figure (porpianong), 152 Tears (Les pleurs), 247 Seymour, John, 302 Standing Figure, 354 Temptation and Fall of Eve (Illustration Seymour, Thomas, 302, 303 Standing youth, 108 to Milton's Paradise Lost), The, 226 Shaka, the Historical Buddha, Starting Out after Rail, 343 Ten drachma coin, 79 Preaching on Vulture Peak, 131 Stately Trees Offering Midday Shade, 123 That Red One, 366 Sharp, Robert, 221

Thirteen Emperors, The, 113 Thomas Jefferson, 222 Thomire, Pierre-Philippe, 224 Three Graces, The, 191 Three Studies of a Woman and a Study of Her Hand Holding a Fan, 205 Three Women at the Tomb, The, 185 Three Worthies in the Fiery Furnace. 160-611 Three-sided relief, 64-65 Tiepolo, Giovanni Battista, 209 Tiepolo, Giovanni Domenico, 214 Tile panel, 145 Time Unveiling Truth, 209 Tissot, James Jacques Joseph, 255 Titian (Tiziano Vecellio), 179 Toggle (netsuke) in the form of a hare scratching its chin with its right hind leg, 141 Tomb group of Nesmutaatneru, 34-35 Tomb treasure of King Aspelta, 43 Torn Hat, The, 310 Torso of a fertility goddess (yakshi), 93 Tray, 275 Tray with design of shells, weeds, grasses, and family crests, 138-39 Triad of King Menkaure (Mycerinus) with the goddess Hathor and the deified Hare nome, 21 Triptych: The Crucifixion: The Redeemer with Angels; Saint Nicholas; Saint Gregory, 162 Troubled Queen, 364 Tryphon, 77 Tunic fragment, 273 Tureen with lid; stand, 210-11 Turn in the Road, 256-57 Turner, Joseph Mallord William, 230, 231 Twelfth-Night Feast, 199 Twilight, 366-67 Two Nudes (Lovers), 353

Two-handled cup (skyphos), 74

Two-handled jar (amphora), 61, 66

Umbrellas in the Rain, 346 Untitled #282,384 Untitled (Blackboard), 379 Upper part of a grave stele, 62 Urbino, Nicola da, 176 Utamaro, 138 Valley of the Yosemite, 318 Vase, 378 Vase, 223, 262 Vase (maebyong), 128 Vase of Flowers, 336 Vase of Flowers in a Niche, 202-3 Velázquez, Diego Rodríguez de Silva y, Vernansal, Guy Louis, 208 Vessel for mixing wine and water (krater), 57, 69 Vessel in the form of a hare, 47 Vessel in the shape of a bound oryx, 40 Vicentino, 176 Victorine Meurent, 244 View of Alkmaar, 202 View of Boston Common, 287 View of New York, 362 Violinist, The, 248-49 Virgin and Child, 210 Virgin and Child on the crescent moon, 164 Virgin and Child with Saints Jerome and Nicholas of Tolentino, 179 Voboam, Nicholas Alexandre, II, 205 Votive double ax. 56

Walker, Kara, 387
Walking dress, 326
Wall painting, 75
Warhol, Andy, 373
Water jar (hydria), 63
Waters, Susan Catherine Moore, 317
Watkins, Carleton E., 319
Watson and the Shark, 295
Watteau, Antoine, 204, 205
Weary, 342

Wedgwood, Josiah, 223 Westwood, Vivienne, 217 Weyden, Rogier van der, 165 Where Do We Come From? What Are We? Where Are We Going?, 260 Whistler, James Abbott McNeill, 342 White Cockatoo on a Pine Branch, 140 White Hat, The, 214 White Rose with Larkspur No. 2, 355 Whitman, Thomas, 303 Wiener Werkstätte, 351 Wild Men and Moors, 166 Willaume I, David, 203 Willson, Mary Ann, 334 Window with Eight Apostles and Other Saints, 172 Wine cup, 286 Winged Isis pectoral, 38 Woman and Flowers (Opus LIX), 241 Woman grinding grain, 19 Woman's buckle shoe, 217 Woman's ceremonial skirt (ntchak), 154 Woman's coat (munisak), 145 Woman's formal dress, 216 Woman's jacket, 183 Woman's shoe, 217 Woman's slipper, 217 Women of Paris: The Circus Lover, 255 Wright, Elbridge G., 332

Wright, Joseph, 221

Yan Liben, 113

Young Prince Holding Flowers, A, 144

Young Woman Wearing a Turban, 334

Zhao Lingrang, 114
Zhou Jichang, 118
Zsolnay Manufactory, 262
Zurbarán, Francisco de, 193

Credits

Grateful acknowledgment is made to the copyright holders for permission to reproduce the following works:

Max Beckman, Still Life with Three Skulls, 1945. © 2008 Artists Rights Society (ARS), New York / VG Bild-Kunst. Bonn

Joseph Beuys, *Untitled (Blackboard)*, 1973. © 2008 Artists Rights Society (ARS), New York / VG Bild-Kunst, Bonn

Margaret Bourke-White, The George
Washington Bridge, 1933. © Estate of
Margaret Bourke-White / Licensed by
VAGA. New York, NY

Stuart Davis, Hot Still-Scape for Six Colors—7th Avenue Style, 1940. Art © Estate of Stuart Davis / Licensed by VAGA. New York. NY

Arthur Garfield Dove, *That Red One*, 1944. Courtesy of the Estate of Arthur G. Dove.

Jean Dubuffet, L'Enquêteur, 1973.
© 2008 Artists Rights Society (ARS),
New York / ADAGP, Paris

Antonio Lopez Garcia, Sink and Mirror, 1967. © Antonio López García, courtesy, Marlborough Gallery, New York

Arshile Gorky, Study for Nighttime, Enigma and Nostalgia, 1931–32. © 2008 Artists Rights Society (ARS), New York Philip Guston, *The Deluge*, 1969. © The Estate of Philip Guston Courtesy McKee Gallery, NY

David Hockney, *Garrowby Hill*, 1998. © David Hockney

Jasper Johns, *Numbers*, 1960. Art

© Jasper Johns / Licensed by VAGA,
New York, NY

Wassily Kandinsky, *Poster for First Phalanx Exhibition*, 1901. © 2008 Artists

Rights Society (ARS), New York / ADAGP,

Paris

Yousuf Karsh, Pablo Picasso, 1954. © Estate of Yousuf Karsh

Yousuf Karsh, *Andy Warhol*, 1979. © Estate of Yousuf Karsh

Ellsworth Kelly, *Black Panel II*, 1985. © Ellsworth Kelly

Franz Kline, *Probst I*, 1960. © 2008 The Franz Kline Estate / Artists Rights Society (ARS), New York

Oskar Kokoschka, *Two Nudes (Lovers)*, 1913. © 2008 Artists Rights Society (ARS), New York / Pro Litteris, Zurich

Morris Louis, *Delta Gamma*, 1959. © 1960 Morris Louis

Henri Matisse, Reclining Nude, 1946.
© 2008 Succession H. Matisse, Paris /
Artists Rights Society (ARS), New York

Henri Matisse, *Carmelina*, 1903. © 2008 Succession H. Matisse, Paris / Artists Rights Society (ARS), New York

Edvard Munch, Evening (Melancholy), 1896. © 2008 The Munch Museum / The Munch-Ellingsen Group / Artists Rights Society (ARS), New York

Edvard Munch, Summer Night's Dream (The Voice), 1893. © 2008 The Munch Museum / The Munch-Ellingsen Group / Artists Rights Society (ARS), New York

Takashi Murakami, *If the Double Helix Wakes Up...*, 2002. Courtesy of Marianne Boesky Gallery, New York. © 2002
Takashi Murakami/Kaikai Kiki Co., Ltd.
All Rights Reserved.

Emil Nolde, *Irises*. © Nolde Stiftung Seebüll

Pablo Picasso, Standing Figure, 1908.

© 2008 Estate of Pablo Picasso / Artists
Rights Society (ARS), New York

Pablo Picasso, Rape of the Sabine
Women, 1963. © 2008 Estate of Pablo
Picasso / Artists Rights Society (ARS),
New York

Pablo Picasso, *The Bull*, December 18, 1945. © 2008 Estate of Pablo Picasso / Artists Rights Society (ARS), New York

Pablo Picasso, *The Bull*, December 26, 1945. © 2008 Estate of Pablo Picasso / Artists Rights Society (ARS), New York Pablo Picasso, The Bull, December 28, 1945. © 2008 Estate of Pablo Picasso / Artists Rights Society (ARS), New York

Pablo Picasso, The Bull, January 2, 1946. © 2008 Estate of Pablo Picasso / Artists Rights Society (ARS), New York

Pablo Picasso, The Bull, January 5, 1946. © 2008 Estate of Pablo Picasso / Artists Rights Society (ARS), New York

Pablo Picasso, The Bull, January 17, 1946. © 2008 Estate of Pablo Picasso / Artists Rights Society (ARS), New York

Pablo Picasso, Head of a Woman, 1909. © 2008 Estate of Pablo Picasso / Artists Rights Society (ARS), New York

Pablo Picasso, Portrait of a Woman, 1910. © 2008 Estate of Pablo Picasso / Artists Rights Society (ARS), New York

Sigmar Polke, Lager, 1982. © Sigmar Polke

Jackson Pollock, Troubled Queen, 1945. © 2008 Pollock-Krasner Foundation / Artists Rights Society (ARS), New York

Robert Rauschenberg, Breakthrough II, 1965. Art © Rauschenberg Estate and U.L.A.E. / Licensed by VAGA, New York, NY. Published by U.L.A.E.

Robert Rauschenberg, Plain Salt (Cardboards), 1971. Art © Rauschenberg Estate and U.L.A.E./Licensed by VAGA, New York, NY

Gerhard Richter, Vase, 1984. Courtesy of the artist and Marian Goodman Gallery, New York

Susan Rothenberg, The Chase, 1999. © 2008 Susan Rothenberg / Artists Rights Society (ARS), New York

Cindy Sherman, Untitled #282, 1993. Courtesy of the Artist and Metro Pictures Gallery

David Smith, Cubi XVIII, 1964. Art © Estate of David Smith/Licensed by VAGA, New York, NY

Alfred Stieglitz, Georgia O'Keeffe: A Portrait (6), 1918. © 2007 Georgia O'Keeffe Museum / Artist Rights Society (ARS), New York

Josef Sudek, Labyrinths, 1969. © Anna Fárová

Kara Walker, The Rich Soil Down There, 2002. Courtesy of Sikkema Jenkins & Co.

Andy Warhol, Red Disaster, 1963, 1985. © 2008 The Andy Warhol Foundation for the Visual Arts / Artists Rights Society (ARS), New York